W9-BZI-334

Raised
in Clay

A Chapel Hill Book

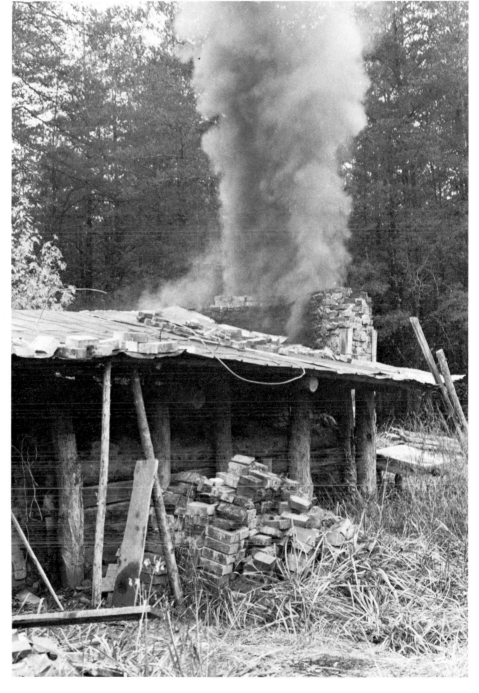

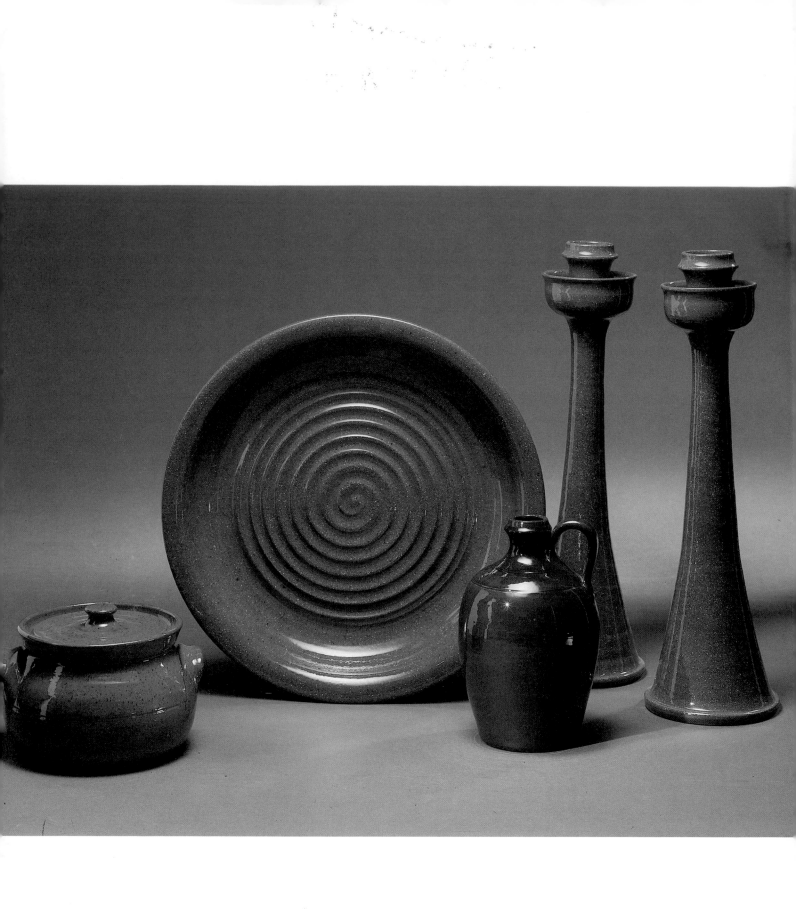

Raised in Clay

The Southern Pottery Tradition

Nancy Sweezy

With a New Afterword by the Author

The University of North Carolina Press | Chapel Hill & London

First published by The University
of North Carolina Press in 1994

Originally published by the Smithsonian
Institution Press for the Office of Folklife
Programs

Original publication of this work was
funded in part by Country Roads, Inc.,
and Office of Folklife Programs,
Smithsonian Institution.

Drawings and diagrams by Daphne
Shuttleworth
Photographs by Tom Jackson, unless
otherwise credited

Page 1: *Wood-burning kiln. Lanier
Meaders Pottery, Cleveland, Ga.*

Frontispiece: *Clear glazed earthenware.
Bean pot, by M. L. Owens, Seagrove,
N.C.; ring platter, by Vernon Owens,
Seagrove, N.C.; jug, by Dorothy Cole
Auman, Seagrove, N.C.; candlesticks, by
Vernon Owens.*
*Photograph by David Jones; courtesy
Randolph Technical College.*

Manufactured in the United States of
America

The paper in this book meets the
guidelines for permanence and durability
of the Committee on Production
Guidelines for Book Longevity of the
Council on Library Resources.

98 97 96 95 94 5 4 3 2 1

Library of Congress Cataloging-in-Publication Data
Sweezy, Nancy.
 Raised in clay : the southern pottery tradition / by Nancy Sweezy.
 p. cm.
 Originally published: Washington, D.C. : Smithsonian Institution
Press for the Office of Folklife Programs, 1984. With new afterword.
 "A Chapel Hill book."
 Includes bibliographical references.
 ISBN 0-8078-4481-0 (pbk. : alk. paper)
 1. Pottery, American—Southern States. 2. Pottery—Southern
States. 3. Potters—Southern States—Biography—History and
criticism. I. Title.
NK4011.S84 1994 94-6655
738'.0975—dc20 CIP

Contents

To the Potters

There is no conscious attempt to express anything; but the curves of the shape do express energy and control. . . . The very texture of the material has become eloquent to the touch. . . . The complete work is filled with a mysterious life like a human personality (Laurence Binyon, *The Spirit of Man in Asian Art* [New York: Dover Publications, Inc., 1965]).

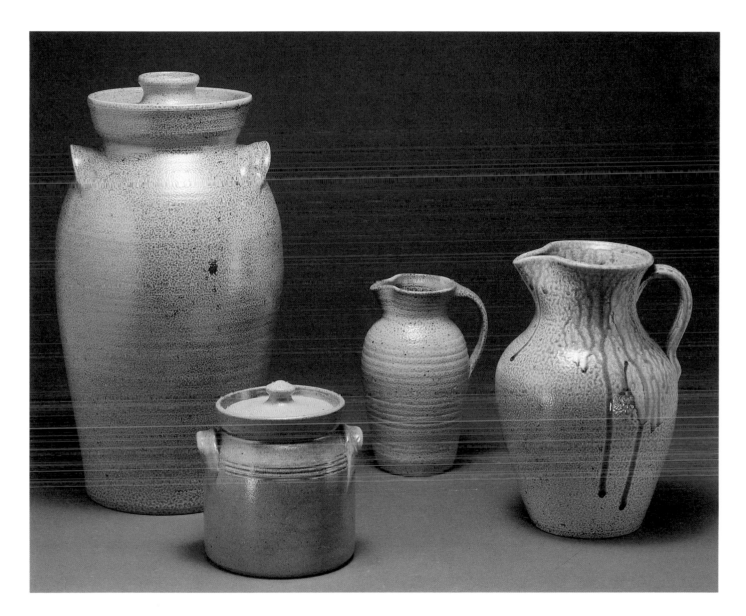

Salt-glazed stoneware. Churn, by Vernon Owens, Seagrove, N.C.; cannister, by M. L. Owens, Seagrove, N.C.; pitcher, by Danny Marley, Seagrove, N.C.; pitcher, by Charles Craven, Raleigh, N.C.
Photograph by Mike Johnson; courtesy Randolph Technical College.

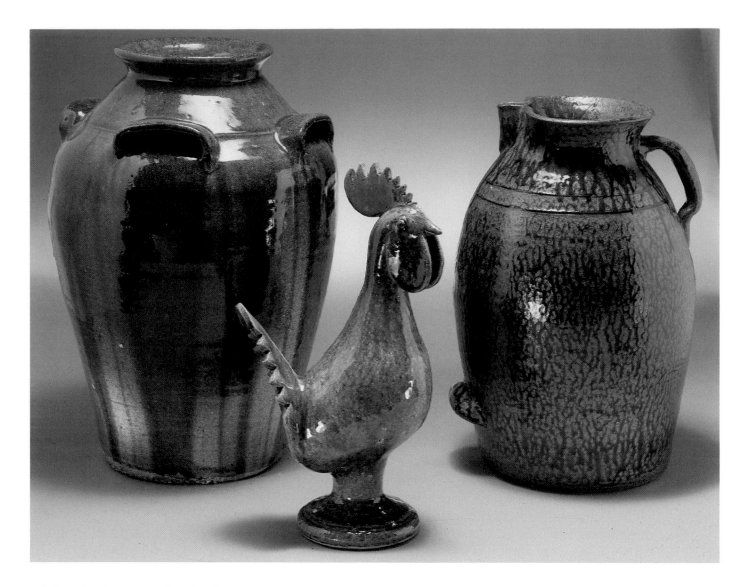

*Alkaline-glazed stoneware. Four-handle
jar, by Burlon Craig, Vale, N.C.; rooster,
by Edwin Meaders, Cleveland, Ga.;
buttermilk pitcher, by Lanier Meaders,
Cleveland, Ga.*
*Photograph by Ben Dowdy; courtesy Randolph
Technical College.*

Foreword

Ralph Rinzler
Assistant Secretary for Public Service
Smithsonian Institution

Raised in Clay is the title of both a book and a traveling exhibition produced by the Smithsonian Office of Folklife Programs as part of its ongoing research on traditional potters, their product and technology. The research documents are designed to provide insight into the cultural traditions of which these crafts are a part and to capture, in the words of the potters themselves, the function, meaning, and value of the craft product and process. For those interested in American history and cultural studies, for practicing or aspiring potters, and for the ever-increasing numbers of those who value traditional craft objects as tangible symbols of our past, these documentaries offer richly detailed accounts of folk craftsmen, their lifestyles and the traditional technologies.

In the summer of 1960, I was recording traditional musicians in the part of Appalachia where western North Carolina, eastern Tennessee, and southwestern Virginia meet. I was surprised to discover, in addition to an impressive abundance of fine musicians and repertoires, a large quantity and variety of skilled traditional craftsworkers. Most of these people carried on the traditions to provide pleasure as well as useful objects for themselves, their families, and their neighbors.

At that time, no survey of southern crafts had been carried out since Allen H. Eaton, working for the Russell Sage Foundation, traveled the area during the early 1930s in preparation for the writing of the first comprehensive report on the subject, *Handicrafts of the Southern Highlands* (1937). American folklorists in the early 1960s had not yet begun their careful study of southern material culture traditions, which began later in the decade. It seemed remarkable that such a rich body of craft traditions should be ignored by scholars, for basketry, overshot weaving, chairmaking, shingle-riving, and most common of all, quilting, were ubiquitous.

As I learned from constant travel between 1960 and 1966, potters were to be found in almost every state from Kentucky to Texas. In North Carolina alone, eighteen traditional potteries were shown on a map circulated in 1967 by Walter and Dorothy Auman, potters themselves, and founders of the Seagrove (N.C.) Potters Museum. Most enigmatic was the fact that the increasingly popular contemporary pottery movement should take its formal and technical models from northern European and Japanese contemporary potters, ignoring totally the handsome forms and glazes as well as the homemade but serviceable technical innovations of traditional southern potters. The contemporary crafts revival had grown as an urban phenomenon, influenced by sophisticated craftsworkers who exhibited in galleries and museums in the major cities of the United States and Europe. In the contemporary pottery field, production work—the making of utilitarian objects for everyday use—was the exception not the rule.

The first research I undertook when I came to the Smithsonian in 1967 was the documentation of a rural southern pottery. The owner, a man of eighty, had retained the original tools, forms, and techniques he had inherited from his older brothers who, with their father, had established a kiln site in 1893. I approached the project with urgency because the old man was ill and seemed unlikely to continue working much longer. Moreover, his sons showed little interest in continuing the craft. There existed, to my knowledge, no written or filmed documentation of these preindustrial pottery traditions, and, to this folklorist newly arrived at the Smithsonian, it seemed important that the objects in the collections be documented in a way that

would enable scholars, craftsmen, and other museum visitors to understand the way in which these objects were made and the kinds of people who made them. *The Meaders Family: North Georgia Potters*, a monograph accompanied by a sixteen-mm film (Smithsonian Folklife Studies, No. 1, 1980), was the first documentary produced by the Smithsonian Office of Folklife Programs and the Smithsonian Institution Press. Others, now in production, include a study of Korean *onggi* (utilitarian ware used in households throughout South Korea) and a study of Jugtown Pottery.

The Jugtown project was designed to complement the Meaders documentary. Jugtown could serve as an example of a southern rural pottery that, in contrast to the Meaders's operation, had been established by an urban couple who were interested in the arts and brought their own aesthetic and entrepreneurial approaches to the endeavor. Everything about the establishment of Jugtown was consciously contrived from the outsider's perspective on rural traditions. The pottery forms were based on a collection of nineteenth- and early-twentieth-century pieces collected in the area. These served as models that Jugtown's founder, Jacques Busbee, used for reference in his effort to train the eye of Ben Owen, a young man who had learned to turn from his father. Owen was hired by Busbee to serve as Jugtown's potter and taught to turn oriental forms. This mixture of Anglo and Asian forms remains a part of the contemporary Jugtown repertoire. The Meaders pottery was the least modern of the rural southern potteries I had visited, while Jugtown had been from the outset the most urban-influenced, self-consciously developed pottery, both technically and aesthetically.

The Meaders and Korean projects were collaborative fieldwork efforts between myself and anthropologist Dr. Robert Sayers, the principal author of the two monographs. In the case of the Jugtown project, as well as this book and the exhibition mounted in conjunction with it, the concepts and planning grew out of the earlier pottery projects. Nancy Sweezy, accomplished potter and director of Jugtown for fifteen years, conducted the fieldwork, organized the exhibition, and wrote the book. The clarity and depth of understanding with which the technology is described in *Raised in Clay* were achieved because the writer had the experience of working as a potter for more than forty years. As Mrs. Sweezy relates, the potters were surprised and intrigued to talk with a woman, who was herself an accomplished potter with an impressive ability to turn ware. They soon understood that she had also a comprehensive grasp of the many and varied problems of mixing clay bodies, glaze chemistry, firing, and kiln types, to mention a few of the challenging aspects of pottery production.

Raised in Clay, like the exhibition, was designed to document the last generation of potters to have direct contact with preindustrial pottery traditions as they existed in this country from the time of earliest colonization. Like the other studies, the book and exhibition focus on the character of the people who carry on the traditions, treating this aspect of the work as carefully as the traditions themselves. Thus one colleague jokingly commented at the first showing of the Meaders family film, "this is humanistic technography." Appropriately so! The potters, like most craftsworkers, are thoughtful people who spend hours working alone, reflecting deeply on the problems and rewards of their craft. More often than not, they are keen witted and quick to share their humor, almost as a test of the person they are addressing. They command a wealth of experiential knowledge, which they generously share with those of us who come to study them. Nancy Sweezy's knowledge of the craft enabled her to gather and to report a uniquely deep stratum of "trade secrets" of the tradition. This engaging and careful study will be of value to generations of potters, scholars, and all who share an interest in American history and culture.

Alkaline-glazed stoneware. Two-handle face jug, by Burlon Craig, Vale, N.C.; face jug, by Lanier Meaders, Cleveland, Ga. Photograph by Ben Dowdy; courtesy Randolph Technical College.

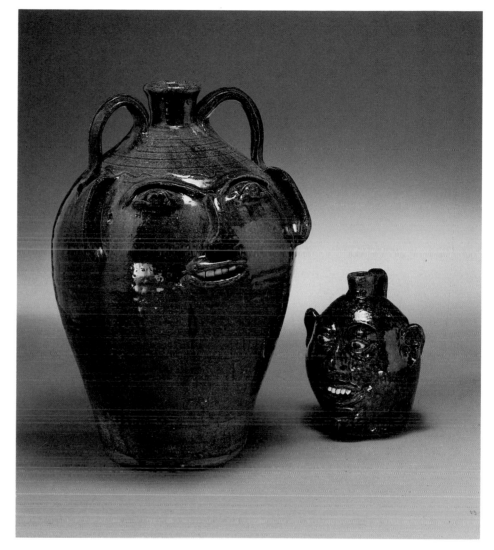

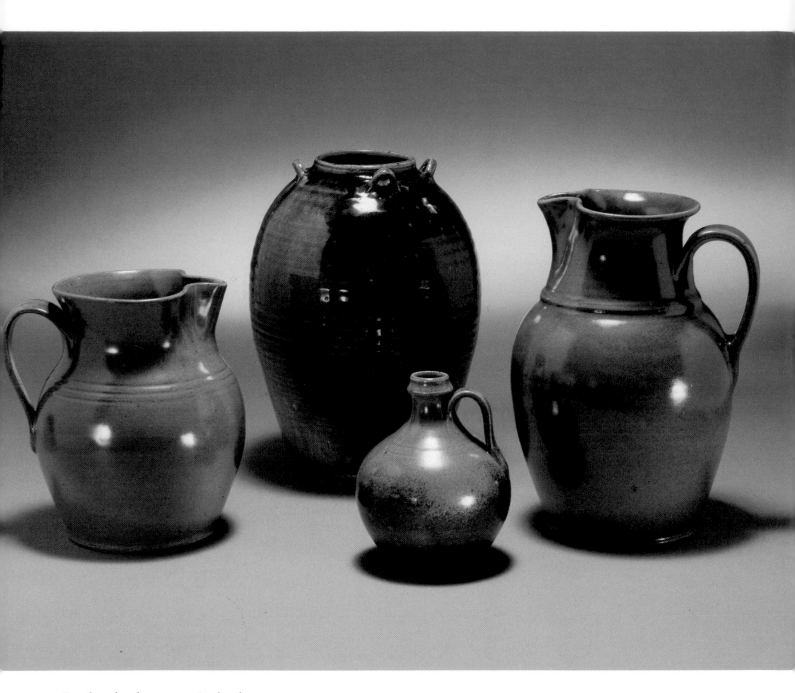

*Frogskin-glazed stoneware. Pitcher, by
Vernon Owens, Seagrove, N.C.;
four-handle vase, by David Farrell,
Seagrove, N.C.; jug, by Vernon Owens,
Seagrove, N.C.; pitcher, by Vernon
Owens, Seagrove, N.C.*
*Photograph by Leslie Bailey; courtesy Randolph
Technical College.*

Glazed ware developed in the twentieth century. Stoneware vase, glazed with chromium-bearing, locally found minerals, by D. X. Gordy, Greenville, Ga.; earthenware pitcher, with fritted feldspathic glaze, by Virginia Shelton, Seagrove, N.C.; earthenware, two-handle vase, by Jimmy Anderson, Ocean Springs, Miss.
Photograph by Leslie Bailey; courtesy Randolph Technical College.

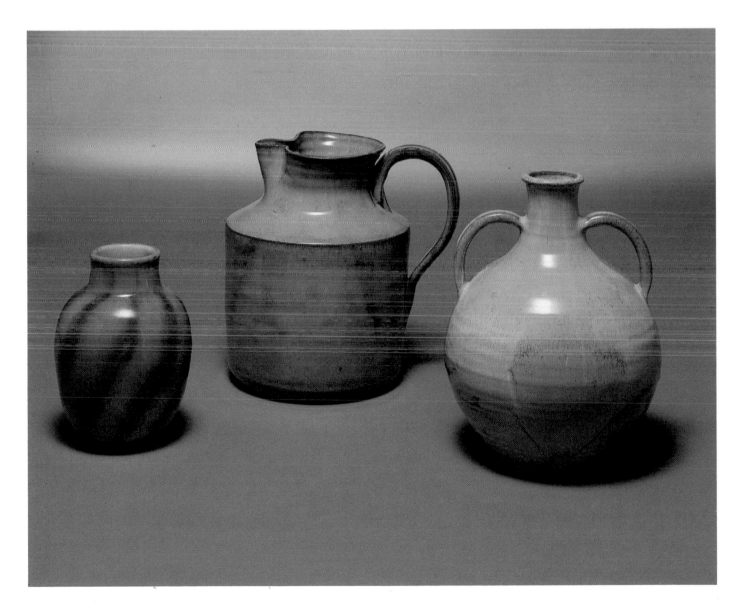

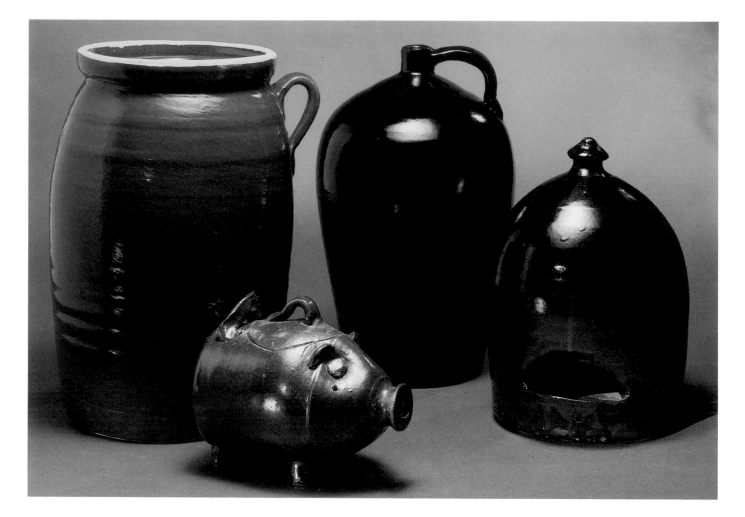

*Albany-slip glazed stoneware. Churn, by
Gerald Steward, Louisville, Miss.;
casserole, by Norman Smith, Lawley,
Ala.; jug, by Evan Brown, Skyland, N.C.;
chicken waterer, by Eric Miller, Brent,
Ala.*
*Photograph by Earl Austin; courtesy Randolph
Technical College.*

Unglazed horticultural earthenware.
Strawberry jar, by Harold Hewell,
Gillsville, Ga.; Palm Pot, by Mike
Craven, Gillsville, Ga.
Photograph by Mike Johnson; courtesy
Randolph Technical College.

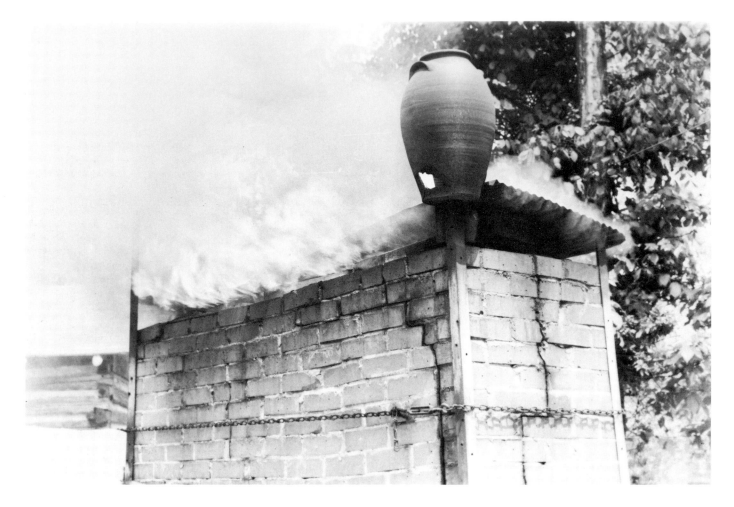

*Chimney of wood-burning kiln with
broken pot as totem. Jugtown Pottery,
Seagrove, N.C.*

Preface and Acknowledgments

The moment I took a lump of clay in my hands thirty years ago and centered it on the wheel, I related to the tactile, physical, and rhythmic experience of raising a pot from clay. I have since been involved in the profession as a potter and teacher, first in New England and later in the South.

Potters have always described the forms they produce in terms of the human body. Pots have feet, bellies, shoulders, necks, and lips. Kilns are also considered anthropomorphic beings, with faces and breasts, eyes and backbones, and unpredictable behavioral patterns. Early potters placed a kiln-god image on top of the firebox, and many of today's potters keep an old pot or some totemic object on the kiln to placate its spirit.

An old and honored pottery industry exists in the South. It is a singular and anomalous extension of a craft that was once an integral part of the American agricultural economy of the eighteenth and nineteenth centuries, continuing in the South after its products had been supplanted in other regions of the country by manufactured objects. The continuous potting industry in the South—unbroken since colonial settlement—may be the oldest traditional craft of European origin still practiced in America today.

The dual elements of continuity and change in the southern pottery tradition are here discussed. Thirty-five traditional potteries remained active in 1982; a few have retained close ties to early wares and production methods, others have developed in new directions. They all share, however, some traditional features. Most potters have been "raised in the mud," their skills and knowledge learned from earlier generations. Most use local clay, stand to turn at the wheel, and build their own kilns; some still fire their kilns with wood. All produce useful, inexpensive pottery in multiples and consider themselves craftsmen, not artists. These potteries retain deep and obvious traditional roots, and individual potters have found myriad ways to adapt their means and skills in changing times.

For twelve years, beginning in 1968, I lived and worked at Jugtown Pottery in Seagrove, North Carolina, directing the work of the pottery for Country Roads, Inc. (a nonprofit corporation) in cooperation with Vernon and Bobby Owens whose family has for many generations made pottery in North Carolina. Ongoing discussion with Ralph Rinzler (a cofounder of Country Roads and then director of the Smithsonian Institution's Office of Folklife Programs) about the evolution of southern pottery, led, in 1981, to his request that I prepare an exhibition and book on the work of traditional southern potters. I visited each of the thirty-five potteries to select one hundred works for an exhibition circulated by the Smithsonian Institution Traveling Exhibition Service and to interview the potters. All were most cooperative and generous with their time. Those potters I knew either slightly or not at all conveyed to me in subtle and rather winning ways that they would like to see me turn a pot. When I had "proved" to be a real potter, a bond was established and responses flowed. I am grateful to all the potters for their time and courtesy.

To allow the potters to tell their own story and to most accurately recapture the vitality of their experience, excerpts from personal interviews are included throughout the text. For historical information, I have also relied on the scholarship of Susan Myers, Terry Zug, John Burrison, Daniel Rhodes, Jacy Troy, and, in particular, Georgeanna Greer.

Photographer Tom Jackson of Godwin, North Carolina, played an invaluable role in the formation of the exhibition and book. In addition to taking excellent photographs, he accompanied me on a trip through the Deep South, transporting pots safely and later assisting me in the arduous task of transcribing lengthy taped interviews. He also wrote drafts for the chapter on process and equipment, developed the clay-processing chart; and provided detailed descriptions of homemade machinery so that drawings could be rendered. I owe him many thanks.

Dorothy Cole Auman and her husband, Walter, have spent many years researching North Carolina pottery traditions, especially in Moore and Randolph counties. I am particularly indebted to them for the long hours they devoted to sharing their knowledge and insights with me.

The exhaustive bibliography on southern potters and potteries was compiled by Stuart C. Schwartz, Curator of History, Mint Museum, Charlotte, North Carolina. The bibliography is a most important resource for scholars and lay readers alike.

Randolph Technical College in Asheboro, North Carolina, sponsored two extensive student photography projects, parts of which are incorporated into the book: field photography under the direction of Bob Heist and studio photography under the direction of Gib Jones. Special thanks are extended to them, to the students, and to Jerry Howell, Departmental Director.

Daphne Shuttleworth has successfully transformed complicated technical information into beautifully rendered pen-and-ink drawings for which I am deeply appreciative.

I must also gratefully acknowledge the readers of this manuscript: Susan Myers, Peter Sabin, Thomas Vennum, and Terry Zug. Sam, Lybess, and Martha Sweezy and Tom Jackson also read the manuscript and made observations that improved the text. Within the Office of Folklife Programs, Jeffrey LaRiche provided me with steadfast support. Arlene Liebenau carefully prepared on a word processor the magnetic tape from which typeset copy was generated. Cal Southworth assisted me in the processing of a large quantity of film.

Hank Willett and Joey Brackner spent a day with me in northwest Alabama, so that I could visit Jerry Brown's Pottery, and Carolyn Ellis Williams was most helpful during my trip to the Marshall Pottery in Texas.

Special thanks are extended to Ralph Rinzler, Assistant Secretary for Public Service, Smithsonian Institution, without whose confidence I would not have undertaken the project.

Three potteries, new or in transition, not included in this survey must be mentioned. In North Carolina, Ben Owen's Old Plank Road Pottery was closed from 1971 to late 1982. It has been reopened recently by Ben's son, Wade, and his grandson, Ben Owen III. Young Ben is a high school student whose potting skills are developing rapidly. Another young potter, Mack Chrisco, whose potting heritage extends back many generations, has recently opened a shop in Seagrove. While his work and outlook have been greatly influenced by the studio-pottery movement, his work is related to that of traditional potters. Finally, in Mississippi, nephews of Gerald Stewart, who were raised around a pottery, are considering the prospects of entering the trade. When I visited central Mississippi, Bill Stewart was making a small amount of Albany-slip glazed ware similar to that made by his uncle.

Historical Perspective

Pottery making in colonial America was developed by a people interacting with a new environment. Emigrant potters crossed the Atlantic bearing knowledge and skills in the making of earthen- and stoneware and, in some cases, in the making of fine earthenware and porcelain as well. The demand for fine ware was supplied in colonial times and long after by imports from England and Europe. Much of the coarser ware for daily use in settlements was also imported. Potters settling here faced a curtailed market and primitive conditions in which they had to locate their own supplies. They used the abundant red clay to make kiln brick and familiar earthenware forms, glazing the pots with a solution of ground lead and burning them in kilns of simple construction at low temperatures. When areas further inland were settled, potters responded to the needs of pioneering conditions by developing a new idiom in stoneware.

The earliest potters settled in the small but burgeoning villages of the southern American colonies, where the king's governors imposed restrictions on—among other things—the making of pottery. It was crown policy that the development of the new colonies be fostered according to established empire patterns, wherein a colony supplied raw materials for industries in the homeland and then purchased back the imported manufactured goods, including pots. Production of some utilitarian ware, however, was permitted in America. The colonists resisted policies limiting their independent growth, and restricted products were often made with the knowledge of the governing English officials. Highly skilled potters in several colonies were producing both earthen- and stoneware. The degree and competency of production was understated in reports to England by Virginia's royal governor, William Gooch, who referred to one shop owner, William Rogers (active 1720-45), as the "poor potter" of Yorktown.[1]

Of principally English and German origins, potters settling in the South came from either northern colonies or directly from Europe. Early settlers wrote home of land and opportunity, and later immigrants—bound by family, communal, religious, or trade ties—joined them. Some potters operated in coastal settlements, others soon settled further inland on the frontier, thereby gaining more open land and escaping colonial restrictions. Many settled north and west of the fall line, where the clay-based piedmont drops to the sandy coastal plains.

In the seventeenth century, the earliest settlers in Virginia are known to have made crude earthenware. During the first half of the eighteenth century, pottery making was well established in Jamestown, Virginia, and at Charleston, South Carolina; after 1750, in North Carolina, in the Moravian settlement of Bethabara and in other nearby regions of the piedmont. Discovery of the Mount Shepard pottery site near Asheboro indicates that a thriving pottery trade was operating from 1775 to 1800 on one of the four early wagon roads built upon Indian pathways in central North Carolina. Sometime after 1815 alkaline-glazed stoneware was made at Edgefield, South Carolina, and from there its production spread both southwest into north Georgia and north into the Catawba Valley of North Carolina. Salt-glazed stoneware was also being made in Moore and Randolph counties of North Carolina. Until nearly the end of the first quarter of the nineteenth century, the pottery made in the South was predominantly earthenware, and thereafter for a century it was predominantly stoneware.

The priority of settlers—including potters and other craftsmen—was, of necessity, farming. A frontier society is isolated and must be nearly self-sufficient; thus, obtaining food and shelter are its primary survival activities. Once grown, however, food must be prepared and preserved, and potters were needed to supply appropriate vessels. Charles Craven's remembrances of his childhood in the early twentieth century on a farm pottery may also be descriptive of early southern pottery work patterns:

> The best time of the year for making pottery was from when we got through with the crops until it got too cold. In early spring it'd get warm enough to work before we ever start farming. And, between time, there was a streak in there before harvest where we had right much time to work. We didn't figure we ever had no time to rest at all—no matter what the situation.

Salt-glazed in a wood-burning groundhog kiln, this pitcher, made in 1982 by Charles Craven, is typical of ware produced for daily use by generations of southern potters.
Photograph by Earl Austin; courtesy Randolph Technical College.

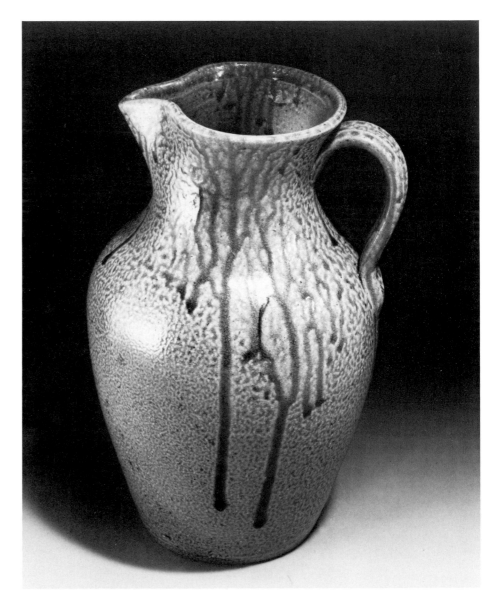

After 1820 stoneware clays were quickly adopted in the South to make the large ware essential to an agrarian economy. Food and liquid had to be contained and preserved, water cooled and transported, oil burned for light. Basins were needed for washing; containers for soap; stewpots and bread pans for open-hearth cooking; and pitchers, mugs, and bowls for the table. Milk was a farm staple, and crocks were needed for cream rising and butter storage and churns for butter making. Meat was salted, vegetables pickled, lard and tallow stored in large jars; cane syrup, vinegar, wine, and liquor were put up in jugs; fruits and jams preserved in small jars. The potters also made sieves, water coolers, funnels, measuring cups, baby bottles, animal feeders, chimney flues, spitoons, chamber pots, inkwells, clay pipes, playing marbles called "peedabs," and grave markers. Clay grave markers are scattered throughout rural regions of the South, including Alabama and Mississippi. At the Union Grove Baptist Church, built in 1885 in Seagrove, North Carolina, large jars were once used as headstones. One inscription read:

Alas, Alack the Day
The Potter Himself
Has Turned to Clay

As the South further became settled in the nineteenth century, the making of utilitarian stoneware spread west as far as Texas and evolved into a particular and distinguished regional style adapted to southern rural living.

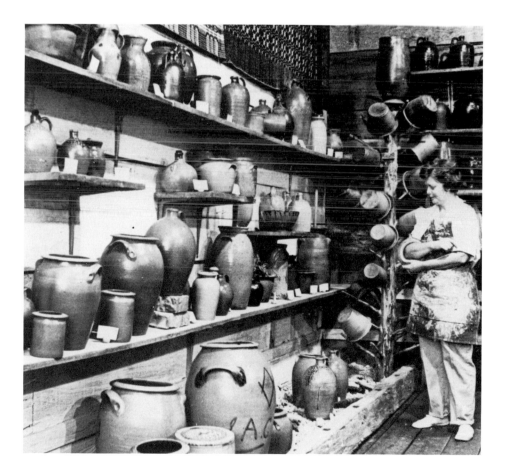

Collection of utilitarian stoneware at the Seagrove (N.C.) Potters Museum. Dorothy Cole Auman stands near a crock tree, on which milk vessels were sterilized out of doors; a ring jug is slung over her arm.
Photograph courtesy Dorothy Auman.

Although the making of stoneware required clays relatively free of iron and kilns sufficiently insulated to reach high temperatures, the setting up of a shop was a relatively simple process, as Kentucky potter Walter Cornelison describes it:

> What you needed was water, a vein of clay, and the wood that was all around. So, you just made and fired your own brick, built a kiln, and started a pottery business. I've heard tell how they would make up a load of pottery in the fall of the year—stoneware fruit jars, churns, jugs for syrup and corn whiskey—and just throw salt on 'em.

From the beginning, pottery was made with equipment constructed by the potter and operated by man and animal power. The need for stoneware grew with the population. Ware was transported beyond the locality of its production first in potters' wagons, then by wagoners who specialized in transporting and selling pottery, and later by the railroad.

Local clay was dug from a pit, then softened with water, and ground in a simple beam mill rotated by a mule walking in a circle. After grinding the clay, the potter picked out any roots or stones naturally embedded in it. After "picking" the clay, the potter wedged and kneaded it, condensing the loose batch and eliminating air pockets. The ball of clay was weighed, turned on a treadle kickwheel, and measured by a gauge set for height and rim diameter. Ware size was calculated and sold by volume; a potter would turn about two hundred gallons of clay a day in various forms, for example, fifty two-gallon churns and twenty five-gallon jars.

The stoneware potter's primary need was to obtain a clay that would fuse sufficiently to hold liquid. The clay had to mature at the high temperature required for ash glaze to become fluid or salt vapors to combine with silica on the pot's surface. If the clay fuses at a lower temperature, it will bloat and finally sag out of shape as it softens; if it is too refractory (resistant to heat), it will not fuse enough to be watertight. Often pots burned in cooler areas of a groundhog kiln were not fully mature, as North Carolina potter Joe Owen reports:

> The Auman pond clay would salt slick as a button, but still . . . it'd seep a little. Now, I'm talking about it would seep water, not bad enough to hurt you from selling it but a little damp. They used so much of it for milk back then and it wouldn't seep milk, so they didn't pay any attention to that.

The most favored kiln of southern potters until recently has been the groundhog. Its predecessor was a fifteenth-century German kiln, the design of which spread throughout Europe by the eighteenth century. The side walls of the European kiln were banked with earth, and the form may have been brought into the South by Moravian potters who settled in North Carolina during the eighteenth century. Other early southern kilns were simple, round, updraft ovens, a type used in England. The shallow, crossdraft groundhog and the later, round, taller, downdraft, beehive are kilns that will reach stoneware temperatures. The groundhog and its above-ground modification, the railroad tunnel are kiln types still in use.

Early stoneware was glazed either by the application of an alkaline ash glaze or by salt fuming. Salt glazing originated in fifteenth-century Germany, alkaline glazing may have been an indigenous southern development. Both glazes were used well into the twentieth century and are still in use at a few potteries.

Salt-glazing potters continued occasionally to burn earthenware in the form of sugar bowls, stewpots, and pie dishes for cooking; candleholders to add brightness to otherwise drab and dimly lit houses; and flowerpots. Some larger salt-glazing shops had a separate groundhog kiln for the burning of earthenware, as salt residue in the stoneware kiln refumes when heated and roughens a lead earthenware glaze. Potters with only one kiln would burn a stack of earthenware immediately after they had

rebuilt the arch of the salt kiln, when there would be only minimal fuming from the low side walls. It was necessary to rebuild the long arched roof of a salt kiln every year or two because of the wear and tear caused by constant firing and the corrosive effect of salt on brick. The lighter earthenware firing also served to "cure out" or temper the new construction.

Alkaline-glazing potters occasionally used stoneware clay and ash glaze to make baking dishes and plates, burning them with larger ware. Unglazed flowerpots were often stacked at the back of the chamber and even into the chimney to choke down the fire in kilns where the flue opening into the chimney was large. In the long, narrow chamber of a groundhog kiln, the heat is intense near the firebox and may be several hundred degrees lower at the chimney end, so flowerpots remained under-fired and therefore porous.

In the late nineteenth century, a clay slip glaze from Albany, New York, was shipped to the South, and many utilitarian production potters began to use this dark brown glaze rather than salt or ash glaze. The close fit of a slip glaze provides a watertight surface, even over somewhat underfired clays. The slip glaze was easily prepared, applied, and burned.

Off-white, thick Bristol glazes were introduced in the early twentieth century and in many areas the light Bristol glaze became more popular than the dark slip glaze. Both glazes are still used in some southern potteries.

The need for farm and household vessels increased with the population during the nineteenth century, and potters set up shops throughout the region. While some potting families remained in one area, others moved about (usually westward) either seeking better clay, farmland, or work as itinerant turners. Knowledge of the craft was spread by these restless potters. New families entered the industry through apprenticeship, which usually began at an early age.

Because of the scarcity of manufactured goods during the Civil War, potters were not conscripted but were required to supply army camps, hospitals, and soldiers with requisitioned vessels. Devastation and neglect of cropland was so great that postwar recovery required a diversified use of the land and natural resources.

Dorothy Cole Auman describes the economic changes in North Carolina that occurred after the Civil War and their effects on the pottery trade:

> The Farm Allegiance Program was set up in the 1870s to show people that if they could just survive this period they'd go back to farming. It educated them in ways to use their farm for cash crops. One was cutting crossties for railroads. There was a revival of making coke and turpentine products; a revival of leather tanning. Trees was the most plentiful thing we had around here, and a lot of these products came from trees. People had to strip the trees of bark to get the tannic acid. The government said if people could get these products to Fayetteville for rail shipment there was an assured market for them.

Since the destruction of cattle herds eliminated the farmers' market for feed corn, the government encouraged farmers to grow the crop instead for whiskey. Traditional potters in the midsouthern states could not supply all the whiskey jugs needed, so neighboring farmers set up shops to make jugs, while others went into the business of hauling jugs to distilleries and jars and churns to general stores located throughout the countryside. Whiskey for local purchase was kept in wood barrels in general stores and decanted into jugs as it was sold.

The ample availability of whiskey in a region depressed by a harsh war began taking its toll, and by the last decade of the nineteenth century, the church league began an effort to curtail the drinking of alcohol.

It was preached that drinking was a social sin by the visiting ministers who went from church to church. That was the beginning of trying to stamp it out. At every legislative session laws were passed to curtail it, such as abolishing sale to minors. By 1910 they had it outlawed here except for some of the bigger stills—which were economically good for the state—and by 1913 these went. But Virginia didn't have these laws until a few years later, so the potters took their jugs to Virginia to oblige them up there. By this time your farmer-potters had gone back to farming, so it was your traditional potter hauling these wares to far off places because they was hanging on. Uncle Arthur and daddy told about the jugs going to a little island off Charleston between 1910 and 1920. It wasn't connected with the mainland, so the laws didn't touch it. They were making whiskey like crazy there and shipping it back by boats. Many and many a wagonload of jugs went to Charleston for that purpose.

After the Civil War, the quality of salt-glazed pottery declined. The change may be attributable to many causes, including general postwar discouragement; poorer skills of the farmers who suddenly took up the trade; a paucity of "lighter'd" (a pine wood, rich with flammable resins), without which it was difficult to bring the kiln to high temperatures. Dorothy Auman speculates that the salt used for glazing may have been different:

Our potters had been picking up salt in Fayetteville when they hauled pots down there. That salt had been dried out of the ocean in shallow vats by the shore—evaporated and scraped out, then shipped to Fayetteville. Sometime before 1850, families would go down from here [to the ocean] and get their own salt supplies for farm or pottery needs. Maybe that salt melted easier with other sea minerals in it, or maybe the commercial salt used later had things added to it that made it harder to melt or to join with the clay.

The making of wood products continued (Seagrove was once called the Railroad-Tie Capital of the World), and farming gradually recovered after the Civil War. Thus, the land-based economy of the South survived, with a rural population still using utilitarian stoneware, but change had begun. Prohibition brought an end to jug making in large quantities. After the First World War, economic development accelerated in the rural South, particularly in the piedmont and flat lands: the textile industry moved into the region from New England, roads were improved, electricity became more widespread. In more isolated areas—such as the Catawba Valley of North Carolina, the mountains of north Georgia, and some lowlands in the Deep South—the need for the old ware continued into the 1940s, and even today a few potteries make churns, jugs, and jars. In most of the South, however, the agrarian economy slowly gave way to a market economy, thereby undermining the need for traditional ware. Those families with a deep commitment to potting and its lifestyle made the changes necessary to reach a new market. Some switched from somber stoneware to brightly glazed, eye-catching earthenware, making shapes that appealed to tourists, such as urns for patios and smaller ware for the home. Other potteries developed their peripheral production of flowerpots in a range of unglazed planters. Shops that changed to either type of ware also gradually began to mechanize clay processing and enlarge their kilns, burning them with oil or gas rather than wood.

Thus, in the three decades between 1920 and 1950, production in many southern potteries was changed in response to demand. Today there are three types of ware produced in the remaining thirty-five traditionally rooted potteries. Nine continue to make utilitarian ware by somewhat modified methods; six make unglazed gar-

denware, and the remaining twenty make glazed earthen- or stoneware by more modern methods.

Utilitarian ware has continued to be made of local clays, glazed with salt, or alkaline glaze or Albany-slip and Bristol glazes fired in wood-burning groundhog kilns or railroad-tunnel kilns. In the last few decades, the ware has been bought by collectors, although some is still purchased by local householders for daily use. In 1982 nine potters were working in ways related to the oldest tradition: Jerry Brown and Norman Smith in Alabama; Burlon Craig and Charles Craven in North Carolina; Cleater, Edwin, and Lanier Meaders and Marie Rogers in Georgia; and Gerald Stewart in Mississippi.[2]

Most nineteenth- and twentieth-century stoneware potters made unglazed flowerpots, firing them in the cooler chimney end of the kiln. As the demand for churns declined in the 1940s and 1950s—particularly in Alabama, Georgia, Mississippi, and Texas—some shops discontinued the production of utilitarian ware glazed with Albany slip or Bristol glazes and increased production of unglazed garden and patio planters. Today these are the largest and most mechanized of the potteries, with individual turners making from three to six hundred gallons of pots daily. The planters are sold to distributors and retailed throughout the eastern United States. In 1982 seven potteries were making this ware: Wayne Boggs and Eric Miller in Alabama; Howard Connor in Mississippi; Joe Craven, Harold Hewell, and the Wilson family in Georgia; and the Marshall Pottery in Texas.

The challenge of making glazed earthenware for a new market has been met by families who had been in the trade for generations, principally in the middle South. Those still potting are the Browns, Coles, Teagues, Owens, and Owenses in North Carolina; the Cornelisons in Kentucky; and William J. Gordy in Georgia.[3] After the First World War, many potters responded eagerly, yet with some trepidation, to the possibilities of developing new shapes and glazes for a general market. It began to be possible for a potter to say, as did Hobart Garner of North Carolina: "A lot of people done things cause their grandpa done it. That ain't my slogan. I want to do something that'll work regardless of who done it."

The ware produced by these potters underwent a metamorphosis, changing from somber utilitarian stoneware to bright earthenware. Large decorative jars, rather than churns, were now made for the patio and garden. Some were shaped like ancient oil jars, others like urns with nonfunctional loop handles and applied ropes of clay inspired by the ancient Near East. Pitchers, resembling those in biblical illustrations of Rebecca at the well, have been made continuously since the 1920s. Between the two world wars, these potteries produced brilliantly glazed huge jars, some more than three feet tall. They were shipped to outlets throughout the East, Midwest, and Southwest. Younger potters at the same time were making smaller wares, including decorative vases and baskets and tableware, such as sugar bowls and candlesaucers. Smaller pieces were equally popular and helped fill kiln and shipping space.

During the Great Depression, customers bought pottery at large stores and gift shops or directly from the potters. Resorts were developed in the mountain and coastal areas of the South, including one in Pinehurst, North Carolina. Tourists greatly influenced local pottery production. Dorothy Auman describes the making of the new pottery market:

> That is why [people at] Pinehurst played such an important part in the changeover for our survival. They had no use for a milk crock or churn, but they were world travelers and had seen beautiful urns and jars. The potters took wagonloads of pottery down there to sell, and those people would

describe what they'd seen. They would draw pictures and say, "Make me this." This is where most of these Roman and Grecian shapes came from. And the hotel would tour people out here in T-models. When I went to the Roman Museum in Cologne, I couldn't believe my eyes. These were the very forms we began making at that time. What we call the Rebecca pitcher, they call a water jar. There were the urns with the fat belly and the narrow bottom. Right then people around here weren't buying many pots. If they needed a crock there was enough still making to satisfy. The potters had to "make" the market; they had to make what people wanted to buy.

Although a potter may have been inspired by the shape of an Asian storage jar, his turning habits, his clay and glazes from local sources, resulted in a unique interpretation and not a replica.

The transition from plain, sturdy vessels for farm and homestead to more decorative garden and houseware was made slowly by building on, and gradually altering, known techniques. For many years the potters used familiar stoneware clays that did not fully shrink or become vitreous fired at earthenware temperatures. Because the stoneware clay did not shrink evenly with the earthenware glaze, the glaze came under tension as it solidified in cooling and crazed (developed a network of fine cracks). Neither clay nor glaze made the pot watertight. Since the large pots were used outdoors in gardens, on patios, and even on sidewalks (as in Miami, Florida), their porosity was an asset. In the smaller ware, such as vases, however, seepage was a flaw. Many customers of the time accepted it as a problem inherent to handmade pottery. Seepage was considered a serious problem when these potters began making principally cooking and tableware before and after the Second World War. Gradually they adjusted their clays and glazes to solve the problem.

Large jars were first burned in groundhog kilns in open chambers or inside saggers (variously sized containers made of tempered clay to protect the glaze surface from the roughness caused by flashes of flame or by ash being sucked through the kiln by the draft). During the transition period in the early twentieth century, the only way to make full use of the firing space was by vertically stacking saggers full of ware, since pots with glazed rims could not be stacked one on another.

During the 1930s North Carolina potter Charles Cole and others sought to refine their kilns and firing methods to produce the newly popular earthenware more efficiently. Tired of setting saggers in the shallow space of a groundhog chamber, Cole built a muffle wall—like a giant sagger—around the inside of the whole chamber. He later modified the kiln by shortening its length and raising its height so that it was vertical instead of horizontal. He also changed the heat source, from wood to fuel oil, which burns more cleanly, so glazes were sufficiently protected by a simple baffle of loose brick surrounding the oil burners. Other potters who built similar upright kilns continued to use saggers for complete glaze protection. Saggers, however, were heavy and consumed a large amount of firing chamber space and were eliminated when potters began making fireclay shelves. According to Dorothy Cole Auman the day Charlie Cole first fired with oil,

he lay the oil drum up on the bank where the wood used to lay, and the oil ran down into the kiln by gravity. He fired it and fired it. Joe [Owen] came, Melvin [Owens] came—seems to me like Ben [Owen] came—to see what it was doing after they quit work. Daddy was still firing the dogged thing, and it wasn't getting any hotter. Somebody said, "Hoist the barrel up," and they did. Then Waymon [Cole] came on, and they all decided it had to have more oxygen to make that oil burn. They were blowing into the kiln, fanning it, trying to make it go. Can you imagine? That's when daddy went down to the machine shop to see if they could make a fan to channel air in, . . . he didn't even know to call it a blower.

Operating a pottery shop for the marketplace was now a full-time occupation. Country potters had always been, and are today, jacks-of-all-trades. Increased production required labor-saving machinery, which at this time was neither commercially available nor affordable, so they built it from scrap material or adapted other machinery. To produce a pug of round clay, a die was added to pugmills used to make brick; hammer mills, originally built to grind grains, were used to powder clay. Potters were constantly inventive. Louis Brown describes a process his father, Davis Brown, used: he ran a clay mixer from a Model-T Ford engine with a belt, replacing the radiator with a wood barrel so that the motor heated the water in the barrel. The heated water was used for mixing clay, thus making the job less difficult in cold weather. Dorothy Auman describes wheels used at that time:

> We had wood wheel heads about three to four inches thick. Didn't have metal ones till after the war. The head and the shaft had to be directly straight, and they tightened it with leather harness. It had been gran' daddy's and was left hanging out in the barn. They was cut to the length, and as they wore out you go back and cut some more. On the under side of the slip box—where it's dry—they would tie the leather harness into a collar where they put axle grease, shaped it to hold the grease. They dug a hole down in the earth floor [of the shop] as big as a plate. Set white flint rock in it. They'd made a little groove on the top of the rock that the shaft would fit on. As the wheel turned the hole would get bigger. Always put grease in there, too. When the hole in the stone got too large, you'd replace the stone or grind your steel shaft again. It had to be pointed, and it was wearing too.

Developing new earthenware glazes was the most arduous and lengthy of the transition tasks. The southern potters had always used simple glazes made with local materials or a single purchased ingredient—such as salt, red lead, or Albany slip. The introduction of Bristol glazes at the end of the nineteenth century marked the beginning of more complex glazing. Glazes were now desired, not only as a practical coating to seal the clay's surface but also as a form of decorative enrichment. To achieve light or brightly colored glazes with surface variation potters combined many minerals and metal oxides.

Early southern potters used lead as a clear glaze over red clay, which became a luminous orange when fired. They also added copper, iron, or manganese to the lead solution to make green, brown, or black translucent glazes. Moravians in North Carolina covered their elaborate slip-decorated ware with a clear lead glaze, revealing the colors in patterns beneath the glaze. Other potters used the technique more simply by quickly brushing floral or other designs in colored slip before firing and glazing. "Dirt dishes," coated simply on the inside with lead, had been made continuously in the South. As a first step in obtaining bright color the potters returned to adding metal oxides to the lead glaze. Color in a transparent glaze, however, is tinted by iron in the clay of the pot and over a red clay becomes murky. Potters learned to opacify their lead glaze, as well as diversify it in other ways, so that they could produce white or light-colored glazes over dark earthenware clays.

Potters acquired knowledge of earthenware glazes in a variety of ways: by experimenting, visiting other potters, learning from ceramic supply firms, studying technical magazines and books. Examples of twentieth-century salt-glaze pieces in the Seagrove Potters Museum offer clues to early experiments with color. Dorothy Auman describes these wares:

> A lot of the time your salt didn't come out good. Seems they put cobalt and water—some of the museum pieces have brush marks—some was dipped or poured on because there is overlapping. Some pieces look like they had

made a slip with cobalt. They put the cobalt on somehow, put the piece back in the kiln, and fired it again. And they tried colored glazes with lead over the salt, maybe just lead and cobalt or lead and copper.

She also remembers from her childhood in the early 1930s other glaze experiments:

They started with just red lead and stains to go in it over stoneware clays because the earthenware was so red. They put the oxides in the old clear glaze because they knew it smoothed out and did O.K. by itself. But, they had a lot of trouble with crazing on the stoneware clay because the body wasn't fitting the glaze. At the same time daddy and Uncle Clarence [Cole] were making the old red lead pie dishes and other shapes because this was the old true orange and tobacco-spit glaze. They had to burn enough of it to make money to buy more experimental materials. They would buy pail after pail of chemicals, and for a long time the pots weren't any good when they came out. It was just trial and error, and they were all sort of watching, trying to formulate their own glazes without state-college help. You know how we are just so dogged independent, don't want nobody to help us. Daddy and Uncle Arthur [Cole] and Uncle Clarence would get together many a Sunday afternoon and compare notes on what had happened during the week on glazes.

Henry Cooper of North State Pottery in Sanford, North Carolina, shared information obtained from a ceramic engineer. The knowledge was brought back to the Seagrove potteries by Cecil, Elvin, and Walter Owens, who were running Cooper's shop. It was, however, a different story at another shop:

A chemist came to work at Charlie Auman's shop for months, and they were doing some pretty things from his work. He made a marbelized glaze—white, brown, and blue. It sort of swerved around. Must have been a clay slip with some lead because it was glossy. They fired it with the regular salt glaze, but he would not share in that with anyone. He went in and boarded up the windows so they couldn't see what he was putting together. He'd lock the door when he went in and lock it when he come out.

While traditional family potters were seeking new forms and glazes in the 1920s, Jacques and Juliana Busbee of Raleigh, North Carolina, devoted themselves to preserving shapes and glazes traditional to the area, first by promoting their sale and then by building Jugtown Pottery in North Carolina's Moore County. They produced a refined version of simple country forms, such as pitchers, stewpots, and plates in buff, orange, and brown lead-glazed earthenware. They also produced salt-glazed stoneware forms, including jugs and jars of local origin and oriental adaptations. The pottery was turned by Ben Owen, using only traditional techniques. Juliana Busbee's extensive promotion drew widespread attention to Jugtown ware and to the tradition from which it came. The efforts of Jacques and Juliana Busbee brought much-needed business to the area's potteries and renewed family potters' awareness of their heritage.

Sponsored by local or outside entrepreneurs, several larger potteries were established in the South in the 1920s and 1930s. Their development was spurred by the art pottery movement, which had produced artist-designed and -decorated ware since the 1870s in other parts of the country in response to the banal design of mass-made objects. Form and glaze ideas filtered into the southern pottery industry from the art potteries scattered around other parts of the country. In the South the shops were run on a craft, not a semi-industrial basis, and they relied on the skilled turners of the region. The Shearwater Pottery in Mississippi was modeled as an art pottery. Dorothy Auman describes this movement:

By the late thirties, through the forties, and into the fifties, the influence from Ohio had reached us. A lot of our potters attached onto the name of their shop "Art Pottery." There was Glenn Art, Cole Art, Smithfield Art. They termed it art more than functional. Potters here decided the reason they in Ohio were making such pretty glazes was because their clay bodies were white. That's when daddy and a bunch of 'em ordered a train carload of Kentucky no. 5 ball clay that burned white and shared it. It made a difference on the glazes. You'd get yellow and pink . . . pastels—bright, clear, beautiful.

Herman Cole's Smithfield Art Pottery was one of the large shops.

He worked twelve to fifteen [hands], most of the time with three to five turners. He had roving turners, part from Georgia, part from this area. They'd stay a month or a year. Bill Gordy, Charlie Craven, Jack Kiser. Jack worked at so many shops. He just made rounds filling one shop, then, while they finished it out and got him up some more clay, he'd go to another. Worked himself a route. Herman had no way of pulverizing his clay. He just ran it through a regular old brick mill, just continuously. Somebody grinding clay about all the time.

The last effort toward a commercial venture of any size in central North Carolina was the Glenn Art Pottery in Moore County, which closed in the late 1960s after twenty years of producing urns, jars, vases, and unglazed flowerpots.

Southern potters agree that it was harder to survive as a potter during the Second World War than during the depression. Workers were gone; wood supplies scarce; glaze materials unavailable; and uranium and cobalt supplies were collected by the government from the potteries. Except for shops making stoneware for farm use, such as Marshall Pottery in Texas, pottery making was designated unessential, and shops were not allotted extra gasoline rations. Many large southern potteries succumbed to these restrictions and closed; most small shops struggled through the war years.

Tourism revived after the war, and potters began supplying wholesalers with small wares, principally syrup or honey jugs and candleholders. Other potters began to sell an extensive line of kitchen and tableware directly to gift shops and from their own potteries. Since profits from wholesaling were constantly decreasing, every effort was made to build up direct retail trade. Some potters had earlier moved their shops to main highways, others worked to attract tourists to their more hidden locations. A catalog published about 1932 by the J. B. Cole Pottery, in Seagrove, North Carolina, offered 524 items for sale.[4]

Your expenses had gotten so drastic. A big piece that taken twenty-five pounds of clay you could do twenty-five one-pound pieces in the place of with less loss in the kiln. If something happened to the glaze on one, you didn't loose the other twenty-four. And those big pieces were so easy to fire crack. You lost so much, almost a third. So, the smaller pieces—I mean eighteen inches on down—began comin' in and, oh, they were so welcome.

With the widespread sale of glazed ware and unglazed gardenware, new versions of southern pottery became well known and are now established in their own tradition. By 1970 the livelihood of potters making homeware was derived from direct sales to consumers of domestic pottery. The basic instinct to make pots for daily use had resurfaced in a new form.

Despite present variations of form and finish, several aspects of traditional pottery

making affect the final product in ways that make it a recognizable regional ware. These include methods of turning and glazing and the potter's skill, knowledge, and perception of the craft.

To turn, a southern production potter stands at the wheel. When I came to the South in 1968 to make pottery at Jugtown, I brought with me a kickwheel, designed for sitting, which was greeted with surprise, polite derision, and the comment, "You can't turn much on that, can you?" After years of experience sitting and standing at the wheel, I now feel that standing is a more efficient position for production turning: the angle of the body is at a better slant to use the whole upper torso above the wheel head, making it easier to reach down into large pots and scoop small pots off a spinning wheel. Potters keep their wheels turning at a constant speed, faster for small pieces and slower for large pieces. In a standing position less effort is needed to pick up a ball of clay, to center it, to examine a pot's profile, to place a finished pot on a long ware board, or move to a wedging board. This greater fluency of body motion facilitates production work. Pots turned rapidly in a production shop tend to retain the first imprinting of the shape; the evidence of deft fingers on the malleable clay remains as the potter minimizes the type and number of motions required to complete a shape.

The potter also finishes the shape on the wheel, thus eliminating the task of trimming away excess clay with a tool when the pot is leather hard. To complete the form while turning requires much skill. The pot wall must be thinned near the bottom and the weight distributed evenly, leaving only a slightly greater thickness toward the bottom for structural support. This must be accomplished with a minimum of motion and expenditure of time or the clay wall will absorb too much water and sag. To maintain speed, the potter keeps the clay surface frictionless by applying water continually.

This turning process determines shape possibilities. A semihard pot can be trimmed with radical undercutting to stand on a small foot without sagging, but soft clay cannot be turned to such a shape. For these structural reasons and practical use, a traditional pot is wide at the base. It is more earthbound than most trimmed pots that have a quality of rising upward or floating, evident in much oriental and contemporary Western pottery. Fullness of shape on a traditional southern pot comes from curves at the belly and shoulder and, to a lesser degree, at the foot. A cutting tool mediates between the hand and the clay and frequently diminishes the pot's rhythmic vitality.

Glazes are kept as simple as possible and are applied in one coat by dipping raw or bisqued pots into a tub of prepared glaze; decoration is minimal (with the exception of slipware); and glaze firing is also straightforward, done generally in an oxidizing atmosphere.[5] Partial reduction occurs automatically in wood firing.[6]

In discussing traditional pottery, it is most important to realize that the central perception of the traditional potter is that his craft is a trade. This attitude governs the making of shapes in multiples without concern about repetition and the method of pricing on a cost-plus basis. Ware of a given size is priced the same, regardless of aesthetic quality. Thus, use of local clay, methods of turning and glazing, a functional view of the craft and its economics are all common denominators defining the product of today's southern potters. Perhaps the most important force for the continuity of these elements has been the way of learning—the passing of skills, knowledge, and attitudes from one generation to the next in an intimate context and over a long period of growth. The differences among them (and from other patterns of their nineteenth-century heritage) have evolved over the past sixty years in response to economic change. The potters all use labor-saving equipment to process clay and, with a few exceptions, use electric wheels and improved kilns of various designs

burned with oil, gas, or electricity. The larger shops use specialized labor, some people only turn, others only glaze or load kilns. Most potteries have adapted their ware to new markets. It is ironic that the work of potters most closely allied to nineteenth-century forms and methods is purchased primarily by collectors, while the work of potters who rely on modern equipment is purchased primarily for domestic use by consumers.

Most potteries use relatively simple, labor-efficient mechanical equipment, often built or designed by themselves. The potteries producing large quantities of gardenware use more complex, automated equipment, yet their ware is saved from the appearance of standardization because it is hand turned and made of local clay. Despite various levels of mechanical aid (without which it would be difficult to earn a living), the trade continues to be a predominantly hand operation, the particular features of which imprint the ware produced with the identity of southern traditional pottery.

Today, this craft is no longer an integral part of the material culture of the South. Pots are bought by choice not by necessity. Customers seek contact with the potters, watch their work in progress, explore their shops, and absorb the flavor of the past. The potter's lifestyle has at its core a control of product, from the digging of the clay to the firing of the kiln. Such visible wholeness is uncommon today, and its satisfactions extend to the buyer who uses the pottery as well as to the potter who makes it. Moreover, these pots are affordable, usable, everyday objects—familiar shapes providing direct tactile and visual pleasure.

It is not likely that the market for any of the ware now made by the southern potteries will vanish. The skills required to make large ware, either in traditional glazed forms or as unglazed planters, however, are likely to disappear. Only a handful of potters retain the capability, and it is not being passed on. Chester Hewell, a Georgia potter, says:

> Daddy makes up to ten-gallon size, but every time he says he ain't going to make no more. They're very hard to make. Few people can make them over eight or ten [gallons]. So these are gradually getting gone, too. Won't be anybody who can make them that big. I can't make them.[7]

The problem of continuity for the smaller ware resides in the potters and their families, in their subjective reaction to the loss of traditional culture. The craft may continue to be handed down within a family or younger generations may decide to enter a different career. In many cases members of the younger generation have opted for a different life and work, although others are realizing the rewards of making pottery and are taking it up as their heritage, as is the case with Daniel and Glory Garner at Teague Pottery in North Carolina.

> Daniel and I plan to stick with this. We could make a lot more money cause he's got other skills, but this kind of life is awful nice. We don't know about the future after us, but we don't want to be the ones that quit.

Potters everywhere have access to a wide range of material, equipment, techniques, and products. The future potters of traditional lineage, raised in a period of eclecticism, may be drawn into new directions. Values so ingrained in the minds of present potters, because they grew up in a clearly defined tradition, may become diluted as times change. The regional distinction of the pottery will inevitably dissipate. For now, however, southern pottery is rooted in tradition and is one of the last tangible aspects of an earlier culture.

Notes

1. C. Malcolm Watkins and Ivor Noël Hume, "The 'Poor Potter' of Yorktown."

2. For a full description of the history of utilitarian stoneware see John A. Burrison, *Brothers in Clay*; Georgeanna H. Greer, *American Stonewares*; and Charles G. Zug III, *Turners and Burners* (forthcoming).

3. There were other potting families and potteries throughout the South that continued to make traditional ware or glazed earthenware in the twentieth century, but they are no longer operating and are, therefore, not included in this discussion.

4. Charles G. Zug III, "Jugtown Reborn," 3: 15–20.

5. In an oxidizing atmosphere the oxygen content of the chamber is sufficient for the carbon of the fuel to burn naturally.

6. Reduction occurs when the flow of oxygen into the kiln is restricted so that the combustion of carbon from the burning fuel and oxygen does not fully take place. The free carbon then draws oxygen from any available source, including the oxides present in the minerals composing clay and glaze. This chemical action reduces part of the oxygen content of these minerals resulting in some change of color.

7. Chester Hewell, interview, courtesy Eliot Wigginton, director, Foxfire.

Process and Equipment

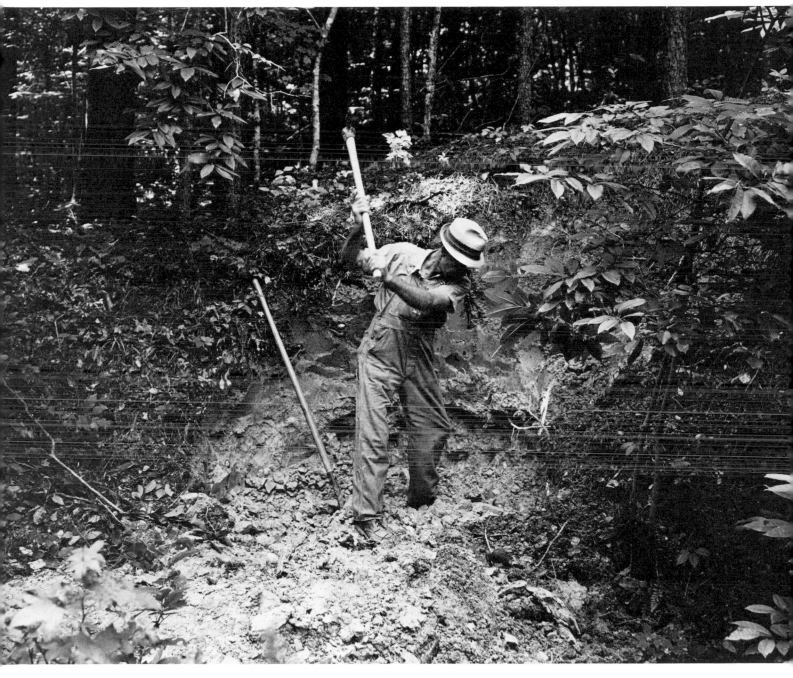

M. L. Owens loosens a pit clay.
Photograph by Sam Sweezy.

Clays and Clay Processing

Seventy-five percent of the earth's surface is composed of the primary ingredients of clay—alumina and silica—in chemical combination with other minerals and metals, particularly iron. During the past two billion years, rock has been ground into grains of clay by the ceaseless motion of mountain upheavals, wind, ice, and especially rain. Small amounts of the purest (or primary) clay has been caught in pockets where it has disintegrated from the parent rock. Most clay, however, is secondary, that is, has been carried away from the site of origin. Weathered to increasingly smaller bits, it is borne downstream to lowlands and settles, forming beds of clay. During the process, grains of pure clay bond with other minerals—iron, primarily, and the carbon and calcium of decaying organic matter. What potters find around the world are varied but similar types of clay. A variety of minerals in rock matrices or in crumbling form is usable for glazes.

Earthenware clays are red because of the presence of iron oxide, which causes them to harden over a range of low temperatures, from 950 to 1,100 degrees Celsius. Because red clay pots are not usually burned to the point of vitrification, they remain somewhat soft and porous and thus able to withstand the slight expansion and contraction that occurs in oven and open-fire cooking. Stoneware clays have less iron, are lighter in color, and require higher temperatures to harden. Stoneware pots are fired to a temperature that allows the clay to fuse, forming nonporous containers suitable for liquids, including vinegar and alcohol (the acidity of which will cause lead to leach from the glazes traditionally used on earthenware pottery). The clay types are appropriately named: stoneware is hard, durable, stonelike, impermeable to liquids, and, although breakable, is little affected by weather or age. A vitreous stoneware pot will ring like a bell. By contrast, earthenware has a "soft" hardness, chips easily, and erodes over time when exposed to natural elements. It is literally "baked earth."

Southern potters first used common red earthenware clay, but from the early 1800s through 1920 they used principally stoneware clay. Today earthen- and stoneware clays are used separately and in a variety of mixtures. Some potters use only local pit clay, others mix local and commercial clays or purchase all their clays. In each shop a particular clay body is developed, suitable for the types of ware made. These clay bodies are subject to change, particularly when local clays are used, as the composition of the clay will differ slightly from one area of the pit to another or from pit to pit.

Clay is usually found in low-lying spots, along creek beds, or earth banks where it is visible because the topsoil has been cut through. If it tests well in the field, it is brought to the shop for further examination. In the field it may be found to have too much sand for comfort in turning or too much refractory (unplastic) material to stretch sufficiently. It may be overly sticky because of the presence of too much carbon from decayed vegetation and, therefore, too plastic. Dorothy Auman describes testing clay in the field:

> We'd test clay out in the field by spitting on it, roll it out like a worm, twist it around a finger to see if it was plastic enough, bite it to see if there was any grit. With less grit it was more plastic—easier on your hands a-turning it. Stoneware clay is shorter than earthenware, so you'd look for something that would satisfy the turners, didn't shrink too much, and yet would fire without warping. Your bog clay was stoneware. You'd see earthenware more on the banks of the road where grass won't grow and trees are stunted. You surely did try to get it out in the open field. Those roots would fight havoc with holes in the pots.

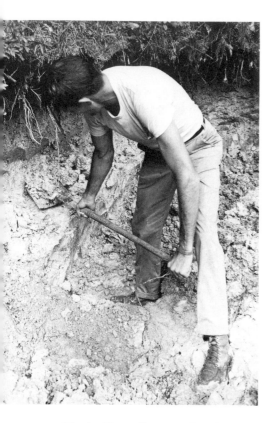

Charles Moore digs out a clay pit. Photograph by Sam Sweezy.

Final testing is in the turning and burning. A very plastic clay may turn well for small pieces, but, being fine grained and lacking the tooth of coarser grains, it may not hold its shape in large or bulbous pieces and will be overly subject to cracking in drying and firing as it has a high rate of shrinkage. A coarser clay will not shrink as much but also will not turn as well. A potter seeks to balance these opposites in a clay body so that it will turn well and shrink little.

What makes clay plastic is only partially understood. Tiny molecules of clay must slip over one another into changing positions as the pot wall is thinned and stretched; water and colloidal gels (formed by bacteria) make this action possible. Therefore, each clay molecule must be coated with a film of water. Such penetration occurs most thoroughly when clay is prepared in a liquid slip. Aging the prepared clay allows complete saturation and provides time for bacteria to grow in the batch to form the desirable gels. To aid bacterial growth, potters often add a bit of old clay to the grinding of a new batch. A very plastic, aged clay has a musty, ripe odor.

Clay Processing

Southern potters agree that the most important single factor in producing a good pot is the clay body. Most argue that clay dug from the earth and processed at home is generally superior to clay mixed from commercially available powdered clays. Yet their methods of producing clay bodies diverge widely; they use a complicated array of both homemade and commercially manufactured machines. These range from the simple method of grinding clay in a mill drawn by a mule to more complex systems varying in degree of mechanization and efficiency. Most potters possess some carpentry and mechanical skills and have had to know how things work, repairing and improving cars, farm machinery, and household equipment with materials at hand. With knowledge and skill, they build equipment to prepare clay. At each pottery the system is unique, although there are definable types of systems. Clay may undergo as many as five different processes in one type of system: drying, pulverizing, screening, wet mixing, and compacting. The potter may add only water to the pit clay or may modify its characteristics by the addition of other local or purchased clays and minerals.

The system of clay preparation used by the earliest potters and by many in this century was simple. Clay dug from a pit was left in the shop yard to break down. As needed, a batch of clay was moistened for a few days in a soaking pit and, when it had softened, was ground in a beam mill drawn by a mule walking in circles around a barrel full of churning clay. After an hour or more of this slow grinding, when the clay was of an even consistency, the batch was removed, blocked in large squares, and stored in the shop—usually in a pit covered with wet sacks to prevent drying. The process continued through the day until a week's supply of clay was ground. Before turning shapes on the wheel, the potter picked roots and stones embedded in the clay by thinly slicing the block to expose debris. He then wedged the clean clay to beat air out of it. In wedging, a chunk of clay is cut in half on a wire (often an old banjo string) strung diagonally across a board. Each half is thrown down hard, one on top the other, onto the board. Cutting and slamming is repeated in a rapid, rhythmical way, a dozen or so times, forcing tiny air pockets to break. The clay is further compressed and deaired by kneading. The wedging board is usually slanted downward away from the potter and spaced a few inches from the wall. The slant makes kneading easier, and the space at the back allows bits picked from the clay to roll off to the ground. Children often helped pick the clay and sat beneath the long wedging board playing with the clay bits dropped there. This final mixing and removing of air bubbles from the clay increases its plasticity and was referred to by earlier potters as "working it on the ball board." Turners have always made up a batch of balls at one time, weighing them for the size pot to be turned.

Weathering clay. Bybee Pottery, Waco, Ky.

*Weathered clay softens in a soaking pit.
Craig Pottery, Vale, N.C.*

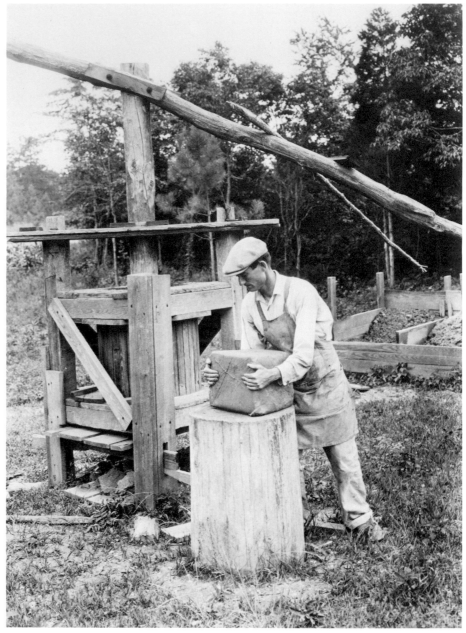

*B. D. Teague blocks clay at mill, c. 1930.
Photograph courtesy B. D. Teague.*

Ben Owen slices clay to pick out naturally
embedded roots and gravel, c. 1940.
Photograph courtesy North Carolina
Department of Archives.

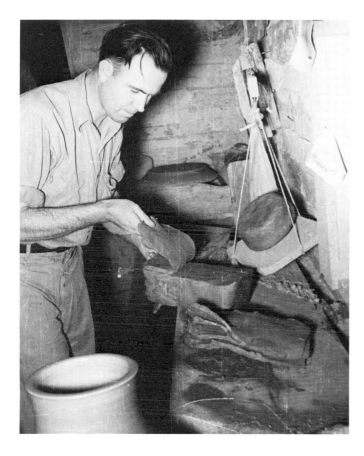

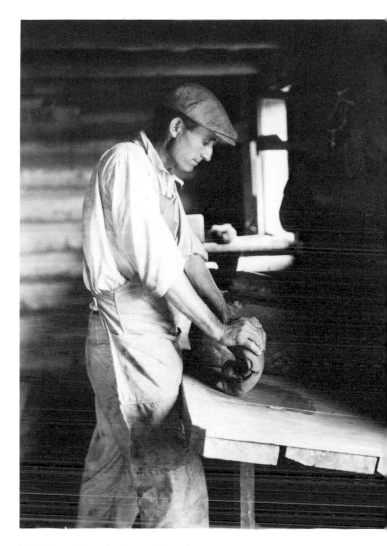

B. D. Teague kneads clay on slanted
wedging board, c. 1930.
Photograph courtesy B. D. Teague.

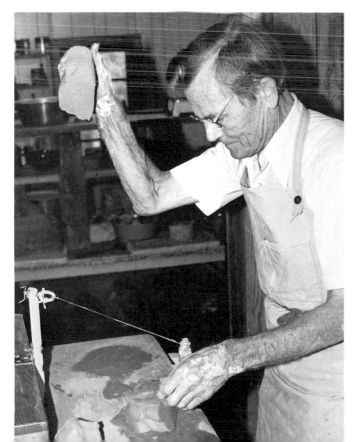

D. X. Gordy wedges clay by repeatedly
cutting it on a wire and slamming clay
halves together to compact clay and
remove air pockets.

Presentday systems to clean, mix, and compact clay involve labor-saving equipment to achieve the same goal: a plastic clay ready to turn. The equipment devised cleans clay by passing it through a screen in either dry, moist, or liquid form; mixes clay by first liquifying it and then removing excess water or by grinding it moist in a mechanical mill; compacts clay and removes air by pugging it.

Storage and Drying
The clay must be stored until processed. During the winter many potters pile their clay outdoors so that freezing and thawing will break it down and improve its plasticity. Clay is dried under a shelter or indoors before processing begins.

Breaking Down
Even weathered clay retains lumps that must be broken down. This process is accomplished in one of three ways: by pulverizing, liquifying, or simply mixing lump clay softened by water.

For the dry-powder system, either a hammer mill, a dry pan crusher, or rollers are used to pulverize dry clay. The hammer mill, originally designed to grind corn for animal fodder, is a high-speed machine with a series of swinging blades or hammers mounted on a rotating shaft inside a cylindrical steel screen. Chunks of dry clay fed into a hopper fall into swinging hammers that shatter the clumps and throw particles through a screen. The fine particles are blown upward out of the way into a funnel and drop down into a catch bin. The force of the hammers pulverizes most small stones and roots. Any material too heavy to be blown upward is discarded. The resulting powder is sometimes fine screened before it is stored.

Hammer mill in operation. Jugtown Pottery, Seagrove, N.C. Photograph by Charles Tompkins.

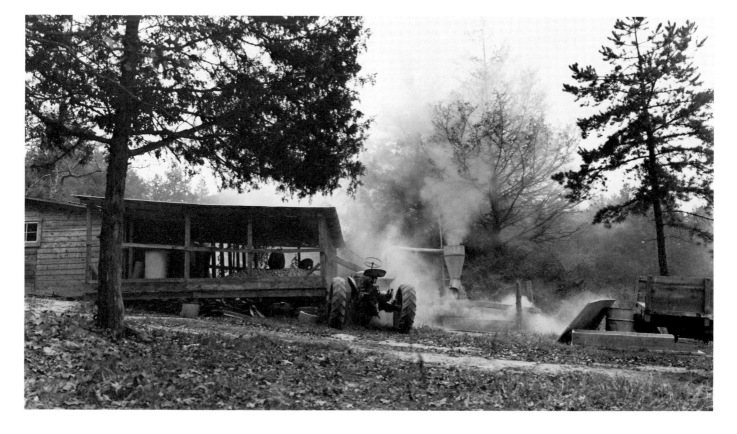

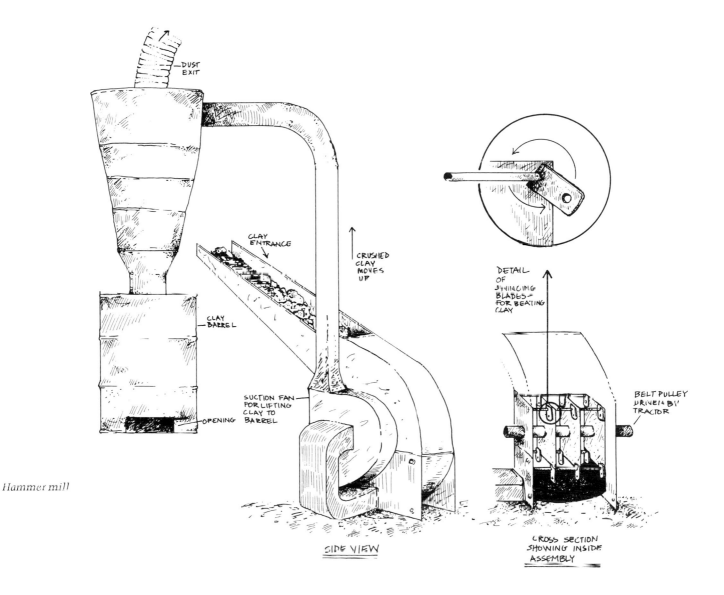

Hammer mill

The dry pan is a ponderous antique dating from the age of steam power. It has massive, steel-tired, cast-iron wheels, weighing about three thousand pounds each, fixed in an enormous frame. The wheels roll on the surface of a revolving, perforated steel pan, crushing clay and small stones. The powder filters through the holes onto a screen that sifts the fine grains through to a holding bin beneath, thus separating out unground coarse materials. Such a dry pan is used to prepare turning clay at the Brown Pottery in North Carolina and a small one is used to prepare sagger clay at the Shearwater Pottery in Mississippi.

The third method of crushing clay is to pass it through paired steel rollers. At the Lanier Meaders Pottery in Georgia, only one pair of rollers is required. At the Marshall Pottery in Texas, red clay for mechanically made flowerpots falls in two-inch chunks onto a climbing belt that carries them through a graded sequence of paired rollers that turn toward each other with high frequency.

Whichever way it is crushed, screened, or powdered, clay—before it is ground—must be remoistened to a doughlike consistency similar to clay that has been

Dry pan machine. Brown Pottery, Arden, N.C.

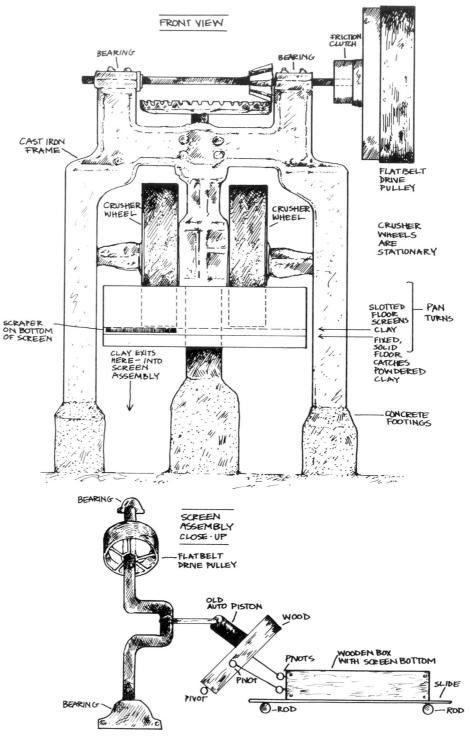

FRONT VIEW

BEARING

BEARING

FRICTION CLUTCH

FLATBELT DRIVE PULLEY

CAST IRON FRAME

CRUSHER WHEEL

CRUSHER WHEEL

CRUSHER WHEELS ARE STATIONARY

SLOTTED FLOOR SCREENS CLAY

PAN TURNS

SCRAPER ON BOTTOM OF SCREEN

FIXED, SOLID FLOOR CATCHES POWDERED CLAY

CLAY EXITS HERE – INTO SCREEN ASSEMBLY

CONCRETE FOOTINGS

BEARING

SCREEN ASSEMBLY CLOSE·UP

FLATBELT DRIVE PULLEY

OLD AUTO PISTON

WOOD

PIVOTS

WOODEN BOX WITH SCREEN BOTTOM

PIVOT

PIVOT

SLIDE

BEARING

PIVOT

ROD

ROD

Dry pan machine pulverizes old saggers for use in making new saggers. Shearwater Pottery, Ocean Springs, Miss.

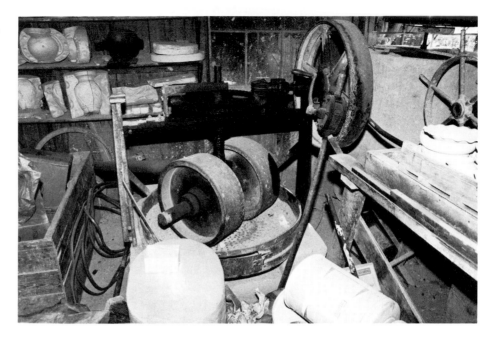

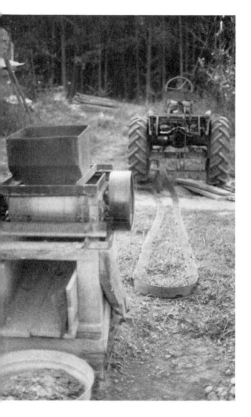

Clay crushing machine with steel rollers. Lanier Meaders Pottery, Cleveland, Ga.

soaked. In one day several weeks' supply of clay can be produced for a small pottery by two people using this system.

For the slip system, either a blunger or a ball mill is used to mix liquified clay. The blunger is a large tank with an agitation blade, similar to a propeller. When dry clay and water are placed in it, they are stirred by the blade until smooth. The ball mill grinds clay with water to obtain a very fine and uniform consistency. The grinding is accomplished with ceramic balls that roll inside a sealed revolving cylinder. Liquid slip is screened, and excess water is removed before the slip is ground. Wet preparation of clay requires several days, and clay is usually prepared by this method each week.

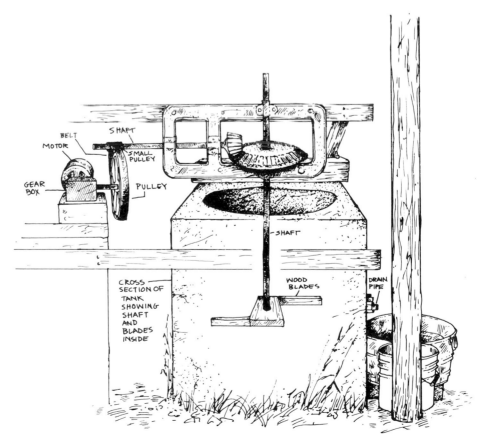

Blunger mixes liquid clay slip. Pisgah Forest Pottery, Arden, N.C.

Filter press removes excess water from liquid clay slip. Cole Pottery, Seagrove, N.C.

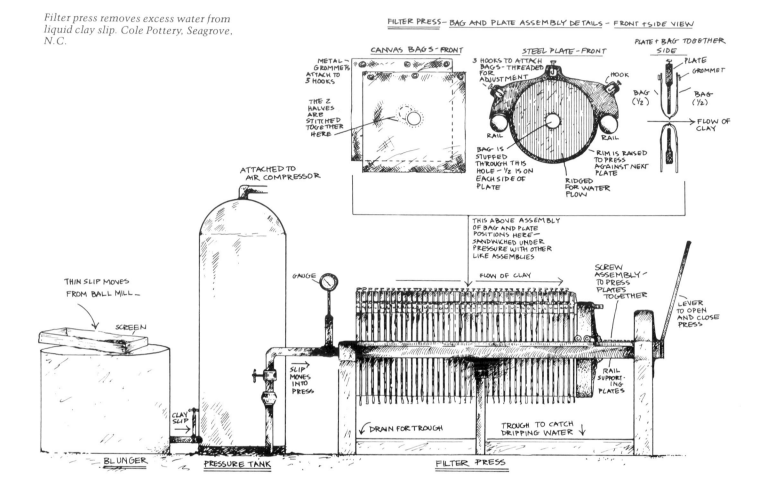

FILTER PRESS— BAG AND PLATE ASSEMBLY DETAILS— FRONT + SIDE VIEW

Clay discs ready for removal from filter press.

Water Removal

Clay mixed as a slip is brought to turnable stiffness by the evaporation or filtering of excess water. Slip clay may simply be left in a shallow open vat to partially dry. The filter press is a complex system, which forces slip into canvas bags where it is held while water filters out gradually over a period of one to three days.

The filter press consists of a steel frame, holding a series of steel plates with concave indentations in each side, and canvas bags (see also illustration, p. 253). Each steel plate has a hole in the center, somewhat resembling a very thick phonograph record, so that when placed together the plates form a tunnel down the center. The bags are like two handkerchiefs sewn together in the center with a buttonhole stitch; thus, a buttonhole fits over the hole through each steel plate, allowing one square of canvas to cover each side of the plate and line the concave steel surfaces. Sandwiched together, a disc-shaped space is created between each facing, canvas-lined, concave pair of plates. The clay slip is forced under air pressure into these disc-shaped spaces as it passes from a holding tank through the central tunnel of buttonholes. Once all the canvas bags are filled, a heavy screw mechanism presses the plates tightly together on a frame. Under this pressure, the water in the slip filters out through the canvas and leaves a disc of very smooth, uniform clay between each pair of plates. Once the water has filtered out, the screw press is loosened, the steel plates pried apart, and the clay discs peeled from the canvas

lining. Since clay processed through a liquid cycle is already mixed to an even consistency, it requires only compacting by pugging or wedging and kneading.

Clay Mixers
Clay that has been dried, powdered, and then moistened or simply moistened to a doughlike state must next be mixed to an even consistency. Mixers have many designs but they all share two elements: a fixed container and a bladed turning shaft. The most primitive mixer is the beam mill, variously called a clay mill, wire mill, clay grinder, or pugmill. A sturdy wood barrel is fixed on a solid timber foundation and fitted with a thick log shaft into which have been driven semiflattened wood spikes. Sometimes wires are strung between the blades to cut the clay and to catch grass and roots. With the lower end of the shaft set in a bearing beneath the barrel, the upper end is attached to a curving or straight beam. The beam is set diagonally, and its lower, outer end is attached to a bar that in turn hangs behind a mule from its harness. The mule pulls the beam in a circular path around the barrel causing the center beam to rotate, slowly cutting and churning the soft clay. Modern versions of this mill are made of metal and are driven by belts or gears and electric motors; the container and shaft may be mounted vertically or horizontally.

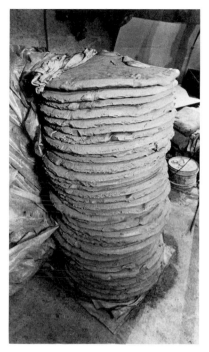

Clay discs prepared by filter press and now ready for kneading and turning.
Photograph courtesy Randolph Technical College.

Mule-drawn clay mill. Jerry Brown Pottery, Hamilton, Ala.

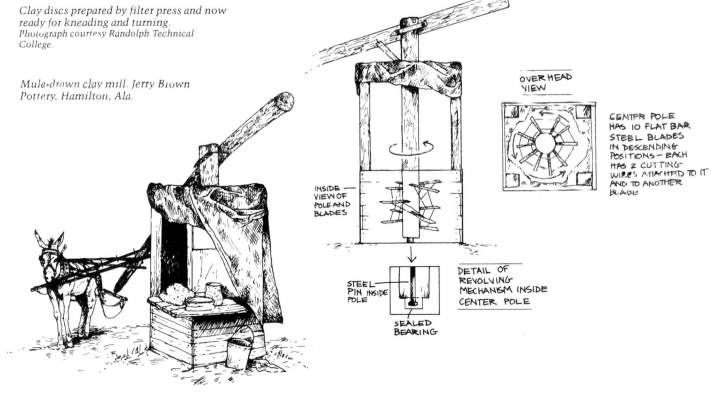

OVER HEAD VIEW

CENTER POLE HAS 10 FLAT BAR STEEL BLADES IN DESCENDING POSITIONS - EACH HAS 2 CUTTING WIRES ATTACHED TO IT AND TO ANOTHER BLADE

INSIDE VIEW OF POLE AND BLADES

STEEL PIN INSIDE POLE

SEALED BEARING

DETAIL OF REVOLVING MECHANISM INSIDE CENTER POLE

Jerry Brown removes churned clay from mill.
Photograph by the author.

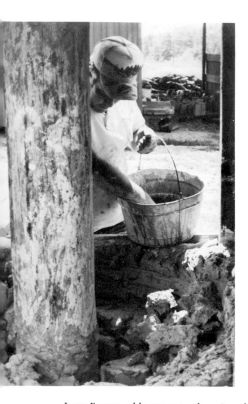

Jerry Brown adds water to churning clay.
Photograph by the author.

Jerry Brown, the author, and the mule Frank.
Photograph by Joey Brackner.

*James H. Owens and Baja Scott attach
blades to center pole for mule-drawn clay
mill, c. 1920.
Photograph courtesy Marie Owens.*

*Charles Brown grinds clay in an open clay
mixer. Brown Pottery, Arden, N.C.*

*Clay-mixing mill. B. B. Craig Pottery,
Vale, N.C.*

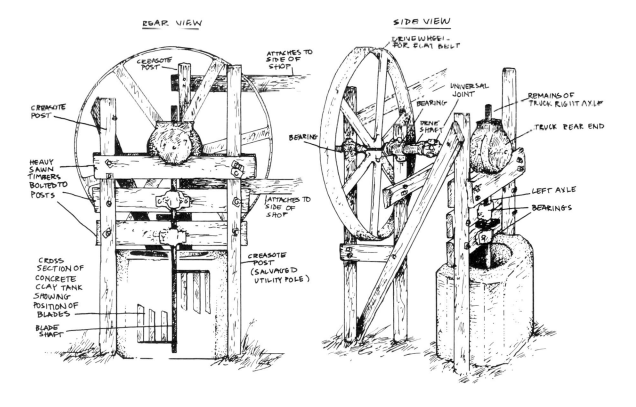

Vertical clay mixer with pugging extruder. Bybee Pottery, Waco, Ky.

Compacting and Deairing

The modern pugmill differs from the mixer in degree more than in kind. The blades of the pugmill container or barrel are generally smaller and are similar to propellers or augers. Thus, with the clay confined to a smaller space and the blades closer together and more angled, the pugmill moves the clay down the narrow barrel as it is mixed, squeezing and compacting it until it is extruded at the end in a solid, uniform bolt. Some pugmills have deairing chambers connected to electrically driven vacuum pumps to remove air from the clay and extrude it ready to turn.

Pugmill compacts loosely mixed clay (visible in wheelbarrow at right). Hewell Pottery, Gillsville, Ga.

Modern deairing pugmill

Using one of these methods, the potter prepares his clay. Norman Smith from Alabama digs his clay with a shovel, hauls it in his pick-up truck, and dumps it in the yard. Then he shovels it into an old beam mill, pours in water, and grinds away steadily until the clay reaches the desired consistency. He digs it out of the mill by hand, carries it into his shop, and wedges it, picking out any sticks or stones he happens to find.

Joe Craven, a Georgia potter, strip mines his clay with bulldozer and backhoe, hauls it in dump trucks by the thousands of tons, and dumps it onto a mountain of clay reserves near his pottery shop. A tractor pushes the clay underneath an enormous drying shed, and, when dry, the clay is fed by a diesel-powered front-end loader into a hopper, which can hold eight tons. The hopper feeds the clay into a crusher that sizes it to particles about three-eighths of an inch wide and conveys it to a dust-collecting room where it is further refined in a hammer mill with a sixty-mesh

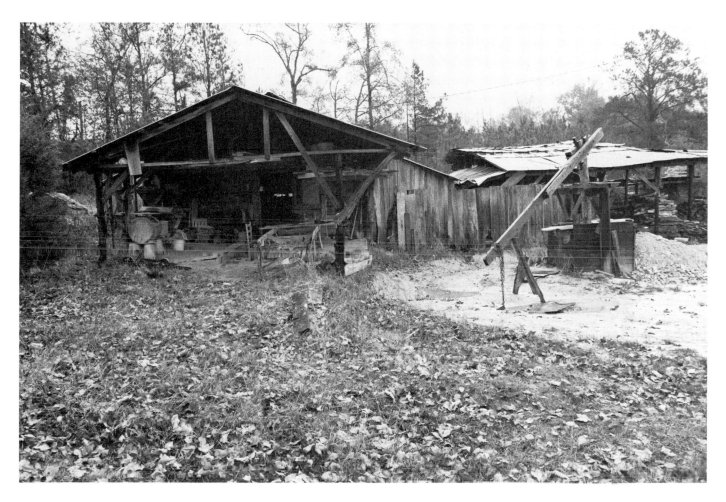

Clay mill, Norman Smith Pottery, Lawley, Ala.

Sheltered clay storage. Craven Pottery, Gillsville, Ga.

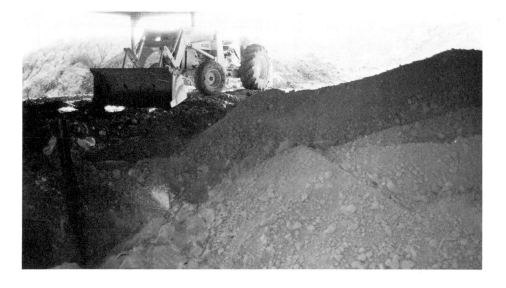

screen. From here the clay is gravity fed into a mixer; gauges are used to measure precise amounts of clay and water. The mixer mixes the clay and feeds it automatically into a pugmill capable of processing twelve tons an hour. The pugmill further mixes, compacts, and extrudes the clay past an automated wire that cuts it into bolts of a predetermined size. Finally, the bolts are stacked by hand onto a wheeled table, covered with plastic, and rolled to the potter.

Despite differences in method and scale, both Smith and Craven designed and built his own equipment, digs his clay within a few miles of his shop, and turns pots measured by the gallon while standing at an electric wheel, the design of which evolved from the treadle wheel. Furthermore, each speaks of his work with great affection and enthusiasm.

Clay-processing chart; note various combinations of steps used to prepare clay for turning on the wheel. Developed by Tom Jackson.

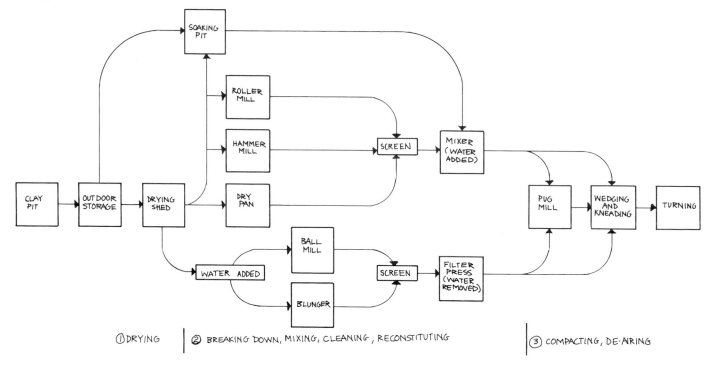

Potters' Wheels

The most fascinating of all pottery skills is that of the turner's. A good turner appears to pull a beautiful form from a lump of clay with almost magical grace. Traditional potters' wheels are made in a wide variety of sizes and shapes, reflecting the potter's needs and mechanical skills. For example, big-ware turners and those with heavy production schedules use wheels with large wheel heads and cribs, while small-ware turners utilize small wheel heads and cribs. Many potters refer to their wheels as "turning lathes."

The treadle wheel has always been the traditional wheel in the South. A beautifully simple machine, it uses a crankshaft to convert the repeated rhythmical motion of the potter's foot pushing a treadle bar out and back into rotary motion and a flywheel to store this energy and deliver it smoothly to the wheel head that holds

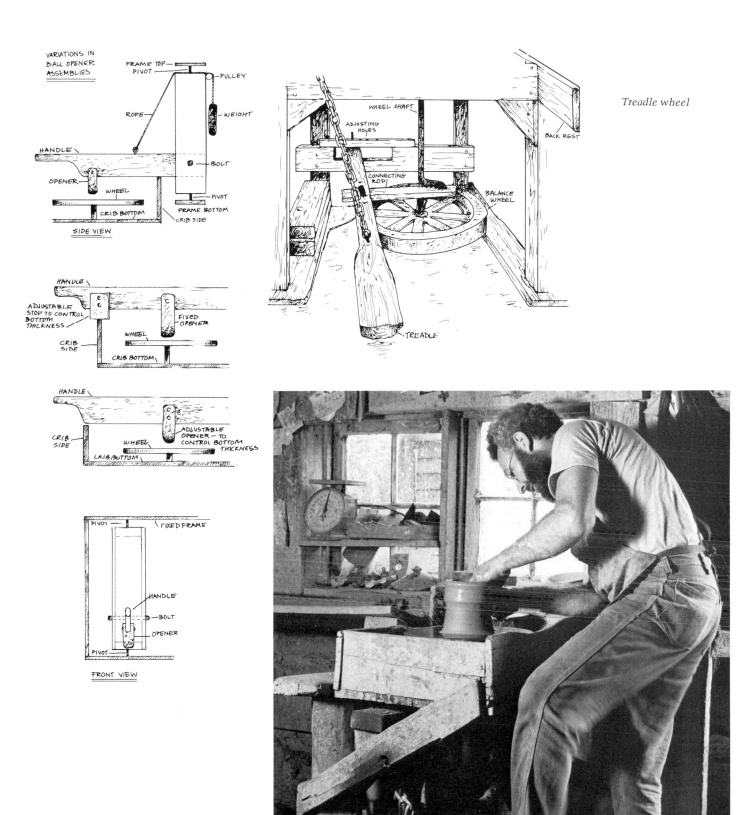

VARIATIONS IN
BALL OPENER
ASSEMBLIES

FRAME TOP
PIVOT
PULLEY
ROPE
WEIGHT
HANDLE
BOLT
OPENER
WHEEL
PIVOT
CRIB BOTTOM
FRAME BOTTOM
CRIB SIDE
SIDE VIEW

HANDLE
ADJUSTABLE
STOP TO CONTROL
BOTTOM
THICKNESS
FIXED
OPENER
WHEEL
CRIB
SIDE
CRIB BOTTOM

HANDLE
CRIB
SIDE
ADJUSTABLE
OPENER – TO
CONTROL BOTTOM
THICKNESS
WHEEL
CRIB BOTTOM

PIVOT
FIXED FRAME
HANDLE
BOLT
OPENER
PIVOT

FRONT VIEW

WHEEL SHAFT
ADJUSTING
HOLES
CONNECTING
ROD
BACK REST
BALANCE
WHEEL
TREADLE

Treadle wheel

Vernon Owens turning on a treadle wheel.
Jugtown Pottery, Seagrove, N.C.
Photograph courtesy Randolph Technical
College.

the clay. The treadle wheel consists of a sturdy wood frame with a box or crib surrounding the head. In this frame the crankshaft is mounted vertically in two or more bearings and fitted with a flywheel at the bottom and a wheel head at the top. The treadle attaches to the crank of the wheel shaft by a connecting rod and also to the frame, so that foot pressure pushing the treadle back and forth causes the crankshaft to turn. Originally, many treadle wheel shafts were pointed at the bottom and rotated in a hole cut in a piece of flint rock. Most potters today use roller or ball bearings purchased from a machine shop or salvaged from another piece of equipment. The crib catches water and clay slip that slings off the turning wheel head. It also holds the potter's tools and water bucket and provides a frame on which to mount a horizontal board to hold balls of clay, an adjustable gauge, a ball opener, or a back rest.

Toggled cutting wires frees finished pot from wheel head; lifters removed pot without distorting its shape.

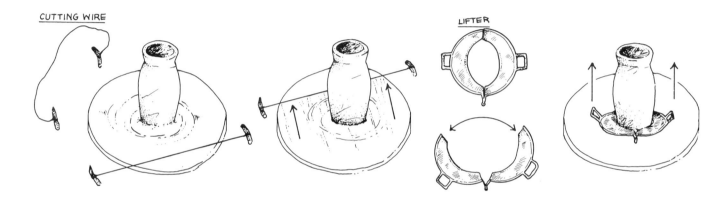

Old wood tools, including ribs to shape pots and rolled coggles to incise banded decorations. Seagrove (N.C.) Potters Museum.

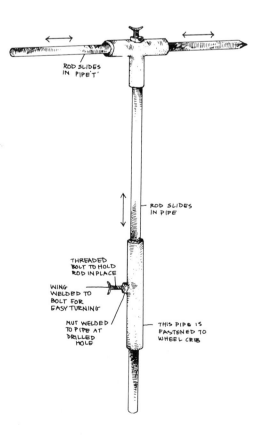

This gauge is attached to the crib of a potter's wheel to measure height and rim diameter of shape being turned.

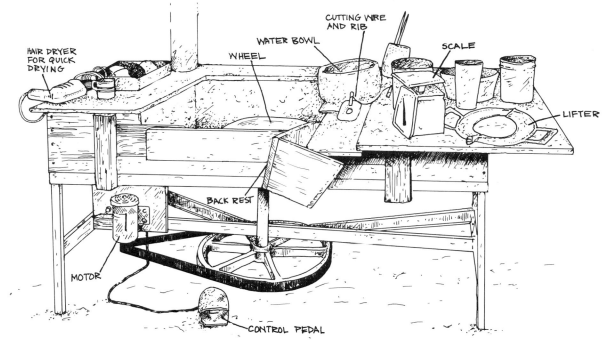

An electric, friction disc wheel designed by H. Eric Miller, Sr., c. 1950, is used at Miller Pottery, Brent, Ala.

Detail of electric wheel built from an automotive rear axle. Gerald Stewart Pottery, Louisville, Miss.

Detail of electric wheel built with parts of a locomotive steam-engine governor as balance weights. Cole Pottery, Sanford, N.C.

Although a few traditional potters now use a treadle wheel, southern potters long ago recognized the production advantages of mechanically powered wheels. They began to use them in the 1920s and 1930s when small gasoline engines became available. Some early wheels were individually powered by one-cylinder gasoline engines, others by a flat belt from an overhead shaft that drove several machines.

Despite a nearly universal reliance on electric motors, southern potters' wheels exhibit a variety of design. Some potters use commercially available wheels as they come from the showroom or modify them to suit individual needs, usually by adding a homemade crib of suitable size to replace the small slop pan provided. More often, however, they use wheels designed and built by themselves or their fathers or grand-fathers. From an electric-power source, they drive them with flat belts, V-belts, drive shafts, and gears; they control speed with clutches, variable-ratio pressure plates, cone drives, and rheostats; they build them from automobile rear ends, pieces of farm machinery, train parts, packing crates, or whatever else can be adapted. With one exception (Pisgah Forest Pottery), turners at traditional southern potteries stand at their wheels—a characteristic that may have its origins in the working require-ments of the treadle wheel, although most potters insist that they stand to turn because it is easier, faster, and more practical.

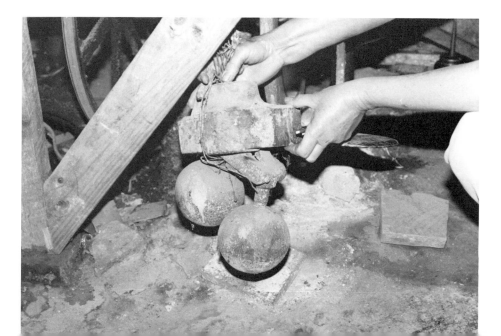

Glazes

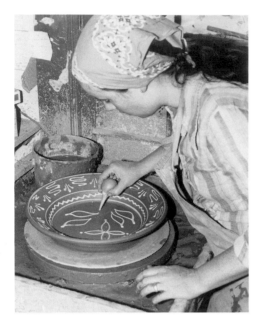

Mary Farrell slip trails decoration on earthenware plate. Westmoore Pottery, Seagrove, N.C.

Potters who settled in the southern Atlantic coastal colonies in the eighteenth century glazed earthenware with lead oxides, a glaze anciently known all over the world. These early potters used red clays that ranged from light to dark orange when fired under a coating of clear lead glaze. Ground iron, manganese, or copper oxides were sometimes added to the lead solution to provide brown, black, or green translucent glazes. Moravian potters in North Carolina decorated ware with slip clay colored by metal oxides, applied by brush or through a slip container onto leather-hard ware later coated with a clear glaze. The slip container—made of cow horns with quill points or clay globular funnels—had a small opening at one end through which the thick slip would slowly pour as the potter moved it to make the design. (Today a small rubber syringe is most commonly used for slip trailing.) While the Moravians used colored slip for elaborate decoration, other potters used the technique more sparingly to apply simple brushed decoration (see illustrations, pp. 241, 247). Since earthenware was not the most suitable ceramic for the large utilitarian pots needed on the frontier, potters settling in inland areas began to produce stoneware by the early nineteenth century. For the next hundred years, they glazed the ware with salt or ash.

Salt glazing by fuming originated in Germany in the fifteenth century and spread to Britain by the seventeenth century. It was brought to America by both German and English potters. The particular form of alkaline glaze used in the South is indigenous. Late in the great American stoneware period of the nineteenth century, the use of natural-clay slip as a glaze reached the South from industrialized northern potteries. The use of Bristol glaze made of commercially prepared chemicals soon followed.

When the economy changed in the more developed regions, particularly in the middle South after the First World War, the market for utilitarian wares declined and some potters began producing for a new market more refined tableware requiring elaborate glazes. These glazes fall into two categories: low-fire earthenware and midrange earthen- and stoneware.

Salt Glaze

Fuming a kiln with salt to obtain a glaze was a technique used throughout the North and Midwest and in the upper and Atlantic coastal states of the South. The technique was also carried to the Gulf Coast states by potters trained in the tradition and was used in Alabama, Mississippi, and Texas before 1850. In the large pottery center of northwest Moore and southeast Randolph counties, the location of central North Carolina's Jugtown, stoneware was glazed with salt almost exclusively from the mid-eighteenth century until the 1920s and sporadically later. It is still burned at Jugtown, Owens, Potluck, and Westmoore potteries.

The technique is simple in principle, requiring only a sturdy kiln able to reach high temperature, stoneware clay, and ordinary table salt. The actual process requires care and skill. The southern piedmont abounds in stoneware clay; the groundhog kiln can reach the necessary temperature; and salt has always been available. There is one problem, however: unless it has a high silica content, stoneware clay will not take salt well. Many stoneware clays are naturally high in silica, especially those that are sandy. Where the silica content was too low, potters added sand or, in recent times, powdered silica (flint).

To burn salt ware, unglazed pots are placed in the kiln. When the kiln has reached white heat, at 1,225 to 1,260 degrees Celsius (C/8 to C/10), salt is introduced into the ware chamber and instantly vaporizes. The sodium of the salt bonds

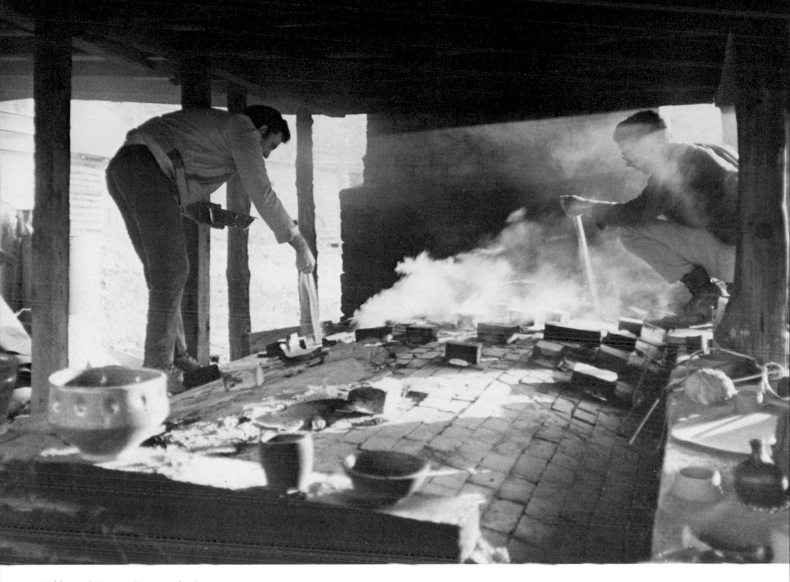

with the silica of the clay, when it is present in the right amount and sufficiently softened by heat, forming a sodium silicate glaze in tiny, clear droplets. The salt chlorine leaves the kiln as a dangerous gas. The degree of iron in the clay determines the pot's color, which may range from nearly white to lighter and darker browns if the fire is predominantly oxidizing, or lighter and darker grays if predominantly reducing. Sometimes embedded bits of iron spot the ware. Too much iron in the clay dulls the glaze and obliterates texture. Wood-fired salt-glazed ware made of clay with low iron content is gray because the atmosphere of the kiln is being sporadically reduced of oxygen content as the flame consumes it. When there is insufficient oxygen, the fire robs the iron in the clay of some of its oxygen, changing the iron from its natural condition as ferric oxide (Fe_2O_3) to ferrous oxide (FeO). The chemical change turns iron from a rusty brown to a light, sea green. (The famous celadon glazes of the Orient are of similar color and result from the same process.) Sodium is a potent alkaline flux at high temperatures and reaches into the clay to bond with the softened, free silica molecules. This action affects not only the pot's surface but penetrates the pot's body to a certain depth. (Most glazes bond only lightly at the interface with clay.) Glaze and clay thus unite revealing simultaneously the pot's clay form and richly textured, tactile surface. Potters often comment that their pots are best when fresh off the wheel, slightly shining with wet clay. A finished pot glazed with salt nearly duplicates this state.

Jar with finely grained salt-glazed texture, by M. L. Owens, Seagrove, N.C.

Jug with fine and heavily grained salt-glazed texture, by Charles Craven, Raleigh, N.C.
Photograph by John Grimmett; courtesy Randolph Technical College.

Pitcher with heavily grained salt-glazed texture, by D. X. Gordy, Greenville, Ga.

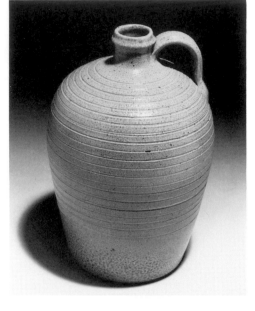

Ware to be salt glazed is either set in the kiln on a single level or stacked with clay separators. Because salt vapors do not descend into a pot, early ware received only a light glazing on the interior. A vitrified pot is watertight without glaze, but some ware did not reach a fusing temperature in the cooler parts of a groundhog kiln and remained slightly porous. In the late nineteenth century, southern potters began lining salt ware with Albany slip to seal the pots and make them easier to clean.

Alkaline Glaze

Because alkaline ash glazes were made of local materials in shops throughout the entire Deep South, they exhibit widely diverse appearances. Ash glazes were developed by potters of ancient times who saw how a glossy skim was formed from fly ash on the shoulder of a pot during the firing of the kiln. Ash alone will melt and run off a pot during firing, but the addition of clay gives body and adherence to the glaze. Sand, found naturally in much clay, adds silica, making the glaze clear and glossy, with less tendency to scum. Early alkaline glazes were made of ash, clay, and sand. This combination was used in Edgefield, South Carolina, by about 1810-20 and is the same formula used in glazes made during the Han Dynasty in China (206 B.C.–A.D. 220). While there is a possibility that published material on Chinese alkaline glazes had reached South Carolina, it is considered more likely that the southern alkaline glaze is of local origin. From 1810 to 1860 use of the glaze spread from Edgefield north to western North Carolina, south and west through northern Florida, Georgia, Alabama, Mississippi, and Texas. The tradition reached its peak in the last quarter of the nineteenth century.

Alkaline glazes are glossy and either transparent or translucent; the amount of iron in the clay determines the darkness of the color: light to deep brown in oxidation; watery blue green or yellow green, olive or even black in reduction. Areas of glaze sometimes show iron red, sometimes a milky white with light blue, resulting from iron containing titanium and calcium. Southern alkaline pots are generally streaked where the glaze has run, a characteristic mark of wood ash when it settles on an unglazed pot in a wood firing. If the glaze is very finely ground it has no

Alkaline-glazed flowerpot, by Cheever Meaders, Cleveland, Ga., 1960s. Photograph by Tom Jackson; courtesy W. J. Gordy.

Four-handle jar, with glaze made of ash, glass, and clay, by B. B. Craig, Vale, N.C. Photograph by Kay Stroud; courtesy Randolph Technical College.

Three-gallon buttermilk pitcher, with glaze made of ash, clay, feldspar, and whiting, by Lanier Meaders, Cleveland, Ga. Photograph by Rob Griffin; courtesy Randolph Technical College.

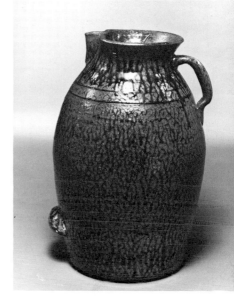

texture. Fortunately, the old stone grinding mills or querns were imperfect. As a result, the pots have a vital and visually exciting surface.

Alkaline glazes have been fired traditionally with wood in groundhog or railroad-tunnel kilns to high temperatures (1,225 to 1,310 degrees Celsius). Since the glazes are frequently runny, the ware is set single level on a sand bed. Various additions or substitutions have been made to the base glaze; iron cinders from foundry waste piles were sometimes added; slaked lime replaced or was used together with wood ash, resulting in lighter color; black iron sand was added; salt was introduced to lighten the color and lower the maturing temperature of the glaze; crushed glass was used in addition to—or sometimes as a substitute for—wood ash. In recent years the tradition has been carried on only by the Meaders family in north

Glass crusher. B. B. Craig Pottery, Vale, N.C.

Burlon Craig's water-powered glass crusher works like a seesaw. To a heavy, wood beam, which rests on a pivot, is bolted a steel bar at one end and a wood box at the other. Placed near a creek just downstream from a low dam, the glass crusher's box fills with water piped from an impoundment. As the box fills, the weight of the water presses that end of the beam down, lifting the end with the steel bar high above another small wood box filled with glass. As the water-filled box drops lower and lower, it dumps the water out; the other end of the beam falls, and the steel bar slams into the box full of glass. Immediately, the water box begins to fill again and the cycle is repeated. The crusher reduces old windowpanes, bottles, and other scrap glass to a fine powder for use in glazes.

WATER FLOWS INTO THE BOX, THE WEIGHT RAISES THE OTHER END OF THE POLE—

METAL ROD

—WHEN THE WATER DUMPS OUT OF THE BOX AT THE OTHER END, THIS END DROPS INTO THE BOX OF GLASS

BOTTOM OF BOX IS METAL

Georgia and by Burlon Craig in western North Carolina. Burlon Craig makes his glaze of glass, ash, clay, flint, and feldspar and grinds it between rocks; Lanier Meaders makes his glaze by mixing ash and clay with feldspar and whiting and simply screens the ashes (see illustration, p. 109).

Clay Slip Glaze

From the earliest days, southern potters experimented with local clays as slip glazes with only limited success. A clay that will melt into a glaze before the body clay vitrifies must be finely grained and contain a strong fluxing agent and a low content of alumina, a very refractory mineral. The Romans and Greeks made their fine slip, *terra sigillata*, by washing and decanting clays until only the finest grain remained. This process can be used to make slip glazes of many clays, but southern rural potters preferred not to undertake such a painstaking process, although in the 1930s North Carolina potter Jacon Cole did experiment with making his own slip glaze by this method. Slip glazing did not enter the southern repertoire until Albany slip (a fine siliceous calcium and iron-bearing clay dug from glacial beds in Albany, New York) reached the South via developing railroad networks in the late 1800s. By that time large production potteries across the country were using Albany-, Michigan-, or Indiana-slip clays for glaze. It was shipped in lump form, made liquid, and strained before use. In a tub of glaze, potters dip and swirl the dry, raw pots, catching both inside and outside in one movement. Bottoms and rims are wiped clean of wet glaze so that the pots may be stacked.

Essentially composed of clay, slip glazes shrink evenly with the pot and fit like a skin. Their high iron content causes the glaze to burn a rusty or dark brown, this color may be lightened to a greenish amber by the addition of calcium or to a frogskin green by a light salt fuming. Because of its close fit and absence of crazing,

Jerry Brown dips a beanpot in a tub of glaze.
Photograph by Joey Brackner.

Hattie May Brown sponges glaze off the bottom of a beanpot.
Photograph by Joey Brackner.

Jerry Brown scrapes glaze from the rim of a beanpot with a specially shaped tool.
Photograph by Joey Brackner.

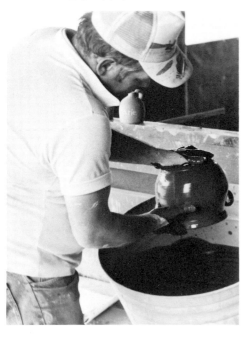

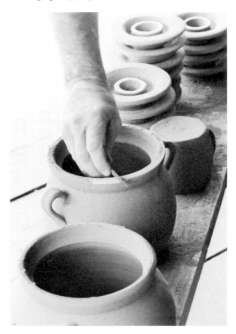

Albany-slip glazed jug, by Norman Smith, Lawley, Ala.

Albany-slip glazed miniature churn, by Marie Rogers, Meansville, Ga. Photograph by Dennis Chambers; courtesy Randolph Technical College.

Albany-slip glazed churn, by Gerald Steward, Louisville, Miss. Photograph by Susan Jones; courtesy Randolph Technical College.

many potters used a slip glaze as a liner to make their sometimes porous salt-glazed ware watertight.[1] The smooth surface of a slip-glazed pot is easily cleaned and has a soft, satin quality. One of the most satisfactory stoneware glazes, Albany slip is highly regarded by potters for its fit and finished appearance, which, like salt glaze, reveals subtleties of form. Slip-glazed ware is currently produced by Jerry Brown, Eric Miller, and Norman Smith in Alabama; Marie Rogers in Georgia; and Gerald Stewart in Mississippi. Salted Albany slip or frogskin is made at Jugtown and West-moore potteries in North Carolina.

Bristol Glazes

Industrialization led to the mining and processing of various glaze ingredients. Bristol glazes were developed to replace both lead and salt glazing in England during the reign of Queen Victoria when an awareness of the importance of hygiene was spreading. Bristol glazes are smooth, durable, and safe; the glaze is thick, white or creamy, and, while dependable, is bland, lacking surface texture, depth, or variation. During the late nineteenth century, southern potters often used Albany slip with Bristol to make a two-color jug: the dark Albany sealed the inside of the pot and covered the shoulder, the white Bristol coated the lower two-thirds of the outside of the pot. Later, Bristol glaze was used exclusively in many potteries and is still used, with bands of decorative blue added at the Marshall Pottery in Texas.

Bristol glaze is made of calcined zinc oxide, whiting, feldspar, and China or ball clay. Because of its high clay content, Bristol glaze can be used on raw ware and for this reason is sometimes referred to as Bristol slip. Bristol glazes mature at low stoneware temperature, 1,135 to 1,190 degrees Celsius (C/2 to C/6). The combination of zinc and calcium oxides forms a eutectic melting point (i.e., two oxides combined in specific proportions melt at a lower temperature than either melts alone). There are many variations of the Bristol-type glaze, some opaque, some almost transparent. In the early twentieth century, a glaze solution with color oxides (usually blue) was sponged on top of the ware just after it was dipped in the plain

glaze, resulting in a dappled decorative effect called spongeware. Color was also occasionally added to the glaze solution: cobalt for blue, copper for green, and iron for brown.

Contemporary Glazes
In this century, the ceramic industry has advanced greatly in its knowledge of glazes. Today's southern potters producing homeware have made use of this knowledge and of commercially available glaze materials.

Earthenware (945 to 1,110 degrees Celsius [C/08 to C/01])
In some parts of the South, lead-glazed "dirt dishes" were made in small quantity throughout the stoneware period. When the change was made to decorative garden and homeware, more complex earthenware glazes were developed made of many minerals, fluxed with white lead carbonate, and opacified with tin, zircon, or rutile.[2] Similar glazes are used today fluxed with frits. Some earthenware potters have raised their firing temperature to eliminate the use of lead and to harden their ware.

Intermediate Range (1,165 to 1,210 degrees Celsius [C/4 to C/7])
Depending on the pottery form and glaze formula, ware in this range is considered to be either high-fire earthenware or low-fire stoneware. The glaze structure is complex. To lower the maturing point of refractory minerals, alkaline compounds (such as calcium, sodium, or potassium), boron, or zinc oxides are combined with feldspar, flint, and clay. Some glaze material may be contained in frits that potters either buy or make. Bright earthenware colors and subdued stoneware colors may be obtained at this temperature. This intermediate ware is more durable than low-fired ware and more economical to produce than high-fired ware.

Stoneware (1,225 to 1,310 degrees Celsius [C/8 to C/12])
Today six shops produce traditionally glazed stoneware in addition to glazed earthenware. Three shops produce only stoneware or porcelain with glazes that they have developed.

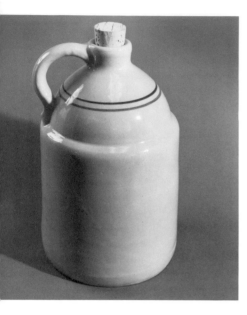

Bristol-glazed shoulder jug made at Marshall (Tex.) Pottery. Photograph by Ed Westcott.

Pitcher with fritted earthenware glaze, by Virginia Shelton, Seagrove, N.C. Photograph by Glen Tucker; courtesy Randolph Technical College.

Candlesaucer with fritted, rutile earthenware glaze, by Nancy Owens Brewer, Seagrove, N.C.

Beanpot with Albany-slip-based earthenware glaze, by Daniel Garner, Robbins, N.C. Photograph by Rob Griffin; courtesy Randolph Technical College.

Fritting furnace. Shearwater Pottery, Ocean Springs, Miss.

The Shearwater Pottery fritting furnace, designed and built by Peter Anderson in the 1930s, is used to produce both soda and boron frits by melting powdered minerals together in a crucible. The circular furnace, overall about four feet wide, consists of a kiln chamber with attached firing channel, set on a separate foundation, covered with a lid that is lifted by an overhead steel cable and pulley.

The crucible is made of two jiggered pots—a bowl with a flowerpot turned upside down in it. A small hole is pierced through the bottom of the bowl and several holes are pierced near the top of the flowerpot rim, which is then placed in the bowl upside down; the two are joined while the clay is still pliable. The crucible is then dried and fired and placed in the chamber directly over the drain hole in the foundation.

The powdered ingredients to be fritted are wrapped in paper packets and poured from a trough through the lid of the heated furnace into the crucible where they melt together to form a liquid glass. The glass runs through the openings at the base of the bowl and pours in a stream down the foundation hole into the bucket of water beneath. When the molten liquid hits the cool water it instantly solidifies into rough lumps of glass. The glass is later ground to a fine powder in a ball mill and is then ready for use as a glaze ingredient.

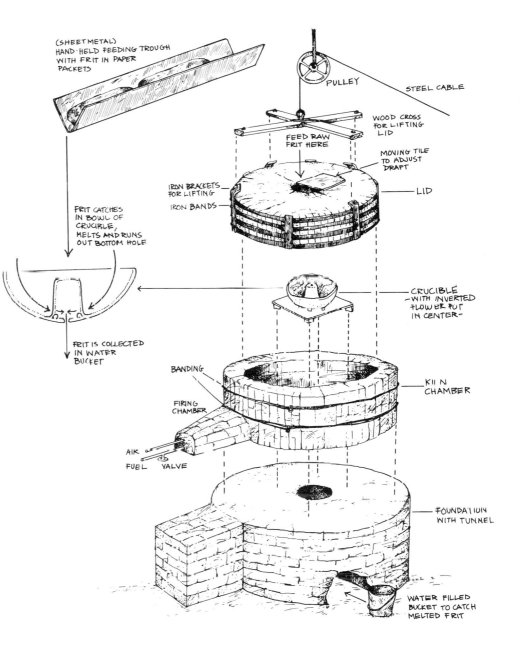

Kilns

The kiln is the heart of any pottery. Here, in the fire, the potter works a final alchemy, converting the base minerals of clay and glaze into vessels of utility and beauty.

The earliest European kilns were round and open at the top. Throughout the Roman Empire, rectangular kilns were used to fire bricks and tile. When kilns were first roofed, holes were left in the arch to allow flame and smoke to escape; at some unknown date, a chimney was added. After the thirteenth century, rectangular kilns were used throughout Europe for the burning of pots as well as bricks. Potters in Britain continued to use the round kiln, which eventually evolved into the enormous industrial hovel and bottle-shaped kilns of the Midlands. During the Industrial Revolution kiln design improved greatly: refractory bricks were made for high-temperature kilns, construction was tightened and reinforced, and downdraft firing was begun. Downdraft is produced by forcing flame and heat downward through the ware, instead of allowing it to simply follow its upward rise. Flame crosses the ware twice, first on its natural rise to the arch and then again as it is drawn downward through a latticed floor to flue areas below, which connect to the chimney. Downdraft firing results in more complete heat circulation and even burning of pottery set throughout the ware chamber, while consuming less fuel because the flow of heat out of the kiln is slowed.

While improved kilns were known by potters in Britain and Europe, southern potters were faced with frontier conditions that restricted them to simplified, roofed kilns suitable for the production of coarse utilitarian ware. Since it was imported, fine tableware, which would have required elaborate kilns, was not produced by local potters. One of the earliest and the most consistently used kiln was the crossdraft groundhog. It was modified in the late nineteenth century into the railroad-tunnel kiln and after the First World War into the rectangular kiln. By the end of the nineteenth century, downdraft beehive kilns were constructed in the South.

Many variations of the basic rectangular and round kilns have been developed throughout the South and a few wood-burning kilns are still in use. Most potters today burn ware in tunnel, rectangular, or round kilns with modern fuels (oil or gas), while others, particularly older potters, use commercial gas or electric kilns.

Groundhog Kiln

A European rectangular kiln developed in Germany in the fifteenth century was the predecessor of the southern groundhog kiln. American potters simplified and adapted the shape to meet local needs and conditions. The downdraft flue system beneath the floor was eliminated and the kiln was made smaller to suit part-time family potting. While the European kiln had an earth embankment along its side walls, the shallower groundhog was built underground, making use of the natural hillside slope for structural support and insulation. The groundhog is essentially a large flue laid horizontally into sloping ground, with a firebox lower at the open end of the slope and a chimney higher at the other end of the rectangle. Only the arch, kiln face, and upper chimney are exposed. It is most commonly sixteen to twenty feet long and six to eight feet wide with a chimney ten feet high.

The construction of a typical groundhog kiln is begun by digging a rectangular shape into a hillside and leveling a floor for the ware bed and chimney, sometimes with a gradual rise of eight to twelve inches toward the back to aid the flow of heat. Around and below the floor level a brick foundation wall is laid and then extended above floor level for low side walls, ten to twelve inches thick. Side walls are from eighteen to twenty-four inches high, except in the very low single-shot kilns (see

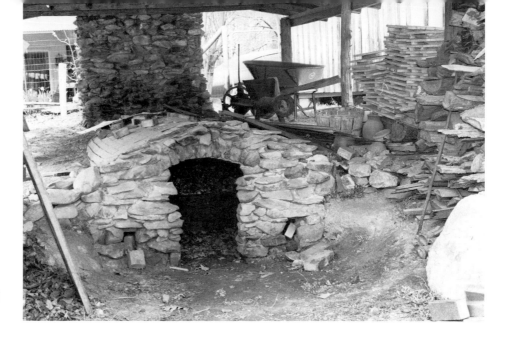

*Dug into the earth for insulation and
support, groundhog kilns were popular
throughout the South in the nineteenth
century.*

*Small groundhog kiln with stone face and
chimney. Seagrove (N.C.) Potters
Museum.*

*Large groundhog kiln. Teague Pottery,
Robbins, N.C., c. 1930; B. D. Teague is
unloading glazed jars.*
Photograph courtesy B. D. Teague.

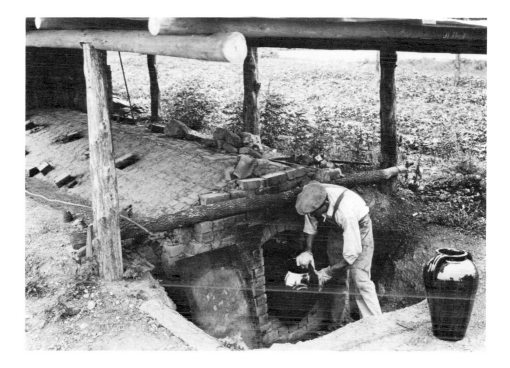

*Groundhog kiln. Cole Pottery, Seagrove,
N.C., 1920s.*
Photograph courtesy Dorothy Auman.

illustrations, p. 90). A low arch is sprung from the side walls usually by means of skew bricks. These lie flat on the wall but are cut diagonally on the upper side to start the curve of the arch. Arch bricks are laid lengthwise as headers or flat as stretchers over a series of flat half-moon wood shapes cut to the desired arc and held upright by lengths of wood lath. The whole framing structure stands on wood posts. To complete the arch, the wedge-shaped spaces between the bricks are filled with brick chips in a mix of fireclay and sand mortar. When the mortar is set, the frame is unpropped and removed or left to burn out. The center line of bricks at the top, from which the arch slopes downward on both sides, are the key bricks, referred to by potters as the backbone of the arch. The interior arch height is not more than thirty-six inches from the floor, tapering down to about eighteen inches on the sides. A

Rebuilding arch of earthenware groundhog kiln. Jugtown Pottery, Seagrove, N.C. 1968.

Kiln with old arch torn out; note firebox in front and flues leading to chimney.

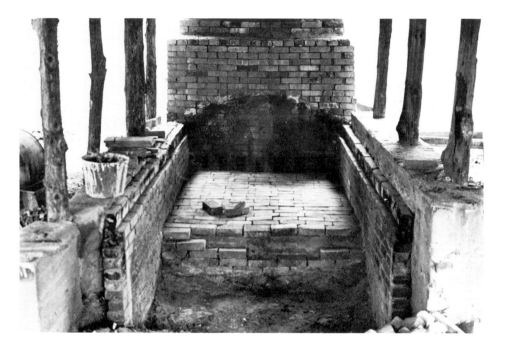

Rebuilding brick arch over frame of wood arch boards.

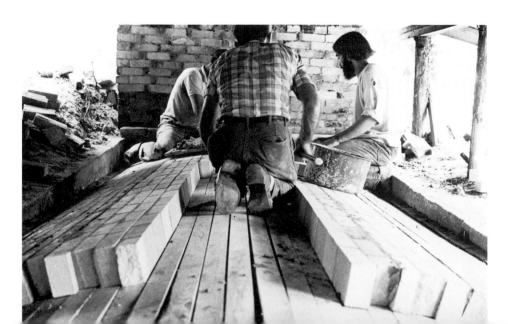

Dropping and removing frame from beneath completed arch.

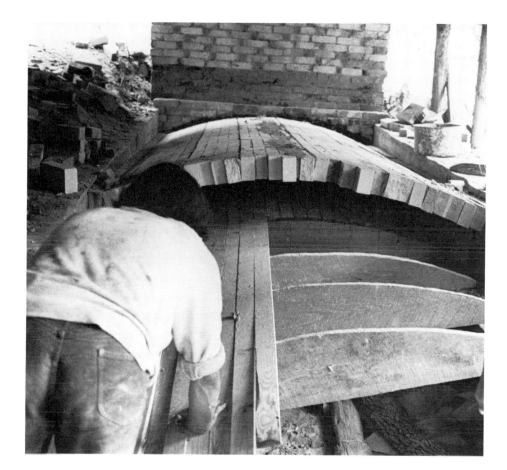

Groundhog kiln. Jugtown Pottery, Seagrove, N.C.

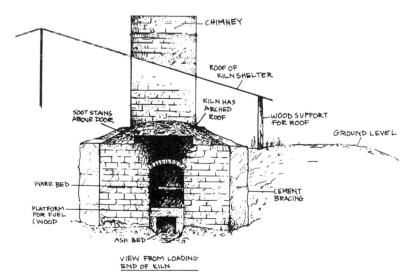

buttressing wall is built out sideways from the firebox to brace this chamber, which receives the most heat stress, and to contain the forward thrust of the earth surrounding the body of the kiln. This buttress may be built of rock or poured concrete. Salt kilns have a series of portholes spaced out over the length of the arch on both sides. They are covered with loose brick until they are opened briefly for salting.

The firebox floor is built at or beneath ground level, eighteen to twenty-four inches below the ware bed. It runs the width of the kiln and is four feet deep to provide sufficient space for the burning of large logs and slabs of wood. The firebox commonly has one mouth for entering the main chamber and for stoking. To facilitate stoking in especially wide groundhog kilns two additional fire mouths are built. These openings may have interior flues for long logs to insure proper heating of the ware-chamber walls. Two or more portholes are built into the lower portion of the kiln face to aid combustion. A recent modification is a grated floor of large firebrick, through which ash falls and is easily removed, relieving ash buildup and increasing combustion.

Although they may taper as they rise, chimney stacks are usually straight and not more than ten feet high. The base of the chimney is built along the width of the kiln at ground level. The height of the stack determines its drawing power. Since the groundhog is a long, jogged flue, a tall stack would draw strongly, heating pots at the front too rapidly and cracking them. In the first firings of a kiln, potters often adjust the stack height, according to whether the kiln burns too rapidly or too slowly. To further protect the ware from sudden or excessive heat, a bag-wall or baffle of loosely set bricks or damaged pots is built twelve inches or higher at the front edge of the ware chamber. Flame is drawn over the top and through slits in the baffle and then down through the pots to the chimney flue.

The flue opening on an early groundhog kiln was simply a continuation of the arch with the front wall of the chimney built around and resting on the arch. To slow the draft, unglazed flowerpots were stacked at the end of the ware bed and on the chimney floor. In later years, the groundhog chimney has been built with interior footings made of brick stacked vertically or laid in arches, leaving a row of flue openings in the chimney base and providing support for the interior chimney wall.

The ware chamber, usually ten to twelve feet long, is coated with several inches of sand or small quartz rocks called flint stone. Salt-glazing potters burn large quartz rocks that on cooling readily shatter when hammered and are then scattered over the floor of the ware chamber. As pots sit on the jagged stone points during a firing, salt fumes circulate freely beneath them, glazing the bottoms. The sharp flint stones gradually salt together and must be beaten apart and eventually replaced. Potters burning alkaline glazes use sand on the ware bed to prevent pots from sticking onto a solid substance.

Potters made their own brick through the nineteenth century and some have continued to fire brick in scove kilns in the twentieth century. Made of fireclay mixed with straw and formed in wood molds, the handmade bricks usually were eight inches square and four inches thick (modern commercial bricks are eight by four by two inches). Unfired brick was stacked in rows on cleared ground, the whole structure was honeycombed with narrow draftways surrounded by a solid brick frame tightly daubed with clay. In large scove kilns, two hundred thousand bricks were burned in a rectangle more than fifty feet long with a chimney in the middle and firebox stoking holes placed every ten feet. The kiln was heated slowly until the bricks glowed cherry red at about 815 degrees Celsius. The firing of a scove kiln of this size took almost a month. Smaller scove kilns were more commonly built at the rural potteries, burning fewer bricks over seven to ten days.

G. F. Cole describes brick making in his father's shop in Seagrove in the 1920s (the bricks were to be used in building a groundhog kiln):

You'd make the mud just like mixing'cement in a wheelbarrow; mix in a little straw to make it open, a little sawdust with a hoe. You made several boxes the size of the brick you wanted, put a little motor oil in at the start to make it slick. Pack the box with the brick clay, hold it by the two side handles, turn it upside down, and the brick would pull right out. We'd scoop and scrape the ground to where it was level—an area big enough for two houses. You'd turn the wet brick over on that to dry. The brick that went into the sides [of the groundhog kiln] were four inches thick, ten inches wide, and eighteen inches long. The ones that went over the top were smaller, same as regular brick except they were eight inches thick instead of four inches. You stood them up on end in the arch. For the arch and firebox, the brick were made of stoneware, which would stand more fire than the red clay.

Sometimes potters saved time by building their kilns of raw, unfired brick and then burning them in place. Often the outsides of the raw brick never became hot enough to burn off the water chemically combined in the clay, a physical change that occurs between 350 and 500 degrees Celsius making clay irreversibly nonplastic. Thus, the brick surface remained powdery, unfired clay. In building kiln walls, where raw bricks are laid next to clay banks, their surfaces would meld with the ground clay, while bricks on the arch smudged together at the top, loosing their individuation.

With steady use, the arch of a salt kiln must be rebuilt every year or two. The constant upward lift in heating and downward settling in cooling inevitably causes unevenness and cracks. Eventually a brick, or, more likely, a group of bricks, swags down too low to be held by the arch tension and gives way. From numerous firings the whole interior of a salt kiln becomes so heavily glazed with accumulated salt and ash (further fluxed by the iron content of the brick) that this glaze becomes fluid in each firing and drips onto the pots. Before they rain down too constantly—indicating heavy kiln use and a weakening arch—the drips often make handsome dark markings on the pots.

After the ware has been set in the kiln (commonly on one level, although small wares may be stacked one on another), the firebox may be partially sealed with bricks leaving an opening for stoking. Sheet metal is usually propped over the fire mouth between stokings.

The burning begins slowly with a small fire to warm the pots and kiln and drive off moisture. This slow fire is often kept burning overnight and prevents the pots from cracking because of sudden changes in heat. Then the potter is challenged to bring the fire to its height with intermittent feedings of increasing frequency. The kiln heats throughout to a deep red glow, to orange, and finally to yellow, until it is ready for the blasting-off period of almost constant stoking. The drama is increasingly vivid, as flame stands out of the portholes and rages eight to ten feet above the chimney. Its rush from the firebox creates a roar. At this level of white heat the temperature increases slowly; the clay of the pots verges on translucency; the glaze is in a viscous, liquid melt; the stoker is wet with perspiration and ruddied by heat. When the heat is not advancing, potters say the kiln is "hanging fire." This intense period lasts two to three hours, usually into the early night.

Judging the fire is an intuitive act, demanding a full play of the potter's senses and memory of other firings. His expertise is based on many factors: the prior performance of the kiln in a particular firing, the load of the kiln, the weather, the color of the heat. The melting of glaze cones, either commercial or homemade of dried glaze, or test pieces hooked out of the kiln may aid the potter. These clues provide only partial evidence, as sudden flame may melt glaze in one area and not

another or fell a cone. Among all the complexities, a potter must develop and rely on an innate sense of timing, a "feel" for when the firing is finished. The drama reaches a climax when the stoking is stopped and the kiln mouth is sealed tightly, but the outcome is uncertain while the kiln cools for two or three days. Then a plank is balanced through the door over the hot firebox bed for the potter to crawl across and reach the pots. Drawing (or unloading) is done by two or three people together, handing the ware from the chamber through the firebox and on out to the ground.

When ware is to be glazed by salt fumes, the potter tests the pot's readiness by sprinkling a little salt through the arch ports onto the shoulder of a pot set just beneath the hole. If the salt melts and runs as it hits the shoulder, the clay is ready and salting begins. Salt will vaporize at 800 degrees Celsius, but the silica content of the clay must be sufficiently softened to bond with the sodium, which occurs in most stoneware clays at 1,200 to 1,260 degrees Celsius. Salt is then funneled, often through a clenched fist, into each port up and down both sides of the arch. Immediately the noxious vapor of hydrochloric acid, which has separated from the sodium, issues in white clouds from all kiln openings and is followed by intense black smoke. Since salt damps the fire, it must be built up again before the second and third saltings. Near the end of the firing, salt may be shoveled through the firebox into the front of the ware bed; then before the kiln is sealed a final stoking melts any accumulated salt on the interior of the pots. More salt is required in a newly built kiln and less as it ages, since an older kiln's interior coat of salt also fumes.

Although the potters in the Jugtown, North Carolina, area use a mixture of pine and hardwood to fire their groundhog kilns, most wood-burning kilns are burned to stoneware temperature with fast-burning, resinous yellow pine. Formerly, small logs and split pine were burned; today, slabs and sawmill scraps fuel the kiln. In firing wood, the kiln atmosphere alternates between oxidizing and reducing throughout the burning (see discussion, p. 32, n. 6). Reduction occurs when the flame, which feeds on oxygen, consumes what is in the chamber and then starts drawing it from any source, including the minerals contained in clay and glaze, which change color when robbed of oxygen.

The groundhog kiln has two disadvantages: it burns unevenly because its heat source is only at one end and it may collect water because it is set in a hole. To obtain a more even heat circulation throughout the kiln, some potters have built flue spaces beneath the ware floor that lead to lowered openings in the chimney, forcing heat to move more fully through the ware in a partial downdraft. Others have simply dug a narrow trench at the rear of the ware bed and lowered the openings to the chimney. Potters burning this crossdraft kiln work with the wide temperature range by placing pots that must be watertight in the hottest front and center areas.

To rid themselves of the water problem—reported to have been at times severe enough to require the bailing out of a firebox—potters learned to build the same kiln above ground, constructing a dirt bank tightly around it. Earth is shaped to slope away from the kiln sides, and ditches are dug to channel off water coming from higher ground behind the kiln. Early kilns were built in the open. When potters later built shelters over them, water was deflected from the immediate ground around the kilns, resulting in less seepage into the kiln. Currently groundhog kilns are used at Jugtown Pottery for salt firing and at the Burlon Craig Pottery for alkaline glazing.

Railroad-Tunnel Kiln

The placement of the groundhog kiln entirely on top of the ground was an intermediate step toward the railroad-tunnel kiln. The shape was designed in 1890-1900 and is still in use today. Built on level surface ground, it has high side walls, which may be partially banked with earth but are essentially shored with timber and rock. The degree of the arch arc varies, with a steeply curved arch it is referred to as a "hog-

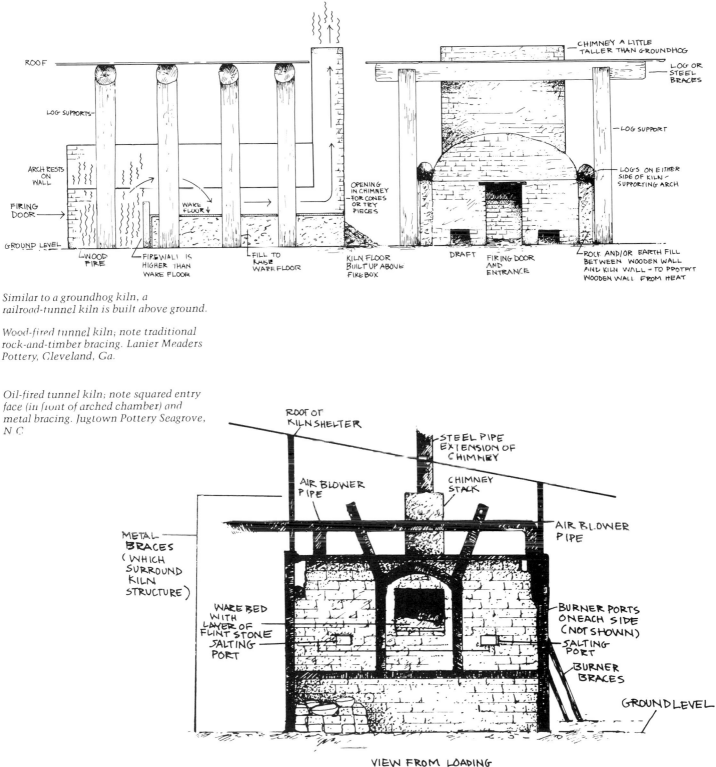

Similar to a groundhog kiln, a
railroad-tunnel kiln is built above ground.

Wood-fired tunnel kiln; note traditional
rock-and-timber bracing. Lanier Meaders
Pottery, Cleveland, Ga.

Oil-fired tunnel kiln; note squared entry
face (in front of arched chamber) and
metal bracing. Jugtown Pottery Seagrove,
N.C.

Large wood-fired tunnel kiln with metal-and-wood bracing. Norman Smith Pottery, Lawley, Ala.

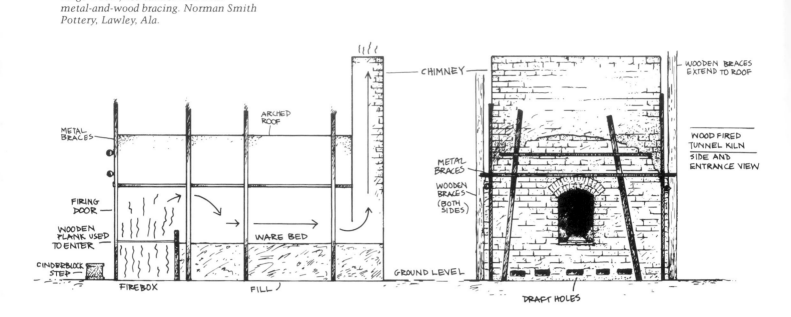

Interior of tunnel kiln; note sand floor, flues to chimney, and high arch. Jerry Brown Pottery, Hamilton, Ala.

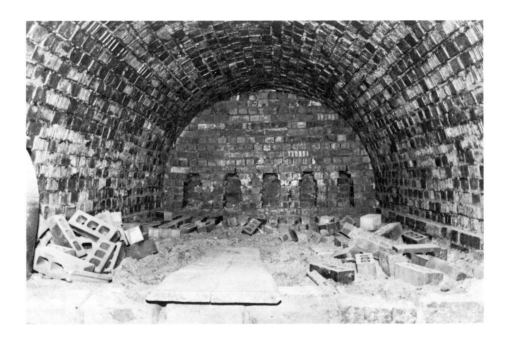

back." By building the walls higher and/or making the arch steeper, stacking space is increased. The firebox remains lower than the ware bed, and the raised chimney height provides more drawing power for the larger volume of heat.

In the Deep South, where this kiln is used to fire utilitarian ware, a low, narrow preheating firebox is sometimes built out from the kiln face to channel heat through the main firebox into the ware chamber. Such distancing of the warming fire assures the gradual heating of large ware to prevent cracking.

*Preheating firebox, which must be built
and torn down for each firing.*

*In constructing preheating firebox, Jerry
Brown daubs opening of main firebox
entry with clay.*
Photographs by Joey Brackner.

FIRE BRICK

STEEL PIPE
BRACE

COMMON
BRICK

FIREWALL

FIRE BOX
(INSIDE KILN)

PREHEAT
FIRE BOX
(OUTSIDE KILN)

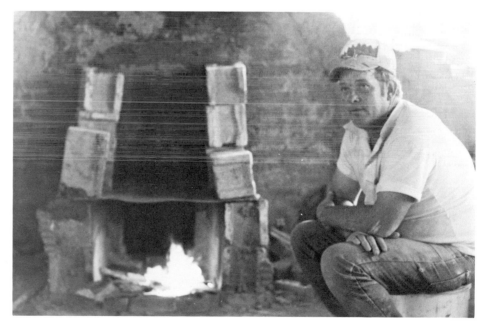

Jerry Brown with preheating fire just lit.

During the early nineteenth century, southern potters were relatively self-sufficient, relying on farming and intermittent potting to provide them with a livelihood. After the Civil War and during the Reconstruction, the South increasingly developed a cash-based economy. To acquire dollars, southern potters began full-time production of ware in quantity. With the same-size floor space as the groundhog kilns, the larger railroad-tunnel kilns could accommodate more pots, stacked in vertical rows, thereby entailing only a minimal increase of labor and fuel to achieve a larger firing. It is also easier to load. In the crawl space of a groundhog, the potter must set the ware while lying on a hip and balancing on an elbow; in the four-foot or higher tunnel kiln, the stacker can sit or crouch, half upright.

In the tunnel-kiln chamber, Albany- or Bristol-glazed ware is stacked foot to foot or rim to rim after contact areas are wiped free of glaze. In salt kilns of this shape, pots are stacked with clay separators: wads of sand-dusted clay rolled into snakes or balls (either soft or preformed and dry). The clay wads prevent pots from sticking together and help balance the stack. Jerry Brown and Norman Smith of Alabama, Danny Marley of North Carolina, and Gerald Stewart of Mississippi currently use this kiln type for burning slip-glazed stoneware with wood or gas; D. X. Gordy of Georgia uses his version of the kiln for burning porcelaneous stoneware, with external twin fireboxes for wood or coal, which lead to internal-combustion chambers parallel to the ware bed. Flues beneath the ware bed lead to an unusually tall chimney. Lanier Meaders and his brother Edwin of Georgia burn alkaline-glazed stoneware with wood in a tunnel kiln.

In recent variations, kilns are downdraft; supports are made of metal not timber; fireboxes are eliminated; and gas or oil burners are placed through the side walls. In North Carolina, Westmoore Pottery burns stacked salt glaze with gas; Jugtown Pottery burns salt glaze with oil, setting larger pieces on a single level and smaller pieces on stilts placed on high-fire carborundum shelves; Owens Pottery uses oil to burn glazed ware set on shelves at low-stoneware temperatures.

Lanier Meaders stacks alkaline-glazed ware, single level, in tunnel kiln.

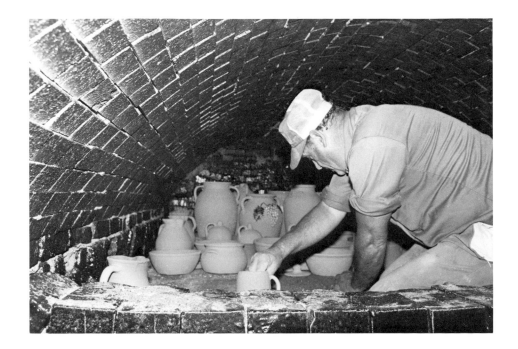

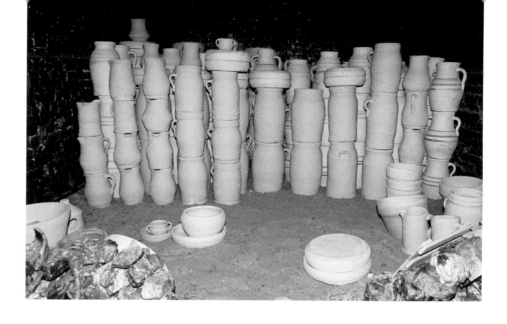

Albany-slip glazed ware in partially stacked tunnel kiln. Norman Smith Pottery, Lawley, Ala.

Rectangular Kiln

The earliest European rectangular kilns were burned updraft, without a chimney; later in a crossdraft, to a stack; and finally downdraft. While a tall, rectangular, updraft kiln was used in Europe and Britain for centuries, the low upright rectangular kiln first came to be used in the South as an evolution of the railroad tunnel kiln and was eventually designed with a downdraft. While the groundhog, tunnel and for bigger shops, the round, beehive kiln—ably served the makers of utilitarian ware, those potters who began to produce decorative and horticultural ware in large quantities during the 1920s and after needed more firing space. They shortened the familiar groundhog/tunnel shape; raised it from a horizontal to a vertical form, tall enough inside for the potter to stand or stoop; and topped it with a low, sprung arch. The kiln has a door entrance and is called a walk-in kiln. Its height requires more than log-and-stone buttressing to prevent the walls from buckling in heat expansion, so the upright rectangle is bound around firmly by metal strapping attached to metal posts set in the ground. The support may be tightened by chains or screw bolts.

Rectangular, upright, downdraft kilns were increasingly popular beginning in the 1930s.

Oil-fired rectangular kiln. Jugtown Pottery, Seagrove, N.C.

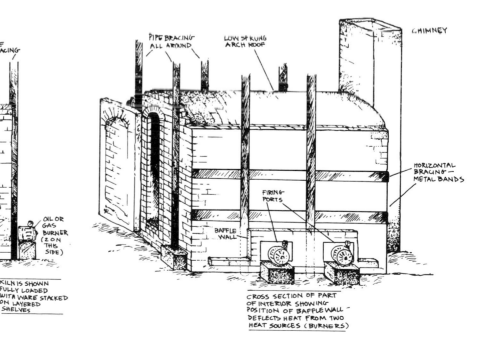

Round, beehive, downdraft kilns were popular during the late nineteenth century.

Two types of beehive kilns. Left: Connor Pottery, Ashland, Miss. Right: Boggs Pottery, Prattsville, Ala.

Round Kiln

Colonial northern potters preferred to use a round kiln, a familiar shape brought from Britain. As the early kilns evolved from an updraft to a downdraft system, the use of round kilns spread from the Midwest through Tennessee and into the South

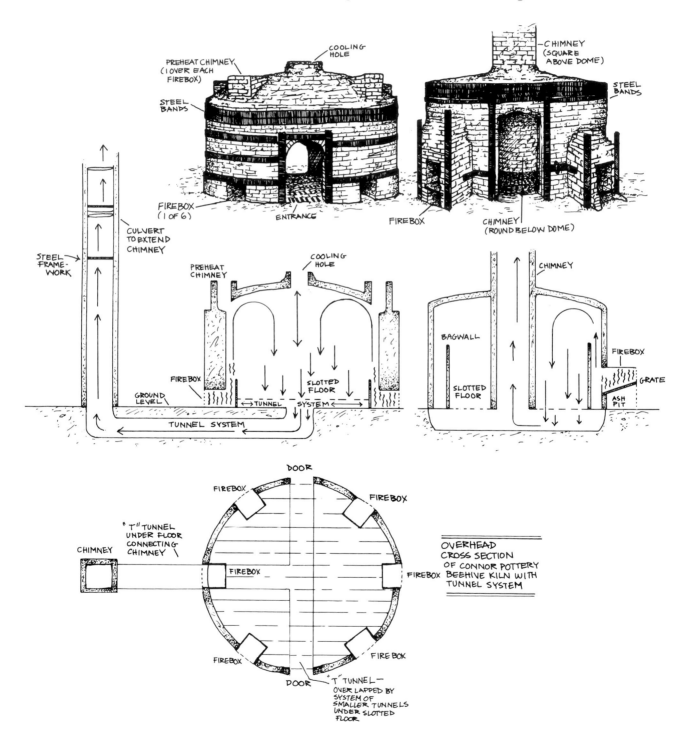

Interior of Connor beehive kiln; note interior fireboxes and flues, which are opened for updraft warming and closed for downdraft firing.

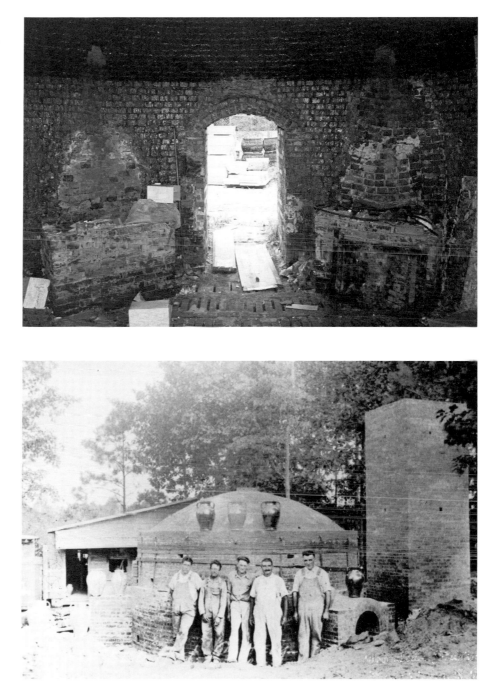

Beehive wood-burning kiln. Smithfield (N.C.) Art Pottery, 1930s.
Photograph courtesy Dorothy Auman.

between 1875 and 1900. The low, domed kiln, frequently referred to as a beehive kiln, was built of circular brick walls stabilized by steel bands with fireboxes equidistant around the exterior. Usually of large diameter, downdraft round kilns were built with either an internal center chimney or an external chimney some feet separate from the kiln.

One surviving but inoperative example with exterior chimney is at the Connor Pottery in Mississippi. Eighteen feet wide, it is fitted with six fireboxes, each with its own short internal chimney, which open at the lower rim of the dome, and with a cooling hole in the center of the dome. In the first twenty-four hours of the firing, the small chimneys were left open to prevent the slow fire from smothering and to allow moisture to escape. Later, these chimneys were closed off, and the forty-foot-tall external chimney, located about eight feet from the kiln, pulled the heat and smoke down from the dome through the slotted brick floor and out through a series of underground eight-inch tunnels leading to a twenty-two-inch T tunnel that enters the stack. After a firing—which lasted about eighty-two hours and consumed nine tons of coal—the tall chimney was shut off, the fireboxes were sealed with brick and clay, and the internal chimneys and center dome hole were reopened to cool the kiln.

Another inoperative downdraft beehive kiln with a center chimney is at the Boggs Pottery in Alabama (see also illustration, p. 127). It has seven external fireboxes with heavy iron grates, a ware chamber twelve feet wide, a circular internal bag-wall, and a single round internal chimney rising from the slotted floor up through the center of the dome. Heat circulates high over the bag-wall to the dome and is drawn down through the floor into seven flues radiating from the chimney. Slip-glazed ware was fired in stacks separated with rolls of sand-coated clay. To tie in and stabilize the vertical stacks, other chunks were wedged between pots across the stacks horizontally. This kiln consumed about four tons of coal per firing and was blasted during the last two hours with dry yellow pine. The blasting stretched to six hours when coal was used, because the shorter flames from a coal fire radiate heat slowly into the kiln.

A small, round, oil-burning downdraft kiln, encased completely in sheet metal, is used today to burn sagger-stacked earthenware at the Shearwater Pottery in Mississippi. A large, round, downdraft kiln sits unused in the middle of the Brown Pottery in North Carolina. The Brown kiln was constructed with two walls; sand was poured between them for insulation and steel cables were set one foot apart around the inner firebrick wall to combat expansion. The walls are twenty-two inches thick, and Louis Brown claims that heat raised the dome several inches when the kiln was fired. The dome is six feet high in the center, and the flame travels ninety-five feet from the middle of the kiln to the top of the chimney. Four to five thousand pieces of differently sized ware were burned in one firing, which took thirty-six to forty-eight hours. The kiln was fired twice a week, for nearly four decades first with wood, then with coal, oil, and finally natural gas.

To burn the machinemade planters and hand-turned stoneware churns at the Marshall Pottery in Texas, four huge, round beehive-type kilns, from thirty-six to forty feet wide, are used. The walls are made of one layer of firebrick, lined with fiber insulation and covered with sheet metal. A large door opens to allow for the setting and drawing out of the ware by hand. The kilns, each heated by eight or twelve gas burners, are downdraft with an outside stack. A hole in the dome and a window in the wall are plugged during firing and opened for cooling. Pots are stacked to a height of six feet where the crown begins. At Marshall they refer to these kilns as "periodic" because they are not continuously fired (see illustration, p. 147).

Bottle Kiln

This kiln type was developed in England during the eighteenth century. In its earlier forms, the bottle kiln had a thin chimney that tapered rapidly above the ware chamber to form a funnel for the exit of heat. One of the later versions of the kiln, developed in Staffordshire, had a conical, bottle-shaped chimney with a bisque chamber placed on an upper level in the shoulder of the bottle. Another version, called a hovel kiln, was a beehive shape with a dome opening for heat exit contained

Updraft bottle kilns were used in the South during the early twentieth century.

Firing of a bottle kiln. Smithfield (N.C.) Art Pottery, 1930s.
Photograph courtesy Dorothy Auman.

Bottle kiln; note second-level chamber for burning of bisque ware. Built in the 1940s at Pisgah Forest Pottery, Arden, N.C., and still in use in 1983.

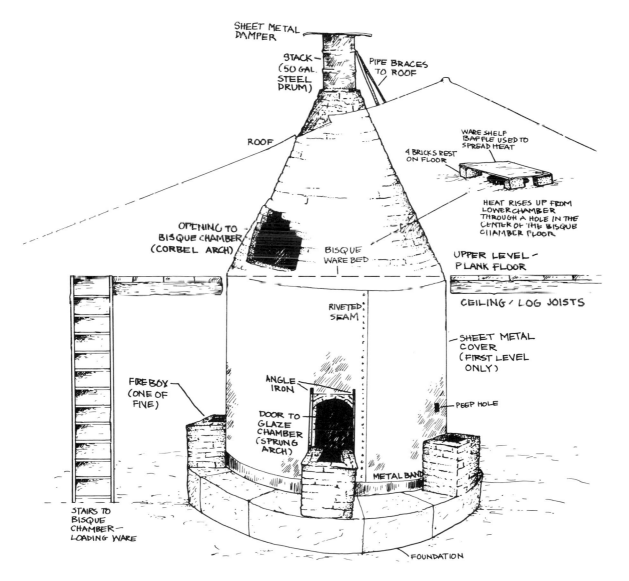

SHEET METAL DAMPER

STACK (50 GAL. STEEL DRUM)

PIPE BRACES TO ROOF

ROOF

WARE SHELF BAFFLE USED TO SPREAD HEAT

4 BRICKS REST ON FLOOR

HEAT RISES UP FROM LOWER CHAMBER THROUGH A HOLE IN THE CENTER OF THE BISQUE CHAMBER FLOOR

OPENING TO BISQUE CHAMBER (CORBEL ARCH)

BISQUE WARE BED

UPPER LEVEL - PLANK FLOOR

CEILING / LOG JOISTS

RIVETED SEAM

SHEET METAL COVER (FIRST LEVEL ONLY)

FIREBOX (ONE OF FIVE)

ANGLE IRON

DOOR TO GLAZE CHAMBER (SPRUNG ARCH)

PEEP HOLE

METAL BAND

STAIRS TO BISQUE CHAMBER - LOADING WARE

FOUNDATION

under a bottle-shaped hovel that terminated in a tall chimney. A kiln with a fifty-foot conical chimney was used at a few southern potteries during the nineteenth century. Herman Cole built two bottle kilns at his Smithfield Art Pottery in North Carolina. Today there is one example of a two-level, updraft bottle kiln operating at the Pisgah Forest Pottery in North Carolina. Constructed on a solid brick foundation and up to the second level completely encased in sheet metal, this kiln has six fireboxes. Short lengths of split pine are fed through the open top of the external fireboxes, where the strong draft is sufficient to pull the heat and flames downward, then horizontally into the ware chamber. Above each firebox, midway up the glaze chamber wall, a peephole allows the potter to observe firing cones and atmosphere color. The second level, containing a bisque chamber, which is entered from the second floor of the building, tapers gradually like a bottleneck to a round stack exiting through the roof. Glazed porcelain is stacked in saggers and on heavy shelves in the glaze chamber of the lower level. Unglazed ware is stacked loose in the upper level so that heat escaping upward from the glaze firing will bisque-fire pots set there. The glaze chamber has one small, sprung-arched door; the bisque chamber has a small, corbel-arch entrance.

Shuttle Kiln

The industrial shuttle or car kiln is a crossdraft kiln utilizing a movable ware bed mounted on wheels that run on steel tracks. Because the ware bed can be wheeled out, it is easy to set pots in this oil- or gas-fired kiln. A commercially manufactured model is used at the Bybee Pottery in Kentucky.

Envelope Kiln

Made possible by the introduction of modern, lightweight refractory materials, the envelope kiln is similar to the shuttle kiln. The ware bed remains stationary and the kiln moves on tracks to envelop the ware. Like the shuttle kiln, the envelope kiln may employ two ware beds, so that one bed may be stacked or unstacked while the other one is fired inside the kiln. Fired by gas or electricity, envelope kilns fire oxidized. Glazed ware is set on shelves; unglazed ware is stacked one atop the other. Several southern potters, including Joe Craven in Georgia and Evan Brown in North Carolina, use this fuel- and labor-efficient kiln.

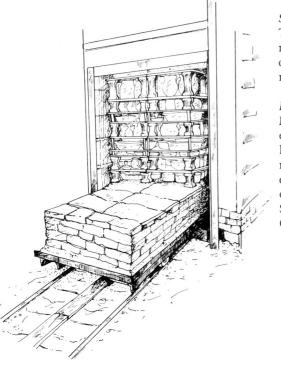

Shuttle kiln, fired crossdraft with gas. Ware bed is on tracks and moves in and out of kiln. Bybee Pottery, Waco, Ky.

Envelope kiln, fired crossdraft with gas. Shell of kiln is on tracks and moves back and forth over two stationary ware beds. Craven Pottery, Gillsville, Ga.

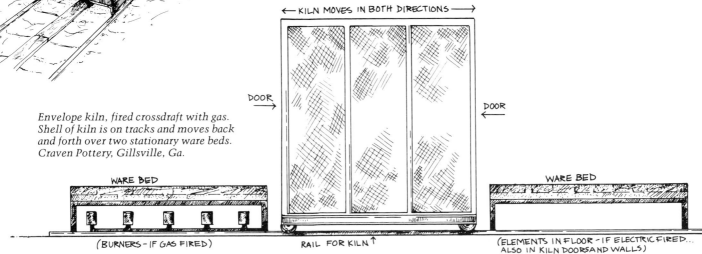

← KILN MOVES IN BOTH DIRECTIONS →

DOOR → DOOR ←

WARE BED WARE BED

(BURNERS - IF GAS FIRED) RAIL FOR KILN ↑ (ELEMENTS IN FLOOR - IF ELECTRIC FIRED... ALSO IN KILN DOORS AND WALLS)

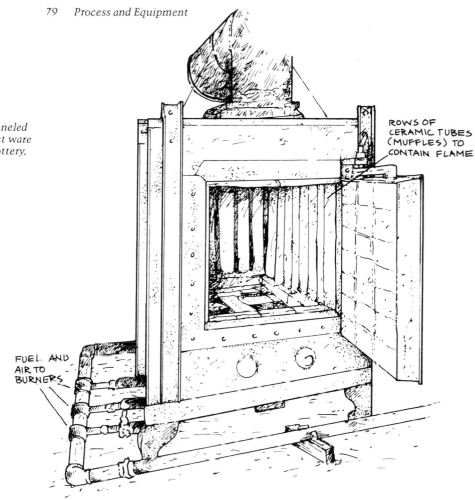

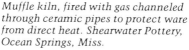

Muffle kiln, fired with gas channeled through ceramic pipes to protect ware from direct heat. Shearwater Pottery, Ocean Springs, Miss.

ROWS OF CERAMIC TUBES (MUFFLES) TO CONTAIN FLAME

FUEL AND AIR TO BURNERS

Muffle Kiln

Used for oxidation firings, the muffle kiln channels flames through rows of ceramic pipes or muffles set inside the ware chamber to produce radiant heat, eliminating the need for saggers to protect the ware from flames. One muffle kiln, currently under repair, has been used in recent years to fire bright glazes on small turned and slip-cast pieces at the Shearwater Pottery in Mississippi. An antique of commercial manufacture, this kiln will be used again, provided replacement parts can be located or custom made.

Electric and Updraft Gas Kilns

Many southern potters, particularly those working with intermediate and low-fired glazes, favor front-loading, updraft, gas kilns or top-loading, electric kilns for convenience and uniformity of firing. A variety of commercially manufactured electric and gas kilns is used.

Notes

1. It is commonly believed that glaze seals a pot against liquid penetration. With the exception of Albany- and other slip glazes, this is not always the case since many glazes do not fit a pot perfectly and therefore are under tension, causing the glaze to yield and develop fine crazed lines (sometimes discernible only with a magnifying glass) either immediately or over time.

2. Frits are made by combining raw minerals to be used in a glaze and burning them together at high temperatures to a liquid glass. In the melt the ingredients are bonded into new chemical combinations, which are retained when the glass is cooled, powdered, and used in glazes burned at lower temperatures. The process binds lead and other dangerous oxides into unleachable and, thus, safe forms.

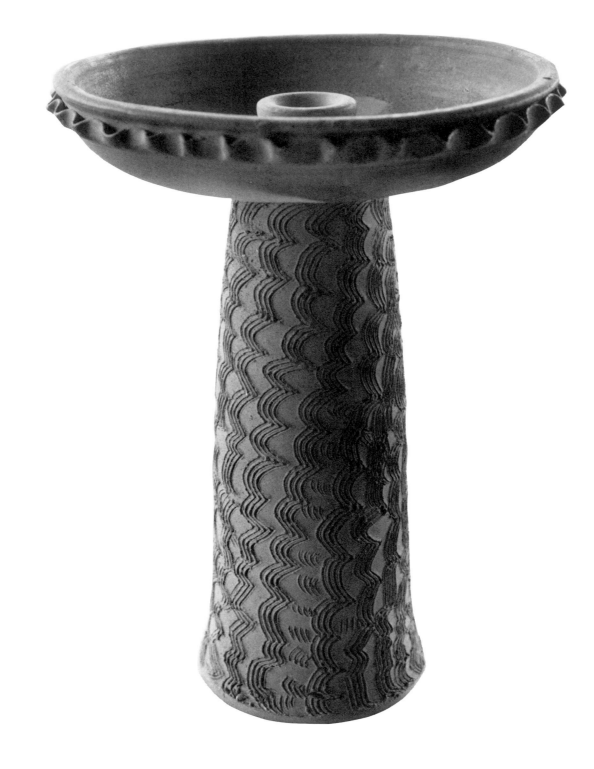

Terra cotta birdbath made by Jerry Brown.
Photograph by the author.

Jerry Brown Pottery

Jerry Brown's mule Frank has adapted well to pulling the clay mill after many years of snaking logs. For twenty years until September 1982, Jerry (born 1942) was in the lumber business. He was raised around a pottery owned by his father, Horace Vinson Brown, a member of the prolific Brown potting family, a cousin of E. J., Davis, and Otto. Horace was raised in his father's pottery in Georgia and became a journeyman turner, making pots throughout Alabama and Mississippi. He worked for Gerald Stewart in Louisville, Mississippi, married Gerald's sister, Hattie Mae (born 1918) and settled in Soligent, Alabama

Hattie Mae Brown, who encouraged her son Jerry to take up potting, remembers ash, salted Albany (frogskin), and Bristol glazing in the early days of the Soligent Pottery and describes the alkaline glaze as "ashes soaked and strained with a little clay added to stick."

It was in this shop that Jerry learned to grind clay and make balls for his father and brother Jackie who did the turning. He "messed around a bit" on the wheel, but when his father and brother died a year apart when he was twenty-two years old, Jerry lost interest.

> I didn't think I could do it by myself. Didn't have any help I could depend on, so I quit. But, I had the fever to go back for several years. It rained a lot . . . nothing to do in the woods, so I got into it. When I first started, I didn't think I could do it. But, Uncle Gerald and my mother helped, and it all fell into place.

Jerry has learned the trade by absorption. From his youth he has retained images of turning and other potting motions, which had been repeated endlessly before his eyes. When he began to turn pots after a twenty-year absence from the craft, he relied on his visual-kinetic memory and the advice of his Uncle Gerald, who spent a few months in Hamilton to help him start up. Jerry had total recall of how much clay was used to make each churn, and in eight months he was making well-balanced five- and eight-gallon churns and ten-gallon storage jars. Jerry's wife, Sandra, beats the clay, makes balls, and sets the pots off for him; his mother, Hattie Mae, helps with glazing and "toting" pots; his stepson Jeff works in the pottery after school; and his son Jeff continues the timber cutting.

Jerry has built a clay mill with a twelve-inch-thick center pole of black gum, a wood he says never rots or splits. He drilled six-inch holes into a three-foot section of the pole and drove ten flatbar steel blades in a descending spiral around it. Wires are wound between the blades, one stretching around near the outer extension, the other nearer the pole to catch roots and other trash in the clay. The center pole of the mill turns on a twelve-inch-long steel pin, one end of which is driven up into the bottom of the pole, while the other is set in a sealed oil bearing. The mill frame is a simple board box roofed over and closed on two sides in which the clay circulates, churning and tumbling as the mule walks in a circle pulling a black gum beam attached to the center pole. The mill can grind 250 pounds of well-soaked clay in two hours. Jerry used to have a little black feist dog who rode on the mule's back two to three hours at a time. When the mule stopped, the dog would jump down and bark to get him moving again.

Clay is obtained from Gerald Stewart's clay pit in nearby Louisville, Missis-

sippi, and is unusually clean. What stone escapes the mill blades and wire Jerry picks out while kneading or turning. Heavy machinery is used to clear the topsoil off the Stewart clay pit, cleaning the clay better than if it were removed with a pick and shovel. The clay vein is six to eight feet deep with two to four feet of topsoil above it and is about ten acres wide. In some places where the clay has been entirely removed, coal deposits have been uncovered. Before it is milled, the pale, buff stoneware clay is soaked overnight outside the shop in the open on a piece of tin; Jerry plans eventually to use a discarded pick-up truck bed as a soaking pit, protected by a shelter. This remarkably plastic clay holds its shape without slumping, as Jerry turns large pieces of fairly soft clay.

He wedges, kneads, and measures the ball weight on a hanging balance scale, then turns the clay on an electric, one-speed wheel in which the wheel head is set unusually low for the pulling up of large pieces. The surrounding crib is deliberately roomy to accommodate the reach and motion of a man Jerry's size.

I enjoy making churns more than I do anything. I had rather make big stuff than small since my hands are so big.

Jerry uses a large 6-by-3½-inch steel chip (rib) and a smaller aluminum one. He can turn a three-gallon churn in four minutes using eighteen pounds of clay to make the shape 14½ inches high. He measures the flange for the churn lid with a seven-inch piece of wood, a technique learned from his uncle. Homemade, hinged lifters are used to remove the pots from the wheel. He is now building a two-speed wheel on which he will use a ball opener. In making a flue thimble (much in demand for wood-burning stoves) he controls the diameter by running a section of yardstick up and down the inside (a seven-inch piece for a six-inch thimble). Instead of using a knife or long pin, he cuts off uneven jug tops with his fingers, a technique often used by traditional potters who keep only a few tools.

Turned ware is set on individual twelve-inch square boards, which are then placed on long ware boards supported by a sawhorse. Ware is left to set up about three hours before being handled. Jerry makes handles by kneading slip from the wheel into his turning clay to soften it further. He rolls this softened clay on the wedging board, tapers it slightly, then butts it onto the jug, pulls it thin and shapes it, curves it, and finally fastens it down.

The pottery is sun dried when possible. Jerry says, "It's a slow go in the shop, but sometimes handles crack in drying outdoors so I have to watch them." He raw glazes the dry pots in a tub of Albany slip (fifty pounds of Albany are used to glaze one kiln load) or in an old bathtub raised on cinderblocks. To remove glaze from the bottom of a churn, it is immediately set down on its rim. When the glaze dries, it is set right side up and the rim is scraped free of glaze with a curved metal tool. Lid bottoms and knobs are also scraped clean to facilitate stacking. The ware is stacked while still damp from glazing in the kiln on loose brick tamped into the sand floor of the ware bed. (Sand allows for brick adjustments so that the pots can be set level.) Churns are stacked mouth to mouth, then foot to foot, with jugs placed on top. Unglazed chimney thimbles and flowerpots are placed at the cooler back and side sections of the kiln, then the large churns in the middle, and smaller churns near the front. More thimbles are loaded at the very front to help protect the churns from flame. A baffle made of a row of fired and cracked churns sounds a tingled warning if the fire grows too fast.

Four people work 1½ hours to stack the kiln. Jerry is on the ware bed setting pots that his young son Jeff hands him from the firebox. From the field of pots set outside the kiln, Sandra and Hattie Mae hand pots in to Jeff. Setting the kiln is timed to begin upon Jeff's return from school, and a small fire is lit to begin drying out the pots directly after the fire mouth is completely sealed (see illustrations, p. 69).

Glazed churns and unglazed chimney flues, by Jerry Brown.
Photograph by Joey Brackner.

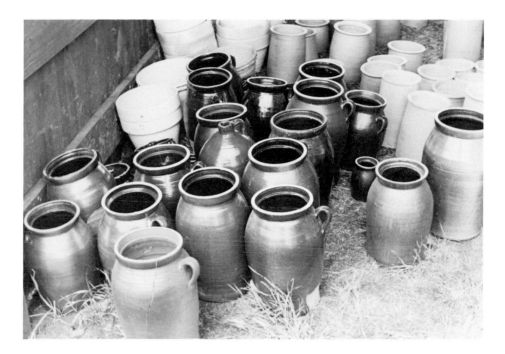

Jerry Brown turning a three-gallon churn.
Photograph by Joey Brackner.

The tunnel kiln measures twelve feet long—with a nine-foot ware bed and three-foot firebox—seven feet wide, and fifty inches high from the ware bed to the arch center. The side walls are three bricks thick, the kiln face two bricks thick. The arch is two bricks thick laid end on end. Salt is added to the mortar for bonding and to prevent crumbling. Fly ash combines with the salt to glaze the inside of the kiln, sometimes dripping onto churns. The walls are thirty inches high from the ground, and the firepit is dug below ground level. Five corbel-arch flue holes, eight inches wide by twelve inches high, lead to the chimney. An earth bulwark, three feet deep and five feet wide, insulates and braces the walls. The bulwark is held in place by eight four-by-four inch planks sunk into the ground. The firebox floor has three sections divided by three-brick high rows to support the firewood and provide draft beneath the fire for combustion. Two ground-level draft holes open from the outer sections.

Directly in front of the firebox mouth is a small brick chamber two feet wide and three feet deep and four bricks high, for the early slow firing. Sheet metal covers the top of this small chamber; another piece of sheet metal, set vertically and covering the open upper portion of the main fire mouth, is braced with stacked cinder blocks to hold it in place. Cracks are completely sealed off with mud daubing. A small fire of wood bark and sticks is then lit in the external firebox and tended every five to ten minutes. It is essential to warm and dry large, raw-glazed pots very slowly and evenly to prevent cracking, especially when the ware is still damp from glazing. As Jerry observes: "One stick of wood at the wrong time and you're liable to lose one hundred dollars." For the slow firing, the twelve-foot chimney stack is covered with sheet metal raised the height of one brick.

Heat, but not flame, passes through the ware from this preheating chamber for the first fifteen hours of the firing cycle. After twelve hours of drying the pots and warming the kiln gradually, coals are pushed into the main firebox and its upper portion is opened for stoking. Jerry explains: "If it's got moisture in it, sounds like a shotgun when it blows, and one pot blowing will ruin a lot of other pots." He stokes

it slowly every fifteen minutes for another ten hours. When the glaze starts melting, he uncovers the chimney, opens the draft holes, and starts the heavy firing. Within an hour the blaze stands out ten feet above the chimney and is held there for three to four hours. "When black smoke starts coming out, it'll look like a thunderhead way up yonder . . . black as soot."

Jerry checks the melt of the glaze by looking through two peepholes in the chimney. If the glaze is sufficiently fluid he stops firing, waits an hour for the fire to die down, then stops up the kiln completely. He burns two cords of wood to bring the kiln to a high stoneware temperature. The kiln requires four days to cool, but Jerry cracks open the firebox door on the third day; live coals are still smoldering in the firebox ten days after the firing is stopped. Jerry starts burning with pine and finishes with oak slabs, which he says will raise the temperature when pine will not. Since his experience has been that pine sap dulls the glaze, he burns only pine wood cut when the sap is not running. His older son Jeff helps fire the kiln during the night. Jerry claims wind disturbs the kiln draft and blows in dust that settles on churns: "In pretty weather the kiln burns faster."

Jerry described the contents of a typical kiln load: two six-gallon jars; ten each one- and one-half-gallon tea pitchers; four plates; one large jug; four mixing bowls; twenty-four each of twelve-, nine-, and six-inch flue thimbles; fourteen large garden-pot saucers; thirteen birdhouses; one birdbath; ten four-gallon garden pots; nineteen five-gallon, sixteen four-gallon, thirteen three-gallon, twelve two-gallon churns; and sixty-five churn lids. This firing represented a total of $1,127.50 worth of ware. He loses no more than four to five percent of damaged ware in a firing.

In the spring of 1983 Hattie Mae and Sandra had four selling routes within a seventy-five mile radius of the pottery; their customers included hardware stores and building-supply companies. They sell increasingly to buyers from stores who come to select what they want at the time of a kiln unloading.

Jerry has become somewhat weary of the brown Albany-slip glaze and plans to experiment with ash and salt, ash and Albany, and off-white Bristol glaze with cobalt blue rings. He even expresses a desire to try "garden slag" (a fertilizer) to see what it will do when mixed with Albany slip: "might put more life in it."

Jerry Brown Pottery
Hamilton, Marion County, Alabama
Stoneware; local clay
Albany-slip glaze
Tunnel kiln; wood; c. 1,310° C (C/12)
Churns, jugs, jars, pitchers, plates, beanpots;
 unglazed flowerpots, birdbaths, chimney thimbles
See also E. Henry Willett and Joey Brackner, *The Traditional Pottery of Alabama*

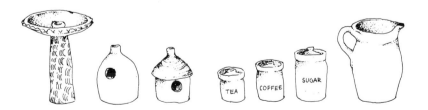

B. B. Craig Pottery

Burlon Craig (born 1914) learned to make pottery while living in the Catawba Valley of North Carolina, in an area called Jugtown since before the middle of the nineteenth century. Burlon's father was a preacher and farmer. When Burlon was ten years old he started grinding clay with his father's mules for neighbor Jim Lynn.

> *Jim wanted me to help him dig and haul clay and get up wood. Every chance I'd get, I'd run in on the lathe and try. I watched him, and he would show me where I was making a mistake . . . helping me all he could. Then he wanted me to go in partners with him. So, I studied it over and told him, "Jim, I'll try it 'til next spring. If I'm not turning out stuff I can sell and get some money, I'll have to quit and help farm." I did work for him for several years, but he was one of these fellows didn't want to work much—wanted me to do it all and give him half the money, and that didn't suit me. So, I worked with the Reinhardts a few years and then went over to old man Seth Richie's to turn for several years until he got sick and died. Vernon Leonard and myself rented his shop and made a little, then I rented the Propst place and made a little out there. Then the war come on, and I went into the navy. When I come out in '45 I come here and bought this place and shop from Harvey Reinhardt.*

For nineteen years Burlon worked full time during the day in a local furniture factory and made pottery at night and on Saturdays. His wife, Irene, and their five children helped by digging and hauling clay and wood. He made wide-mouth jars in which to store homebrew, sauerkraut, and pickles; jugs for vinegar, moonshine, and molasses; and churns, particularly the two-gallon size for making butter. Milk, cream, and butter were kept in clay containers in a spring box; a piece of cloth was stretched over the top of the churn, and then a homemade wood lid was placed over the container to keep it clean and free of insects.

> *That used to be my job—to go down and get the milk from the spring box every night for supper when the cornbread came out and right before we got ready to eat. Cornbread and milk . . . I still love it.*
>
> *I sold all the churns I could make after the war, because all the other old shops was shut down. The general stores here still want me to make them—so some people around here still want 'em to use. Course I know people buy a bunch of stuff and use it to set on the porch.*

Burlon digs his clay out of the side of a bank from a swampy area ten miles away. The damp clay is easy to shovel and is transported by wheelbarrow to a truck. If the ground is muddy, he puts on boots and carries the clay in a five-gallon bucket. In the fall he digs and hauls his year's supply, about six tons of clay. Although the work is strenuous, the supply is assured; he estimates the clay field at about one hundred acres. As he is digging he mixes in "short" clay from the edges of the pit. At the interface between the pure vein and the soil, the clay is somewhat contaminated with sand and other nonplastic materials that make it "short," less shapable. The short clay does not turn well by itself, but while the pure clay is plastic and does turn well, it lacks the stamina to stand up without the tooth of the coarser clay. According to Burlon:

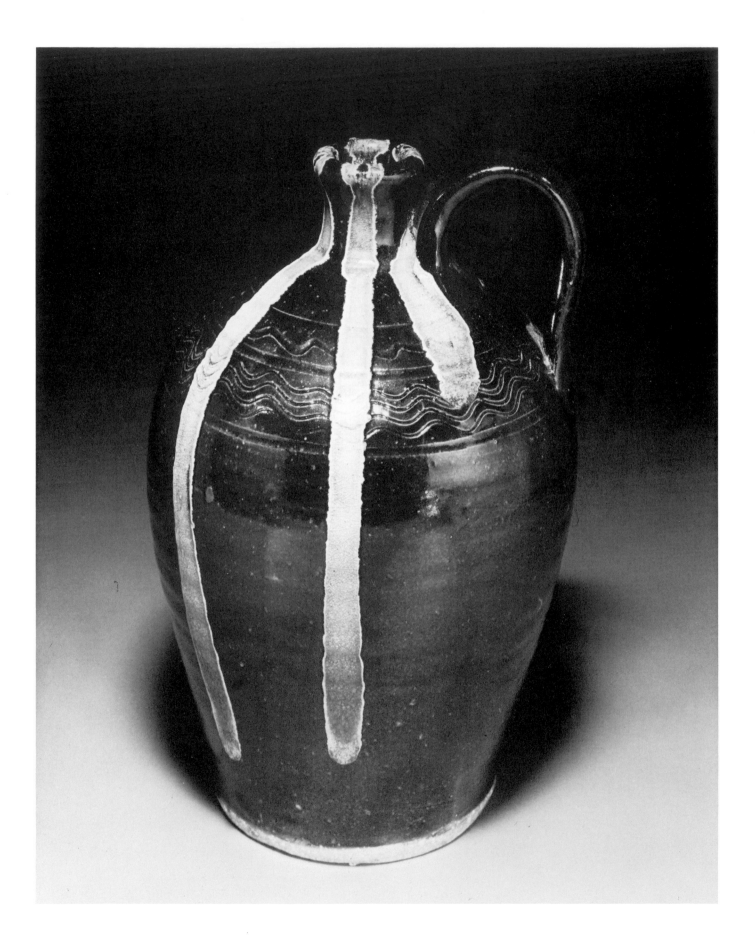

Legend has it that the Indians found the clay where the buffalo crossed the river and used it to make bowls and clay pipes. The first potters to settle the area found it from the Indians.

Burlon piles the clay into a bin on the ground outside his shop. To render the clay more plastic, he allows it to freeze and thaw over the winter. To prepare it, he first soaks it in a cement box built next to the clay pile, then shovels it into the clay mill (see diagram, p. 45). He grinds the clay to a slightly hard consistency.

If you leave it a little bit hard, it'll grind quicker than it will if it's real soft. I temper it down [with water] to where I want it right just before I take it out.

When it became too expensive to feed the mule, Burlon built a clay mill from a truck rear end and an old cast-iron water wheel and pulley rescued from a stream bed (see diagram, p. 45). He salvaged the wheel knowing he could power it with his tractor slowly enough to prevent the clay from heating. He grinds 150-pound batches for fifteen minutes. The process is repeated four or five times. While one batch is being ground, he carries another batch to the shop, where he squares it in blocks and sets it in a cemented corner of the earth floor, covering it with moist burlap "tow sacks." Usually he lets it age but notes, "sometimes I get in a hurry wanting to turn, you know." He picks out small stones as he works up his clay or while he turns a piece.

Once in a while you'll get [a stone] like the end of your thumb, but most of 'em is like a bean or a pea. You'll feel 'em when you go to turning. There's not that many—maybe get three or four out of one piece, and then turn half a dozen pieces and not be any in it.

In addition to large and medium storage vessels, including churns and cannister sets, Burlon makes what he calls "miniatures," average-size mugs and other small pieces. He also makes unglazed flowerpots. Around 1974 he began fulfilling requests made by collectors for monkey and ring jugs, face and snake jugs, and glass-streaked jugs. These unusual pieces are so much in demand by people "off from here" that his production has become increasingly focused on them. The face jugs are slowly made.

I'll maybe turn three hours then start putting faces on. You got to put it on while it's soft so it'll stick on the jug. I turn maybe half a dozen or a dozen, put them over by the heater so I can put the face on the same day. They don't have to be set up as much to put snakes on them as faces. I can finish ten face jugs in a day—good size, but not the biggest. I put the teeth in when the clay is soft.

Burlon now fires his kiln (one of the few surviving authentic groundhogs) about four times a year with five to six hundred pieces in each burning. Harvey and Enoch Reinhardt built the brick kiln in 1935. To make the brick they first tested different clays. When they found one low in iron, they made 125,000 bricks of it, stacked them in a scove kiln, and burned them day and night for two weeks. Burlon has had to rebuild the chimney and the kiln front, where proximity to the fire wears brick out first, but the arch and walls remain as they were constructed more than fifty years ago.

The kiln is built into the ground with the top of the arch just curving above the ground level. This very shallow kiln is referred to as a single-shot kiln. The arched chamber top has beneath it only two courses of straight brick wall from which the arch is sprung. The kiln is nineteen feet long and slopes upward slightly toward the chimney end to draw the flame completely through the pots. The ware bed is floored with two to four inches of sand. The chimney is narrow, low, and wide (twelve inches above the arch). Burlon claims this chimney works better than a tall chimney.

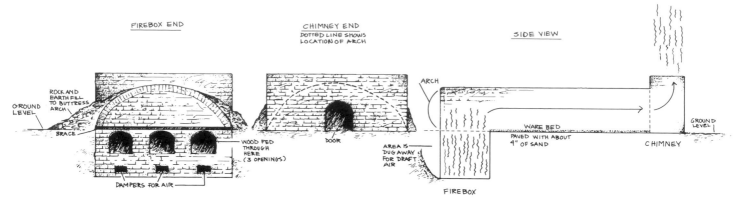

Single-shot groundhog kiln

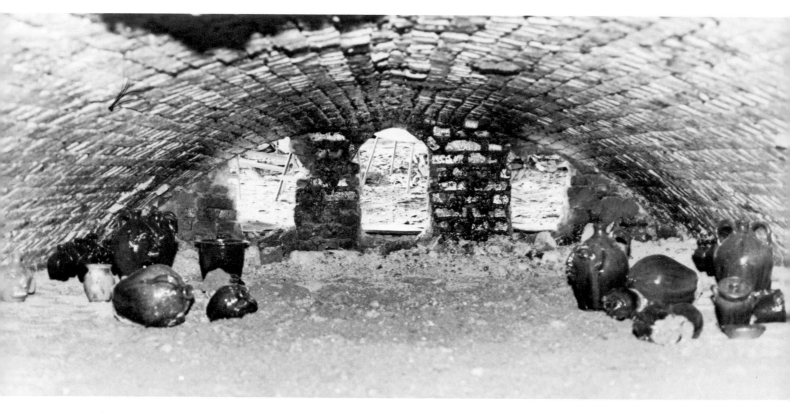

*Interior of single-shot groundhog kiln;
note shallow arch and sand ware bed.*

*Enoch Reinhardt built another kiln just like this one and put a tall chimney on
his, but it burned too fast. He burnt the first row of jars so hot till they would
drop down and still not finish the upper end.*

The base of the chimney on the kiln side rests on the arch. Directly below this
chimney wall are two eight-inch-square brick columns that carry the weight. The
back of the ware bed opens as a flue into the chimney. The rebuilt chimney is fire-
brick inside, mortared with daubing mud, and regular brick outside. Burlon loads
the kiln through a chimney door that he bricks up for each firing. At the other end of

the kiln is the firebox with three openings. The middle opening is the largest for stoking with big slabs; the two smaller side holes are necessary to heat the sides of the wide kiln.

You want to stand to the side of the holes when you're firing not right in front of one. If you can get over to the side, you don't get as hot.

Beneath these fire mouths three draft holes provide air for the burning wood. The shallow arch was turned one brick deep (lengthwise) without wedge bricks by the addition of mortar in the wedge-shaped spaces at the outside end of the bricks.

To build this kiln you dig out the size of the kiln down to solid dirt, then build your foundation walls, two rows of four or five bricks down in the ground. When that is laid, you fill the inside with sand, so then you have sand on one side and earth on the other, level with the top of your foundation brick. Then you continue your foundation brick two more brick up all around, lay a third row of brick lengthways, and start your arch from inside that brick over arch boards. On top of the arch there's rock and dirt laid on each side, with maybe a yard in the middle left clear. That weight holds your arch brick down when they want to expand in the heat. Without that, they would probably fall in a short time.

The kiln is set for burning with large alkaline-glazed pieces requiring the most heat toward the front. The clear- and Albany-glazed pieces are placed further away from the fire, with small pieces set among them in empty spaces. Unglazed ware is placed at the back and in the chimney, where pots may be capped one on another. "People here never heard of stacking, you know." The kiln is designed to cover big ware snugly without wasting space above.

Burlon makes his alkaline glaze with ground glass, sifted oak ash, body clay made into slip, and small amounts of flint and feldspar. The glass (usually scrap windowpanes) is ground to powder by waterpower from a nearby stream at the rate of a gallon of powder every twenty-four hours. Earlier potters devised this seesaw mechanism, tripped by running water (see p. 55). After the ingredients are sifted and mixed together, the solution is ground by hand between grinding rocks for an hour or more. Most pots are ash glazed, but Burlon also dips about thirty pieces in Albany slip for each kiln firing. As he loads the kiln, he balances a piece of glass on the rim or handle of a slip-glazed jug. These glass pieces melt in the fire, making two or more almost-white streaks down the side of a pot, an old decorative technique. He also produces swirl ware—traditional to the area—by combining clays of two colors (his regular stoneware and lighter burning Tennessee ball clay) in alternating slices, gently rounded in the shape of a ball, turned, and coated with a clear glaze. His wife, Irene, decorates some of Burlon's smaller pieces with blue-and-white flowers of slightly raised clay slip.

Burlon's clear glaze is made of equal parts frit, glass, and a white slip clay with flint and feldspar. He has recently started adding a couple of spoonfuls of Epsom salts to every five gallons of glaze, having discovered that "it holds the glass up there and makes your glaze clearer, too."

We potters burn by the soot line. When you start, the kiln is clean from the heat of the last fire. As you build up a slow fire, your ash pit will soot over first. You watch your soot line, and as it moves on down the kiln, you move your blaze on up. You can see exactly where your soot line is way up in the kiln—all the way to the top of the chimney inside. When the soot is burned off and the kiln is white all the way, then you can fire as fast as you want. When you get the chimney clear, that's when you go to work.

It takes some eight hours to remove all the soot, followed by two hours of

"blasting off," a hard, steady firing with the blaze standing five to six feet out of the chimney. The total firing cycle is ten or eleven hours and consumes three cords of pine slabs. Burlon estimates that in the hottest part of the kiln near the firebox the temperature reaches 1,540 degrees Celsius. The kiln was once tested with cones set to bend at 1,320 degrees Celsius, they deformed and completely melted. During firing, both chimney and draft holes are left open; afterward, while the kiln cools for three days, they are closed tightly.

The pots are set out in the yard by the kiln, still warm from the firing, and selected by waiting customers seeking an ash-glazed pot made by Burlon Craig, one of the few potters who still work in the old stoneware tradition.

My idea is to make a pot with proportions—a width and a height that looks good together. There's no set rules in that, you know. I've seen some nice shapes of pottery in every shop that I've been at, but I have seen stuff that I didn't like the shape of. You make your bottom too narrow and a piece too high, it'll almost fall over itself. Of course, I'm partial to the jar shape because that's what I'm used to, that's all I've ever made and that's about what the oldtimers made.

B. B. Craig Pottery
Vale, Lincoln County, North Carolina
Stoneware; local clay
Alkaline glaze made of glass, ash, clay, flint, feldspar
Groundhog brick kiln; wood; c. 1,310°C (C/12)
Jugs (face and snake), jars, churns, milk crocks,
 vases, bowls; unglazed flowerpots, strawberry
 jars, birdhouses
See also Daisy Wade Bridges, ed., *Potters of the Catabwa Valley
 and* Charles G. Zug III, *Turners and Burners* (forthcoming).

Burlon Craig

Charles Craven Pottery

The Craven family were among the first settlers in Moore County, North Carolina, to make pottery. It is speculated that as early as the 1760s Thomas Craven (1742–1817) was a potter in Moore County; his son John was known to be a potter in the eighteenth century. Many Cravens have followed the trade, both in North Carolina and Georgia. Charles Craven's father, Daniel (1873–1949), and grandfather, J. D. Craven (1828–1893), were both turners with shops of their own in Moore County. Charlie's brother, Farrell (1911–1972), was a turner, who worked for many North Carolina shops, including the Teague and Ben Owen potteries. Charlie's sister, Bessie Craven Teague, married B. D. Teague, who started a shop in Moore County, currently operated by their grandson, Daniel Garner.

Charlie (born 1909) and his eight brothers and sisters were raised at the pottery, and his earliest memory of turning is of standing on an upturned crock to reach the wheel.

> I hung around the shop all the time when I weren't big enough to work. Every time I'd get a chance at an empty wheel, well, I jumped on it and be trying. Nobody showed me nothing about it. I'd watch and then try, knowing what I had to do to make it work. First, if you don't get in in the center, there ain't no use [to keep trying].
>
> After I got where I could make little stuff, I thought I was pretty good at it then. One day my dad wanted me to make some for the next kiln. I wanted to go fishing so bad that day I didn't know what to do. I was thinking, "I've got to do something about this here fishing deal, I can't stay here and make this stuff." So, I started tearing 'em up—something the matter with every one. I told him, "Well, it looks like I just as well quit. I can't make one." He caught on to what I was up to and told me, "You got a certain amount to make before you quit. You can tear 'em up or you can make 'em like you're supposed to." I seen right then I wasn't going fishing, and I didn't tear up any more.

Daniel Craven's pottery was a family affair. He and his sons did all the turning—first the oldest, Charlie, then Farrell, while another son, Brack (Braxton), prepared clay and burned kilns, salt glazing the old stoneware forms. They had on their land a clay pond and an ample supply of oak wood. The clay was prepared in the simplest way: it was softened with water, ground in an old beam mill by a mule, and stored in the shop under damp burlap bags.

> It would take near half a day to grind a mill full [five hundred pounds], but sometimes we'd grind enough in a day to last a week. The clay worked well. You could take it right out of the mill and start turning it. The old mule mills didn't get the clay as hot like some of them electric mills. It wouldn't affect it toward turning.

Before it was turned the clay was sliced into thin layers so that stones and roots could be picked by hand from the clay.

Their groundhog kiln (eight feet wide by twenty feet long) held about five hundred gallons of utilitarian ware, which made up a wagonload. Set in the kiln on a bed of flint stone, the ware was passed to the stacker, who worked prone, braced on

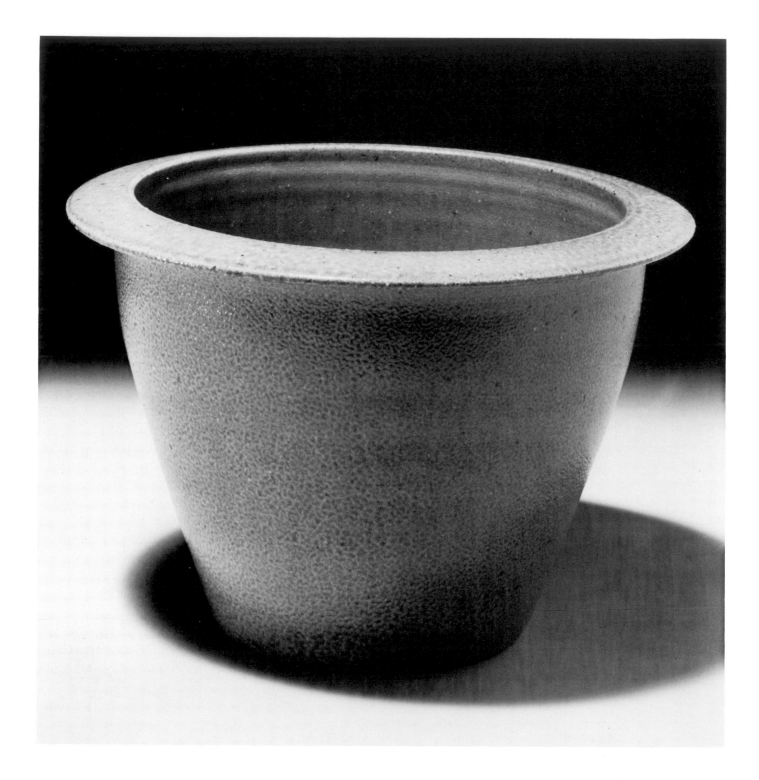

Salt-glazed cream riser with flange for tying cloth made by Charles Craven. Photograph by David Jones; courtesy Randolph Technical College.

an elbow in the shallow bed, by a line of people, who were often referred to as "stackdoodles."

> *All daddy would do was stack the kiln—wouldn't be no moving around. Two or three of us in the kiln, other one outside. One would pick it up and hand to another.*
>
> *If he wanted any new flint [for the ware bed], he'd throw some big rocks in them hot coals when he was firing. Later, he'd throw the rocks up on the ware bed and break them up.*

Occasionally they made a kiln of flowerpots and "dirt dishes," firing them in the salt kiln at a low temperature so the salt on the kiln interior did not fume.

> *They liked that because they didn't have to use salt and didn't have to get them near as hot. The dirt dishes were glazed inside only with red lead. When somebody wanted some, he'd make a bunch.*

The regular stoneware firings to the higher temperatures took ten hours, 1½ cords of oak, and a wagonload of rich pine wood, called "lighter'd."

> *We bought the lighter'd off somebody else's land. I remember many a time helping haul it, paid seventy-five cents a load, all we could get on a two-horse wagon.*
>
> *We'd fire 'em up about seven A.M. and finish after five in the afternoon. Fire with oak wood till an hour before we finished, then use fat lighter'd. The fire would be coming as tall as a ceiling from the chimney. Between fires daddy would take him a little salt, throw it in there, and he could see it on the pots. If it melted and run off as soon as it hit, he knew it was about ready. Maybe fire it one more time and then, "That's enough now, let's put the glaze on." He used about two gallons of salt. Once in a while, up at the chimney where it didn't get as hot, you're liable to see a red spot on one.*

At the end of the firing, after the kiln had cooled a bit, they covered the chimney with sheet metal and daubed the firebox cracks. Next morning they raised the chimney cover a little at a time to hasten the cooling.

If a wagoner were waiting for the ware, the kiln would be unloaded the day after the burning.

> *Sometimes I was scared my clothes would catch on fire. You had to handle the pots with something to keep from burning your hands. Once in a while you'd hear one crack.*

Charlie remembers Daniel turning one hundred gallons a day; at four cents a gallon he had made four dollars worth of pots. He would quit by the middle of the afternoon, saying that was more than he could earn at any other work.

Daniel had an unusual way of mending a pot that had cracked in drying. He set the pot in the kiln and put over the crack a piece of glass, which melted in the fire and sealed the crack perfectly. The only decoration the Craven shop ever used was "just a little bit of blue smalts, maybe a ring of blue around a piece, but not much even of that." Charlie's mother, Alice Sheffield Craven, made molded stoneware clay pipes. She burned them with lighter'd splinters for half a day and sold one hundred for thirty-five cents.

The Cravens had two wagoners hauling for them, Clark and Henry Spencer.

> *One brother or the other would be there every Monday. We sold it to them for four cents a gallon and they sold it for ten cents. Then the hardwares marked it up, and I guess they made more than anybody. If it was hard to sell, the wagoners might cut [the price] to eight cents to get rid of it.*

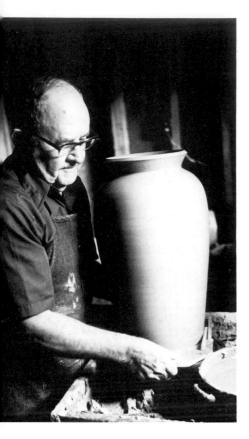

Charles Craven with churn.

If one quit, the other was ready to take over. They'd take 'em to different places around over the country to hardware stores—customers they had lined up to supply. They'd sell to individuals on the way, maybe at campsites, but they didn't stop along the houses. Had a place they could tie their mules to the back of the wagon and a place there to feed 'em. They'd make a bed up in the wagon or under it, have a little something along they could cook—coffee, frying pan to make breakfast. They'd want to leave on Monday evening or Tuesday morning. Be about Friday or Saturday when they come back. Wanted to leave again on Monday evening. They always waited for a full load of our pots.

The family farmed in the summer, but during the rainy season Charlie's father would say, "Let's get us some clay and make a kiln of pots."

Charlie remembers that when Jacques Busbee, founder of Jugtown Pottery, first came to Moore County, people were afraid of him because they were not certain of his intentions.

He came to our shop, and my daddy would warn, "Be careful what you say around that man." After he started his shop, he come up there and tried to talk my daddy into letting me go down and work for him. Daddy wouldn't never agree to it, said he needed me at the shop.

Most small family potteries could not support the needs of grown men as well as other members of the family. As each son reached about eighteen years of age he usually left home to find work elsewhere. Daniel continued his pottery after Charlie and Brack left home, closing it only after his youngest son, Farrell, left.

When Charlie turned eighteen he left home to work in High Point in a furniture shop, but he was soon sought out by Henry Cooper of North State Pottery in Sanford, North Carolina. Two Owens brothers were already working for Cooper, Walter turning and Jonah glazing and burning.

Jonah was liable, especially in wintertime, to get everybody started working and he'd take off and go rabbit hunting.

Charlie turned at North State for two years, then he and Brack built on the family land a log building in which to make pottery. The venture failed "because Brack was used to payday, and it didn't come," so they returned to the furniture shop in High Point. Soon Herman Cole sought out Charlie to turn at his pottery in Smithfield. Charlie worked there for twelve years (beginning in 1928) and learned to make the very large pots he had always wanted to turn. Some were urn shapes with a rolled top and two handles, thirty-four inches tall and made in three sections of sixty-five pounds of clay.

Herman Cole went out of business in 1940 "because it was costing more to make the pottery than he got back selling it." Charlie then turned at Royal Crown, a large pottery in Merry Oaks, North Carolina, until wartime restrictions on glazing materials forced the closing of the business in 1942. After the war, Charlie settled in Raleigh and went into the produce business, but on retiring in 1973 he bought an electric wheel and set up a small shop in his back yard. He has turned earthenware for the Teague Pottery in Robbins, North Carolina. In 1982 he arranged for the burning of his stoneware forms—including churns, jugs, and pitchers—in salt glaze at Jugtown Pottery in Seagrove, North Carolina.

My daddy always made churns—even three-, four-, five-gallon ones—in two pieces. I've wondered since how come he couldn't have made these churns in one piece. I make 'em in two pieces, too. I didn't think [there was] no other way to make 'em except like he did.

Churns, jugs, and pitchers drying in the Craven shop.

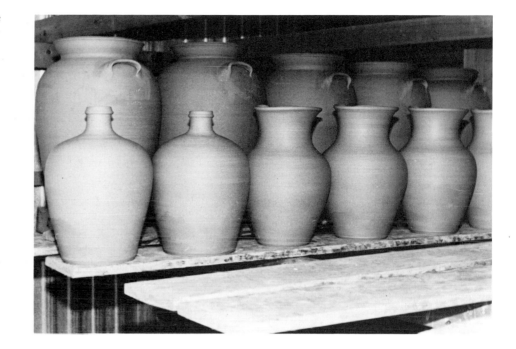

Charles Craven Pottery
Raleigh, Wake County, North Carolina
Stoneware; clay from, and salt-glaze fired at,
 Jugtown Pottery
Earthenware; clay from, and feldspathic-glaze fired
 at, Teague Pottery
Churns, jugs, jars, pitchers, ring jugs,
 candlesticks, bowls, cannisters, teapots

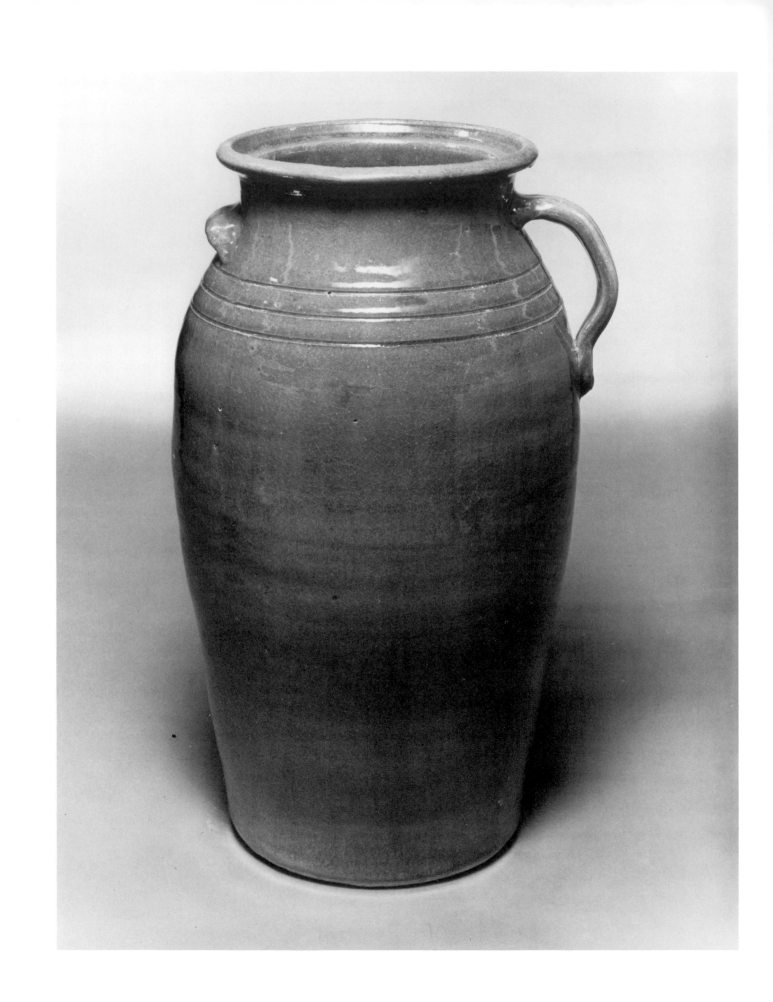

Cleater Meaders Pottery

Stoneware churn with brown glaze made by Cleater Meaders.
Photograph by Glen Tucker; courtesy Randolph Technical College.

Cleater Meaders (born 1921), a cousin of Lanier and Edwin Meaders, was raised in the Mossy Creek area with his eight brothers and sisters. His father, Cleater James Meaders (1880–1934), was Cheever Meaders's brother and also a potter, who produced utilitarian Albany- or Bristol-glazed ware.

My father had a place in the shop we could slide on under and watch him turn and sometimes he'd say, "You make it while I go to dinner." He'd do all the glazing and when it come to our stuff, he told us, "When I glaze it, it's good enough." What he didn't glaze, we knew to make again. We got the idea that maybe too much of that stuff was getting rejected, so we built our own groundhog kiln and fired our pots. We built a little stand between the road and where my father set his pottery out, so people had to come by ours first. We had about a two-by-three-foot ware bed and a two-foot fire box. We did real good until my father caught us using his wood instead of cuttin' our own.

Once when daddy was running out of wood, he sent me and my cousin to get a load. He had a old '27 T-Model truck, and I was so small that I couldn't operate the pedals to drive it. My cousin set at the bottom of my feet and worked the pedals and I drove it, and we went and got a load of wood for my father when he was burning. Course there wasn't much traffic, not but two trucks in the neighborhood, ours and Mr. Frank Pugh's and his wouldn't run. There were no gulleys on the road, it was nothing, only a trail. All you might do is run off down somebody's pasture.

It was six of us boys, and, just like any potters shop, we was learning to turn, and we all had our own job.

One job was loading the groundhog kiln. Cleater's father developed an unusual way of getting ware into the low bed through the kiln opening.

The loading entrance to the old kiln was through the chimney. We put a big, wide poplar board down—about fourteen inches wide by sixteen feet long—which went all the way from the ware bed inside to the open area outside where the pots to be fired were assembled. We put gravel on it, and it was level, propped up all the way out. Another board was slid on top of the gravel to carry the pots from outside into the kiln. My father or one of my older brothers would be setting the kiln in the ware bed, take the pots off the board, send it back to us, and tell us what to put on the board to slide in next. Two men could load a kiln easy that way.

The Second World War separated the family as the young men went into the service.

We left as children and came back all of us men folk. No way six of us could make a living up there at the pottery shop. The desire for folk pottery kind of died along then too.

The family made two or three kilns together after the war, then spread out to live and work elsewhere in Georgia, while their father kept making ware at the old pottery. In 1946 Cleater went to work in a shop building aircraft in Mobile, Alabama. In his home he set up a small pottery and built the wheel he uses today. In 1966 he was

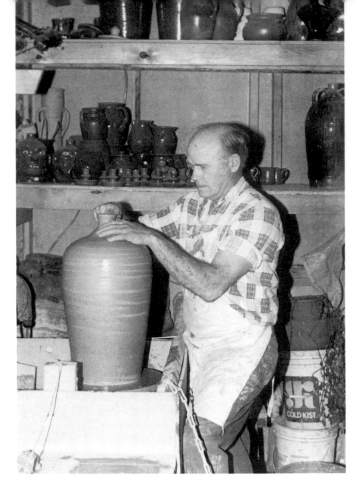

Cleater Meaders turning a jug.
Photograph courtesy Cleater Meaders.

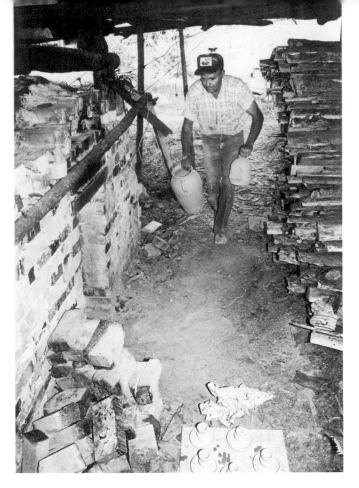

Cleater Meaders loading his brother's
kiln. Lanier Meaders Pottery, Cleveland,
Ga.

moved to Warner-Robbins, Georgia, and built his present home in Byron. He has
been potting full time there since his retirement in 1978. Periodically during the
last thirty years, he has brought his pots to be wood fired at Lanier's or Edwin's kiln.
He also fires in an electric kiln at his own shop. He feels close to the mountains and
during the summer of 1983 he built a kiln on his own land in Mossy Creek.[1] Until
then in return for "slippin' in" a dozen pieces, he helped load and burn his brother's
kilns and shared the cost of the wood. At his home in Byron he uses an old treadle
kickwheel to turn clay he has dug from his land in the mountains. He processes the
clay in an electric pugmill built by his brother John Rufus. He mixes one hundred
pounds every day and likes to age it three to four days.

Cleater fires two glazes in his electric kiln: a feldspathic Albany-slip glaze, with
a dash of red iron oxide to make it a richer, deeper color, and a feldspathic glaze,
with a bit of iron or manganese to achieve an off-white tint. He burns some jugs and
other shapes in a brown glaze to 1,190 degrees Celsius (C/6) and others, coated with
alkaline glaze, to a higher temperature in a wood kiln. He also makes tableware of a
lighter-colored clay in the white glazes, adding a band of cobalt blue for decoration.
"Problem in the old days," Cleater says, "was trying to find something to glaze
with."

If there was a broken glass jar, you kept it, and you got out and hunted more.
You'd go to people's fireplaces and get their ashes—anything to mix a glaze out
of. We never did glaze with salt. The clay we've got won't glaze with salt, and
we were always afraid of what damage it does to the kilns.

To sell the ware required ingenuity, and survival often meant thinking on one's
feet and making various social adjustments.

They used to carry ware over the mountains in old wagons, usually two
together. When they got to the foot of the mountain, they would drop off one

wagon, hitch both teams to the other, and pull it to the mountain top, then walk back with the four mules, and get the other one. My father would take one or two of us when he'd go with a load to sell. We'd go till he'd sold it all—two to three days sometimes. On the way back we had all that old straw for packing the pots, and we could swap it for things to eat, like stalk bananas, or maybe we'd get a frying pan. One place we used to stop and try to sell, but they wouldn't buy. They did finally ask if we had any with the handles broke off. My uncle said, "Yes, I've got five or six churns with the handles broke off," and he'd take 12½ cents a gallon for them. He'd been selling 'em for ten cents a gallon with the handles. She said, "Well, I just believe I'll take them." He said, "All right," and by the time he got up in the truck, he had his pocketknife out breaking handles off.

Back when they were making churns and jugs, this country was full of bootleggers making . . . that's all they had. We sold to bootleggers during the depression—no two ways about it. The revenue officers used to come up to daddy's shop, and there'd be four to five hundred gallons sitting out in the yard. The next day they'd be all gone, and that officer would come by and want to know who you sold them to. Daddy'd say, "I didn't ask the man's name. He had the money and I sold them to him."

The bootleggers knew they could depend on us. Most of the liquor ended up in Atlanta or Athens—university people got most of it. And the police force down there was the propagators of it, the chief operators. They would buy any amount you would take them. Around here they had it worked out. The revenuers sent word ahead they were going to look on such and such a branch [stream] on a certain day. Some stills would be cut down occasionally, but they never did catch anybody. Then, maybe the guy running the still was going to move and would send word to the revenuer . . . come on and cut it down and get your name in the paper and get reelected. They're still making it, and they'll make it just as long as there are the Scotch-Irish.

Cleater Meaders Pottery
Byron, Peach County, Georgia
Stoneware; local clay
Feldspathic Albany-slip glaze, alkaline glaze
Commercial kiln, electricity; 1,190°C (C/6)
Tunnel kiln; wood; c. 1,260°C (C/10)
Jugs, churns, pitchers, beanpots, tableware, mugs,
 cream-and-sugar sets
See also John A. Burrison, *Brothers
 in Clay*

Note
1. See *Foxfire* (Fall 1983).

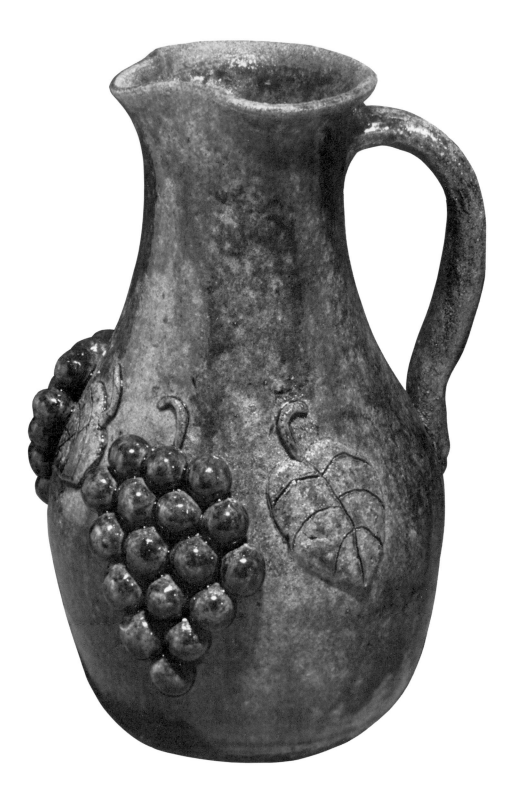

Edwin Meaders Pottery

Alkaline-glazed pitcher with grape design made by Edwin Meaders.
Photograph by Glen Tucker; courtesy Randolph Technical College.

Edwin Meaders, familiarly called "Nub" (born 1921), is a son of Cheever and Arie Meaders and brother of Lanier. He lives in a small white house within sight of the old family pottery with one of his four sons and several dogs. His shop is a tiny, tar-papered building, with a kiln shelter attached to the far end a few yards behind the house. A pasture road leads beyond the hedge to the chicken house and garden. It is a quiet, slightly rolling, open piece of land sparsely dotted with trees.

Edwin worked full time at a local lumber mill until recently and also helped at his father's pottery.

From the time I can remember I was working there, up to the time he quit [1967]. They was a few years when momma worked with him and I didn't. But I would help them haul clay, wood, get ready for the burnings. I'd go down in the bog and get the creek settlings. It's just a real yeller clay, but it'll melt at a lower temperature, and it just makes a good glaze. I done that all through the years he was making.

I remember my uncle made a glaze he called iron sand glaze. The iron sand come out of a gulley, and it was just pure black sand, black as a chunk of coal. Used to be some iron mines down there. During the Civil War they mined and smelted it. There was a vein of iron went through there. Naturally that iron sand come from along those veins. It made a more red brown glaze, and it would hold just like metal or glass, it wouldn't seep. But they never did make much of it, they'd just rather get out and get up glass for the glass glaze. There was some other rocks they'd melt on it. It would be melted but just an old mat look, not shiny.

Edwin made some pots while helping Cheever. "I always made a little along but not to live on." His beginnings in the trade were in childhood.

I learnt to turn when I was a-working with [Cheever]. I can remember having to get some things to stand on, get some of them to turn the wheel for me—there's a lot of fun like that. I've liked it all—firing, turning . . . it's just something that's amusing to me.

Edwin built his own shop and kiln in 1969–70, but it was not until 1979 that he potted steadily and customers found him.

When people found out I was making it why . . . I didn't have no more problems. Sold everything I made. Would've been better off making it all the time, but I had four kids. I couldn't wait on the business to build up, I had to have it [income] then, and I could make it quicker by the week on the job than I could making pots. A person has to make the best decision.

His compact shop contains a wheel, wedging table, and shelves for boards of pots. It has an earth floor and two windows, and tools are hung on the wall. Edwin's clay mixer is outside the shop; he also prepares and applies glazes outdoors. A local machine shop made, according to his design, a variable-speed electric wheel. A belt and pulley turn the shaft of the large, eighteen-inch-wide wheel head.

It works good. I get the clay where my daddy used to get it, about two miles south of here. It's out of bottom land, but not real down in the bottom. Lots of

103

Interior of Edwin Meader's shop; note drying pitchers with modeled grape decoration.

Edwin Meaders

clay been dug there, and it's zigzagging around about to come to the end of that vein. But right nearby in the same clay pond no telling how much there is, probably, two to three acres of it. Daddy and myself located it years ago. He was real excited over it but he never would ask those folks, cause it was where they was farming, and he didn't want to cause them no problem. I'm going to ask them if they will sell it before I change clay. Where I'm getting it now has sand in it. Part of the clay is white, part is gray; layer of muck at the bottom with mica in it I always throw in with my clay. Makes it turn better. I usually dig in the spring and fall.

Back at the shop he throws the clay off the truck onto a prepared spot on the ground and covers it with a tarpaulin. He adds water to soften a portion of it for half a day. While he grinds it in an electric mixer, built by his brother John, he adds more water. He blocks the ground clay, stores it in plastic bags, and lets it set for three or four days. "When you first take it out of a mill, it just don't work good."

In the shop, Edwin kneads and wedges the clay on a flat, plaster wedging board, picking out stones and weighing it. He makes pitchers, jugs, roosters, and lidded jars of many shapes and sizes. His mother, Arie Meaders, began making roosters and pitchers with modeled grape decoration in the 1960s. Edwin now makes them in his style:

If people want the grape stuff, I make it . . . some want plain stuff, some want the roosters. I like to see people get what they want. If I'm just making plain stuff, I can make twenty a day. If I'm making with the grapes, I can make six of them pieces by working all day long. It takes longer to roll them grapes, cut the leaves, than it does to [turn] them. It takes more than a day to make three roosters, [working] just as hard as I can go.

To make the roosters, he turns three pieces—the base and the lower and upper body—on the wheel late in the day and then cuts and puts them together the next morning. Once the rooster body is constructed, he prepares the partially hollowed

head and makes the tail, comb, and gills by rolling out the clay and then cutting the shapes. When the body and base are stiff enough not to bend out of shape, he adds these remaining parts. The eyes are inserted into bored holes in the head and are affixed with a solution of clay. In the semihard clay he writes his name.

I studied a long time before I really got into it. I've been making them for two years, hadn't lost one in busting or cracking. Probably made four hundred.

When his ware is dry, he raw glazes it. He uses only one glaze made of Albany slip, whiting, feldspar, and some body clay, which closely resembles an ash glaze. He would like to use ash but has no grinding rocks. In a big tub of liquid glaze, he says, "I dip them, I roll them, and I set them off to dry, then rub the glaze off the bottoms to make them smooth."

The small (five feet wide by seven feet long) tunnel kiln is burned with pine slabs for ten hours.

A fella put a cone in the kiln that took 1,200 degrees Celsius [C/7] to melt it down. I've got a place I can look in the upper end and see the pottery. I get me a piece of wood and throw down between them, and that blaze comes around. If the ware's ready, it'll shine—you can see it just as good as if it was settin' on the outside. When it's not glossy all the way down to the bottom, I have to fire it some more.

The kiln is made of common red bricks that have melted together. The inside shines as though glazed, but the arch is firm and the lines of individual bricks are faintly visible.

Recalling his life as a potter, Edwin reminisces about earlier experiences of his family:

Once my uncle had to go to Mossy Creek Church where he was a trustee and they was electing teachers. He left his sons Christopher and Ray to mix glaze. Christopher went and got the ashes and stuff and screened them with an old screen sifter as always. They had a set of glaze rocks to grind it with . . . and he had went and got the ashes mixed up with commercial fertilizer. He didn't know it until he had done got it ground. By that time his daddy had done got back, and he knowed not to say nothing to him. His daddy told him, says, "Son, this is the awfullest, funniest looking, smelly glazing I ever used." But later he said that was the prettiest kiln of churns they ever fired. They was. I seen them myself.

Edwin enjoys his work.

I'm well pleased with making pottery now cause I've just got a job at home— don't have to be going to these places. I work a lot of time when I don't feel like working. If you be your own boss, you only fudge on yourself anyway.

Edwin Meaders Pottery
Cleveland, White County, Georgia
Stoneware; local clay
Feldspathic Albany-slip glaze
Tunnel kiln; wood; c. 1,260°C (C/10)
Pitchers (plain and with raised grape decoration),
 roosters, milk crocks, jugs
See also John A. Burrison,
 Brothers in Clay

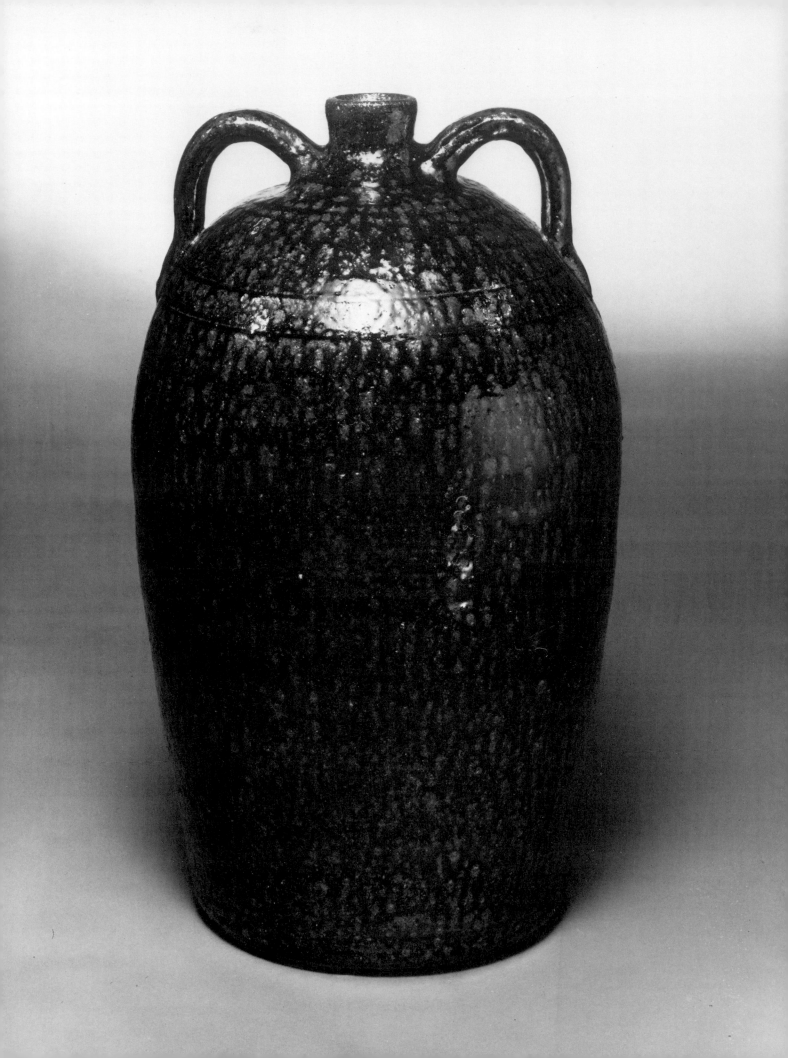

Lanier Meaders Pottery

Alkaline-glazed five-gallon jug made by Lanier Meaders.
Photograph by Rob Griffin; courtesy Randolph Technical College.

The Meaders family remembers the land at Mossy Creek as heavily cultivated fifty years ago.

> Now the countryside is all grown up in trees. Back then, if there was a spot level enough that you could plow, we had cotton or something planted on it. All the pines growing around here was cleared. Where we used to farm, we've cut timber off it twice.

Mossy Creek runs south of Cleveland, Georgia, through a rolling piedmont just below the rise of the Appalachian Mountains. As early as 1849 pottery shops were established at Mossy Creek by the Dorsey and Craven families. Christopher Meaders and his family moved to the area in 1848 to farm cotton. His son, John Milton Meaders, built a pottery in 1893 and hired local potters to work it, using his six sons as helpers until they learned the trade.

> If there was anything done, he was going to see that those boys did it. He'd rather sit on that front porch and make sure it was well carried out. He could do it from there, too. He was a rocking-chair man.

One of John Milton Meaders's sons, Cheever (1887–1967), took over the pottery in 1920. Lanier Meaders (born 1917), son of Arie and Cheever, is presently keeper of the family homestead and pottery. He was raised in the pottery, performing myriad tasks, from cutting wood to loading kilns with his brothers and, occasionally, his mother, sisters, and aunts.

> I can remember the first pottery I ever made very well. It was small jugs and pitchers not over three inches high. I made two hundred of them, and they got fired. My daddy and uncle hauled them off somewhere—up about Clayton—and I thought I was going to get a nickel apiece for them. But, my uncle swapped them for a typewriter, and I never did get anything out of it. I was nine or ten years old, and I believe that was the biggest disappointment I ever had in my life. I've not forgotten that till today.

Lanier, who has not married, lives at the family home with his mother, Arie Meaders. He has worked with Cheever off and on in the pottery and at jobs away from the home, helping his father after hours and making ware when he was temporarily laid off. Father and son each seemed to prefer working alone. When Cheever died in 1967, Lanier returned to run the pottery. As he was bothered by people coming to see how pots were made, "it was just like a public park," he left the pottery for a time in 1969 and 1970. After recovering from a heart attack, he returned in 1971 and has since run the pottery alone. Arie Meaders had worked in the pottery for thirteen years until 1969, designing and making small ware with raised and painted decoration.

The Meaders shop is a small, tar-papered frame building with an earth floor. Two wheels are located near the small windows. A wood heater and a glaze tub stand in the center of the main room; wedging board and clay mixer are near Lanier's wheel; and racks for drying boards are built against the back and side walls. A smaller room in back has additional drying racks and is used to store glaze mate-

rials. The old balance scale, with plow-points and hammerheads for weights, hangs against the wall.

The Meaders have used the same local clay for ninety years. Lanier describes it as a very high-temperature clay,

Arie Meaders holds a rooster she made in the 1960s.

> *a metallic clay, made off these rock up here over a period of probably millions of years. It's alike in these valleys because it's in pockets and couldn't wash out. It was trapped in here.*

Lanier adds another clay to lower the maturing temperature of the clay body. He identifies it as a red silt, a secondary clay from the Okmulgee riverbed near Macon that matures at 1,190 degrees Celsius (C/6). Because it is a finer grained clay, it is less likely to crack during raw glazing.

The clay is left outside to weather until Lanier is ready to prepare some of it for turning.

> *I've got some rollers that I made—just two steel rollers running together— pulled by a tractor. Lot of people thinks it's a syrup mill. I run it [the pit clay] through that first, and it mashes up little rocks or anything in it. Then I put it in the mixer and stir it up. I judge as near as I can to the right proportions to make it work [when adding the clays together in the mixer]. I put it in plastic bags. It works better if I could keep about a month ahead.*

In 1960 Lanier replaced the mule-drawn beam mill with a horizontal, electric clay mixer. He still turns on his father's treadle wheel. The crank was taken from a 1927 Chevrolet and the flywheel from a Fairbanks and Morris one-cylinder gasoline engine. "I've got accustomed to it—the coordination between the power I put on that thing and my thinking that goes with it—they work perfect." Lanier has a vertical backrest with slanted seat, cushioned with pieces of quilting tied around it. He either stands or leans back on the seat while turning. "It's standing and not leaning back and leaning back and still not standing." The wheel has a large wood crib built around its sixteen-inch, twenty-year-old wheel head. His turning tools are a ball opener, a gauge (used only occasionally), two metal "scrapes," and five wood "scrapes" made of flat pieces of walnut, dogwood, and cedar, without thumbholes.

On a turning day early in the morning, he forms all the clay balls needed for the day, covers them with a wet sack and plastic bag, then leaves the shop for awhile. He will work about four to five hours during the day making up to thirty one-gallon pots. To turn a pitcher, he opens the centered ball of clay with his thumbs, uses the ball opener to finish the bottom, and then pulls the clay up part way with both hands. Then, with his left hand inside the clay wall, he makes two pulls to raise it. On the third and final pull, he uses the metal scrape, and if he is in a hurry, he will pull from the bottom with the metal scrape. Lanier uses wood scrapes to shape the form and incise rings on the pot when the shape is finished.

> *There's not a great deal to turning, but main strength and awkwardness. It looks easy, and I guess it is for some people, but it's not one of the things a person could take for granted and go on with.*

The pottery is dried in the shop, by heating the stove if necessary, and then raw glazed.

> *I do not bisque fire anything—never have. Nobody did up here . . . raw glaze and raw fire. The glaze I'm using now is what they call a "Shanghai" or "baccer spit," but to me it's just plain, old, wood ash glaze. It's the stuff we've always used here since I can remember. The ashes I'm using, I just screen 'em out, I don't run 'em through the mill any more. I've got a fine screen that takes everything out of it. Don't leave anything, just the dust. That saves about*

Lanier Meaders glazing a churn.

seventy-five percent of the work. Then I use the body clay back in it to set it, and I'm using feldspar and whiting in place of the pounded-up glass, which is the same stuff as the glass would be anyway. It's about fifty percent clay, forty percent wood ashes, and ten percent feldspar and whiting or lime. I reckon that's the oldest known glaze in the entire world. It's supposed to come to this country from somewhere in China, but it don't necessarily have to come from Shanghai—just so it come from China. Well, anybody mention China in this country, Shanghai is the first word that comes in the mind.[1]

He stirs the ingredients together in a large galvanized tub filled with water and dips the pots into the glaze by spinning the pieces horizontally to coat them quickly inside and out.

I just sort of baptize them. One problem I used to have is not putting it on heavy enough. If I feel good and watch my clay and get it mixed right, then I don't have any problem at all. But if I've got too much Okmulgee clay in it, then I've got to put the glaze on thin, but if I've got too much of this metallic clay we've got up here, then the glaze has got to go on real heavy. There's just little things like that that a person can let get by, if he's not watching it.

Before the glaze is applied, the bottom of the pot is waxed with paraffin heated in an electric frying pan to repel the glaze and thereby prevent the kiln sand from sticking to the ware. He glazes one day and sets the kiln the next morning, when the ware is dry again. Before it is dry, a raw-glazed piece, weakened from soaking up the glaze water, is most vulnerable to breaking.

You've got a trauma period after glazing and before it's dried out. That's when people come in and want to help me—they insist on helping me. The only thing to do is let them break something, and as soon as they break it, they hit it for the door, and they're gone. It sort of tickles me, though, once in a while, you know, it aggravates me too.

To measure the temperature of the kiln, Lanier makes glaze cones. He boils the water from a can of glaze on the heater and, when it reaches the right consistency, rolls the thickened glaze into cones. When he sees the cones melting, he knows the glaze is melting on the ware.

Lanier's tunnel kiln, sometimes called a "hogback," is built above ground and has a deep, rounded arch instead of the shallow arch of a groundhog, resulting in a comfortable four-foot high space from the ware bed to the top of the arch. The entrance to the kiln is through the firebox. The six-by-twelve-foot ware bed is covered with several inches of creek sand. The chimney stack, rising about five feet above the kiln arch, is cracked and beginning to lean away from the kiln. The twelve-inch-thick kiln walls are braced every few feet by vertical oak poles set deep into the ground. An outer wall of two-inch oak boards is built against the poles, and the twelve-inch space between contains clay, topped with rock. A fourteen-foot log braces the top of the kiln wall and holds it together. When he rebuilt the kiln in 1980, Lanier lowered the walls a little and rounded the arch, making it a half circle. He wanted more space inside at the top to increase circulation, enough for the fire to pull in sufficient oxygen for proper combustion (see illustrations, pp. 1, 70; diagram, p. 67).

That's another thing people have got a misconception on. They say wood burns. Wood does not burn. You get wood hot and it forms a gas and the gas burns. The wood don't burn at all.

I get about 125 pitchers in it. If it's three-, four-, [or] five-gallon churns, I get about eighty-six of them—that's on one level—then I can stack another row

on top of them. I can stack five rows through the middle of the kiln. I don't stack . . . I never have, but I can, if it ever come down to it.

Cheever always fired the ware in one layer, and his son continues in the way he learned. Also his customers want the rims glazed, and to stack pots one on another, the glaze must be removed from the rims.

When the kiln is set, Lanier starts a small fire in the firebox, "about like you'd have in a fireplace." He uses some oak logs at the start, but after the ware is tempered he increases the heat rapidly by burning pine slabs. He builds heat gradually for eight hours, until the pots are translucent; then in the last two hours, he stokes it, much like firing a boiler. Pitchers and face jugs are fired for ten hours. When the kiln is full of large pieces—churns and jars—the firing lasts longer. The kiln can be unloaded after thirty-six hours of cooling, but he usually waits two or three days.

If I don't feel good, if I'm rather tired, I wait till somebody comes along that wants to buy some pots and get them to unload it. I have let it set a month. . . . But I have a fishhook out there. I reach in there to get one.

Earlier the firing was "blasted off" at the end with rich pine.

Can't still get it but once in a while. Used to take a mule and take the lighter'd down off the mountainside. Then we had something that would make smoke. I can't say it heated any better than just common wood—makes a big, black smoke and more or less choked the fire up.

Lanier burns his kiln now about once a month, "I try to get twelve firings a year." He now makes more face jugs and pitchers.

If I work hard and [am] not being bothered, I can make ten face jugs in about eight hours. But, now, I can do that for one day but not the next day. If I work on an average of six days, I can make thirty-five to forty. But, if I work for six days, it's about six months before I can do anything else. I mix up the white clay for the eyes and teeth on the face jugs—silica and kaolin, that's all it is.

Lanier would shape his pots a little differently if he had the proper size lifters to take them off the wheel as fast as he can turn them. For every size pot Cheever had a set of lifters, which are now rotting in the shop. Notes Lanier:

What you've got to work with determines the shape of anything a whole lot. . . . What I really like on a pitcher takes a little bit longer to make: would be a small bottom, tapered up to a round belly with a high shoulder, and come in with a smaller top. If you pour out of that, you won't pour all over the county. Dad's pitchers didn't have any shape to them, just straight up, mine are too. I make handles squared so you can get a-holt of it. I never knew him to put on a straight handle in my life. Somehow or other it got cropped off a little. I think he really didn't care, just so it had a handle on it. I've known him to go to the shop after dark, use a lantern for light, and handle up what he made in the day. Next morning he'd go back and redo some of them, they were so bad.

Lanier says he would care more about making pots and would make better pots if he lived in a time when people were using his wares in the old ways. His ware is now bought mostly by collectors from near and far.

A lot of people that was raised right around here [have] never been to the shop. Haven't seen it, don't know what it is, but still they read about it and are trying to collect up a few pieces. They think it's way off someplace.

Lanier expresses ambivalence about the making of pots.

What makes the best potter is somebody that's hungry. He's got to be hungry

and in debt and about to be foreclosed. If he's like that, he's got to make a good product. But, if he's got plenty of money, always had a silver spoon in his mouth . . . Lord, what difference does it make?

Lanier Meaders Pottery
Cleveland, White County, Georgia
Stoneware; local clay
Alkaline glaze made of clay, wood ash, feldspar, whiting
Tunnel brick kiln; wood; c. 1,260°C (C/10); glaze cones
Face jugs, plain jugs, pitchers, bowls, jars, vases, churns, flowerpots
See also Ralph Rinzler and Robert Sayers, *The Meaders Family and* John A. Burrison, *Brothers in Clay*

Note

1. Cheever made his "Shanghai" or ash glaze of iron-bearing pond-clay settlings, wood ash (preferably oak), and powdered glass, ground together wet between flat hand-turned glazing rocks.
 Silica and alumina are obtained from feldspar and calcium from whiting. Glass is made of silica, alumina, and other minerals, frequently calcium.

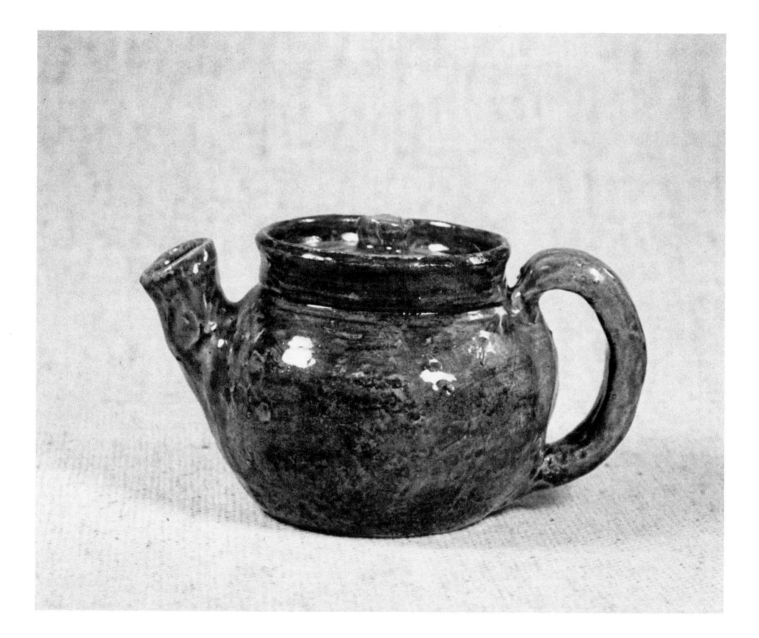

Marie Rogers Pottery

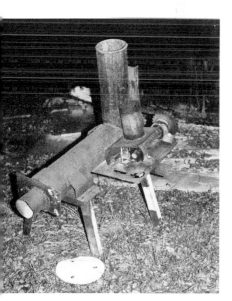

Albany-slip glazed teapot made by Marie Rogers.

Clay mill constructed from a post-hole digger and auger bit.

The term Jugtown was first used to define areas where pottery making had become an industry in the South. Four such areas are best known: two in North Carolina, one in South Carolina, and one in Georgia. Marie Rogers is the widow of the son of the last Georgia Jugtown potter, S. Rufus (S. R.) Rogers (1883–1954). The Bishops, who were early potters in the area, were cousins of Marie's husband, Horace (and also of Bill and D. X. Gordy); and Horace's mother, Ida Salter, was also from a potting family. The father of S. R. Rogers, Starling Adolphus (1860–1911), is considered to have been the most skilled potter of the family. His father, Frederick Rogers, came into the area from Virginia and married into the Brown potting family.

Marie remembers visiting old potteries, but only took up the work when she married Horace W. Rogers (1917–1962). Horace, a fourth-generation potter, worked with his father at the family pottery and cotton farm. They made stoneware churns, pitchers, and flowerpots raw glazed with Albany slip or a Bristol-type glaze of clay, flint, feldspar, and Spanish whiting. In his early years S. R. Rogers used alkaline and salt glazes and also fumed Albany slip slightly with salt. At the present pottery site, in Meansville, Georgia, ware was burned in a groundhog kiln approximately eight feet wide, sixteen feet long, and four feet high. Churns were stacked one on top the other in the hotter front section of the kiln, with pitchers and jugs atop unglazed flowerpots in the cooler rear chimney area. At the start of a firing the main firebox was closed off with soft rock. Two shallow fireboxes, extended from the kiln face were used for preheating. When the ware was thoroughly dried by this gentle heat and the kiln brick warmed, the main firebox was opened and the burning of large pine cord wood begun, with the addition of rich pine, if they could get it.

> *They made little [clay] trials with a hole in them, put them in the back part of the chimney. After thirteen to fourteen hours, when they'd see the fire coming out the top of the chimney, they'd take an iron rod, run it in the back, and pull a trial piece with glaze on it.*

Horace worked with his father until he went into military service. When he was discharged he moved the family to Pike County and built a pottery.

> *His dad was getting pretty old then, but he helped Horace some, turning. They still made churns and all. My husband made a pitcher with a lid, and he made a cup attached to the lid. That was for use around the creek. They'd make coffee in the pitcher and drink it out of that cup. They also put coffee in jugs around the fire.*

Horace made pottery until he died in 1962. Marie worked and raised their children, "practising pottery" periodically until she began to sell pots in 1978.

At the pottery there is still a large stockpile of weathered clay dug by Horace from Potato Creek swamp. Marie says that this rough, porous clay is only suitable for small pieces and that the Rogers once used a finer grained clay for churns. From the clay pile, Marie digs out a portion with a maddock, wets it, chops it, and grinds it in a tiny, homemade mill. It is constructed from an old post-hole digger set horizontally on a stand and has a funnel leading into it, with an auger bit to churn the clay and push it out. Marie adds water as needed to the already slaked clay. The reddish brown raw clay fires to a dark brown. She turns on her husband's old treadle

Marie Rogers stands by her treadle wheel.

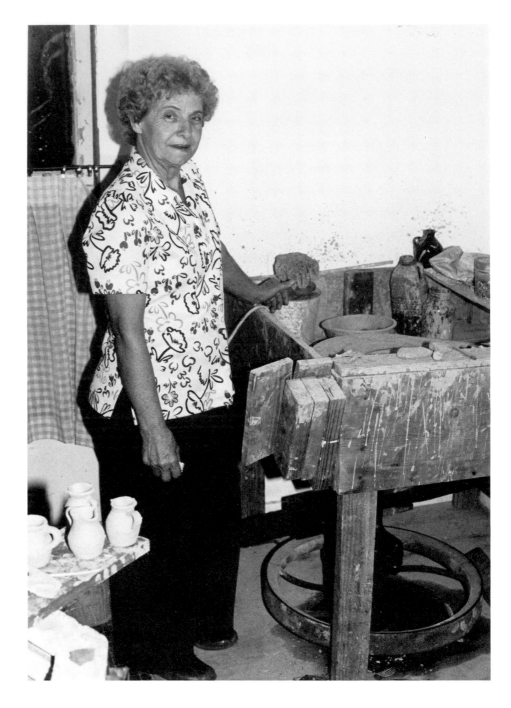

wheel (originally made in a blacksmith shop) in a room at the back of her house used for laundering as well as potting. In the same room are drying racks, electric kilns, and a "ball bench" (wedging board), where she picks the clay clean and kneads it. It is crowded, but Marie's production is limited and her pots are small. She works at night sometimes and on weekends.

> *When I come in it'll be late and sometimes I want to work. I was kindly scared to go out across the yard to the old shop, and by the time you run so much electricity . . . [it is too costly].*

Pots have not been made in the old shop in twenty years; Marie uses the space for clay preparation and storage. The old kiln, with the arch partially torn out, is behind the shop; Marie grinds her clay in the open area between the two structures.

Marie makes only small ware in shapes similar to what her husband and father-in-law used to make, including pitchers of several sizes, bowls, teapots, jugs, and miniature churns. She makes more face jugs than any other item. The pots, glazed in Albany slip fluxed with Gerstley borate and fired in an electric kiln to 1,225 degrees Celsius (C/8), are sold principally through the Tullie Smith House in Atlanta.

In her father's and husband's shops Marie had served as a helper, involving herself as much as possible and always eager to learn more. Among other skills, she learned to glaze the ware.

> *The Albany clay would come in a barrel in chunks with some rocks in it. Now you buy it all blowed up some way or other—powdered. We'd soak it and strain it, keep straining it, finally through cheesecloth. We'd take our finger, and if it dripped about twice off the end or either kind of coat your fingernail, he'd say, "Oh, it's ready." Sometimes I'd put wood on the kiln. He and his daddy and Tommy Stewart would be turning, and I'd say, "I want you to show me how." "O.K., make the ball up, pack it real good, don't leave air bubbles in it, put it on the wheel, and hold your hands still. You can do it." My hands would wobble all around, you know, and finally I just made a pot one day. But, we had the two girls, and I couldn't do too much when they were young.*

Marie, with enthusiasm, courage, and determination, is re-entering the craft on her own now. Earlier she had been a helper; now she is in charge of the pottery. She is continuously teaching herself, using as examples the pots she has inherited and relying on her memory of pottery-making processes.

Marie Rogers Pottery
Meansville, Pike County, Georgia
Stoneware; local clay
Albany-slip glaze
Commercial kiln; electricity; 1,225°C (C/8)
Small churns, teapots, bowls, jugs, cups, face jugs,
 cream-and-sugar sets, candleholders
See also John A. Burrison, *Brothers in Clay*

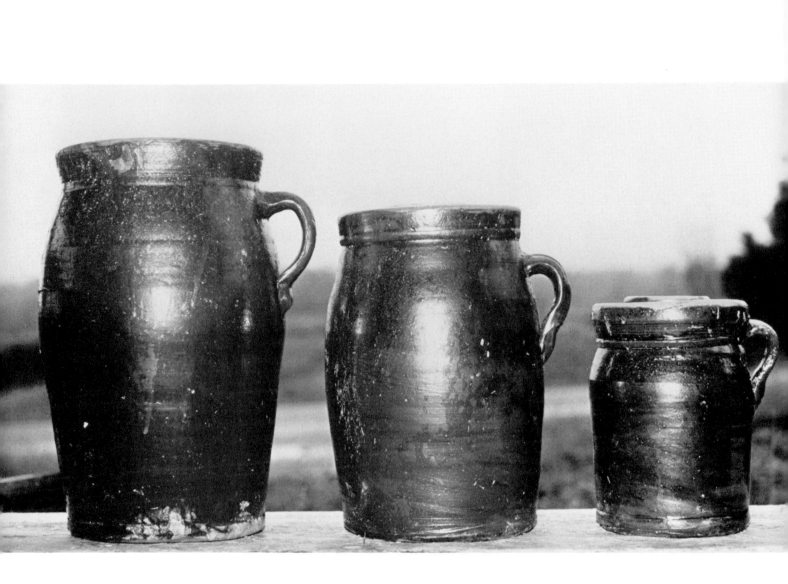

Norman Smith Pottery

Michigan-slip glazed churns made by Norman Smith.

Norman Smith (born 1904) is a back-country potter who has worked near his home all his life. He was born and raised in a log cabin with eight other children four miles from where he now lives. He and his brothers and sisters had to wade or swim across a creek to get to the schoolhouse.

> *I'd slide off into the branch, fall in. I just couldn't walk a foot log, [especially when] icy weather come. Get up there and I'd be a-crying, my feet was hurting—freezing. She put me right by the heater and wrap my feet up. We finally never did go much.*[1]

When his mother died at the age of thirty-eight, his father remarried. Norman and his step-grandfather dug and tested local clays by burning them in a stove oven. Encouraged by the results, they bought a secondhand wheel and built a groundhog kiln over which they mounded rocks. Norman began to teach himself to turn and later learned more by working with an itinerant potter.

> *I had one bad eye. The only thing I had to do was play on the wheel and drink whiskey. Next year after we started, Charlie Brown from northwestern Alabama came and turned for us. He didn't stay long. Nice seeming fella, played the fiddle all the time. I started making pottery at seventeen, been at it sixty-one years.*

Norman turned while his father and brother hauled ware to sell with a Model-A truck. They made glaze in his father's shop, using ash left in a hopper from which they had dripped lye to make soap.

> *The ash was rotted already where they'd stayed so long. Mixed 'em with water and strained them through flour sacks, then let that settle and get thick. It had to be thick as your fingernail to be thick enough. I don't think we mixed anything else with it then, except [we] got some sand and put in that.*[2]

Later, they mixed Albany-slip clay with it, which made it stay on the ware better. They sold their ware to general stores and whiskey makers.

> *They were all around, and it was the best trade—ten cents a gallon. Sometimes they'd make enough business in whiskey to have to have 125 gallons a day. We'd have to burn fast enough to get that.*

When he married in 1932, Norman started his own pottery while still farming. He has lived and worked in Lawley, Alabama, since 1940 with his second wife and their four daughters. Since their marriage, Irene Smith has helped her husband in the pottery.

Norman has always made pots of a local clay, using a single source at a time. In some areas it was necessary to remove ten feet of topsoil to reach the clay vein; he and Irene now dig their stoneware clay from a roadside bank and pile it on the ground or by the clay mill. Formerly, the freshly dug clay was contained within a wood frame. Now it is left on the earth; Norman claims a little dirt does not hurt it. Because the clay crumbles when it is wet, it is not chopped before soaking; Norman simply shovels what he needs into the soaking box and sprinkles it with water.

After a few days, he puts the softened clay into an old beam mill, which mules once pulled. A tractor is now used to drive the mill (see illustration, p. 47).

> *After I worked so many mules to death, I thought, I'll never get to heaven. So, I stopped that and put my wife to work.*

A mule pulled 150 rounds to grind a mill of clay. Now, in one hour, enough clay is ground to turn two hundred gallons. Norman carries the clay to the shop in a wheelbarrow, throws it down in a corner, and covers it with wet burlap sacks. Because there are so many rocks in the clay, he only picks out the largest. Indeed, one of his pots may have a stone embedded in the wall or a hole where one has blown out, a characteristic of many early pots.

Norman has turned eight-, ten-, and twenty-gallon crocks; his limit is now five gallons.

> *I used to turn right smart—grind a mill a day and turn it. Stay with it from daylight to dark mostly. I used to go to the house and eat dinner, and in fifteen minutes time I was back in the shop. When I started, I worked at building up my pottery what time I wasn't in the field. One New Year's Day I 'bout turned up a bunch of it, but I didn't have the shop daubed yet, and it all froze.*

He worked on a treadle kickwheel until about 1970, when he had an electric wheel made for himself in Selma. While working at the wheel, he leans back on a board just as he did when he turned on the kickwheel. His wares are mostly flowerpots, churns, and jugs, although he refers to all his shapes (except churns) as "pots." These include mugs, teapots, casseroles, pitchers, piggy banks, and chamber pots. In warm weather the ware is dried in the sun, but during cold weather a homemade stove is used to heat the shop and dry the pots set on shelves built above the stove. He made the stove by cutting a gasoline drum in half and placing the halves end to end on the earth floor. He builds a fire at one end, the heat travels through the horizontal flue rising slightly with the pitch of the ground to the stack.

When dry, the ware is raw glazed with Michigan or Albany slip. He applies glaze in the shelter outside the turning shop by dipping and rolling pots in the liquid glaze. The mixed glaze is stored in a tub made from a wood barrel set horizontally on a stand at waist height, with several staves cut partially away for an opening. Some years ago Norman made a white glaze (probably a Bristol glaze) to cover the bottom two thirds of a jug, which was glazed at the top with a dark Albany slip. Until the mid-1970s, he made a soft blue glaze of feldspar, zinc, and cobalt.

Norman has always fired with wood. There are three kilns now at the shop, two stand outside the shelter unused and disintegrating. The large sheltered tunnel kiln now in use is ten feet wide, five feet tall, and fourteen feet deep. Churns with unglazed rims are stacked upright foot to mouth. Inside each churn, small pieces—mugs and pitchers with glazed rims—are set on stilts. Irene stacks the kiln to the very top, placing unglazed flowerpots at the back (see diagram, p. 68; illustration, p. 71).

> *It takes a mighty hard firing [to melt the slip glaze]. This clay now gets a little too hot, . . . pots stacked together sometimes stick. It's got to be fired slow so it won't bust the pots. I warm it up one day with about a half cord of wood. Start again at two A.M. next morning and fire slow 'til eight or ten, then just go on with it pretty fast for sixteen hours [total]. It takes four cords of wood to burn.*

Norman estimates that he is burning to about 1,260 degrees Celsius (C/10). He gauges the fire by drawing out small test samples from a hole near the chimney to see if the glaze has melted. The Smiths now fire the kiln about three times a year.

Norman has had water and kiln problems over the years. The floor of an early shop often became damp, ruining pots set on it. His first kiln steamed and never

Norman Smith

reached the proper temperature. The next kiln, a round one with a central chimney and five fireboxes could not be fired fast enough. Others collected moisture or did not draw well, or the bricks could not withstand the heat and melted.

We had seven wet years. It rained mostly, and water just come seeping up when I was trying to burn the kiln. I had a tough go of it. I would never have went on if I could have done something else. Next kiln I built up some above the ground.

Norman's brother helped him build the present kiln about fifteen or twenty years ago, "out of any kind of brick I could get." It was built on the base of an older kiln and works well. To burn the kiln with pine saplings and slabs, Norman and Irene stoke the fire from opposite ends of the firebox door. "If we get too much blaze, I'll dash some water in there and cool it down." When the firing is finished, he stops up the kiln tightly and lets it cool for three days before unloading it.

Firewood slabs are obtained from the sawmill, stacked to dry, and cut with a chain saw.

Every time I get a chance, I get a load. When I want to get something else or go fishing I come back by and get a load of slabs.

Drying rack built above stove made of two halves of a gasoline drum.

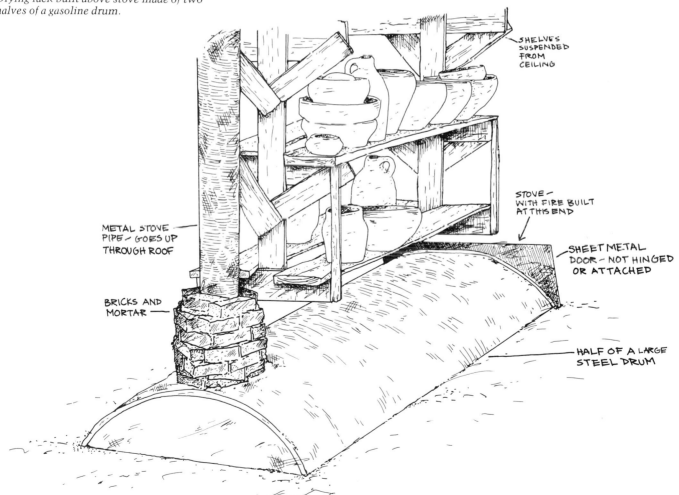

SHELVES SUSPENDED FROM CEILING

STOVE — WITH FIRE BUILT AT THIS END

METAL STOVE PIPE — GOES UP THROUGH ROOF

BRICKS AND MORTAR

SHEET METAL DOOR — NOT HINGED OR ATTACHED

HALF OF A LARGE STEEL DRUM

His shop, a log building with sloping earth floors, has attached to one side a large open shelter for the kiln, on the other side a small storage lean-to, and in front another open shelter for drying and glazing pots.

First shop I had here the termites got to eating on it. The logs rotted 'til they stoned down [sank down on the stone foundation]. Got to where we had to walk sideways to keep from bumping our head. Finally, I tore that down.

Norman once peddled his pots in nearby cities, including Birmingham and Selma, but for many years now he has sold them from his front yard. Ware is scattered about the road, and customers search for lids to fit the churns.

Used to sell pitchers for twenty-five cents a piece. I'm getting three dollars now. I went up on 'em, but I still don't charge like my wife. I still sell at a low price, cause I was raised up in hard times. About three years back, people would take off whole loads of flowerpots, but this year, last year, they're all scared to spend their money.

Pottery is a lifetime occupation, and many potters simply slow down instead of retiring. A half-brother of Norman's has made some pottery, and when he retires, they may work together. If they do, Norman aims to build a groundhog kiln, which, he says, burns best of all.

Norman Smith Pottery
Lawley, Perry County, Alabama
Stoneware; local clay
Albany- or Michigan-slip glazes
Tunnel kiln; wood; c. 1,260°C (C/10)
Jugs, churns, pitchers, mugs, teapots, chamber pots, piggy banks, casseroles
See also E. Henry Willett and Joey Brackner, *The Traditional Pottery of Alabama*

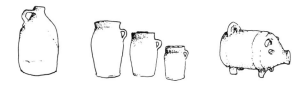

Notes

1. Norman Smith, interview, courtesy, Eliot Wigginton, director, Foxfire.
2. Ibid.

Gerald Stewart Pottery

William C. Stewart, grandfather of Gerald Stewart, came to America probably from Scotland and settled in South Carolina. Gerald's father, Homer W. Stewart, moved his family to Mississippi and in 1888 established the Stewart Pottery a few miles east of Louisville. Of Homer's children, three sons became potters, including Gerald (born 1917). A daughter, Hattie Mae Stewart, married into the Brown pottery family and is currently working with her son Jerry Brown at his pottery in Alabama. Gerald's home and shop are located five miles from the pottery site where he was born and raised.

> There used to be trees everywhere, lots more than today. We had a farm as well as the pottery. My daddy raised cotton, corn, and peanuts. Cotton was the cash crop, the rest was for the family and stock. We had hogs, beef and milk cows, chickens, horses, and mules. We ground the clay with a mule. My grandmother did a lot of spinning and weaving, but my mother did not, she quilted.

At age twelve, Gerald (pronounced with a hard G as in get) began to turn six-inch flowerpots. At that time, in the late 1920s, his father was making flowerpots and utilitarian ware glazed with Albany slip.

> And he salt glazed some too in the same kiln. When he fired Albany after a salt kiln the ware had pretty green streaks. He made a right smart [amount] of salt before he got into Albany. And that white glaze [Bristol], too. Late in his pottery work he made unglazed urns and birdbaths as well as flowerpots. He died in 1932 when I was sixteen. The three of us boys kept the shop going. Then my older brother James Thomas started a pottery over on Highway 14, and my brother Winfred kept the one there at home. I worked with both.

A pottery at the old site has recently been started up again by his nephew Bill Stewart. Gerald began his own pottery in 1965. His home is on a main highway, dotted on both sides with ranch-style houses behind which is open country. His daughter lives across the road. The pottery shop (thirty by forty feet) is down a little slope behind the house. In front of the shop is a pile of clay; next to it are concrete blocks stacked to hold ware boards of drying churns; attached to the shop on the left is the kiln shelter.

Gerald is a tall, gaunt man in his midsixties who displays an archaic southern courtesy and gentle manner. He works alone, at his own pace, and only in warm weather. The shop, built nineteen years ago, is identical to shops used by generations of southern potters. It has an earth floor—probably the best foundation for standing work—and two windows.

His clay is dug and hauled for him from a brick company pit four miles away. Since it comes from twelve to fifteen feet beneath the topsoil, it is free of gravel and newly deposited organic matter. In Gerald's opinion it is a fine, plastic stoneware, good enough for his nephew Jerry Brown to haul from Mississippi to Alabama. Gerald's supply is dumped outside the shop.

> I bring it into the shop in a wheelbarrow as I want it, dump it into my soak pit [an old bathtub sunk in the ground]. It soaks over night then goes into the vertical clay mixer that me and my nephew made. It's got a shaft and two steel knives, one in the bottom and one on top, and steel wire in those knives on

Albany-slip glazed churns (five-gallon and miniature) made by Gerald Stewart.

Churns made by Gerald Stewart drying in the sun.

each side The clay turns out at the bottom. It turns real slow, so the clay doesn't warm up

His flat wedging board is covered with canvas. He weighs and kneads the clay, then rolls it around into a ball, "just like you do mixing dough." He built a large crib around the wheel and leans his hip against a board attached to one side—a carryover from the treadle-wheel backboard.

The wheel is built out of the back end of a car. There's your axle going out—put your big pulley on it—and here's your electric motor—put a little pulley on it. By changing pulleys you can vary the speed [see illustration, p. 51].

Actually, however, he does not change the pulleys, but rather runs the wheel at one speed, taking each small pot off the wheel as it is turning. His gauge is a pointed stick, which he pokes through a slot in a larger piece of wood; it is held firmly to the wood with a C-clamp. To ensure a standard size and fit of lids on churns, he has cut ribs of wood, one for each size churn, which he inserts to measure the flange where the lid will rest while he is turning the piece. Lids are turned to match various churn sizes with the aid of a flat, notched measuring stick. Although Gerald makes churns of up to five gallons, most are of the three- and four-gallon size, the latter requiring twenty-two pounds of clay. He also makes cuspidors, toy churns, and unglazed flowerpots. The ware is usually dried in the sun.

Good hot sun and kinda windy days, it take 2½ days to dry the churns. I put them out right away and put handles on them out there.

Outdoors, at a metal table near the ware boards, he mixes glaze into which he dips

the raw pots, sponging glaze off the rims and bottoms. The pots are then left out to dry again.

While Gerald currently is rebuilding the back of his old kiln to shorten the ware bed by half, he has been firing in an electric kiln. His tunnel kiln (seven feet wide by eleven feet long and four feet high in the center of the half-circle arc) was built of common red brick made with a mortar of red clay with salt added to melt the clay and weld the brick together. The kiln interior is entirely glazed over. When he first built the kiln he packed dirt several feet deep against the walls with a maul and braced this earth bulwark with a wall of planks supported by creosoted wood posts. To support the kiln walls, metal posts were sunk in the ground through the packed earth and tied together with metal cable.

Now the way they used to make the kiln arches, they wouldn't stand up too long. They laid the brick up single. I turn mine edgeways [making an eighth-inch thickness], and I cut the wedge brick where the arch turns.

Pots are stacked in the kiln on a bed of sand straight up, foot to mouth, "so they'll get a little air, won't smother." For several years until recently, he burned this kiln with a combination of natural gas and wood for a thirty-two-hour firing to 1,260 degrees Celsius (C/10). First he raised it to red heat with gas, then he burned pine and oak slabs as well as gas for the last fourteen hours. After loading the kiln, he bricked up and daubed the firebox entrance, leaving a small sixteen-inch opening at the top. This opening was covered with propped up sheet metal, set aside only to stoke the firebox. When the firing was finished, he sealed this stoke hole and covered the chimney. Earlier, when he burned only wood, he used three low fireboxes extending from the kiln face for preheating in the fashion of an old Stewart family kiln and the Jerry Brown kiln (see diagram and illustration, p. 69). He removed the fireboxes when he added gas burners. He fires the shortened kiln with gas because it is difficult to get wood and cut it. He says firmly that he will be glad to stop burning with electricity when the alterations to the tunnel kiln are complete.

Gerald works on custom orders and sells only from his shop.

People come here from everywhere—New York, California, Washington—and from nearby, too. They come in and want me to make them something. People near here know I'm not going to be in the business too long and they want a churn. I've stayed in it all the years because I like it. I like doing anything with my hands.

Gerald Stewart Pottery
Louisville, Winston County, Mississippi
Stoneware; local clay
Albany-slip glaze
Tunnel brick kiln; gas; 1,260°C (C/10)
Churns, pitchers, mugs, beanpots, cuspidors,
 unglazed flowerpots

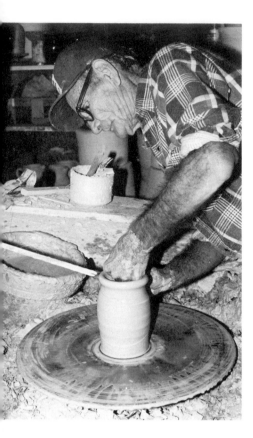

Gerald Stewart turning a miniature churn.

Unglazed Horticultural Ware

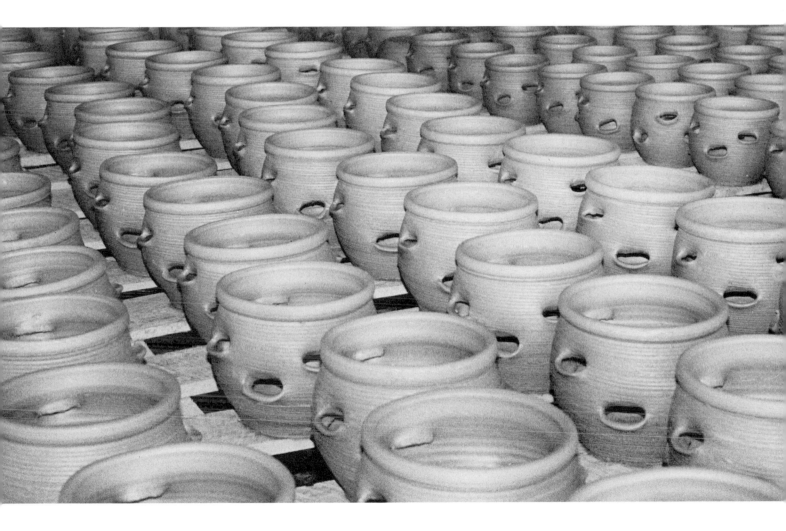

Strawberry jars. Wilson Pottery, Alto, Ga.

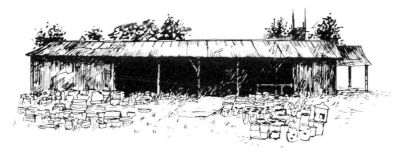

Boggs Pottery

The Boggs family has made pottery in Alabama for more than 150 years. By 1831 the Boggs & Pitman Pottery was operating in Rock Mills near the Georgia line. The owner of the present Boggs Pottery, Wayne Boggs (born 1941), is a sixth-generation potter. His father, Horatio Boggs (born 1912), worked in Rock Mills where he was born and at several potteries in Alabama, including a pottery built in 1925 by Hogan Tatum (located on the present Boggs Pottery site, near Montgomery). Horatio married Hogan's daughter, Sara Nell, and bought the shop from him. His father-in-law and father, James Andrew Boggs (1872–1961), worked for him as turners at the family pottery. Such marriages between southern pottery families occurred frequently and served to consolidate family skills and fortunes.

The shop produced Albany-glazed stoneware, burned in a round, coal-fired kiln (see diagram, p. 74). The kiln once burned well but now requires too much labor and fuel to operate economically. The kiln walls are four-bricks thick, and, Wayne observes, "look how much fuel you have to use just to heat the bricks." The common red brick used to build the kiln was made in Montgomery of the same clay the Boggs family have used to make unglazed pottery since 1945. While the old kiln held twice as much ware as the one now used, it had a seven-day cycle, the new kiln can be fired every third day.

> We would load the old kiln during the day and [at] about five P.M. start fires in the bottom of three fireboxes. At three A.M. next morning we'd light fires in the bottom of the other four fireboxes and burn them until late that afternoon. Then we'd move the fire to the top part of the fireboxes onto the grates, fire it once an hour all night and into the next day. Sometime that morning it would be done.

Some thirty years ago Horatio Boggs bought a clay pit near the Montgomery brick mill to ensure a supply for the production of unglazed gardenware. About ten years ago the state of Alabama decided to build a road through the land and bought it from him. Before the highway was constructed, two-hundred truckloads of clay were dug out. The pottery uses 150 tons each year. At this rate, their supply will be exhausted in a couple of years. They are not worried, however, since much of the slightly rolling Alabama land covers good turning clays.

To process the clay, a tractor front-end loader dumps a batch from the large, weathering pile into a pick-up truck. The truck is then driven into the shop and the clay is soaked in the truck bed. From that height it is easily shoveled into the mixer.

> The mixer I built has both a vertical and a horizontal shaft in it. We throw the clay in the top of the vertical part where it is mixed and pushes itself down to the horizontal part and out. Then we set it down on pallets and cover it. When we get ready to use it, we run it back through a regular pugmill and temper it. Depending on who wants it and how big of a piece they are making, we add water to get it to the right softness.

They grind gritty clay in a dry pan crusher and strain it before wetting it down.

Ralph Miller, a cousin of potters Hendon and Norman Miller who formerly operated the Miller Pottery at Sprott, Alabama, has turned for the Boggs Pottery for thirty-five years and, at age seventy-five, still works part time to make the larger

Earthenware bird jug made by Wayne Boggs.
Photograph by Mickey Leapley; courtesy Randolph Technical College.

Wayne Boggs; note clay mixer in background.

Beehive kiln (no longer used); note coal in foreground.

pieces. The smaller pieces are turned by Wayne and his nephew Malcolm Boggs. Although Wayne grew up working around the pottery, he has been turning only since 1981. When his health allows, Wayne's father is at the wheel turning up to ten-gallon jars, he claims that working in the shop is the best therapy for him. As is the case with many potters, the turners work best when accommodating orders: for example, before my visit in 1982, an order of fifteen hundred three-pound pieces had been turned and dried in just two days. In addition to the turners, two other men help in preparing clay and loading the kiln. The turners rarely work at their wheels more than three days a week.

The shop—a metal building on a concrete foundation—is a large work space of eight thousand square feet. Clay is processed at one end; the kiln is at the other end, where pots are also stored; the wheels and drying racks are in the center.

Wayne built his wheel in a sturdy frame with a large crib. To change the speed of the wheel, he varies the electric voltage by means of an a.c.-d.c. converter. In his opinion this electrical system controls the speed of the wheel better than the standard mechanical system. In most large production potteries advanced technology is used alongside simple manual processes. For example, although the turning speed of Wayne's wheel is electronically controlled, he measures the height of a series of pots by positioning the point of a sharpened stick of wood held in a chunk of soft clay.

The new kiln was built by an incinerator company in Baton Rouge in 1976 when ceramic fiber was first commercially introduced. The fuel system had to be modified because the blowers on the burners provided by the manufacturer did not supply enough air to burn the gas properly. This resulted in an atmosphere reduced in oxygen content and therefore unable to reach the proper temperature. To remedy this, Wayne cut holes in the kiln above the burners and added two small blower fans.

The firing schedule is the same in the new kiln as it was in the old one, only

shorter. They set the kiln, then turn the burners on low at five P.M. By three A.M. the next morning, moisture has evaporated, and the temperature begins to rise more rapidly to 1,040 degrees Celsius (C/05–C/04), which is reached around five P.M.

Unglazed gardenware is produced in assorted forms, including a gourd-shape house for martin birds. It is sold to nurseries, garden centers, and hardware and grocery stores. A large local factory, Cafco, uses the small clay containers to make dried flower arrangements, which are then sold to Sears Roebuck and Company and J. C. Penney Company, Inc. Using a Boggs pot as a model, in 1983 Cafco began producing the containers in the Philippines. The pots are made abroad and shipped back for less than half the cost Wayne would have invested in making the same pieces.

Marketing disadvantages and competitive overproduction of certain types of gardenware have led Wayne to consider diversifying his production. He wants to cast both earthen- and stoneware and is now exploring the possibility of using a ram press to make open shapes, such as platters.

> *Hand-turned production is too limited. If your potter gets hurt or something happens to him, you're out of business. Molds and machines just take an ordinary person to learn how to run them.*

New stoneware would include churns and pitchers finished in a traditional way in brown (Albany slip), brown and white (Albany slip and Bristol glaze), and white (Bristol glaze) with blue rings.

Wayne continually assesses both the pitfalls and prospects of a changing economic base, facing decisions of the same nature as those his father confronted forty years ago. He would like to direct production in his small plant to a variety of ware, thereby securing its future.

Boggs Pottery
Prattsville, Autuga County, Alabama
Earthenware; local clay
Unglazed; some local impressed banding
Rectangular, fiber kiln; gas; 1,040°C (C/05 C/04)
Planters, strawberry jars, cactus pans, kettle pots;
 gourd-shaped birdhouse
See also E. Henry Willett and Joey Brackner,
 The Traditional Pottery of Alabama

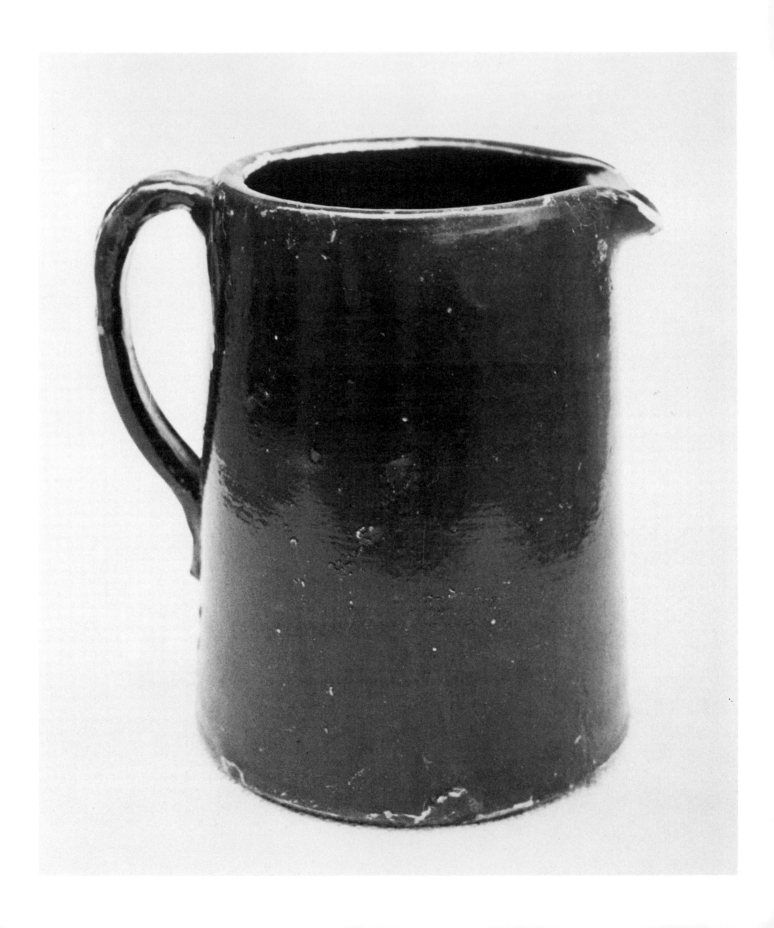

Connor Pottery

Albany-slip glazed pitcher made by Howard Connor.

The Connor pottery began with Charles Tipton Connor (1878 – 1954), father of the present owner, Howard Connor (born 1923), who tells how it started:

> My granddaddy was a ship builder in Saint Louis. My grandmother had a railroad boarding house. My daddy ran away from home when he was seventeen because they wouldn't let him work at a pottery. See, his right arm was crippled. When he was born that arm was pulled, and his family didn't think he could ever learn to turn. But it was crippled just right to fit a piece of pottery. He came to Holly Springs, worked in a pottery there, and got a chance to learn on the wheel. A man named Anderson owned that shop once, but potteries back then would change hands quite a bit. They were like hillside sawmills—scattered around the countryside. Sometimes these small southern potters had their kickwheels out under a shade tree.

Charles Connor did not stay long at Holly Springs. His son says, "He hoboed all over the country working a half a dozen potteries in Tennessee and Kentucky, Texas and Oregon." He helped build the first big beehive kiln at Marshall Pottery in Texas and then stayed ten years, managing the pottery for S. H. Ellis. Howard was born in Marshall.

> My mother used to carry me to the pottery—I guess to entertain me while the other kids were in school. She'd kick the old wheel and sit me up on the crib [frame around the wheel head], and I'd play with it. From then on I never did stop. Once I made a little seat where I could reach the wheel and make the little pieces he was wanting me to practice on. When he come in you'd think I'd a-hit him, he was that upset. He said, "You get off that wheel now and tear that seat down." See, he didn't want me sitting to turn.

Harold settled down to serious turning when he was twelve. He began by making candleholders and went on to taller pieces to learn "the knuckle draft and the rib draft." His father kept him on each shape until he mastered each draft and could pull up the wall of a shape evenly.

The elder Connor had built and sold potteries and turned for others for forty-five years before he settled with his family in 1940 at the site of the present pottery in north Mississippi, close to Tennessee. He had always made utilitarian large ware glazed with salt and, more frequently, with Albany slip. Howard and his brother Alfred worked with their father. While they were in the service during the Second World War, he was unable to operate the home shop. On their return in 1946 he was eager to start again.

> [My father] wouldn't let me rest when I come in. He had a little old raggedy building out there and kept saying, "Let's go back down there." I did and been in it ever since. The only thing you could sell was what you made. He wouldn't let us handle a piece of boughten merchandise [which other potteries had started to sell]. He told us, "Don't get big, stay small. I've been both places—big and small. Your best way is to stay small." He died in 1954, and me and my brother got a taste of getting bigger.

Howard and Alfred enlarged the pottery, employing at one time thirty-five peo-

ple to make jiggered, cast, and turned ware. After 1948 the Connors principally produced unglazed patio pots, urns, jars, log planters, and other flowerpots. In 1960 they began making charcoal burners on the jolly wheel (jigger). A limited production of glazed stoneware was continued until 1965. During their years of potting, the Connors have used two glazes on the stoneware: first Albany or Michigan slip; then a white (Bristol-type) glaze made of feldspar, Spanish whiting, white lead, and ball clay. Some items were glazed with both white and brown glazes. They processed local clay in a screening ball mill, which they designed and built, and used a slip pump to glaze the interior of open shapes. To maintain increased production, Howard in 1959 built a second large beehive kiln, after the design of those at the Marshall Pottery. Still standing but no longer in use, this kiln is eighteen feet wide (see diagram, p. 74, and illustration, p. 75).

> *The [three-foot] walls are made of just regular old mill-run brick. We thought the thicker the walls the more heat you were saving, but the thicker the walls the more heat you use. For a thirty-foot kiln, now they use only a fourteen-inch insulated brick, and that's all you need.*

To build the dome of the round kiln, Howard used a gauge on a center pole with a movable arm to swing full circles, raising it at each course of brick. The dome rests on "skew" bricks, cut diagonally, one side resting flat on top of the wall and one side slanting to begin the curve of the dome. Metal bands surround the kiln to offset heat expansion and support the weight of the dome. Sand is added to the clay mortar to raise its melting point.

> *This kiln was built mostly of scrap. My finances was short then. But, now, this old kiln here would last another one hundred years, [if] you keep patching it.*

Glazed ware was stacked at the center of the kiln above tiers of unglazed pots on fireclay shelves (12 by 24 by 2½ inches) made at the pottery. The outer rim was set with large birdbaths and bowls with a loose, open stacking of lighter weight pots on top of them. With a six-foot stacking height, caution must be taken to prevent raw ware from breaking under accumulated weight. Nearly eighty-two hours and nine tons of coal were required to burn this kiln to 1,250 degrees Celsius (C/9) and five days to cool it. When it was in full fire, two big shovelfuls of coal were put in each firebox every twenty minutes.

> *We had shifts of men working it around the clock. Cause you'd last about what . . . six hours or so? Not over two wheelbarrow loads of ashes was left in the six holes [fireboxes] out of nine ton of coal. It was an Alabama soft coal. Probably if we'd had that Kentucky hard coal, would have used less coal and maybe less time, because, see, that soft coal, it burns fast. But at that time, you didn't have to watch [expenses] like you would now.*

The pottery building burned down in 1967, and although it was rebuilt the next year, handmade ware was gradually replaced by concrete pieces, and pottery production dwindled. Against the advice of his father but in keeping with the times, Howard made overly ambitious plans for the pottery. He had looked to the large production potteries in Ohio as models. Unable to finance a monorail drying system or purchase other advanced equipment that would enable him to compete with them, he slowed down and finally stopped pottery production in the main shop. He has fired handmade ware in the big kiln only a few times since the plant was rebuilt but has continued small-scale production of charcoal burners in the big plant and makes Albany-glazed pottery, using an electric wheel and kiln. He has considered quitting altogether several times, but he likes to make pottery and to demonstrate turning the old shapes.

A charcoal burner, a portable heater popular in the South during the nineteenth

Howard Conner

century, was widely used to keep irons hot when laundering outdoors or, rather unsafely, as indoor space heaters. More recently it has been used for outdoor cooking or by waterfowl hunters as a heater in a blind. The vessel is made of two thick walled, clay shapes: a shallow bucket with holes cut throughout the bottom and a pan into which ash drops. Around the two forms is fastened sheet metal to which a metal bail handle is spotwelded. The thick clay wall absorbs and radiates heat so well that it requires very little charcoal for maximum heat production.

In his house Howard has an old churn used for fifty years by his wife's grandmother. He bought it from her when she was ninety-five years old for ten dollars and started saving pennies in it.

I used to hear old potters sit around and talk. They said when they made a churn of money they were going to quit or die. I don't lack much of having it full.

Connor Pottery
Ashland, Benton County, Mississippi
Stoneware; local clay
Unglazed; Albany-slip glaze, with frit
Commercial kiln; electricity; 1,190°C (C/6)
Jugs, jars, pitchers; unglazed charcoal burner

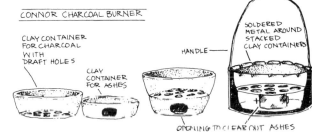

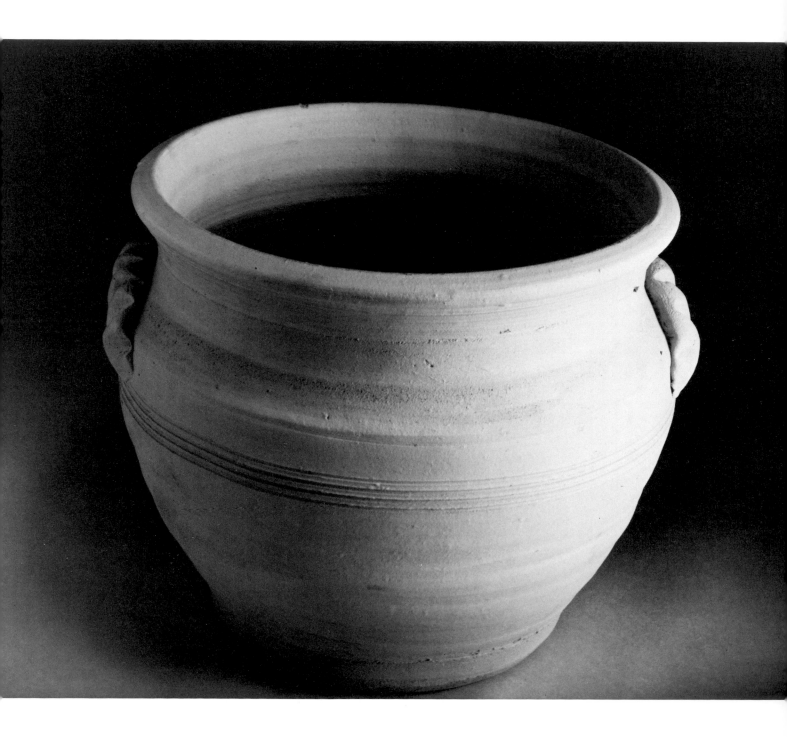

Craven Pottery

Earthenware garden pot made by Mike
Craven.
Photograph by Earl Austin; courtesy Randolph
Technical College.

The Cravens are one of the oldest pottery families in the South. Potter Isaac Henry Craven settled in the north Georgia Mossy Creek area in the early nineteenth century. His sons did not continue in the trade, but a grandson, Robert Craven, built a shop near Gillsville, and a great-grandson, Billy Joe Craven (born 1947), in 1970 set up the present Craven Pottery southeast of Gillsville.

Joe is an intense man, an aggressive entrepreneur, and an excellent turner. In his first year of business his gross income was twenty-five thousand dollars; twelve years later, gross sales from his total enterprise approached six million dollars. Handmade pottery accounts for only about fifteen percent of the company's sales yet earns a rather staggering $750,000. For pleasure Joe raises Santa Gertrudis cattle and flies his own airplane.

Joe began work at the Hewell Pottery in 1961 as a laborer, preparing clay and setting the kiln. After work he would try the wheel.

At a point they saw I could produce and started showing me a few things. Carl Hewell taught me most, and the rest I just picked up by working. But I've been around pottery all of my life because my daddy bought pottery in the fifties and peddled it from Miami to Washington, D.C. There were five potteries in Gillsville then—Ferguson, Hewell, Holcomb, Pardue, and Wilson—all making the same unglazed ornamental pottery we're making today.

The Craven shop is one large, high-ceilinged room of 14,500 square feet, with metal walls and concrete floor. No space is wasted, nothing impedes the rapid flow of pots as they move through the various production stages. Clay processed in a far corner of the rectangular building is directly accessible to a row of turners at their electric wheels. Drying racks stand between the turners and the two large kilns. At the entrance is a small storage area for some finished pots. Despite its size, Joe considers it a "little" shop.

We're heating and cooling a very small area, so we keep our overhead down. The working hours for the turners are staggered. Two of our potters start at four A.M. others at six, and the rest at seven and eight A.M. Every day there are seven turners, and there are two more part time. Fourteen people altogether work in the pottery. We have a continuous process. We finish every pot we make every day, regardless of the weather, in the sixteen hours. We figure by that time we have made a trailer load of pottery.

Behind the building is a hill of earthenware clay. Joe owns two tracts of land with a large reserve of clay on them. Men and equipment are hired once a year in the dry season to dig clay with a backhoe and bulldozer and haul two to four thousand tons of clay to the pottery in dump trucks.

We don't use that much in a year—we keep building a reserve inventory. Probably have six to seven thousand tons accumulated over twelve years by hauling a little more than we use every time.

To facilitate rapid drying without cracking the clay, a commercial coarse stoneware clay is added to the local clay. The system of preparing clay for turning—crushing, wet mixing, and compacting—is entirely automated.

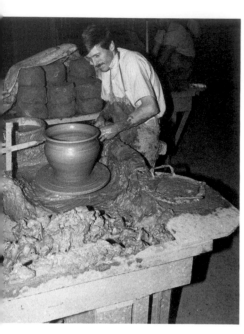

Mike Craven turning a planter.

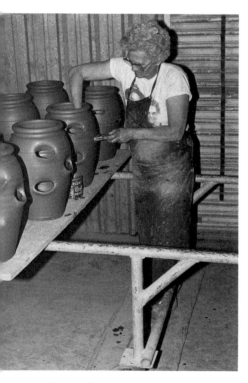

Mamie Craven cuts openings in strawberry jars with a tobacco tin.

Joe studied mechanical engineering at North Georgia Technical School. He has designed and had built most of the equipment used in the shop. The wheels and the feeder hopper, which holds eight tons of clay, were built in a local machine shop according to his specifications. At the pottery were made the crushers, conveyer, clay grinder, and pugmill, a crossbreed of two types of pugmills. Of his hybrid machine, Joe says:

There is not a company that builds one for our application without a vacuum or with the capacity we need. It will run twelve tons of clay an hour, but we can't use that much. We have stationary as well as revolving teeth (seventy-nine knives) in this mill that rip the clay apart and a tapered—what we call a "butterfly"—end that puts it back together by compacting the clay right much. We turn it about nineteen rpms, which is reasonably slow. Keeps the clay at a low temperature, and therefore you don't kill your bacteria that make the clay plastic. On the end of our pugmill we have an automatic cutter, operated off electric clutches and brakes. By a measuring device we can get real equal weight on each size [that is cut], and we turn a dial to change sizes, with a tolerance of one eighth of an inch. A little wheel measures the length of the extrusion coming out of the mill. It's fed into an electrical counter. As the counter reaches a certain number, it activates the clutch, throws it in gear, and crops the wire through the clay, and the brake stops it. Counts to the number again and does it again.

They do not deair clay because it tightens the body, making it less maneuverable, harder for the turners to manipulate and slower to dry and fire.

Joe claims that the automated equipment minimizes labor. One person continuously prepares clay to serve all nine potters. Each potter has a table that the clay preparer rolls to the pugmill, extrudes the proper amount according to the size needed, stacks the clay on the table, covers it with plastic, and rolls it back to the potter. In 1981 average production for the shop was twelve thousand gallons a week; a year later the average was fifteen thousand gallons a week. (Some weeks production might be as much as nineteen thousand gallons, others, as little as thirteen thousand.)

The ware is mostly large, from three- to ten-gallons, and is turned with skill and dexterity. Such work requires considerable strength and stamina, and the turners are mostly young men, including Wayne Hewell (nephew of Harold Hewell) and Mike Craven (Joe's brother). Each potter turns six to eight hundred gallons of ware a day. Women do the finishing work, including handling and cutting strawberry jars. Joe's mother, Mamie Craven, and Mike's wife, Vicky, work daily in the pottery, while Joe's wife, Karen, who came from the local Brownlow potting family, works in the office.

On boards across the large midsection of the shop is placed turned ware to be finished, handled, and cut. The strawberry-jar openings, for example, are cut with a Prince Albert tobacco tin, with the cutout piece of clay removed and the rough edges smoothed over with a wet finger. The pots are then placed on tiered drying racks, which are moved continuously closer to the kiln as the pots are drying. Large fans move hot air off the drafts at the top of the kiln and through the pots to dry them. The largest pots are dried for three days before they are fired in the kiln. Usually a pot is ready to sell four days after it is made.

Pots are fired daily (except Sundays) in a new envelope fiber kiln capable of handling present needs as well as future production expansion. The fully automatic firing cycle is started by pressing a reset button and burns the kiln to 1,005 degrees Celsius (C/06).

We start our kiln at seven thirty in the morning. It goes onto high fire after six

hours. In two more hours it's up to temperature, then we hold it on a soaking cycle for two more hours, which keeps the heat plus or minus ten degrees by automatic switches cutting the gas on and off. We soak it because our pottery is pretty thick and needs soaking to "cook" all the way through. Otherwise there can be "coring," which is a center of charred clay [carbon] between the exterior and interior surfaces of the clay wall. We let the kiln cool for twelve hours before reloading, but you can move it in three hours. I've done it in two. Only the load has to cool.

Planters in various sizes and shapes comprise the majority of Craven ware. The standard size is a five- or six-gallon planter; the largest pot is a ten-gallon strawberry jar. The ware is priced—as well as turned—by the gallon.

Most pottery is principally made for wholesale and is transported from the kiln to one of the company's seven large trucks. The business also consists of items manufactured in other buildings at the plant, such as concrete gardenware and potting soil, and items purchased elsewhere for resale, including an extensive line of housewares and imported Italian terra cotta pottery. Joe wholesales to distributors, chain stores, retailers, and garden centers throughout the South. He is building a new manufacturing and distribution center nearby on eighteen acres of land bordering Interstate Highway 85. There he plans to make churns and jugs of stoneware clay, glazed with Albany slip.

I think the demand is there. We'll filter the cost analysis versus the demand, and then we'll decide. We're interested in dollars and cents basically. Just because grandpa done 'em that way doesn't make us want to do 'em that way. We're changing, and we're making it work. The turnover—as far as potters go—I have never lost one. [We have] what we think is a fair salary, an insurance program, a retirement program, and a profit-sharing program. It's really a good little company to work for.

His employees say that Joe is the best turner of them all, and, although he is the owner, he still feels he is one of them.

I like pottery. I like to make pottery. That's my life. I got kind of misplaced in being the proprietor here. I got moved out of the shop. I know and understand pottery and clay. Business I don't enjoy as much. I don't have much chance to get on the wheel. I turn an average of two days a week, maybe less.

Craven Pottery
Gillsville, Hall County, Georgia
Earthenware; local clay
Unglazed
Envelope fiber and brick shuttle kilns; gas; 1,005°C
 (C/06)
Planters (standard 5-6 gallons), strawberry jars
 (up to ten gallons), Rebecca pitchers, urns,
 birdhouses, birdfeeders
See also John A. Burrison,
 Brothers in Clay

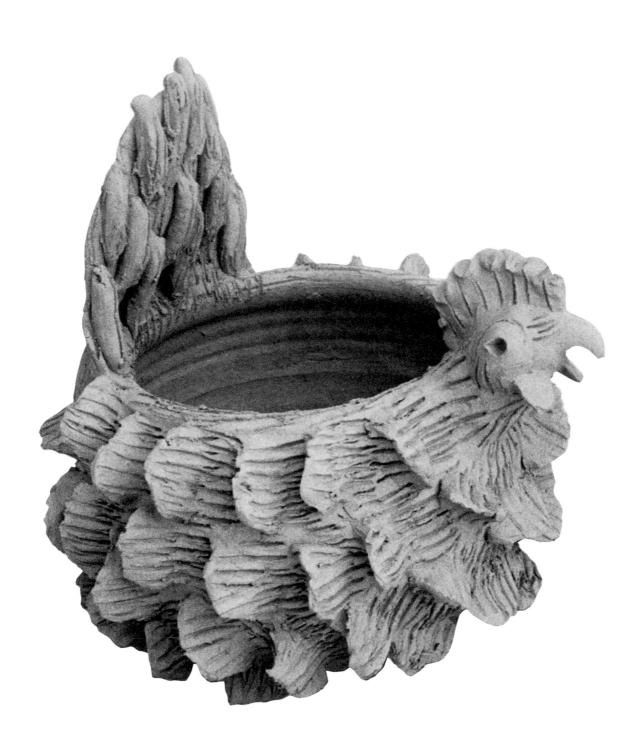

Hewell Pottery

Earthenware rooster pot made by Grace Hewell.

Hewell Pottery in Gillsville, Georgia, in the rolling foothills just south of the Appalachian Mountain chain, produces a variety of unglazed earthenware forms for the terrace and patio. Ada Hewell, the elderly widow of Maryland ("Bud") Hewell (1891–1964), traces their heritage:

> Bud's gran'daddy, Nathanial Hewell, was a pottery maker [as was his father, Eli D. Hewell (1854–1920)], and I have great-grandchildren doing it now. They are the sixth generation. I've heard them say the Hewells came from New York and from overseas somewhere, but I don't know where.

The pottery is very much a family business, with Ada and Bud's son, Harold Hewell (born 1926), the present owner; workers include Harold's wife, Grace; their son Chester and his wife, Sandra; their children, Matthew and Nathaniel; Harold's brother Carl; and a nephew Kirk.

Harold's mother, Ada, recalls that after her husband worked for the Meaders family in Cleveland, Georgia, and the Johnson Pottery near Anderson, South Carolina, they returned to Gillsville:

> We come back here some fifty years ago and put up a log shop about twenty-four feet square. Nobody but my husband and my boys worked in the pottery for a long time—later there were Hills, Holcombs, and Cravens. We used to have an outside man that ground clay, stacked it up in the shop. They made churns, jugs, pitchers, chambers, and flowerpots. The churns and such were glazed in Albany or a glass glaze. He'd get the broken bottles at the Coca Cola place and beat the glass. Then we'd sift it—just like your meal—and put it with ashes and clay to make the glaze. He turned on a treadle wheel—made eight- and ten-gallon churns, but more six- and five- and three-. He made the first wheels that was pulled by electricity, which was so much easier on them. The flowerpots were made of the same stoneware clay but burnt at the upper end of the kiln, where they just had the red color to them. I made balls for them, handled, but I never tried to turn. You couldn't work more than two or three days before you had to tote it out to the sun. You really had to move if it rained. He burnt most any kind of wood, but he'd blast off with the rich pine. We had that rich pine wood to cook with before we had an electric stove.
>
> They stopped making churns in the early fifties. We kept our old churn and the cow till our children were all married off, then we sold the cow and went to buying milk like everybody else. Bud had made vases when we were in South Carolina, so he made some when we moved back here—glazed them only on the inside. Some customers painted them.
>
> We made lots of syrup jugs for Georgia syrup. Way back then they made face jugs and the jugs you tote on your arm [ring jugs]. When my husband was a kid they made their own dishes, "dirt dishes," just glazed inside, but they never made the small tableware up here. Ain't nobody likes to turn little, bitty stuff, is there?

Clay was ground with a mule at the old pottery. When the Hewell children were growing up they would "grind every day until maybe sundown from right after

school broke." The utilitarian pottery was Albany-slip glazed and burned in a groundhog or tunnel kiln. Harold remembers his first introduction to the trade:

> *When I was a kid they carried all the family into the shop, just a big log cabin. You just played around, and when you got big enough you began to help. I was making small things when I was ten. But it wasn't till after military service that I came back and really started learning.*

Harold worked with his father until he retired. In 1967 he built a bigger shop. It is long and narrow (35 by 150 feet) with an earth floor sloped downward at the kiln end. Windows light the work area and help warm the building.

Harold not only schedules the work of others and maintains an efficient operation but is himself the largest producer. His day begins at seven thirty A.M. (or earlier) and ends after five P.M. Some five hundred tons of clay are turned each year.

The clay is dug at two local sites, one containing a red brick clay, the other a finer grained earthenware clay taken from a pit that has been mined for seventy-five years. Harold expects the supplies to last for another ten to twenty years. A small percentage of commercial earthenware clay is added to the local mix to improve turning.

> *This is alluvial clay that over a million years has settled down with sand shifting over it, grinding it down into fine particles. It's usually found in swampy areas, because the runoff brings all the sediment in there.*

A contractor digs the clay with a backhoe and hauls it to the pottery in dump trucks. The Hewells stockpile it outdoors and bring it gradually under the shelter for drying. The dry clay is pulverized in an old hammer mill at the rate of three tons an hour. The clays are mixed as they go into the hammer mill and screened. The screened clay is carried by conveyor belt to the wet mill where it is mixed with water. The wet mill can mix one thousand pounds in five minutes.

Several clay batches are processed in the evening and left covered overnight to cool and restore plasticity, which is lowered by the heating of the clay during grinding. The next morning, after Harold has assigned the turners their day's work, the

Hewell shop, floor plan.

Harold Hewell turning a large planter.

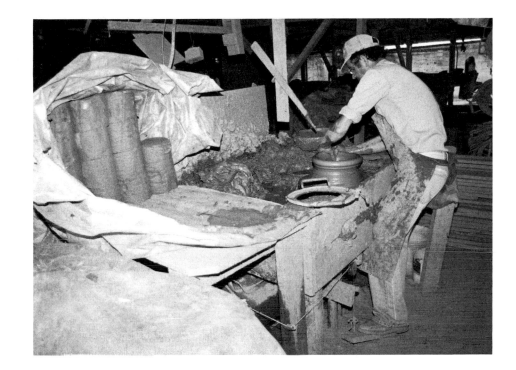

clay man pugs the clay and delivers to each wheel bolts cut to specific sizes. The pugmill has four differently sized heads, one head can put out three rolls at a time. A frame with stretched wires is used to cut the bolts into various lengths. Each morning the day's clay is prepared in 1½ hours and mixed fairly soft to make the turning of large ware easier.

The turner starts with a cylindrical bolt just as it comes from the pugmill; tall bolts are mashed down a little before centering. Harold turns about five hundred gallons (or twenty-four hundred pounds) of clay in a day; Henry and Chester each turn 350 gallons; and Grace makes a quantity of small, up to one-gallon, pots. Two younger men, related to the Hewells, are learning to turn as they have time from other tasks. Harold describes the turning process:

> We have never used ball openers much in this area. In opening we have a bit of a rest that we brace against on the wheel. We just slam the lump of clay on the wheel, center and open it up, true it once, then pull 'em up with an overhand draw [one hand lapped over the other]. As you pull it up [to eight or nine inches], you'll have to turn a little of it loose till you get on up. We're doing it on the right-hand side [around two o'clock], thumbs are inside. From there on one hand is inside, one outside. Sometimes we use a "push-up" [raising the clay walls with inward pressure from both hands outside]. Then we use the knuckle draw, then the chip is used twice, still pulling it up the first time, then refining and smoothing it out. The second time is shaping and might actually shorten the pot a little. When the shape is finished, we do any decorating with rollers made of plastic furniture casters. We have used wood rollers or even spools and cut little indents into them.

Each potter (except Harold) is responsible for finishing the bottoms of his or her pots when they have stiffened. Grace, who does the handling, rolls out rounds of tapered clay and carries them down a line of pots on a tray. First, she scratches an area of the pot on which to fasten the handle and then "just jobs them on." She then

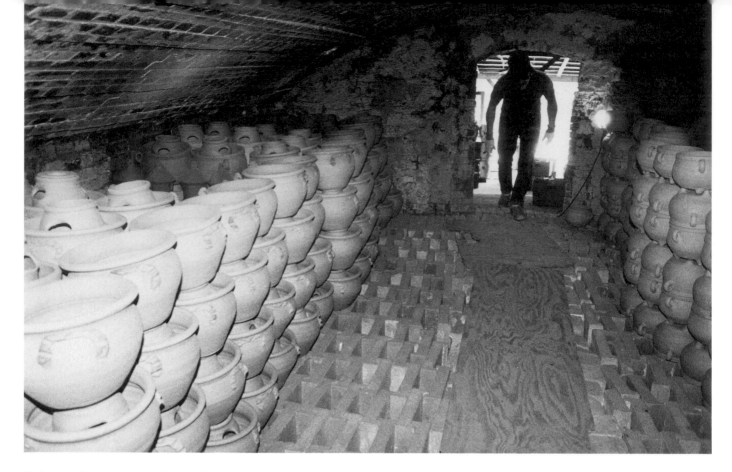

Unloading the rectangular, downdraft kiln.

draws them out and fastens them down. The pottery dries on ware boards set across frames running the length of the room in two rows, filling nearly all the space between turners and kiln. As the pots dry, the boards are pushed further and further down the racks to make space for newly turned pots. At the far end, the dry pots are removed and carried the short distance to the kiln for burning.

The rectangular downdraft kiln has four corner chimneys and entrances at both ends, an unusual if not unique construction. Pots are set in from the near end and removed after firing through the far end and set under a shelter to await packing. When the kiln was first built in 1967, it was fired with wood, later with no. 2 diesel oil, and since 1972 with natural gas. In a day's time, the interior is stacked solid with pots, with Rebecca pitchers two deep leaning against the walls.

To reach 930 degrees Celsius (C/09), the firing cycle burns exactly twenty-seven hours, with heat measurement read by a pyrometer. It is heated slowly until the interior is cherry red and then fired rapidly.

Chester generally takes care of it till midnight. Then I go down and sleep by the kiln and get up with it once or twice until six A.M. It's not too bad.

The kiln holds five thousand gallons of ware and is fired once or twice a week. A crew of five loads the kiln, mixes clay, or packs the trucks.

Grace Hewell (a cousin of the nearby Wilson potters) describes how she became involved in the pottery:

I just married me a job in 1949 [at age sixteen]. I went to work just as quick as I come home from my honeymoon, and I loved it. I learned to finish. Then one day I decided I wanted to turn. Harold said, "You can't learn to turn." I said, "Well, I don't know, I might can. I've learnt everything else I wanted to." So I got on the wheel. First day I made two dozen, next day three dozen, next day four dozen. Next thing I knew they had me on the wheel making 'em in a big way to sell. Ever since, been making pots, cutting strawberry jars, handling any kind of pot, lugging washpots [putting lug handles on them], cutting jack-o-lanterns. There's nothing in the pottery I can't do, even fire the kiln. I turn up to one-gallon pots.

Nathaniel Hewell about to scratch a design in his pot.

I'll be making three hundred quart-size strawberry jars today, then cut three holes in them, rub the bottoms. This is the slowest item I make. Usually I take pots off while the wheel's going full blast. But with these I have to stop it and take it off with the clamps. One day I made 1,070 jack-o-lantern hats, cut 120 gallons of strawberry jars and 40 birdfeeders; handled 40 pots; cooked three meals; swept my floors; and went and jogged three miles. I don't sit down unless I'm macraméing. Never turn on the TV. The big boss, Harold, tells me what to make by the day—he don't want me to get the fidgeties overnight, I reckon. Everybody asks me what kind of dope I'm on that I have so much energy. I don't take no kind of dope or medicine—only for my ulcerated stomach. I just eat my chocolate bars and go right on.

Chester and Sandra and their two children, Matthew and Nathaniel, live about a mile from here. We've got a hundred-acre farm, and we gave them part of the land, and they look after all our cattle over there. I enjoy it more working with the whole family. You just feel more secure and you're part of something. There are my grandchildren coming along, learning. Matthew gets up every morning in the summer and comes to the shop rather than to stay at home. He's eleven, and he made 3,300 pots this summer. I feel very fortunate to have my family working with me. There's so many families this day and time that don't get along. I feel just like God gave me something real good.

The Hewell Pottery catalog contains forty-four shapes (mostly planters) in sizes up to five-gallons. They make six-, eight- and ten-gallon sizes, but not as stock items. The shapes are named for their style (Aztec Strawberry Jar), their resemblance to some organic shape (Pineapple Pot), or the process used in decorating them (Thumbprint Cactus Bowl). Strawberry jars are most in demand. Next in popularity is the jack-o-lantern (originated by Chester) and then the washpot. For transport, heavy plastic is shrink wrapped around pallets stacked with ware. Most of the ware is sent east to distributors from Massachusetts to Florida and some as far west as Missouri.

Harold is building a larger, more efficient fourteen-thousand-square-foot plant, designed to accommodate increased production and eliminate the moving of ware by hand. There will be two shuttle kilns, either one can be fired daily.

We'll roll the ware right up to the kiln on rolling racks and directly load the ware car, which then rolls into the kiln. Now we have to skip one day before unloading, and we can't bring it out that fast by hand. We'll have to put on more potters. We're going to use the local young men who show good interest.

In the new plant, Grace and Chester are eager to try a little Albany-slip glazing (adding a frit to lower its melting temperature) and will fire it on top of the stacked terra cotta ware. Glaze goes into the kiln as a powder adhering to pots. At the height of the fire it is a thick, viscous melt, which hardens to a glass on cooling. A potter can only see the glaze in this state by looking through a peephole into the white heat of the kiln interior. To see glaze in its melt is so ephemeral and exhilarating an experience that its absence is a loss to potters who burn only unglazed ware.

Harold and Grace both express hope for the continuity of their family's traditional craft.

I heard Matthew telling Nathaniel last night, "Nathaniel, don't you know that one day Granny and Paw-paw are going to get old and die, and we're going to have to run the pottery building? Now you're going to have to get busy and start learning how to make some pots." Nathaniel answered, "O.K., Matthew. I'm gonna learn to make pots. I'm just practicing on chickens now. I've got plenty of time. I'm gonna make pots."[1]

Matthew Hewell at the wheel.

Hewell Pottery
Gillsville, Banks County, Georgia
Earthenware; local clay
Unglazed; some with fluted edges and coggled designs
Rectangular, brick kiln, with four corner chimneys;
 gas; 930°C (C/09)
Planters, strawberry jars (up to ten gallons), kettle
 pots; birdhouses, jack-o-lanterns
See also John A. Burrison,
 Brothers in Clay

Note
1. Grace Hewell, interview, courtesy, Eliot Wigginton, director, Foxfire.

Marshall Pottery

The first kiln built at Marshall Pottery in 1895 was a groundhog, made of rock with a brick arch by a man named Rocker from Kentucky, who squatted on what was then swamp land. The pottery did not thrive, and in 1907 its fourth owner signed the property over to Sam H. Ellis (1861–1938), placed the deed under a rock, packed his wagon, and left town. Ellis had emigrated from England in 1893 and plied his blacksmith trade for the Texas and Pacific Railroad shops in Marshall. He had watched the turners at the pottery with interest and cosigned a note with the former owner to borrow money to improve the kiln. He kept the unexpected gift of the struggling business, retained the potters, and rebuilt the kiln. When his children were old enough to help, he left the railroad shop and began the family industry. Three generations and seventy-seven years later, it is the largest commercial enterprise of its kind in the United States, using sixty tons of clay daily to produce flowerpots mechanically. The family also continues the production of hand-turned stoneware. Pete Payne (born 1915), a potter with them for forty-seven years, demonstrates turning in the Old World Store, and fourth-generation Ellises hand decorate some of his wares. In the main factory seven other potters turn stoneware.

Sam Ellis and his sons originally produced stoneware churns and jugs, which they hauled for sale as far away as Shreveport, Louisiana. In some remote towns, eggs—worth five cents a dozen at the time—and ribbon cane syrup were used as currency and were brought back to sell in the Marshall grocery stores. In the "moonshine" area, customers met them at certain crossroads to avoid revealing the location of their stills. Whenever the oldest son, John (1894–1978), departed with a wagonload, he was given fifty cents a day for the care of the two mules and fifteen cents a day for himself.

Atterberry Shannon (born 1904), who began working for Ellis at age nine and continued for fifty-seven years, remembers accompanying S. H. Ellis on wagon hauls. When they stopped to eat Ellis would instruct him.

> He told me to eat lots of the peppermint candy there along with some crackers and then drink as much water as I could. Peppermint candy was different then, because I know for a fact that when you ate it and drank lots of water, your stomach felt like it had had a steak.[1]

John Ellis also recalled working summertimes at the pottery when he was twelve:

> He worked me for fifty cents a day, and he would give me a check. I'd take it home and give it to mama. I'd get the same check back the next weekend, but in the meantime I got a quarter for spending money. When that check got old and torn, it was replaced by another, and that one was circulated.[2]

Atterberry Shannon describes the early days of the operation:

> Everything was kind of crude. All the pots were made of the white clay [stoneware]. Glaze was kept in a wood barrel and strained through a flour sack. Ware didn't always look right, but if it wasn't cracked we didn't let 'em know about that. After a while somebody'd buy it. Used to make a lot of "ant guards," which were a round bowl in the center for the table foot, then an

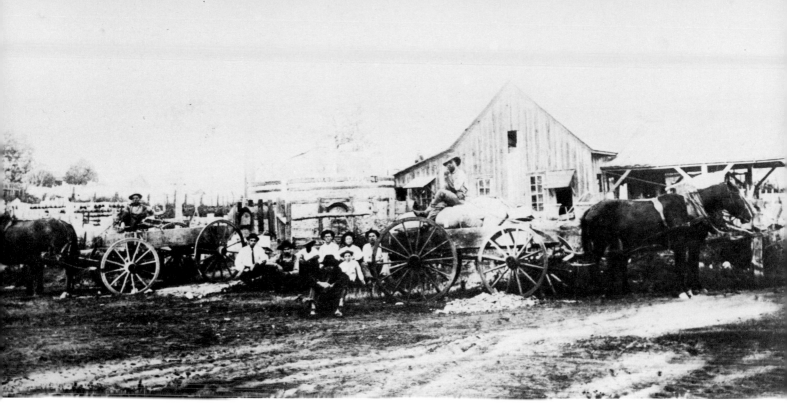

Marshall Pottery, 1908; note beehive kiln
and workshop.
Photograph courtesy Carolyn Ellis Williams.

outside circle for water so the table leg wasn't wet. Made them for beds too. We
made combinettes till bathrooms come in and pushed them out.

In those days, a turner working for the Ellis pottery was expected to make fifty
ten-gallon jars a day and could proudly refer to himself as "a five hundred-gallon
man." Spurred on to exceed even this high rate, John Ellis learned to make one
hundred ten-gallon jars a day; he never learned, however, to make churn lids.
Sam Ellis had eleven turners.

They hadn't become extinct yet. Some mighty good ones would come in here,
but pretty near all of them was whiskeyheads. On the weekends they'd get
the Express. The shipment would come in and they would get on it and they
wouldn't work until about the middle of next week. They were drifters. They'd
work two to three months and then they would go.[3]

The large ware was salt glazed in wood-burning beehive kilns until 1915 when the
pottery switched to Albany and Bristol glazes and to firing the round kilns with nat-
ural gas. In 1911 a fire destroyed the pottery. In the years after rebuilding, produc-
tion shifted with demand. Jugs for cane syrup were replaced by tin buckets, clay
fruit jars replaced by glass jars, and the need for churns declined. Prohibition, how-
ever, increased demand for large homebrew jars and five-gallon jugs for bootleggers.
Later during the depression a return to farming revived the production of churns and
storage jars. In 1940 clay samples were brought to the pottery from a newly dug well
in the neighborhood. The test pieces burned down to a glassy puddle in the stone-
ware kiln. This red clay was earthenware, and, with its discovery, Marshall entered
the flowerpot business in earnest.

Atterberry Shannon pinpoints the turn in the fortunes of the pottery to when
they found this clay, bought an old flowerpot machine, and went into the red clay
business. He claims that the flowerpots were rough and not much good by today's
standards, but they sold.

Bristol glazed pitcher with cobalt
decoration, turned by Pete Payne at
Marshall Pottery.

We didn't have nothing to grind clay with, just washed it, but that one machine
ran day and night. Finally bought some old filter presses in Dallas—made all the
ware look better—both stoneware and flowerpots, and then the place began to
grow.

Atterberry always jiggered, never turned. He claims to be the first black to run a jigger machine in any of the nearby potteries. "At that time white folks was running those machines, black folks were not on them." For twenty-seven years they had been jiggering flowerpots up to nineteen inches in plaster molds, but with the discovery of the red clay they switched to pot machines.

During the Second World War, pottery for farm use was exempted from material and gasoline restrictions. After the war, with production of utilitarian stoneware dwindling in the Midwest, Marshall, and other southern potteries, continued to make what was needed. The popularity of plastic flowerpots in the 1950s threatened their growing flowerpot business but only temporarily. After another fire in 1961, they rebuilt the plant with modern equipment of their own design and the business has grown ever since.

In the 1950s and 1960s Marshall made birdbaths, flowerpots with attached saucers, rabbit feeders, baskets, vases, bowls, twenty-four-inch strawberry jars, ten-gallon jars, and six- and eight-gallon churns. Production of these wares has been discontinued, as it is considered a poor investment of time. Some of this ware was produced in color by adding stains—green, pink, yellow—to the Bristol glaze, and washpots were glazed in black. The stoneware now made consists of jugs, pitchers, cookie jars, churns, churn-shaped water coolers, and spoon jars.

The business is currently operated by the children of Sam and John Ellis. Wesley Ellis (born 1930), son of John, manages the factory, while his sister Carolyn Ellis Williams (born 1926) is researching and writing the history of the family and pottery. Isabel Ellis Mitchell (born 1924), daughter of Sam, and her husband, Shields Mitchell, manage the Old World Store, which handles an extensive line of housewares and hand- and machine-made pottery.

Stoneware at Marshall Pottery is made of three types of clay found in Harrison County and is hauled in and dried under a huge shed. A forklift carries the clay from the pile and dumps it into the chipper hopper, a machine with crosscirculating blades that crumble the clay into two-to-three-inch bits. From the chipper a measured amount is carried by bucket elevator into a liquid mixer in which water is added; the slip is then stirred and piped through a screen into a holding tank. It is then pumped by gauged air pressure into filter presses, squeezed overnight, and removed the next morning in plastic cakes. It is rolled on a buggy to a deairing pugmill and, after pugging, is transported on a cart to the plaster wedging table. Hinged to the wall behind the table is a series of cutters, which can be pulled down by a lever to cut five pugs simultaneously. Each roll is squashed by hand into a ball, and the balls are delivered to tables next to the potters' wheels.

Clay pile

The turners work rapidly with the soft clay. In one hour a turner can make seventy-five to one hundred straight-sided quart pitchers of 2½ pounds of clay. The turners use steel chips with thumb-grip holes; gauges to measure height; sponges, metal lifters, and wood templates to measure churn flanges for lid settings. Beside each wheel is a ware board on which turned pots are placed. The slurry from the wheels is not reused because it contains a high proportion of fine grains that wash into the turning water and change the clay color and consistency. The waste slurry is hauled back to the pit.

Two blue bands are brushed on each shape while it is on the wheel. The decorating slip consists of a body clay with glycerine and cobalt. The spiggot hole for water coolers is cut with an apple corer immediately after the cooler is turned.

Other workers move the ware boards into the drying room, which is behind the row of wheels. When the ware has set sufficiently, handles are pulled and applied by two men who tend the drying room.

At the end of the day, each man's production is examined for correct form and decoration, and ware not up to standard is culled. (Up to fifteen pieces may be eliminated each day for a given potter.) The best potter now is James Alexander, who turns 150 to 170 three-gallon churns in eight hours. The turners are paid by the piece. Wesley Ellis, who manages the plant, says, "they make a real good living at it."

Helpers will step into apprenticeship when there's an opening. Anyone can get into it if he's ambitious. We put them into making balls, then handling. There's always an extra wheel available, and when they get caught up they can practise on it. The potters help them learn to turn. It takes a few years to get the speed. And then consistency is the secret. People call from other towns and states wanting jobs as potters. But they are mostly potters from the north who know nothing about production.

The turned ware is left in the heated drying room overnight. The next day pots are turned over onto small, square, wood bats, and the bottoms are smoothed on a hand-turned wheel. The finisher uses a flat metal tool with a V cut to shape the bottom edge before sponging it smooth. When wood lifters were used, this tool had two wire cutters to eliminate dents on the bottom made by the lifters. The pots are left upside down to continue drying. If the top has not changed color (indicating dryness), the rim is set into a ring, made from a fired red clay saucer with the middle cut out, to hold it straight and prevent warping. A heater with two fans is at the far end of the room, and two open gas burners are in the center of the room. Over three days' time, the pots are moved gradually into the hotter end of the room. When completely dry, pots are stacked on pallets and moved by a forklift, or on rolling buggies, to the spray-glaze area.

The Bristol-type glaze used here since the 1950s, called the "old dipping glaze," is made of feldspar, zinc, borax, whiting, and a liquid gum with water, to increase glaze adherence. The glaze is clear, although it appears opaque and creamy white, the color of the clay body beneath. Glazing compounds are weighed on standing scales and then milled in one of the large ball mills for three to five hours.

Glaze is sprayed on the ware produced in the factory. A single raw clay pot is placed in a raised position on an inverted flowerpot, which in turn is placed on a wheel head. Thirty wheel heads circulate on a moving belt; each wheel head is triggered to turn a full circle on reaching a sprayer, in a kind of automated dance to receive the sprayed glaze. The conveyor belt moves steadily; the wheel heads are set to rotate as a pot passes the sprayers. Two sprayguns glaze the outside of the pot, one sprays the inside bottom, a fourth and fifth spray the inside walls. Intervals between the bursts of spray have been calculated to prevent further application of glaze on

an area not yet dry from a prior application, which would cause the glaze to peel off the pot. The pot is picked up by hand at the end of the circle and examined, and the edge of the bottom is wiped clean. The glaze is brought to the spray area in tanks and then attached to an air-pressure tank.

Glazed pots are removed to another drying room where they remain until they are stacked for firing on shelves permanently set in a shuttle car. All stoneware, except large churns and coolers, is fired in a shuttle kiln. Since the rims of the cookie jars and lids are unglazed, they can be stacked on one another for firing. One-gallon churns with glazed rims are fired at the top of the shuttle cars. One of the two cars is rolled out daily, unloaded, and reloaded while the other is being fired. The firing cycle lasts thirteen hours, beginning at seven A.M. and switching off automatically at eight P.M.; the kiln is burned with natural gas to 1,190 degrees Celsius (C/6). Two-, three-, and five-gallon churns with unglazed rims are stacked and fired in thin-walled ceramic-fiber beehive kilns (which have burners located at the top of the wall).

At the Old World Store the same stoneware shapes produced in the factory are turned by Pete Payne with the assistance of three apprentices; some of his production is more elaborately decorated with blue underglaze painting executed by younger members of the Ellis family. Pete hand dips his pots in the glaze; he says that spraying is slow and the result too thin. The ware is fired in a one-car shuttle kiln. He signs his pieces MP (Master Potter) Peter Payne, MPI (Marshall Pottery, Plant 1). He says: "Right now there's a need for potters, here and anywhere. People are going to want it handmade."

Marshall Pottery

Marshall, Harrison County, Texas
Stoneware; local clay
Bristol glaze; with cobalt blue banding
Shuttle kiln; gas; 1,190°C (C/6)
Pitchers, churns, water coolers, cookie and spoon
 jars
See also Georgeanna H. Greer,
 American Stonewares

Notes

At the end of January 1984, Marshall Pottery was sold by the Ellis family to a group of investors from Longview, Texas.

1. Atterberry Shannon, interview by Carolyn Ellis Williams, March 1982.

2. John H. Ellis, from lecture by Wesley Ellis on the history of Marshall Pottery, delivered at the Harrison County Historical Society, 1977.

3. John H. Ellis, interview by Georgeanna Greer, March 8, 1976.

Miller Pottery

Abraham Miller set up a pottery shop near Mobile, Alabama, when the Civil War ended in 1865. He had moved to the South after emigrating to New York from Germany. In the early twentieth century, he and his family settled to central Alabama, near Sprott, where they made stoneware. Abraham's son W. M. Miller continued the shop, and his great-grandson, H. Eric Miller, Jr. (born 1950), runs the Miller Pottery today.

> *My grandfather started the pottery there. They salted for a long time, and then they found out that it ruined the kiln. It didn't cost so much at that time to rebuild, but [as] it got to costing more and more they had to quit. Then they worked with Albany slip and a white [Bristol] glaze.*

Eric's father, H. Eric Miller, Sr. (1914–1983), and uncle Norman Miller (1905–1972) grew up working in their father's pottery business and continued it together for some years, but in 1964 they parted company after a disagreement. Norman built his shop just down the hill from his father's shop and Eric, Sr., moved from the countryside to the town of Brent so that he could fire with the natural gas available there. In 1970 he retired, after forty-five years of turning, leaving the business to his son, Eric, then twenty. Eric's mother, Mary Frances Miller, had learned to turn when she was over forty and helped make pots for five years.

Eric is a quiet, serious young man in his thirties, determined to make ware of distinction in design and quality, despite the frustrations of working alone.

The family land in Sprott was chosen originally because of its ample supply of clay.

> *There's a mountain of clay over there that my grandfather started digging. It's some good clay, about the best there is for garden pottery.*

Eric says that this buff-burning stoneware clay, which fires to 1,225 degrees Celsius (C/8), behaves like an earthenware clay: "It just doesn't bind together like stoneware." Its coarse texture and porosity make it an ideal clay for gardenware. At the family clay pit, a bulldozer pushes up a pile to last several years; it is aged in the open.

> *After it's weathered a couple of years it works better than when it's first pushed up, and we'll go get a truckload as we need it.*

For the small amount of Albany-glazed ware he produces, Eric buys a kaolin-type clay in Tuscaloosa. There is fine-grained stoneware clay on the family land, but it is so deep in the ground that it is too expensive to retrieve.

The pit clay is stored behind the shop in a box near the clay mill. It is shoveled damp into the clay mixer, then water is added to mill it to the right consistency—harder for large pots, softer for small ones. Six batches are mixed at a time, picked from the mill by hand, and thrown loosely into a compartment in the shop. The clay is covered, aged for a day, then pugged and weighed; it does not, however, require kneading or wedging. The few stones in the clay are picked out by hand, even during the turning process. The shop uses four electric friction disc wheels (made in a local machine shop; see diagram, p. 51), including the prototype Eric, Sr., designed in the 1950s. The potters use ball openers and gauges stuck into the clay ball. Metal chips

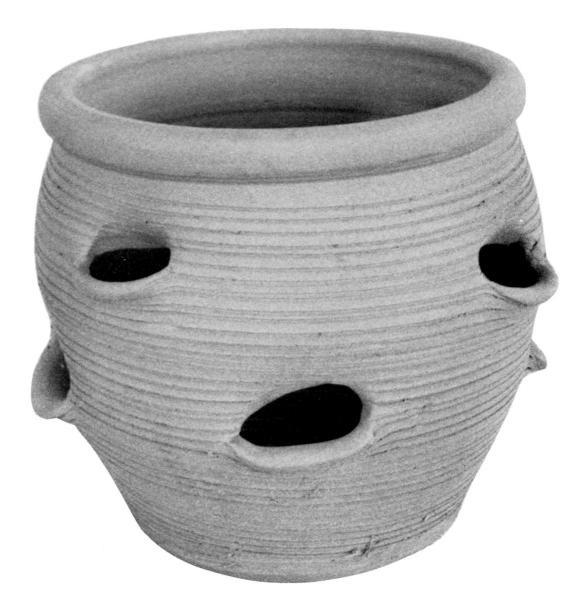

*Earthenware strawberry jar made by
Jimmy Wilson.*

covering an area 80 feet wide and 120 feet long. The kiln shelter is attached to one side; there are several other large buildings for storage and sales.

> *We're still in the old time way here. They ain't nobody that's firing the stuff by wood that I know of but us now. Used to, we kicked it [the wheel], and used a mule to grind that clay. We do the same way now except we have a power mill for the clay and a power "lay" (lathe or wheel) for throwing.*[2]

The principal supply of clay is from a pit used also by the Cravens and Hewells. Added to this clay are two other local clays and a small amount of commercial earthenware clay to "help the pottery dry faster so it won't blow up in the kiln." Ricky says:

> *We hire people to dig the local clay every two to four years; a hundred truckloads at a time come here. It takes a month of hauling because all the potteries come in together. It looks like Stone Mountain—it's a big pile of clay.*

The clay is pushed under a shelter. John Wiley prepares clay directly from the clay pile for the turners each day. A passage with a removable panel has been cut in the building wall, and through this opening Wiley shovels clay chunks into the mill and then adds water to soften the clay while it is being ground. For most ware the clay is ground soft; flared forms, however, require stiffer clay to hold their shape. To catch sticks and grass lodged in the clay, a web of wires is strung through the steel teeth of the mill.

There are three turners: Jimmy, Wayne, and Gene Wiley.

> *Each turner does his own "ball beating" [wedging] and pulls rocks out of the clay then. A lot of rocks you can turn over—it doesn't bother you—but you need to get the big rocks out.*

When one room is filled with pots, the turners move to wheels in another room and turn there. In a four-day work week they can fill one drying room with three thousand gallons of pottery. Turners are paid by the piece and can make 600 to 750 dollars a week. Jackie's wife, Elaine Wilson, does all the handling and finishing.

The Wilson Pottery has developed a drying system to eliminate the stranglehold on production that is caused by the need to dry pots, especially large ones, thoroughly but slowly. This is a particularly dire problem in summer, when pots will not dry in humid air. Consequently, every production pottery either endures the bottleneck or eliminates it, usually by building a drying room heated with costly fuel. At the suggestion of a local engineer, heat from the cooling kiln is conveyed to the turning room by suction fans through flexible conduits that are closed off while the kiln is firing. The ware is dried slowly for the first twenty-four hours, then the kiln heat is drawn in, and the ware dries out completely overnight.

The Wilson's large wood-burning kiln is a remarkable structure, designed and built by Javan Brown in 1964 (see illustration, p. 72). With a ware chamber eight feet wide, fourteen feet long, and five feet, ten inches high and a firebox six feet deep, the kiln is built of walls made of double rows of common red clay brick. For reinforcement, a concrete wall was poured next to the original wall, then another wall was built of single brick, which was finally surrounded by a wall of wood boards. The nearly four-feet thick walls are held snugly together by vertical steel beams tied by horizontal steel-threaded rods banded around the kiln. The walls have proven durable, although now and then arch brick must be replaced, one or two at a time. Two tall corner chimneys, with large flue holes at the base leading from the ware chamber, stand at the far end of the kiln. Once a year the inside of the kiln (arch and walls) is daubed with a protective coating of fireclay. The firewall (or bag-wall) is built of brick, stacked with small openings between them for heat circulation. On this wall is set a loosely laid baffle of old pots—cracked, scorched, and coated with

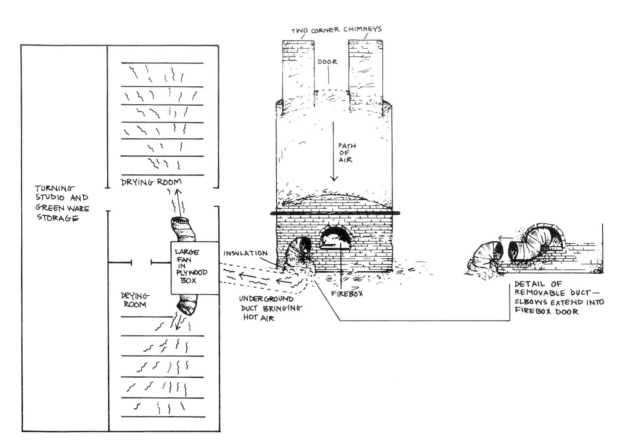

TWO CORNER CHIMNEYS

DOOR

PATH
OF
AIR

TURNING
STUDIO AND
GREEN WARE
STORAGE

DRYING ROOM

LARGE
FAN
IN
PLYWOOD
BOX

INSULATION

DRYING
ROOM

UNDERGROUND
DUCT BRINGING
HOT AIR

FIREBOX

DETAIL OF
REMOVABLE DUCT—
ELBOWS EXTEND INTO
FIREBOX DOOR

*Wood-burning rectangular kilns; note duct
system devised to convey heat from
cooling kiln to pottery-drying room.*

Heat ducts entering shop from kiln.

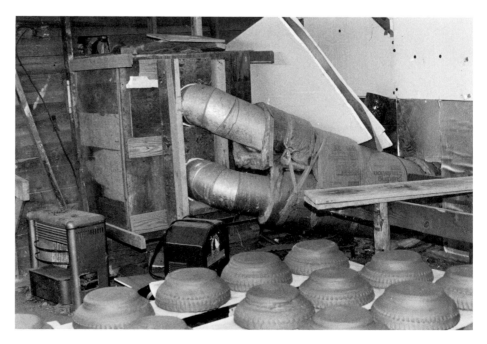

ash—to further protect the new ware from the direct flame. The entryway to the kiln chamber, between the chimney stacks, is built up and taken down at each firing. The chamber floor is made of large, loosely set firebrick, two layers deep on top of red earth.

We stack it tight, cap it over all the way up, put birdfeeders and jugs on top. Rebecca pitchers are stacked along the wall. The second one rests on the lip of the bottom one, and it tilts back against the wall of the kiln. Got to be done right or they'll tip over and break. It takes 2½ to 3 hours to set it; an hour to pull it.

Jimmy starts a low fire in the kiln at four A.M., then John Wiley burns it through the day to about five P.M. He raises the temperature to 980 degrees Celsius (C/07) in ten hours, then holds it at that level for a two-to-three-hour soaking. The temperature of the kiln is gauged by looking at the color of the heat through a peephole in the door. The kiln is emptied while still very hot.

We take the eye [entry door] down at six A.M. Next morning, put the fans on and start pulling the ware at eight—with gloves on. We always empty it fast.

The kiln can hold eighteen hundred gallons or approximately one thousand pieces. It is fired regularly once a week; when the three turners work full time, it is fired twice a week. Fifty dollars worth of slab wood is burned at each firing, and Jimmy estimates that it would cost between three and four hundred dollars to burn the kiln with natural gas: "We used to think it was old fashioned to burn wood, but it's not as old fashioned as it used to be." The kiln is closed except during loading and unloading and rarely cools off completely. This not only provides heat to the drying room but prevents ware already stacked in the kiln for the next firing from absorbing moisture from the atmosphere. Thus, both kiln and pots are "preheated," saving fuel and labor during the next firing. With equipment that might be considered outmoded for production of large ware, they have developed a remarkably energy-efficient process.

The terra cotta planting pots produced by the Wilsons are now limited to five standard shapes, some decorated with fluted edges or scratched designs. They also produce jugs and churns, birdbaths and feeders, and sometimes even piggy banks.

It was more interesting when we made more shapes and before we got into selling gifts. We didn't realize we were getting into that so deep. We'd have a slower pace and a happier life without it. But, we're in it now, and Dad likes to sell it.

The giftware items—which account for a large portion of the total business at the Wilson Pottery (as well as at the Craven and Hewell potteries)—began with the potters' buying gardenware for resale in response to a demand their own production could not fill. Wilson sells to shops in Appalachian Mountain resort towns, such as Gatlinburg or Cherokee, and through wholesale distributors. Retail sales do not account for more than one percent of their handmade pottery business. They have thought of adding glazed stoneware, but because they lack access to the types of clay and or wood needed to produce it, they continue to produce what Ricky calls "just the old red stuff." "As long as we're in the pottery business we'll keep making it by hand—we've got that much pride in it."

Wilson Pottery
Alto, Banks County, Georgia
Earthenware; local clay
Unglazed; some with fluted edges or scratched designs
Rectangular, brick kiln; wood; 980°C (C/07)
Planters, strawberry jars; birdhouses and feeders;
 jack-o-lanterns
See also John A. Burrison,
 Brothers in Clay

Notes

Background historical information was provided by Foxfire interviews, courtesy, Eliot Wigginton, director.

1. Jimmy Wilson, interview, courtesy, Eliot Wigginton, director, Foxfire.

2. H. A. Wilson, ibid.

Glazed Ware Developed in the Twentieth Century

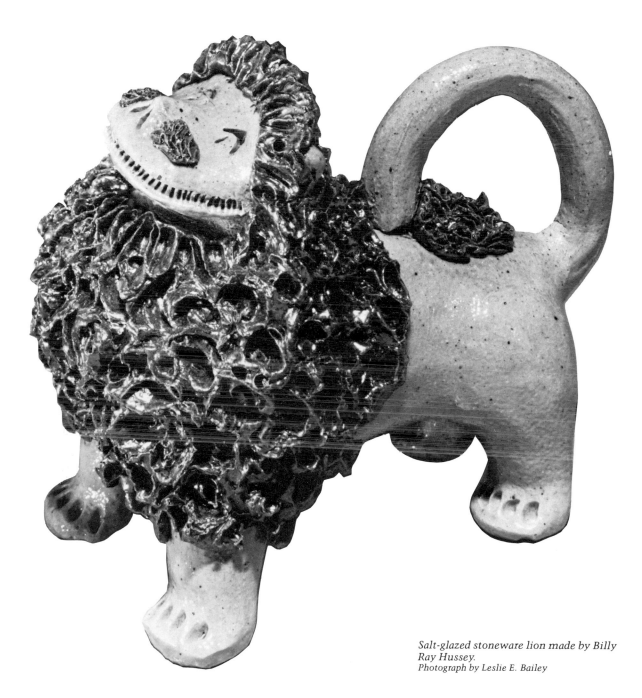

Salt-glazed stoneware lion made by Billy Ray Hussey.
Photograph by Leslie E. Bailey

Brown Pottery

Earthenware casserole with glazed interior and lid made by Robert Brown.
Photograph by Kay Stroud; courtesy Randolph Technical College.

The Brown potting family is descended from William Brown, a potter born in Virginia c. 1784 whose son, Bowling Brown, was the first potter to set up shop in the Jugtown area of Georgia. Over eight generations, twenty-five or more Brown potters have pursued the craft throughout the South—in Virginia, the Carolinas, Georgia, north Florida, Alabama, Mississippi, and Texas. Charles and Robert Brown, who now operate the Brown pottery in Arden, North Carolina, refer to their fore-bears as "a bunch of gypsies."

Their grandfather Davis Brown (1895–1967) and his brother, Javan (1897–1980), learned to turn in Atlanta at a pottery owned by their father, James O. Brown. Davis turned also at shops in Georgia's Jugtown and in Alabama. In 1923 Davis and Javan moved to North Carolina and built the present shop, calling it the Brown Brothers Pottery. Ella Brown, Davis's widow, who helped in the shop, describes their ware:

> Him and his brother, they made churns and pots—things they could put on a truck—and go deliver them to hardware stores. He mixed his own glazes, ash and sand; then we went to buying Albany slip. He did turn some casseroles at that time. Then we gradually went into making "artware," vases and face jugs and everything.

A huge urn made in 1925 sits unfired by the entrance to the Brown Pottery. Javan turned the bottom part on the wheel and set it on the floor, then Davis built it up by coils of clay to more than six feet high with a nine foot circumference. Evan Brown, Javan's son who now operates a nearby pottery, remembers its size vividly:

> It was built up shoulder high, almost finished . . . but wet. They had a chain hoist slung over the rafters going down in the pot. Louis and I were just little bitty kids. One afternoon we went down the chain into that vase. I climbed out but he couldn't, and I couldn't pull him out. So, I had to get somebody. We both got a licking for that.

When Germany invaded France in 1939, the cooking ware made in the French town of Vallauris was discontinued. A New York distributor, seeking to replace it, found Davis Brown and contracted with him to produce this ware, which Brown stamped Valor Ware. An additional eighteen hands were hired to produce the ware, which was cast, jiggered, and hand turned. Casseroles and other kitchen and table-ware were wood fired in a large round downdraft beehive kiln built by Davis and his son Louis in 1939. Later, this kiln was fired with coal, then with kerosene, and finally with gas.

Charles and Robert learned to turn in their grandfather's pottery, with help from Davis and Javan who was often at the Brown shop turning large pots for Davis even after he had built his own pottery at Valdese. They turned small pieces for the shop during school holidays and often demonstrated pottery techniques for groups touring the area, as Stephanie Brown (Charles's daughter) does now.

Over the years the whole family, after school or other work, helped Davis, and when he died, his grandsons Charles, at eighteen, and Robert, at fourteen, although still in school, devoted themselves to the pottery, working with their grandmother and the part-time help of their father, Louis. Robert says, "It was hard without grandpa."

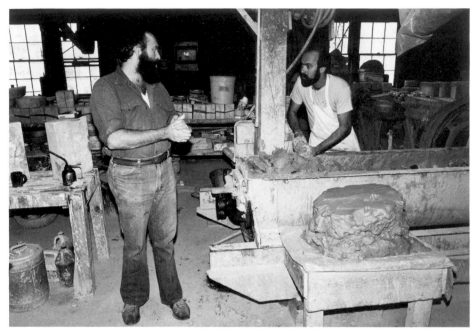

Charles Brown mixes clay at an open mill operated by a Model-T Ford piston, with Robert Brown at left.

large part of their business—are jiggered and turned by hand. They turn large casseroles because a heavy, full mold is difficult to carry and requires that the wheel be stopped so that it can be lifted out. Small molds can be removed while the wheel is running. Robert operates the jigger wheel and turns large pieces, while Charles turns small pieces. Johanna, Robert's wife, and Lillie, his mother (Mrs. Louis Brown), put on handles, glaze, and operate the sales shop.

The ware dries on open racks inside the shop. Ware boards are made with two high sides so that they can be filled with small pieces and stacked like boxes one on another. They use what Charles calls "the old iron-oxide glaze," a basic feldspathic glaze, fluxed with a frit: for brown they add iron, for green they add copper. The unmilled glazes are mixed in garbage cans. Casserole rim flanges are waxed so that lids can be fired in place. Casseroles are glazed only on the inside by pouring glaze in and out of the bowl. Pots to be completely glazed are waxed on the bottom and then dipped in cans of glaze.

We'll take the pieces we've just glazed and stick them right in the kiln because we slow fire. We don't hurry anything. We stack the kiln as we're going because we don't have room for everything out here. As soon as the kiln is loaded, we start it—usually at midnight—and let it coast on low heat. It can steam itself by the next morning through two top draft vents. We close the vents in the morning, turn on two bottom elements and the two side elements. So, it builds heat all day, and by eight P.M. she'll be hot.

They fire a forty-six-cubic-foot envelope kiln, in use since 1975, to 1,165 degrees Celsius (C/4). It has two stationary cars for stacking wares and a kiln shell of reinforced brick, which moves on a track to cover first one car, then the other. The Browns find the electric kiln completely satisfactory and estimate that it is cheaper than a gas kiln, although they would prefer the kiln shell to be made of fiber for

more effective heat containment. The new kiln is safer to burn than the old round beehive, the last firing of which was nearly a disaster.

It was the night Martin Luther King was killed. We got gassed and like to have died right here. The wind shifted and started blowing down the chimney—fumes were coming out in here. Everybody was tired. I thought it was just me, daddy thought it was just him. Nobody bothered to say, "Hey, I feel funny." Dad passed out and fell into the hole that goes round the kiln. I got sick and fell on the floor where I got enough air to revive and realize. I run and crawled to the house yelling. When they first come down, they couldn't get in without going out for breath. Then they got in and got daddy out. You talk about a headache the next day. . . . That's not the way to go. You see, it builds up so slowly you get accustomed to it. But, you can't stop firing. . . . We went back in there and opened windows, raised the damper to pull more air through the kiln, and burned it out.

The Brown's business now is divided between retail and wholesale. To their grandfather's line of ware the brothers have added quiche dishes, clay cookers, and garlic pots. Thinking of the future Robert says:

I'm not opposed to firing [some] with wood, I'd like to do it. You might have to fire with anything you can get if things get worse. I'd like to build a little salt kiln because we've never really done it, not in our lifetime. The only thing you could use it for would be something to play with. Mercedes [Brown] told me when they had a good wood fire going people would all gather around and you'd have more of an outing . . . sometimes make music and dance . . . just make a party of it when they fired.

Brown Pottery
Arden, Buncombe County, North Carolina
Earthenware; local clay
Feldspathic, fritted glazes
Envelope, brick kiln; electricity; 1,165°C (C/4)
Casseroles, stew and beanpots, platters, quiche
 dishes, jugs, mugs; unglazed chicken roasters
See also John A. Burrison, *Brothers in Clay*

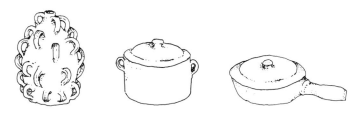

amounts of silica and feldspar to achieve a rich brown. Walter Cornelison remembers the turners of utilitarian ware:

> *The old potters who turned stoneware were heavy handed. They turned so many pounds to the inch. They were good potters. I've seen them stand at a kickwheel all day long and make eighty- to ninety-three-gallon churns a day. The strength and endurance of these men was fantastic. They were eccentric to the point of being plain mean from all this hard work. Uncle Webb was as eccentric as could be and good, and he knew it. My grandfather was paying him, but he never worked for anyone. Once he made a vase about twenty-four inches tall and set it off the wheel. I was watching, and it gradually faded away and fell off. I thought it was the funniest thing I'd ever seen, till he ran me out of the shop.*

Many potters in the region burned their kilns with coal, which was hauled from mines on railroad spurs and later by truck. Walter remembers driving through the mountains to deliver jars and churns, then stopping at the mine forty miles away to pick up a load of coal to haul home.

Although the demand for utilitarian ware continued through the Second World War, the Cornelisons saw that it would diminish and had began producing brightly glazed garden and patio wares as early as 1915. For some thirty years, they produced both types of ware, burned in separate kilns. Bybee Blue was the first glaze color developed for the new ware. Other colors followed as variants of the same base glaze, including a "gold" made from uranium, supplies of which were collected from the shop by the government during the Second World War. The stoneware clay was used to make the new ware but was fired at a lower temperature, 1,190 degrees Celsius (C/6).

> *They may have been overfiring the clay for their stoneware. You can get by with it a little, but you're not getting the best out of your clay. Possibly he was a little under with his gloss colors. I don't think they went by that much.*

During the 1940s Ernest Cornelison developed a line of dinnerware, accessories were later added, while churns and gardenware were gradually discontinued.

> *The potters who grew up making the heavy big ware had difficulty changing their skills to the making of small ware. Along comes shapes that need that little extra, . . . and they didn't git it. Most of the heavy-handed potters never learned to turn that delicate, thin pottery. Whether they couldn't or wouldn't, I'm not sure. I only know one man who made the transition well to the small ware: Floyd Hilton, from Hickory, North Carolina, who worked here for my grandfather. Old potters always told me, "You'll either master the clay or it'll master you." Uncle Webb truly mastered it, but he couldn't have made the shapes of today graceful and right.*

Ernest Cornelison expanded the shop after the war. He bought jiggering machines, built a shuttle kiln, hired salesmen, and shipped pottery throughout the country. But the work broke his health, and expansion, which brought less skilled workers into the shop, caused the quality of the ware to decline. Walter has chosen to reduce wholesaling and to focus on a growing retail trade.

The ware made today includes dinnerware and such table accessories as batter bowls, mugs, and teapots. Flat dinnerware and straight-sided mugs are jiggered. Turning clay, softened slightly by water, is used for jiggering. In 1982 forty-five percent of the production was jiggered; forty-five percent, turned; and ten percent, cast.

When Walter assumed responsibility for the pottery, he tested the clay and found its best-fired strength to be at 1,165 degrees Celsius (C/4). He then adjusted all the glazes to that temperature.

Soft clay (from mound in corner) is placed in the mold to shape bottom of plate.

Clay is spread out in the mold by hand.

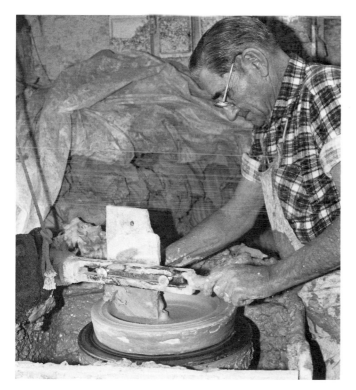

Top of plate is shaped with template on movable arm.

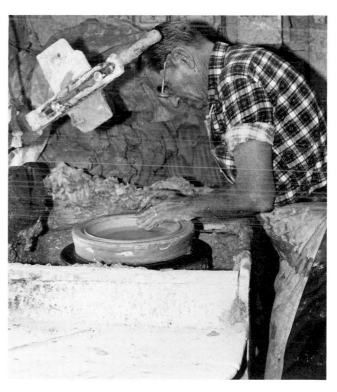

Rim of plate is shaped before the mold is removed from the wheel.

Jiggering ware.

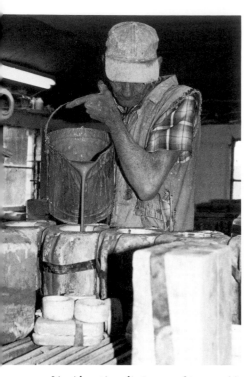

Liquid casting slip is poured into mold.

We're talking about a clay with no mixture, nothing, not even washed. We do so little to it—nature is doing most of it. We leave it outdoors in snow and rain. Freezing and thawing break it down. We do have a pugmill and grind the clay in it to an even consistency by feel. Naturally, a little age on the clay, bacteria setting up on it a bit, makes it more pliable. We try to keep a mill or two ahead. In a hurry, we use it right out of the mill. It's a pure, clean vein with some sand pockets in it. . . . Clay and sand, they're first cousins anyway.

Production is gauged by how many handles the finishers can pull and apply on pieces made in one day. Unlike most turners, Walter does not put handles on his pots. He believes it is not an efficient use of his time. Two women do all the handling, crimp pie plates, sponge bottoms, and oversee the processing of drying pots from the time they leave the wheel until they are glazed. The pottery is raw glazed, and dipping it requires skill.

Your glazers have to be pretty efficient and know what they're doing to raw glaze. Our men have been at it long enough. They put their hands in it and know immediately by feel if it's right. The pot can crumble right in your hand when it hits that glaze and when the extra weight of glaze is on the inside and being poured out. I like bisque, but fuel being what it is today, . . . [we do without it].

The pottery has seventeen glazes, which are not used all at once. They discontinued the black glaze rather than raise prices when cobalt became very expensive. Currently the shop uses ten glazes, but if any color does not sell, it is discontinued.

My grandfather had certain shapes that went into certain colors. If you wanted a mat rose piece in the Bybee Blue glaze, he said, "No, that's a mat rose piece." With all due respect to my grandfather, I think that was ridiculous. The customer is saying, "I've got a color scheme in my home and that color fits there." If they can't have it, we just lose. It's that simple. I don't really think any of our glazes are inappropriate for any of our forms. With the conservative shapes and colors that we have, it would be hard to get a bad combination.

The shuttle kiln built in 1947 was used with two cars until about 1956. With one hundred cubic feet of firing space, the kiln held more ware than they could produce in a day, and they felt that "the kiln was running us, instead of us running the kiln." The structure weakened with a door at each end, and so they closed up one end and use only one car. Later they replaced the brick walls with fiber-insulated steel walls and a flat top. The kiln is usually burned five times in two weeks or three times a week as production demands. This modified shuttle kiln is actually very simple.

It has thirty-two glorified bunson burners, which are set up, lit, and fired manually. It has twelve peepholes in which I set three cones each. I light the gas and proceed to fire it by eye. We bring the heat up slowly, lighting the side burners only after the first hour of warming. After 2½ hours, it's set at the highest setting and burns by itself through the night. Next morning, if part of it is ahead or behind, I can remedy that in the last hour and drop C/4s all round. The door is slowly cracked that afternoon, and it comes out the next morning about eight A.M. Then the kiln is set again. It's a constant process of either being set, fired, or drawn.

Walter Cornelison has continued the evolution of a simple, cleanly formed tableware begun by his father. His sons, however, are pressing for changes, which he is resisting, although he is willing to listen:

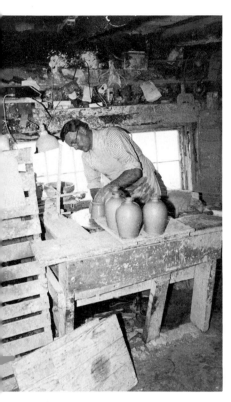

Walter Cornelison at the wheel.

I'd like to be flexible, a potter who can change with the times. I'd like to forego being an eccentric who can't change, but I doubt I can. Our very concept is to be flexible, in colors, shapes, and sizes, whatever the public wants. But, there comes a point where you don't want to compromise. . . . I want to make something you need and are going to use. That means keeping a reasonable price range. We're dealing with a continuity of generations. Bybee Pottery really stands for something you can live with for a long time.

Bybee Pottery
Waco, Madison County, Kentucky
Earthenware; local clay
Feldspathic glaze, in several colors
Shuttle kiln; gas; 1,180° C (C/4)
120 pieces in catalog, including cooking and tableware, cannisters, pitchers,
 hurricane lamps

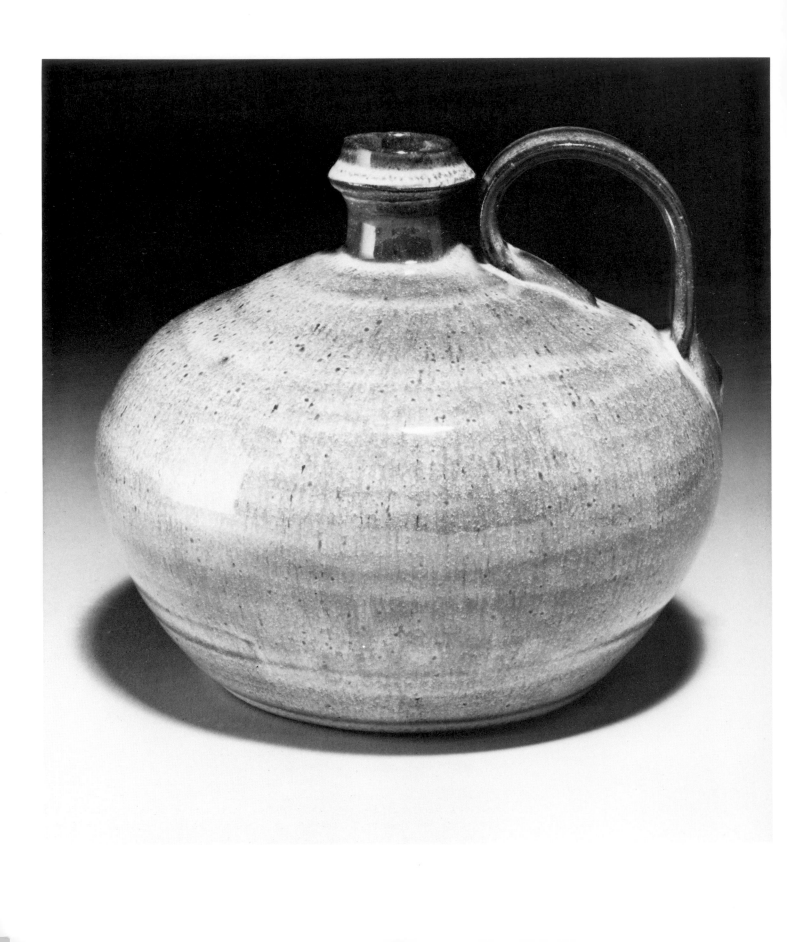

Cole Pottery

A direct line of Cole potters have been working in the northwest corner of Moore County, North Carolina, for more than 150 years. The first Cole potter, Raeford Cole (born 1799), worked in Steeds and was the great-grandfather of Nell Cole Graves (born 1908) and Waymon Cole (born 1905). Waymon and Nell grew up on the family farm a short distance from where the present pottery was built in 1923 by their father, Jacon B. ("Jace") Cole (1869–1943). Earlier Jace had been a turner at several potteries, including Hiltons near Asheville and Chriscos, to which he walked twelve miles daily "backwards and forwards" from his home in Seagrove.

Jace eventually set up his own pottery where he made Albany-slip and salt-glazed utilitarian stoneware, sometimes decorated with blue smalt. He sold the pots from the attic of the small shop. Waymon looks back to his childhood:

My dad made pots and sawmilled and always had a farm. They'd raise the wheat and take it to Moffit's Mill with three or four big old long flour bags, hold 150 pounds of flour. I'd go with him and it wouldn't be long till we went back again. We grew cane, too. He'd make about 250 bushels of wheat, 400 bushels of oats for the livestock, and corn, too. He raised his own beef and hogs, had milk cows, and a yardful of chickens. I could milk. Whenever my mother's temper got just a little bit up, why I was a real good milker.

Waymon remembers the slip glazes used at his father's shop, including frogskin (Albany-slip glaze slightly salted):

The frogskin crock was a good pot, it would hold anything. We kept food cool in the spring run in frogskin crocks. We made other slipware, too. Take the clay we was turning and make it liquid. After it set, you'd skim off that fine top [the fine-grained clay was suspended while the coarse-grained clay sank to the bottom of the container], mix it with the frogskin, or put it on instead. The clay was about a chocolate look, and it would burn an antique white when you put salt on it. We used that Albany slip way years and years before I was ever born.

The utilitarian ware was burned in a groundhog kiln. They started the fire with quartered dry pine or oak logs.

Toward the last we made that-there black smoke roll. We had a lot of lighter'd. Back out from Steeds they was thousands and thousands of acres of it, it hadn't never been used for nothing. We could buy it all we wanted. You can't get it now for kindling. We used to burn the lighter'd knots in the fireplace, that's the way we kept warm and got light too.

Jace taught Waymon to turn. He had been helping wedge clay and pick it and watched his father on the wheel.

I was eager to get in and when I was fourteen he said, "You can do it now just go right ahead." I'd dicker with it when he was off the wheel, and he kept showing me. Just to have my hands in the clay all the time was wonderful to me and still is. After I got up to where I could handle the wood, I'd fire out the kilns for him. Where the pottery set [in the groundhog kiln] was ten feet long and half as wide, tapered up toward the back, chimney stack not over eight feet high but wide. I was eager to see what I could do and how much I could do.

Jacon and Rhocita Cole, 1926.
Photograph courtesy Dorothy Auman.

Nell was also learning by working in the pottery.

> *It was exciting. I could hardly wait to get home from school to get down here.*
> *I'd come here first and then do chores, get in wood, milk the cows. When I was*
> *real little I thought about being a nurse, but that went out whenever I went to*
> *helping at the pottery. When I was thirteen he said it was time to start me*

Waymon Cole, cousin Fairy Mae Cagle,
and Nell Cole stand by groundhog kiln,
1920s.
Photograph courtesy Nell Graves.

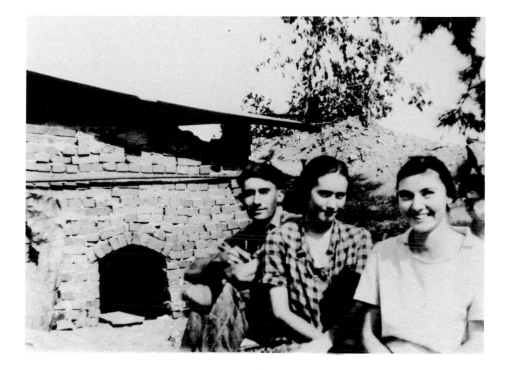

making pots. At first, he'd make a ball of clay and turn it for me, and then I
could make a nice little piece. Then one day he said, "This is the last time, . . .
you can do it yourself." Boy, that gave me a tough one. But I was on from there.
I made small shapes and got to making tiny doll cups children played with. I
never tried to make the big things, just from five pounds down.

Somewhere about nineteen and twenty-eight [1928], he started making
some flowerpots too and lettin' them be pretty colors. When he got to makin'
earthenware, he built a large kiln and used saggers to keep ashes off, cause he
was still burning with wood. It was an upright kiln so the fireboxes were on
each side and the chimney in the back. It took maybe ten to twelve hours to
burn. They didn't know what temperature it was, they just burned it till it was
done.

Until 1940 Cole Pottery continued to make utilitarian stoneware while
also producing glazed earthenware. Nell and Waymon agree that it was tourists from
Pinehurst who drew them into exploring new shapes and glazes for earthenware.

These customers would want a fancy pie plate, maybe fluted on the edge, or
a casserole or a fancy vase. It wasn't but just a short while before the neighbors
bought it just like the tourist. They hadn't ever had nothing [pottery] to cook
in.

These northern people came down after Christmas and spent the winter
in Pinehurst. They would come and draw for us what they wanted. Then we
could change the shape a little, make it more ours. People didn't want the old
jugs for syrup. When they'd go back north, we'd have enough orders for the

summer. It was just me, my dad, and Nell in those early days. We didn't get too much through in a week, but it amounted to just as much then as a big kiln does now. There wasn't as much money handled, but the money went further. If we could have just got a happy medium and helt it.

We had a good farm and a good income, well fairly. . . . Well, then it weren't too much either when you were selling pottery at ten cents a gallon, but, it didn't take much. We didn't have to buy nothing at our house but coffee, sugar, sodey, and salt. If your earnings was ten to fifteen dollars a week for the whole family, you was wealthy.

When we made garden urns I wedged my own clay. Didn't nobody want to fool around with sixty pounds for you. I was tremendously strong, not to get out here and prizefight but for this. It didn't bother me a bit. I think that man up yonder just set me down here to do that.

When the war went by and got out of the way, we went to firing with oil. The advantage of oil is it's less work. Got to where people didn't want to cut wood for you.

Local potters agree that Jace Cole developed the low-fire glazes quickly. Nell says he read some books on the subject, learned to use the familiar lead to flux a mix of feldspar, whiting, flint, clay, and color stain. Waymon also studied glaze chemistry and continued to develop glazes. The Coles survived the depression, probably because they solved production problems for the new ware and because Jace was also an adept businessman. From late fall to June, tourists from Pinehurst visited the pottery after having traveled over rough, dirt roads.

There weren't nothing but mudholes down here then. They was thirty-six miles and no restaurants, so customers would eat with us. My mother would be down there waiting on people and it come twelve, she'd say, "Let's go up and have some dinner." They was wild to get into the old house and delighted in that home-cooked food. It didn't hurt that she wore a bonnet all the time, either. Right now Virginia cooks dinner in the shop every day, and people will say, "What are you cooking?" Sure as hell got to hang around a little and get in line. I like it that way. I can set down on a stump and eat with anybody. When I was raised up, you happen to go to a neighbor's house at mealtime, they'd get up and fix you a plate. Weren't no use to say no.

We didn't know a lot of other potting families, our life was around our family. When the Busbees opened Jugtown, they would come up here and visit my daddy and mother in a wagon. That was about the closest pottery then. Later we went to Jugtown but not often, cause my daddy didn't have a car.

Coles made both stone- and earthenware of clay from the Mitchfield area north of Seagrove where an uncle had a farm.

He was a pot maker, too, and he dreamed that he found the clay between two branches. It was a terrible dream, almost useless. . . . But, he got up, got his maddock, and took off. By George, he come back with some in a bucket. That was the Mitchfield clay the potters used for so long. Best clay I ever saw for salting. And then they sold it all to the Pamona people, I hate they ever got it. Then we had to go look for clay and, we got it out of Smithfield. We had some Mitchfield yet, and, if we mixed a quarter of it with the new clay, it was a little darker, but far out beautifuller.

They have used the Smithfield clay from a region further east in the state for forty years and will continue to. Once a year in dry weather Waymon, his great-nephew Mitchell Shelton, and a helper load sixty to eighty tons of clay with a trac-

Nell Cole Graves with customers.
Photograph courtesy Randolph Technical
College.

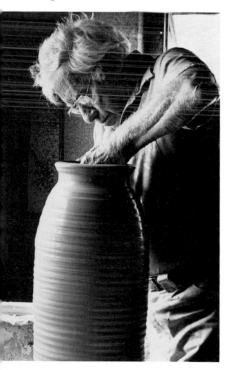

Waymon Cole turning a large jar.
Photograph courtesy Randolph Technical
College.

tor and trucks. At the clay pit a top seam of red clay merges into a gray blue clay in a vein running about twenty-five inches deep and several acres wide. They mix equal parts of the iron- and noniron-bearing clays and store it in a large open shed at the shop. It is made into a slip in a large ball mill that holds five hundred gallons and two tons of stone that grind the clay. The slip is screened as it is pumped to a holding tank, then forced into a filter press under air pressure. The pressing goes on for three days and produces seventy-five cakes of plastic clay two inches thick, a total of three thousand pounds, an amount sufficient for a week's work. The clay is pugged, stored, and requires only a little wedging to remove air pockets. Waymon takes pride in the clay body: it is a perfectly plastic clay, allowing the potters to turn the ware very thin. Waymon claims that it is the processing and not the clay that gives it unusual plasticity. Clay from the filter press

> *don't do anything, only what I want it to. It stays where I put it. Heap a-times I make maybe a blunder, and it really helps me correct it. Other clays I'd have to start over. It don't go on mess himself up.*

Their niece Virginia Shelton (born 1923) turns a large portion of the total output of the shop. Her son Mitchell (born 1951) turns whenever he is not preparing clay, running the fritting furnace, or mixing glazes. Waymon turns daily, making large pieces—bowls, churns, umbrella stands, platters. Nell likes to turn, but since Waymon underwent a hip operation, she has done much of the glazing, continues to do all the selling, and has little time at the wheel.

The finished pots are set out on long bare tables and shelves in the barnlike sales area and sell so quickly that no one bothers to put price tags on them. Nell simply keeps the prices in her head. She usually does all the kiln burning, lighting one up at four A.M. once a week, although Waymon takes over when necessary. A few outside helpers assist Mitchell in clay preparation, loading and unloading kilns, and grinding the bottoms of finished pots on the emery wheel. Other young family members work part time, making balls for Virginia or finishing the turned ware. A cousin Sidney Luck turns when he has free time from teaching. Thus it is very much a family affair as is customary in such potteries.

Waymon turns on a wheel he "tacked together with a headblock of cast iron made by the foundry man." By manipulating the pulleys, he can adjust it to run at different speeds, but Waymon prefers to keep it at one speed. For very large pieces he uses another wheel geared down to run very slowly. His turning chip (which he calls a "rip") is made of formica scrap. He used to whittle out rips from white-pine shell boxes obtained from hardware stores. Because the pine was soft and had no grain, he found they would outlast his father's apple- and persimmon-wood tools. To narrow the long neck of a bottle shape he uses a chair rail as an inside support. Waymon, who has turned for sixty-four years, still remembers his father's work with admiration:

> *My dad had the most skill. He was never nervous over it. Ten or nothing might be there watching him, he was the same. Made a pot just like you would write a word.*

Cole pottery is glazed in a range of soft and bright glazes, from white to bronze, and is identified by such names as Burnt Sugar and Dove. These feldspathic glazes, fired at the C/6 medium range, are made with frits designed by Waymon and produced in the shop. Boron or soda are smelted with other glaze ingredients into frits, changing them from soluble to insoluble materials. With these frits for flux, it is possible to obtain clear and luminous earthenware colors. They use their forty-year-old fritting (or smelting) furnace to make the frits. The resulting chunks of glass are then ball milled to powder for thirty-six hours. Waymon dreams of having a dozen

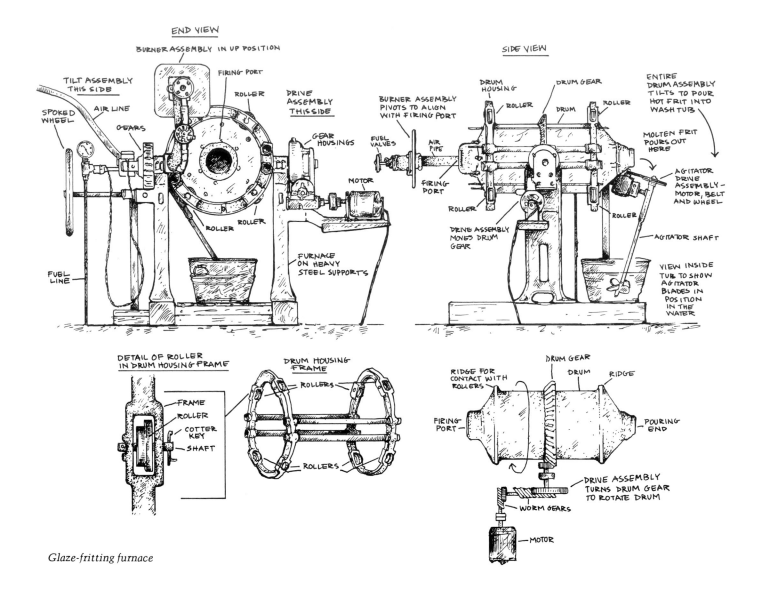

END VIEW

BURNER ASSEMBLY IN UP POSITION

TILT ASSEMBLY
THIS SIDE

FIRING PORT

ROLLER

DRIVE
ASSEMBLY
THIS SIDE

SPOKED
WHEEL

AIR LINE

GEARS

GEAR
HOUSINGS

MOTOR

ROLLER

ROLLER

FUEL
LINE

FURNACE
ON HEAVY
STEEL SUPPORTS

SIDE VIEW

DRUM
HOUSING

DRUM GEAR

ROLLER

DRUM

ROLLER

ENTIRE
DRUM ASSEMBLY
TILTS TO POUR
HOT FRIT INTO
WASH TUB

BURNER ASSEMBLY
PIVOTS TO ALIGN
WITH FIRING PORT

FUEL
VALVES

AIR
PIPE

MOLTEN FRIT
POURS OUT
HERE

FIRING
PORT

AGITATOR
DRIVE
ASSEMBLY—
MOTOR, BELT
AND WHEEL

ROLLER

DRIVE ASSEMBLY
MOVES DRUM
GEAR

ROLLER

AGITATOR SHAFT

VIEW INSIDE
TUB TO SHOW
AGITATOR
BLADES IN
POSITION
IN THE
WATER

DETAIL OF ROLLER
IN DRUM HOUSING FRAME

FRAME
ROLLER
COTTER
KEY
SHAFT

DRUM HOUSING
FRAME

ROLLERS

ROLLERS

RIDGE FOR
CONTACT WITH
ROLLERS

DRUM GEAR

DRUM

RIDGE

FIRING
PORT

POURING
END

DRIVE ASSEMBLY
TURNS DRUM GEAR
TO ROTATE DRUM

WORM GEARS

MOTOR

Glaze-fritting furnace

furnaces to frit each glaze separately with all its components and coloring metal oxide. As it is now they smelt the two clear frits, and what is left in the chamber from one firing does not interfere with the quality of the other.

You can't use the same furnace to smelt whole glazes with their color. Frits are like the human race of people, they're hard to agree. Sometimes they fight like nobody's business. You've got to overcome that and make them work together.

The ground frit is mixed with other glaze minerals and color oxides, then screened through 120-wire mesh. Glazes are kept in washtubs or old bathtubs, which rest on brick in the room furthest from the turning area. Between the turning and

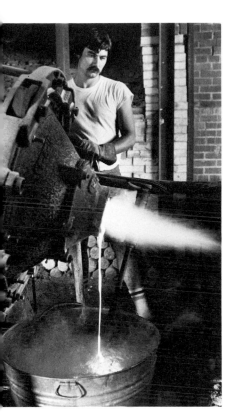

Mitchell Shelton operates fritting furnace; he is pouring liquid glass into a bucket of water.
Photograph courtesy Randolph Technical College.

glazing rooms is the kiln room, with three large kilns, two small ones, and the fritting furnace. Each room is actually a building to itself, with the earth foor and three buildings simply following the contour of the rising ground, so that it is an up- or downhill walk between them.

The pots are dipped, the glaze is brushed slightly off the bottoms, the pots are then set in the kilns on stilts. The large kiln, built in 1975, is six feet wide by eighteen feet long by eight feet high with six flat burners combining air and oil. It is usually fired every other week.

Many of the shapes and glazes used today were originally developed by Jace and have been adapted to higher temperatures and oil burning.

The Cole Pottery presently produces a huge volume of ware. They are constantly welcoming people, engaging them in talk while they work. "I like to meet people, and I like to leave 'em happy."

I'm satisfied with what I'm doing. I get up whistling and I go home whistling. I just go along without any real hurry now. Sometimes you prosper by your mistakes. I don't like having too many mistakes, but I don't mind prospering.

Nell adds, "when I hear Waymon whistling, I know it's time to go home."

Cole Pottery
Seagrove, Moore County, North Carolina
Earthenware; local clay
Feldspathic and fritted glazes, in several colors
Rectangular, brick kiln; oil; 1,145°C–1,180°C
 (C/2–C/6)
Kitchen and tableware, including casseroles, pie
 plates, teapots, pitchers, mugs; jugs,
 jardinieres, vases, umbrella stands

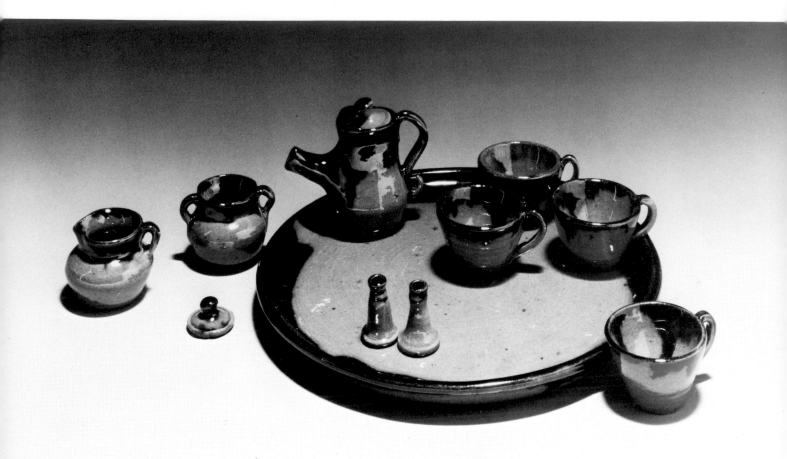

Cole Pottery

Earthenware miniature tea set with clear and black glaze made by Celia Cole Perkinson.
Photograph by Kay Stroud; courtesy Randolph Technical College.

Arthur Ray Cole (1892–1974) was a fourth-generation member of a North Carolina pottery family, son of potter Ruffin Cole, brother of C. C. Cole, and cousin of Waymon and Nell Cole. Since his death in 1974 his daughters, Neolia Cole Perkinson (born 1927) and Celia Cole Perkinson (born 1924), have operated the family shop in Sanford. Another Cole Pottery in Sanford is operated by his son, G. F. Cole.

Arthur Cole learned pottery making in his father's shop in Seagrove, where utilitarian ware was salt glazed. In 1927 Arthur built his own shop nearby and unloaded his first kiln of ware the day Neolia was born. He limited his production to brightly glazed earthenware burned in a groundhog kiln protected by saggers. In 1934 he moved to Route 1 in Sanford so that his pottery and sales shop would be accessible to motorists traveling south or north.

Neolia remembers growing up in the pottery when Sanford was only sparsely settled:

> There was nothing, just little dirt roads off Highway 1 for people to get to their houses. . . . There were six of us kids in the family that worked, the youngest was crippled and couldn't. You started out when you were four or five. Daddy would show us not to pick it up by the lip because you might break it. We'd come down the steps carrying a piece to the kiln, scared to death we were going to break it. If we did, we'd try to hide it. There was an old house place above ours that burnt down. It had an open well, and we just practically filled up that well with bisque pottery we broke, hoping daddy wouldn't find out about it. But he sure could tell right quick if any were missing.
>
> If there was anything you were big enough to do, you did it. We didn't have running water so we'd draw it from the well at the house and carry it in buckets to the shop. Course we had barrels to catch rain water, too, to save us steps. We worked in the garden, too, and with the hogs and the cow.
>
> We didn't have a pasture to put the cow in, so we staked her out with a long chain. My younger brother, Truman, was taking care of her, and one evening he went down to get her up. He was taught to walk her on the shoulder of the road, never up on the highway. Alright, we heard a racket, somebody hollerin', and daddy looking out. Truman was coming up the middle of the road standing on that cow's back, and her runnin' with a switch in his hand and hollering, "Hi-ho, Silver, get 'um up." Daddy . . . I mean daddy got him. He got one more thrashing for that. Course all the rest of us kids we're just dying laughing at him. Afterwards he said "Well, that's alright, I enjoyed it." I can see him now comin' up the road.

As younger Cole family members came to turn, first Foister, then Celia and Neolia, they began by learning to make small pieces, graduating to larger pots as the next child came along. Arthur always turned very large ware, although he sometimes hired other turners, such as Elvin Owens, Jack Kiser, and Bill Gordy. When he made the very large pieces—thirty-five pounds or so, in three sections—one of his children kicked the wheel while he stood on a box to reach down into the pot.

Coles ran a thriving wholesale business during the depression.

The shops would take anything we set back for them. We'd put it in the loft, till

183

we had a big truckload. They'd bring the truck and spend the night at the house. We'd all crawl out of bed at three A.M. and start carrying pottery out, sitting it on the ground. We loaded it straight into the truck with wheat straw—smaller pieces rolled in newspaper and packed in straw inside bigger pieces. There was very little breakage.

The Second World War affected the Coles, as it did most potteries. Foister and Truman went into military service, and Celia married and moved across town, leaving Arthur, his wife, Pauline, and Neolia to run the pottery. Labor scarcity during the war caused them to build a more energy-efficient oil-burning tunnel kiln; they continued, however, to place the ware in saggers.

Wholesaling continued after the war and production increased with the return of Foister and Celia, but with rising costs there was a strong incentive to develop the retail business. Despite the departure of Foister in 1959 and a fire that destroyed the pottery, large numbers of customers periodically swamped the Coles with business. It was well known in North Carolina that their kiln would be unloaded Friday evening, which resulted in near bedlam early Saturday morning.

We'd open at seven A.M. Some of them would come in here at two A.M. to get in line—lay a box or umbrella to keep their place and go back to the car to wait—winter and summer. I've seen as many as 250 automobiles lined up on the shoulder of the road on both sides and people walking half a mile to get to the shop. It was a mad rush when we opened. Sometimes there would be five or six people together. Some of them in the bunch wanted pottery, brought the rest to help. They would fill boxes, take them to the counter to pay, then sit out back and pick out whose was whose. By ten A.M. there was nothing left on the shelf.

In 1971 highway improvements forced them from the site. Arthur fought bitterly against the move but ultimately rebuilt the shop a few miles away, where it now stands.

You can't pick up kilns and wheels and stakes overnight and put them down again when you're seventy-seven. Thirty-seven thousand dollars is a measly, piddling sum for a man who has his entire life work, generations of know-how, and all his business at stake.[1]

Their clay comes from a big vein in Smithfield mined by the Coles for the past fifty years. It is bluish gray with streaks of white and red, which mixes as an earthenware clay. Twenty tons are dug and delivered each year. Clay to be prepared for turning is brought into an enclosed shelter from a covered pile outdoors and set on the ground by the mill for soaking. Old clay, hardened over the years, has formed into the shape of a bowl around the rim of the soaking area. In this bowl new clay is sprinkled, chopped, and left covered for a week or more, to become moist and ready for the mill. Inside the mill, designed for brick making, is a series of increasingly fine screens to clean the clay, which is recycled five times. The mill, purchased in the late 1930s, replaced the slower mule-driven mill; it is run by an electric motor, with a belt attached to a large wood wheel. If the pit clay sticks in the mill because it is too wet, the Coles "sprinkle a little flint or feldspar to make it catch up."

During the late 1930s, Arthur purchased three wheels of a type used commercially in Ohio and converted them for his own use. The one he turned on had been a jigger wheel. The counterweights were removed on the other two wheels, which are still in use, and were replaced by metal from a steam-engine governor obtained from a railroad repair shop in Seagrove (see illustration, p. 51).

Neolia and Celia glaze pots in the kiln room behind the clay area. Twenty tubs of glaze sit on the floor, sixteen of which are used regularly. To dip the pots in the glaze, Neolia sits on a little stool, kneels, or squats in front of the glaze tubs. The

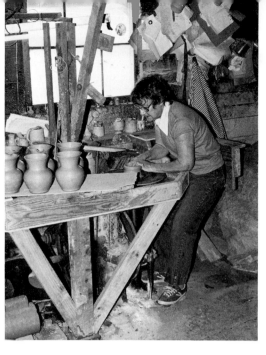

Neolia Cole Perkinson at the wheel.

Celia Cole Perkinson

variously colored glazes are melted with frits in a range from C/03 to C/4. Many of the glazes now used were first developed by A. R. Cole first for wood, then oil firing. The range of temperatures to which the glazes are now fired is the result of the uneven burning in the oil-burning kiln. Sometimes there was a difference as much as 260 degrees Celsius within this kiln. Glazes, therefore, were designed to mature at various heat levels. Today these same glazes are burned to their particular temperatures in separate firings of the electric kilns. They began experimenting with electric firing in 1977 and find their glazes improved and costs reasonable.

Many of the pots made today are smaller versions of shapes developed in the 1930s.

> We looked at magazines for forms, some. But also we had a lot of people come that had in mind what shape they wanted. They'd describe it and they'd watch as we formed it on the wheel. They'd maybe tell us, "No, a little bigger here, a little smaller there." I still do that. We adjust what we make to what goes out.

They have added several pitchers, a tall candleholder, tumblers, and a jack-o-lantern. Celia produces miniature pitchers, jugs, bowls, and tea sets; their youngest brother, Winfred, makes miniature animals. On the bottom of a pot she has made, Neolia sometimes writes messages in the damp clay, such as, "Snowing Today," and "To have friends, you have to be a friend" or on jack-o-lanterns, "Formed and shaped by the hands of Dr. Neolia Cole."

Cole Pottery
Sanford, Lee County, North Carolina
Earthenware; local clay
Feldspathic and fritted glazes
Commercial kilns; electricity; 930°C–1,095°C (C/03–C/4)
Kitchen and tableware, including casseroles, pie
 plates, teapots; jardinieres, vases, umbrella
 stands, jack-o-lanterns

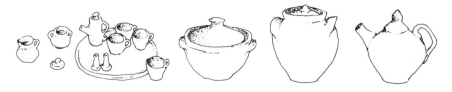

Note
1. A. R. Cole, interview, *Raleigh News and Observer*, January 21, 1972.

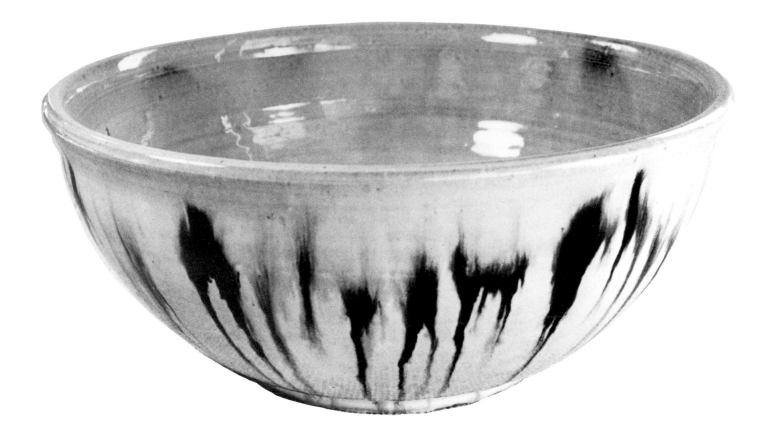

G. F. Cole Pottery

Stoneware punch bowl with white-and-rust glaze made by G. F. Cole.

G. F. Cole (born 1919), called variously General, Foister, or, by his wife Peggy simply Cole, is a fifth-generation potter, son of A. R. Cole and brother of Neolia Cole Perkinson and Celia Cole Perkinson.

As he grew up Foister worked up clay and watched his father at the wheel and wanted to turn. He began at age nine. To use the shop's only wheel, Foister had to raise both himself and the treadle by doubling the chain, "kind of like an old cow chain holding it up," and pegging two links together. Then, by standing on a box he could kick the treadle and reach the wheel head. His father never showed him how to make pots but would select certain pieces that Foister had made and burn them.

> People were bragging on you, you know. That's what got me going. It didn't take me long to learn. I had more problems learning to ride a bicycle than I did learning to turn pottery. It was so easy for me, I just couldn't understand why everybody couldn't do it.
>
> After a year, when I was ten, it got so I had to turn so much pottery after school to help fill a kiln. My younger brother Truman saw what was happening to me so he just helped load kilns, and when that was done he could ramble the creek banks, which I wanted to do too, but the turning never ended.

In two to three years Foister was making pots fourteen inches tall, and by age eighteen he could turn twenty-inch vases and the very large pots in two or three sections. He worked full time at the pottery after high school until he went into the air force during the Second World War.

During these years Foister was active in all aspects of production with his father: making bricks, building kilns, developing glazes. What gave them the most problem in the groundhog kiln was the possibility of the arch spreading out.

> But it wasn't the brick giving way. We'd cut a couple of big oak trees, we never did use cedar, which would have lasted longer. We laid the trees down beside the walls of the kiln, filled in the space with rock. Outside the trees you would drive cedar posts, anchor them down in the ground to hold the logs in position. You make this backdrop before you start your arch going over. In a couple years the wood would rot and let your arch sag down, and you'd have to turn a new arch.
>
> You had to keep the whole kiln area dry under a shelter, and you cut a ditch around your kiln to keep the water away. What happened—everybody gets relaxed or a little lazy—water was coming in against the log. Maybe in half an hour you could have prevented that, but you didn't. You seen it and just walked by. Many of a time I've had to dip water out before I could even start firing the kiln. Sometimes the firebox would fill half way full of water.

In the early years three-quarters of A. R. Cole's production consisted of large decorative pieces; even the small pieces, such as baskets and candleholders, were decorative. Tableware, including sugar bowls, teapots, and "dirt dishes" glazed with red lead, was also made. When it was time to rebuild the kiln arch, they would "catch it before it fell" with a couple of salt burnings. Any salt that built up on the walls was fumed off in the next bisque firing. Foister says of his father, "He did that

187

[the salt glazing] to bring memories back to himself, because when he came up, that's all he knew." Once, however, they did not catch the arch before it fell in.

> *To unload the kiln daddy would go in first and break the pots loose from the flint stone bed, he never did trust us to do it. It was a long ware bed, and you stayed on your knees bent over under the arch. In the front he'd hand pots to somebody in the firebox, who handed them on to another person outside. After he got back aways, somebody would crawl up on the ware bed behind him till there was a line of four people getting it out. Once daddy was way in, my brother behind him, me in the firebox, another outside. All of a sudden that crown gave way and fell in on me and my brother right up to where daddy was and stopped. It was quite a weight, but of course it crumbled around us. I raised up through it and my brother did too. He looked at me and said, "I'm not hurt if you're not." We've laughed a lot about that. It didn't break many pots because it was mostly emptied.*

Foister's father taught him about glazes. Potters who successfully made the transition to earthenware learned by trial and error the complexities of low-fire glazes. A. R. Cole's interest in learning did not stop when he had some workable glazes.

> *He experimented with colors and chemicals other than for necessity. He did it because it was just a pleasure to do certain things. I always liked it, too. You'd take a piece of bisque pottery that maybe was cracked, break it into little plaques, and attach a wire through them. Put some mixture you wanted to test on with a brush, and sometime after the fire was at the last stages you could just gradually ease it down into the kiln through an eye in the crown. The glaze would melt and you'd take it out and look at it. If it wasn't melting enough, he'd add more flux. When he got it about right, he'd add color. He'd have two to three poles with tests on them hanging into the kiln—looked like fishing on a river bank. He made the mix-up with little pinches, and he knew how many ounces that would mean when he mixed up the batch. He'd scratch on the soft bisque with a nail to give himself some clue what he had done. When he got it settled, he'd write it down, sometimes on the wall, sometimes on paper, just what happened to be around. Mostly he did his figuring and kept his formulas in his head somewhere or another.*

G. F. Cole watches his father, A. R. Cole, turn a pot, c. 1937.

The Cole shops have always had earth floors. Foister, who now works on a wood floor, says of the old surfaces, "You don't feel comfortable on anything else." The Seagrove shop was a log building off the main road and had no electricity. Most work was done during daylight, and the Coles rose from bed early to make full use of the sun's light. By each wheel was a tiny window.

After the war Foister worked again with his father until 1959.

> *Then he and I got too near alike, I think, so I went to work at a local textile-machine manufacturing company, and they moved me to South Carolina where I stayed to the last of 1977. But I'd still make pottery, too. I had me a wheel in the carport.*

He continued to make low-fired ware but also experimented with higher firing and soon moved permanently to a stoneware range that burns 1,190 to 1,225 degrees Celsius (C/6 to C/8).

Foister and Peggy returned to Sanford on retiring in 1977 and built a shop where he now produces familiar Cole shapes at those low stoneware temperatures. His clay body is composed of equal parts Kentucky clay purchased in powdered form and clay dug from the family pit in Smithfield.

We'll never use it up. It'll be there when we're gone, our children, their children. It's back down off the Neuse River. I've been told a wagoner found ▮ *He was hauling somewhere's in that area for a Hancock who made pottery down near Smithfield.*

Foister believes that commercially processed clay lacks strength.

The hammer mill beating the [commercial] clay makes it hot, which maybe changes the molecules. I make a ball of clay out of what I buy and another ou▮ *of the pit clay, and it's just altogether different. You need the pit clay with th*▮ *other to make it stand up.*

His pit clay is stored in a wood container. To prepare it, he puts several hundr▮ pounds in a vat, sprinkles it with water, and lets it soak a week or two until satu- rated. He runs this clay slowly three times through a screening pugmill, adding t▮ powdered clay into the hopper until he attains the proper consistency. He can use▮ directly from the mill.

The fingers on the mill don't do a lot of scrubbing together of the clay. They ▮ *slice it like knives, so no heat is built up from friction.*

By adding powdered clays he can vary the body for use with a particular glaze; for instance, he adds a heavy iron clay when he wants a redder body. He blocks the c▮ in twenty-five pound chunks and wraps them tightly in plastic. He turns at a modern electric wheel, using a gauge and a wood chip.

He makes a range of cooking and tableware, jugs and jars, and some special pieces including a hummingbird feeder. The ware is glazed in a variety of colors f▮ three base feldspathic and Gerstley borate glazes. Other glazes are used on specia▮ occasions, for example a chrome green at Christmas. He fires in electric kilns pre- ferring the middle range, C/6 to C/8, because he can achieve the brilliant colors associated with earthenware in this more durable ware.

I always overfire them to C/7 or, if that's not enough, to C/8. The kiln shuts ▮ *automatically, and I've been turning it back on for thirty to forty-five minute*▮ *If the glaze has got a weak look, I don't like that, I boost it on up there.*

The small turning shop accommodates two electric wheels, a wedging board▮ desk, some shelves with books, papers, and pots on them, and a comfortable chai▮

G. F. Cole at the wheel.

Peggy Cole trims a "Roman" pitcher.
Photograph courtesy Randolph Technical College.

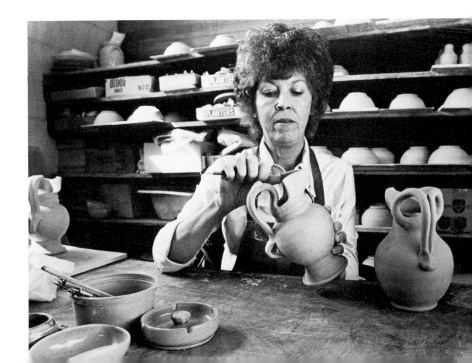

The pottery is dried on shelves in the adjacent kiln room, where glazing, kiln loading, and firing are done by Peggy Cole.

Their son Ray Cole has recently moved back to Sanford and is taking up the trade with them. Foister says:

> *Of course, I'd like to be able to just make pottery without thinking about an order or other things, where I could just actually lose myself in it. But you really can't do that and make a living at it.*

Many potters who grew up digging clay, kicking a wheel, and firing a kiln with wood express a nostalgia for the old way of living and working, among them G. F. Cole:

> *If I had my time to live over I would be in an old log building somewhere or another. I'm not sure if I would have an electric wheel or not.*

G. F. Cole Pottery
Sanford, Lee County, North Carolina
Stoneware; local clay
Feldspathic and fritted glazes
Electric kilns; 1,210°C (C/6–C/8)
Cooking and tableware, including bowls, soup tureens, pie
 plates; jars, jugs, hummingbird feeders

Evan's Pottery

Earthenware casserole with brown flecked glaze made by Evan Brown.
Photograph by David Jones; courtesy Randolph Technical College.

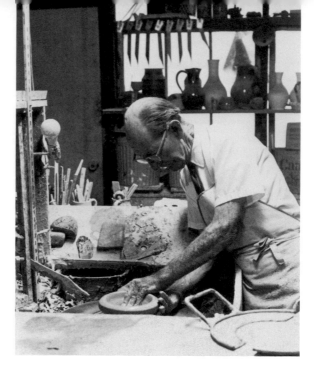

Javan Brown at the wheel.
Photograph courtesy Mercedes Brown.

Evan Brown (1924) represents the sixth generation of the peripatetic Brown pottery family. His father, E. J. (Javan) Brown (1897–1980), worked in the family pottery in Forest Park, a suburb of Atlanta, and turned at many potteries in North and South Carolina, Georgia, Alabama, and southwestern Florida. Evan and his two sisters attended six or seven different schools as the family moved from shop to shop. Evan first learned to make utilitarian Albany-slip and Bristol-glazed stoneware. Although he never produced salt or ash glazes, he did work with all kinds of kilns, including beehive, bottle, and the tunnel kiln.

> *That's what I thought a groundhog was. I'd never seen one you had to crawl in before I saw those at Seagrove. If your clay will stand stacking, no use to have it so low. We would wipe the bottoms and tops of pieces and turn one churn upside down over the bottom of another with a beer mug or pitcher under it, top it off with jugs and churn lids. We made some good cooking ware with stoneware clay—beanpots, Yankee pans [a pan with a wide rim that stacks well].*

As early as Evan can remember, he worked around a pottery. He learned ball making first. By age seven, he was turning rabbit crocks, and by age ten he was making all types of ware except churns. His principal instructor was his father: "If I'd get into something I couldn't handle, he'd just put his hand on it and show me how to do it."

During the late 1930s, Javan and Evan worked at the Bower Pottery in Atlanta, where artware, such as large oil jars, was made in two-piece molds.

> *The jars got to coming apart at the joint. Daddy was running a jigger machine and said, "Why don't I just turn those things for you?" They were amazed anybody could turn oil jars that big, [so] they put up a potter's wheel and that ended his jiggering.*

After high school Evan joined his father and Uncle Davis at the Brown shop in Arden where he made the molds needed for the French-type cooking ware Davis was contracted to make. When he returned from the air force after the Second World War, Evan worked at the old shop at Forest Park and made churns and rabbit crocks.

> *I used to sell to a jobber, who sold them to the wholesaler, who sold them to the hardware, who sold them to you. We made churns by the tractor trailerload down there. Churns didn't just up and stop.*

Both Javan and his brother Otto steadily made building materials sold directly to hardware stores: thimbles, chimney tops, and "city bottoms" (flue liners with a

flange to fit into a ceiling above a stove). The chimney top was T-shaped, made in three pieces cut and worked together, "the two top pieces kind of drooped, so it wouldn't rain in." At this time, they also went on the road to sell. According to Evan's wife, Mercedes, Otto could sell anything:

> We had a '49 Lincoln, big car, filled with pots. We drove through this small town in southern Georgia. Uncle Otto hollered out the window, "Pots for sale, get 'em while they're hot." We sold to hardwares and lumberyards. We'd drive up, and Otto would go in and say, "Cap, where do you want me to put this stuff?" "What stuff? I didn't order anything!" "Yeah you did, and I brought it." It usually worked.

The family moved from Atlanta to Skyland, North Carolina, to be near Davis Brown in 1955. Evan spent six years clearing land and building a home, wood-burning kiln, and shop buildings. When the pottery was ready, he started making Albany-glazed churns and feeders. Javan, his brother Otto, and Otto's son Jimmy were occasional turners for him, and Mercedes was a working partner, putting on handles, glazing, and selling.

> She kept after me about trying colored glazes. I was always crazy about glazes, always mixing up some kind of concoction.

In the early 1960s, he started mixing glaze tests in small Prestone antifreeze cans.

> There was no definite switchover, it just kinda worked in and out as time went on and the market changed. I worked color glazing in with whatever we happened to be doing. We didn't switch to a lower temperature or different clay all of a sudden. Finally, I stopped making churns.

In 1970 Evan began using natural gas rather than wood fuel. Mercedes remembers:

> It got to where we couldn't get the wood. They'd promise and wouldn't bring it. Once Evan started firing, and we wound up with not enough wood. It was three A.M. when I got up and the wood was gone, and the kiln wasn't hot enough. He was tired from coming off the job twelve hours before [for thirty-two years, Evan worked as an air-traffic controller] and didn't know what to do, so I had the idea of taking the wood he had for building down from the rafters where he stored it. It just took a couple of good firings of the dry pine, and the temperature went right up there. We burnt up the building boards, but we didn't lose the kiln. It takes a long time to make a kiln of ware that big. One time Otto's kiln fell in while he was firing. They were having a pretty good time and went right on firing it. They saved part of it . . . you just don't lose a kiln.

Evan used local clay until his source ran out in 1981. He has since found locally only small deposits, most of them too sandy. He once followed a gold prospector because the man had told him that he was running into clay while digging a stream.

> Clay right out of the ground works better. It's got life in it. The other [commercial] clay, they calcine the life out of it. They dry it in those rotary kilns, and that calcines the fine grains in the clay, changes the nature of it.

Evan expects to find a source of natural clay in Alabama, but meanwhile he blends three powdered clays shipped from Tennessee. This mix is suitable for medium-size pieces but lacks the strength of the local clay for very tall or fat shapes. The mountain clay he has used is strong but so plastic that he must add kaolin or fireclay to reduce shrinking and cracking.

Evan built a clay mixer, following the design principle of the mule-powered mill: an upright shaft with pins is surrounded by a barrel, with gears on top to turn

Clay mixer with pugging extruder

the shaft. In this mill he drymixes commercial clays and then adds water. The crumbly moist clay is compacted and squeezed through a tapered end directly onto a wedging board. When he prepares natural clay, it is beaten in a hammer mill, screened, and then carried by an auger bit to the top of the mill. It is dropped in the mill and mixed with water. Evan's wheel is a 1917 Patterson friction drive with variable-speed control.

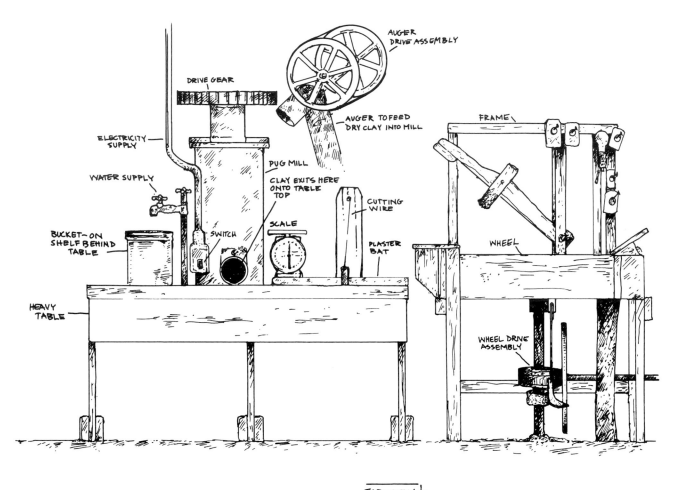

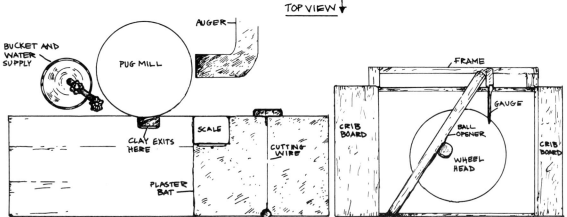

Evan Brown, the author, and Mercedes
Brown in sales shop.

*It was made for churns. I bought it during the war, on leave from flight
training. This shop that daddy and his brothers worked at during the First World
War burned down. They were selling everything for scrap iron, so I hired a
truck, went up there, and bought the clay mill and two wheels for junk. Had to
rebuild it because the discs were warped and the bearings burned out. It was
originally designed to use a line shaft turned by steam or gasoline motor, so it
had a clutch on the wheel, which I removed and put on a small electric motor. I
never used a treadle wheel again, but I've got daddy's old one and Uncle Otto's,
too.*

Evan weighs his clay and measures the height of turned pieces with preset gauges
made of locking metal shelf brackets; each bracket is cut to a different length for rim
diameter measurements and numbered according to the piece being made. He has a
supply of lifters of many sizes, which he uses to shift pots from the wheel onto indi-
vidual bats.

The two basic glazes used at the pottery are modifications of a Bristol stone-
ware glaze. With these glazes, metal oxides, stains, and various methods of applica-
tion, a considerable range of color and texture can be achieved. A dark Albany-slip
glaze is also produced. The pots are bisqued to C/4 in the large gas kiln, then dipped
in glaze, sometimes twice. They are currently glaze fired to 1,190 degrees Celsius
(C/6) in small electric kilns. Evan has designed and is building an all-fiber, electric,
envelope kiln with two ware beds and a movable frame. The ware beds will be two
by four by three feet; one bed can cool and be reset while the other is fired. Twelve
small ceramic tube burners will fit under each bed.

Evan has taken courses in ceramic engineering at Clemson State University
and continually experiments with tools and equipment. He admits that his book
learning has helped him understand technical aspects of the process and solve clay
and glaze problems. He strongly believes, however, that there is no substitute for
experience.

There are always options open to potters who have made various kinds of wares
at different times in their lives. Mercedes says:

*He knows so much from being raised in it. He was at so many places when he
was a little boy. He gets this dream of going again. Lord, he's on one of those
dreams now. . . . He wants to make these big, tall pieces again.*

Evan's Pottery
Skyland, Buncombe County, North Carolina
Earthenware; local and commercial clay
Bristol-type glaze; Albany-slip glaze, with frit.
Envelope, fiber, kiln; electricity; 1,190°C (C/6)
Kitchen and tableware, including pie plates, mugs, lasagne
 dishes; vases, urns, umbrella stands, water coolers
See also John A. Burrison,
 Brothers in Clay

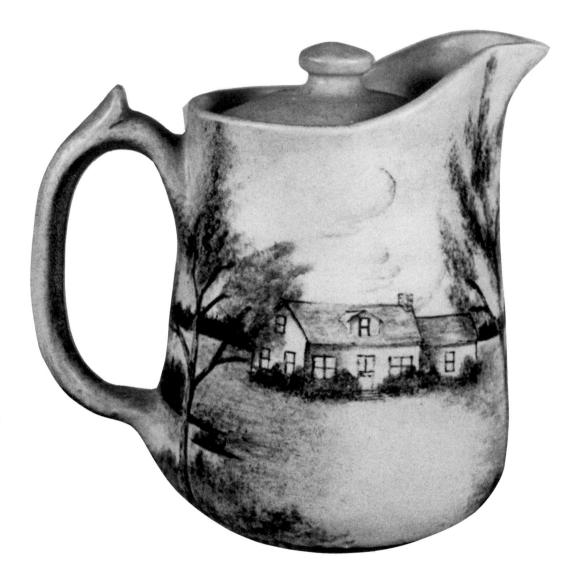

D. X. Gordy Pottery

Lidded porcelain pitcher with brushed decoration made from local minerals made by D. X. Gordy.

D. X. Gordy (born 1913) was raised around the large-ware pottery run by his father, W. T. B. Gordy, in Meriwether County, Georgia. He worked in that shop and at his present site with his father until the senior Gordy died in 1955.

> *Hardest thing I made was two vases 4½ feet tall. Took seventy-five pounds of clay to turn. I got one up as high as I could, then my dad kicked the wheel and I stood up on the wheel crib and finished it. The last big pot I made was at Westville, a fifteen-gallon jug in three splices . . . sixty-five pounds of clay. To make those great big ones you have to splice it because the pressure you're putting on the clay. The bottom, as you come up, has got to be thinner and will collapse if you don't make it in sections.*

After his father died, D. X. began making smaller wares.

> *As far as tradition is concerned, I think I got as much from my mother, more in lots of ways. She didn't know anything about pottery till she married my daddy. She loved to draw and do all kinds of needlework, but when she married she had to work in clay. I'd say my art came from my mother, and my beginning—the way I do it—came from my daddy.*

D. X. has always liked to draw, and one day he decided to paint scenes on his pots. He has since developed the technique as a part of his unusual work with glazes. For years he has been making glaze from materials he finds near his home. He says, "I used to get rocks when I was a child and put them in daddy's kiln." All the materials needed for his glazes and clays can be found within one hundred miles of home, but D. X. prefers to purchase powdered feldspar, silica, and calcium from Georgia. While he considers the forms he turns to be "blanks" for either decoration or glaze, they must be suitable and well-turned shapes.

> *I've always been inspired by Greek art and architecture. For proportion and balance, they were the best in the world. Even the old jugs I tried to give a well-balanced shape. I didn't want to just throw it up. Then also I was influenced by Chinese and Korean glazes. But, first, mother nature is my teacher. There everything is in perfect form and balance. Course, the way we're cutting trees now we get 'em distorted. I also love the work of American Indians and Egyptians . . . add all that together.*

D. X. says he would never give up the old methods. He works with equipment that he has built: a treadle wheel, clay mixer, rock pulverizer, and glaze mill, for which he made the porcelain stones that grind the glaze. His ware is burned with wood in a kiln he designed and built.

His clay is a porcelaneous off-white stoneware. Even when mixed with nonplastic materials (flint, feldspar, whiting), the clay portion of the body (forty percent Georgia kaolin and ten percent ball clay) provides sufficient plasticity to make the batch a good, turnable clay. D. X. washes the mix, screens it through a piece of cotton organdy, siphons off the separated water after twenty-four hours, and spreads the moist clay out to evaporate on shelves in the shop and tables in the adjoining house. He prepares enough for one kiln—about 250 pounds—and has found that aging does not improve it.

He works the clay by hand, kneading and wedging it before turning. He uses his pugmill for the rougher sagger and wadding clay (used to separate saggers), which he digs locally, and mixes about forty pounds for each firing. He can turn two hundred pitchers and other "bread-and-butter" pieces a day, but he uses his time as he

Centering

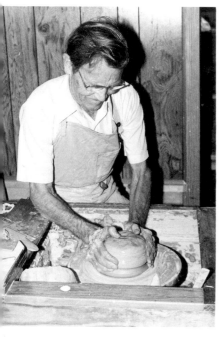

Opening

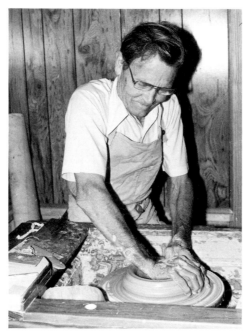

Beginning to pull up clay

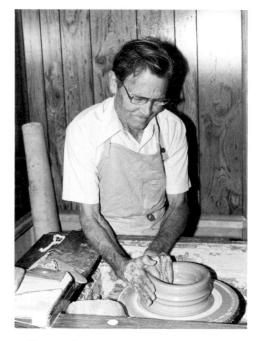

Pulling up clay

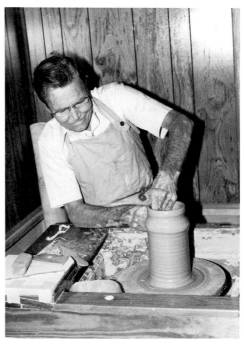

chooses: he may make a vase one day and take all the next day to decorate it. Before a pot is completely dry, he "turns out" the bottom by inverting the pot and tooling it to make it concave.

For glazing and painting his "found" materials are common Georgia red clay; white kaolin; mica; white and black iron sand; bauxite (an aluminum hydrate); a "no-name" mineral (high in silica with potassium, magnesium, and iron); manganese; and three sources of iron, limonite (an iron hydrate), ocher, and magnetite (an iron concentrate).

> *I don't always know what I'm using, just what it will do. The ancient Chinese were doing it that way, and neither one of us know exactly what we're doing. You get more surprises that way.*

He also uses cattle bones, because they are readily available and contain less iron than other bone ash, and sometimes wood ash from hardwoods burned in his kiln, such as oak, hickory, and beech. He avoids pine ash as his experiments have proven it to produce a rough-textured glaze. He once burned his kiln with corn cobs, and the resultant ash used in a glaze produced a handsome silvery gray, but the kiln burning involved so much labor he has not repeated the experiment.

> *I don't use many ash glazes because it takes so much wood to make enough ash. There are so many trees I don't want to burn just for the sake of getting the ash. I can get the same minerals from rocks and I'd rather work with them. I get results, when I grind rocks, from things I don't even know is there.*
>
> *The high temperature makes your glazes and body all one. My glaze formulas are really part of my clay formula. I like the oneness of things.*

He obtains copper by grinding wire into filings, mixing one part filings to two parts sand. He calcines the mixture in his kiln and uses it in a red glaze.

Shaping with rib

Pulling in neck

Finishing neck and lip

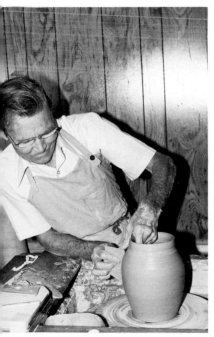
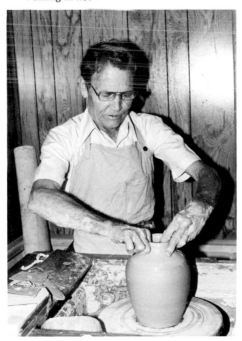
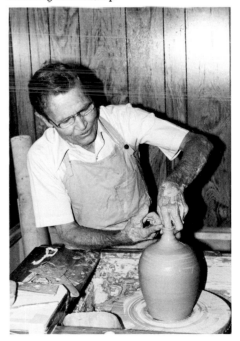

D. X. uses many combinations of minerals to make his glazes, but they all have a feldspar base. The brown colors all come from limonite, sometimes in combination with locally found manganese. Limonite is also used to temper the blue of cobalt oxide and produce celadon greens.

To prepare minerals for use in glazing or painting he crushes rocks, then washes, calcines, and grinds them to a powder. Sometimes he paints on bisque ware, fires it a second time to secure the paint, and a third time to glaze it. He also paints scenes directly on raw ware, adding a little glaze to the color, which then fuses in the bisque firing.

What I paint with is almost a monochrome, one color brown with different values. My scenes are not sharply drawn. First I paint everything in, then cut away to the finest lines. The decoration goes all around with no beginning or end. It may be an old mill, a covered bridge, a log house. When I'm putting so much work on it, I have to be selective. I use bowls, plates, vases, wine or tea sets. Sometimes I use a translucent mat glaze, and it's a bit hazy, like looking down through water. Sometimes I do the scenes without any glaze and burnish the colors after firing with fine aluminum sanding paper. I paint the natural scenes that we don't see much of any more and I think by doing that I'm preserving something. I also do inlaid and embossed decorating.

The wood-fired kiln has a four-foot-square ware chamber. D. X. believes the square shape provides optimum heat circulation. Heat is pulled to the center of the kiln and drawn below the ware bed through a tunnel leading to flue openings and the twenty-foot chimney.

You want to build your kiln to make the fire work very hard to escape. You build it tight and you make small flues inside the kiln for the heat to squeeze through. At the same time you have to pull it through. The smaller you make your inside flues, the taller you have to make your chimney, and this is the way you get it the hottest.

Also, in building a kiln you don't want to build any joints together. Build the walls each separate and the chimney separate or tie them very loosely with brick. Then the kiln will expand without cracking the brick. I have angle iron around the kiln walls and way down in the ground, and they're tied together with steel rods. You want the walls strong—after all, they support the arch—strong but flexible. When the walls expand and I can see a little fire through it, I fill in those cracks with mud as it expands.

The brick in this kiln my dad and I made in 1935 and we moved 'em here in 1936 and built a crossdraft [groundhog] eight by twelve feet. Later I tore that down and used what brick I could salvage to build this. It's a single ten-inch wall. A single old brick is laid crosswise, then two on top going the other direction. I used new small brick to tie in the big ones, and I used red clay— from where I dug out to build the kiln—and sand for mortar to not let air go through the walls. I thought I was designing something different when I built this kiln. Later I found one in a book just like it built in Dresden, Germany, in the fifteenth century.

The firing chambers are built out slightly in front of the kiln face and extend to the back wall parallel to the ware chamber on each side of the kiln. They have upper and lower doors. The fires are stoked through the lower door for fourteen hours, thereafter through the larger doors; increased draft enters beneath the burning wood.

D. X. loads the ware in saggers, which have no ventilation holes, stacking them with a roll of wadding clay around the rim (like a thick mortar between brick), which helps to set them level and prolongs the life of the sagger. He then seals and

preheats the kiln for one day and into the night, "until I think it's about bedtime." If it is a bisque firing, it will reach 980 degrees Celsius (C/07) in fourteen hours; if it is a glaze firing, it will be burned for twenty-five to thirty hours after a day of preheating. He keeps the fire oxidizing as completely as possible until the glazes are mature or fluid. Then the air supply is decreased, and wood is put in more often but in smaller quantities for an hour, which results in reduction of the glaze. At the very end, D. X. gives the fire a good stoking to reoxidize the surface of the glaze to create a subtle blend of color.

> *When I'm burning coal, I like to finish up with wood for the last thirty to sixty minutes. One time, burning coal, I didn't have enough wood so I cut the tops from some little pine trees growing around, threw them in the kiln, then sealed it up completely. I got some of the most beautiful copper reds.*

D. X. does not use cones. From a test in which magnetite melted, he believes his kiln reaches a temperature of 1,540 degrees Celsius. When the glaze on trial pieces drawn out with an iron rod is melted and the firing is finished, he fills any cracks showing light with the daubing mud, seals the fireboxes tightly, and lets it cool for two or three days. In his opinion slow cooling toughens the glaze as annealing toughens blown glass.

> *I give my kiln credit for my glaze making. I sometimes get the feeling there's something around helping me. I believe knowledge goes on and on and something from along in the past is telling us. . . . We do too many things exactly like somebody else was doing it.*

D. X. has taught pottery in the classroom, at workshops, and to anyone who seeks information from him. Intermittently between 1969 and 1974, he worked at Westville, a restored village in Lumpkin, near Columbus, Georgia. While there he built a traditional pottery and groundhog kiln for the production of salt-glaze ware and made brick for the rebuilding of the village. D. X. speaks of his craft:

> *We've had a lot of potters [in the South]. All this tradition business worries me a little. I think all the bad traditions should be thrown in my kiln and burnt up, and all the good ones kept.*

D. X. Gordy Pottery
Greenville, Meriwether County, Georgia
Porcelaneous stoneware; commercial clay
Feldspathic glazes, containing local rock minerals,
 some with brush decoration
Square, brick kiln; wood and coal; c. 1,540°C
Vases, jars, pitchers, bowls, wine sets, tea sets,
 plates, mugs
See also John A. Burrison,
 Brothers in Clay

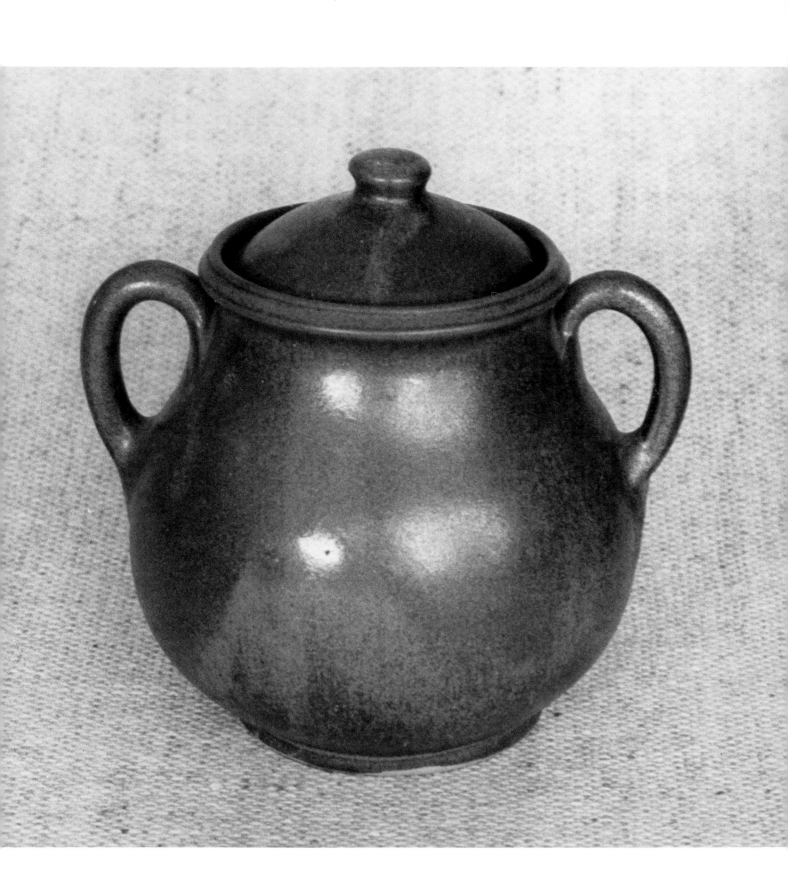

W. J. Gordy Pottery

Stoneware sugarbowl with brown glaze made by W. J. Gordy.

The Gordy family emigrated from Scotland to Maryland and traveled by covered wagon to Hancock County, Georgia, where they settled in 1789. W. T. B. Gordy, father of Bill (born 1910) and D. X., took up pottery in 1907. He learned the craft from his mother's family, the Bishops, who had been potters in Thomaston, center of Georgia's Jugtown area, since the 1840s. W. T. B. Gordy learned the craft in the Bishop Pottery. Bill's cousin Curtis Bishop (1892–1961) was one of the last Jugtown potters. Bill describes his early years:

> *I was born and raised in pottery in Fayette County, which is now part of Atlanta. We moved from there to Meriwether County for better clays when I was twelve, and made domestic ware, like churns. Daddy worked Albany and a Bristol glaze and had a large kiln—about two thousand gallons—which took four to six cords of wood to fire. Then wood cost two dollars a cord and a five-gallon jug sold for $1.25. Oh, Lord have mercy, my daddy used to take out a kiln of Albany sometimes and just sit and admire it. He was always a slow firer, didn't believe in rushing his kilns. I learned a lot from him, especially in firing.*
>
> *[Earlier] he'd do worlds of sand and ash glaze, with different kinds of wood ash. Some woods carry more iron. You can make an eggshell white out of orange trees. Oak is high in iron, pecan is a little less. The further south you run into less iron, especially in Florida. Pine is the worst for your ash glaze. I run some [ash] glazes yet, it's just a challenge that I feel I want to do. Later, Dad went to [the more brightly] glazed ware and smaller pots, but, he didn't have the facilities or the knowledge of glazes to do what he wanted to do.*

Bill has always experimented with glazes. When the family shop was producing Albany ware, he found that lithium carbonate added to Albany slip gave beautiful yellow streaks to the glaze. When he opened his own shop in 1935, he worked with Bristol and Albany glazes but soon developed the brighter glazes then in demand. From the 1930s to the early 1950s, bright pinks and reds, yellows and pastel colors were popular. Bill succeeded in obtaining the colors at stoneware temperatures in feldspathic glazes rather than by the more accepted procedure of melting the glaze with lead at earthenware temperatures. He fired the ware in saggers in a wood kiln to 1,225 or 1,260 degrees Celsius (C/8 or C/10).

> *But you never saw potters that didn't like earth colors, so when the trend began to switch back it just tickled us to death. My daddy used to like anything in an earth color . . . like the trees.*

Bill left home at twenty-two and worked as an itinerant potter. He worked first at the Reed Pottery near his present location, then for a year at the Hilton Pottery in Hickory, North Carolina, where they glazed with glass.

> *They had a "pounder" to crush glass bottles, windshields, broken window lights. Mixed the glass with a little lime to make it deflocculate and a little clay to hold it together. They were making big urns, some forty inches high, and burning to stoneware temperature by eye. But that was 1932, and the bottom fell out. Mr. Hilton sold ware cheap and had an enormous business, but he was one of the fellows who spent as fast as he made it. My daddy was of that type, too.*

Electric wheel with brass wheel head

Bill left Hilton to work at the Kennedy Pottery at Wilkesboro, North Carolina, where they were making churns, jars, and flowerpots. Florists throughout the state used Kennedy flowerpots, and while there, Bill would sometimes turn in a day more than a ton of clay or about 380 gallons. He was restless, however, and wrote to Herman Cole, owner of Smithfield Pottery. Cole responded immediately, "Come on down, I can use you right now." Smithfield was the largest art pottery in North Carolina at that time, making earthenware vases, dinnerware, and many other forms for house and garden by turning, jiggering, and casting.

There were thirty-six of us working there, seven kilns—one was a bottle kiln forty-nine feet high [see photograph, p. 77]. He had four of us potters, and all we did was turning. We didn't work the clay—nothing—whenever it left that wheel we were through with it. Had one man didn't do nothing but make saggers. He had a tremendous business. Every Saturday morning a load of pottery went out of there to Macy's in New York. This was in 1933 and 1934. I worked with Charlie and Farrell Craven there. Charlie could handle the big ones, and he didn't quit at half-done. I enjoyed it fine, but it's a killer. I did my part of it for several years. What I didn't like—it's right on the Neuse River and felt like the humidity was 110 percent. But I made fifty-five to sixty dollars a week, when a cotton-mill hand was making ten to twelve dollars.

He went back to Kennedy's in 1935 and later that year bought the present site. The property was a cottonfield when he bought it but near needed raw materials and

the main road across Georgia from Detroit to Florida, and Bill had his eye on the tourist traffic.

During the Second World War Bill served in the navy for twenty-seven months. He says now, rather ruefully, "Of course, a destroyer is no place for a potter."

For the garden-, table-, and other homeware produced at his own shop, he dug local clay and washed and screened it. In the fall he prepared the liquid clay and dried it outdoors in vats, each holding up to five hundred pounds. The bottom of the vats was covered with an inch of white sand and lined with cotton sheeting.

When the clay began to crack, you take your finger and go in there and line it off. In two or three days you can just lift up each piece. After washing you didn't have to mill it, just wedge before turning. I didn't quit digging local clay and washing it because I wanted to. I just ran out of energy.

Currently he digs some clay—"prettiest clay I ever saw"—in Attalla, Alabama, a site he has used for forty-five years. He adds it to other stoneware and to fire or ball clay. To complete the body of nine ingredients, he adds flint, kaolin, and feldspar, bentonite (for plasticity), talc (for greenware strength and glaze fit), and sometimes Lizella (Georgia) clay for iron. For cooking ware, fire clay is used in the body rather than ball clay.

To prepare the clay body, he dries the Alabama clay, then pours it with water into a Jack Daniels whiskey barrel fitted with an agitator, which breaks up the clay chunks. This slip is poured through a brass screen to catch any roots or stone. Measuring and mixing the portions of powdered clay in a large box, he then adds them to water and the clay slip in his mixing mill. The prepared clay body is aged for three days.

Bill built his electric wheel with a high-sided crib, "so it won't be slinging clay all over the floor and all over myself," and installed a rubber clutch to engage the motor when pushed by his knee to one side. For eighteen years he has used a wheel head made of brass that he prefers to aluminum, which carbonizes, and to steel, which rusts.

They've had power wheels since I can remember. Most were horse-and-a-half gas engines, since the rural potteries didn't have electricity.

For turning tools, he uses formica ribs purchased at electronic supply shops, wood ribs, a gauge, a ball opener, and lifters. To perfect the line of a shape, he trims his pots with a cheese cutter with a stabilizing roller.

He learned glaze chemistry by reading books and by questioning local teachers. He now has two principal feldspathic/zinc glazes: one is lime based, the other borosilicate based. He designed his most popular glaze, Mountain Gold, which has a metallic luster, in 1951 when earth colors were regaining popularity. He also glazes with other colors and with Albany slip for black and brown glazes, claiming, however, that the slip glaze does not work as well as it used to, a frequent complaint of potters who have had long experience with it. The glazing building is across the yard from the turning room, which is attached to his house, and Bill prefers to haul the pots back and forth rather than risk contaminating the glaze with clay. He weighs his glaze materials on a balance scale and then mixes and dips them in the traditional manner.

Until 1950 Gordy ware was fired with wood in a large upright kiln. Since then, most glaze firing has been fueled with gas, although he occasionally used the old kiln "because some of the prettiest glazes I ever made was with wood." He continued bisque firing with wood until 1960. Using gas kilns and pyrometers now, he turns while firing, tending the kiln steadily only during the last half hour as it reaches 1,225 degrees Celsius (C/8). Since Bill glazes his pots so no clay will show at the foot, he sets them into the kiln on clay wads to prevent them from sticking to

Bill Gordy

the shelves. The pilot flame is run all night; by six A.M. when the pots are dry and hot, the main burners are started at medium level, and heat is increased steadily until C/8 is reached at six P.M.

The tableware produced includes a large sugar bowl and a covered butter/cheese dish with a high rim for easy grasp—both shaped after early American pottery forms. In 1959 he started making a red-eye gravy dish, which has a spout opening at the bottom to prevent grease from pouring off the top.

Because Bill worked in so many shops and his father hired turners from the Southeast, Midwest, New England, and Texas, his shapes display a variety of influences. He expresses some nostalgia for the early ways:

> *I don't love it the way I'm doing it. . . . I'd make churns and jugs—there would be a big sale for them—but the kilns I've got are just not big enough to run them big churns. You need a kiln that will hold six hundred gallons. I've kept on telling myself I'm going to build a new wood-burning kiln for salt glaze, but I'm always busy and just haven't done it. I guess I was born thirty years too late.*

In a manner reminiscent of Javan and Davis Brown, Bill Gordy works in a shirt and tie. His shop is unusually tidy without clay scraps and dust. Although Bill and his brother D. X. are alike in that each is focused on refining and perfecting his ware, they have responded to different challenges: D. X. to teaching and Bill to marketing.

> *You cannot go back in the brush and hide. They are not going to find you. When I put the goods on the market the customer's got to know it's good, and he's going to tell his neighbor. Just word of mouth. That little man is mighty good, you know. Up to the Second World War people looked on pottery like it was an aluminum cup, but in the last thirty years there are lots of people that know what goes into pottery, the value of it. I used to tell my neighbors, "I came here for the snowbirds going North to South. One day you'll wake up and buy it, too." And, that's happened.*

W. J. Gordy Pottery
Cartersville, Bartow County, Georgia
Stoneware; commercial clay
Feldspathic glaze
Gas kiln; 1,225°C (C/8)
Cooking and tableware, lidded pitchers, teapots,
 butter/cheese plates, red-eye gravy dishes; vases,
 cutout lanterns
See also John A. Burrison,
 Brothers in Clay

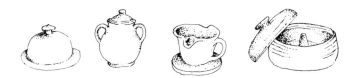

Hickory Hill Pottery

Earthenware batter bowl with blue glaze made by Danny Marley.
Photograph by Glen Tucker; courtesy Randolph Technical College.

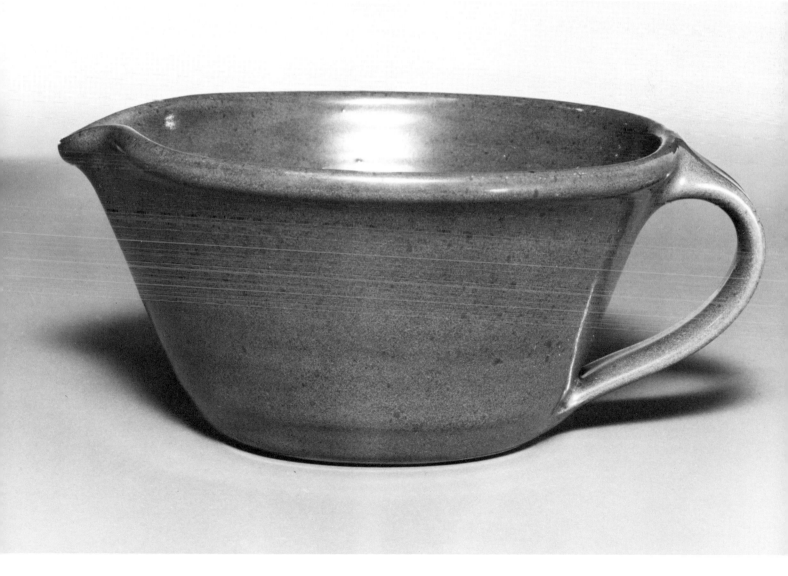

207

Danny Marley (born 1965) dates his interest in pottery from the day he walked up to Westmore Pottery in 1979 and saw Mary Farrell working at the wheel.

> *It was the turning—just that you could take a piece of clay straight out of the ground, turn it, and make something useful. Just looked like something I always wanted to do.*

He continued watching after school, tried the wheel, and the Farrells saw promise in him. Soon he was working for them after school and during the summer, learning to "lay" the kiln, glaze, and mix clay. Mary taught him to turn small bowls and cups, then taller straight-sided crocks and other pots. An apprenticeship grant from the National Endowment for the Arts in 1982–83 provided him with the opportunity to increase his skills in turning large and difficult pieces and in firing. With the help and support of his family he has also set up a pottery at home. His father built a wheel for him after an M. L. Owens design and Danny made a tiny wood-burning kiln (two by two feet by eighteen inches). Encouraged by his success, he has also built a tunnel kiln with a ware bed 3½ feet deep, 3 feet wide, and 23 inches high to the arch. Since 1980 he has burned the kiln with round wood (dogwood, oak, gum, maple) and pine slabs to 1,190 degrees Celsius (C/6) in twelve hours, in a clear oxidizing atmosphere, and also to 1,250 degrees Celsius (C/9) in fifteen hours, in a partly reducing atmosphere for frogskin glaze. The first time he fired it, with Dave Farrell's help, it kept choking up.

> *We fired on it all evening and couldn't even get the C/5 down. We had given up completely. I mean both of us were tired. The shelter had burnt down [previously]. I was ready to tie that thing down and get rid of it completely. But, when we'd give up the C/5s went down while we were just sitting there. We put just a little wood on at a time and it was magic. Them cones started falling, from C/5 to C/9. In thirty minutes it was done. We had been choking it with too much wood.*

By attending pottery courses at nearby Montgomery Technical School, Danny has increased his knowledge of glazes and improved his turning, but he has reservations about such instruction.

> *The name of the course was Production Pottery, but it's not that. I turned a series of cups and mugs, like he asked. I turned them all the same shape and as fast as I could. He came over and said that's not what he wanted, he wanted every one of them different. After that I started just doing what I wanted to and took some of his advice. I didn't like the pots coming out of there, they were more art than they were functional.*

While Danny has developed his own C/6 glazes and forms and produces frogskin stoneware, he has also begun to produce salt-glazed churns, jugs, jars, and smaller pieces.

> *The salt glazes are so simple and look good. I just like the old traditional forms from this area, jugs, pitchers, churns. I think it will come back. People will really see where there is a need to preserve these old [shapes]. We use a churn for kraut and pickles.*

Danny has found clays on the family property, tested them, and found they make a fine stoneware body that salts well. He found a white clay in a nearby field. Although the clay melted down in the kiln when he made a pot of it, he thinks it may be usable in a glaze. He has rebuilt an old hammer mill, purchased a tractor to pull it, and plans to build a clay mixer. He has also bought more used equipment, including a second wheel and an electric kiln for bisque and some C/6 glaze firing.

He works in a small outbuilding behind his family's home and is constructing a

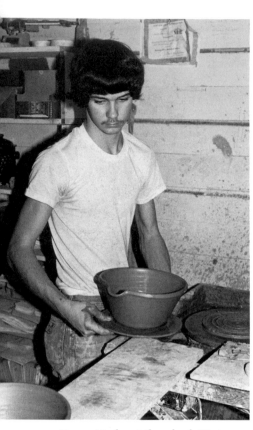

Danny Marley at the wheel. Westmoore Pottery, Seagrove, N.C.

sales and production building from old tobacco barns. Once in a while his friends come to his shop to watch him turn, and he demonstrates pottery making at North Moore High School where he was a student. He is prepared to earn his living as a potter before he is twenty:

> *In this area—the way I look at it—you've not got many choices. You're either going to be a farmer or work in the mill or make pottery. I don't believe I could be kept in the mill the whole day, you never get to see the outside. In pottery you can always get out.*

Hickory Hill Pottery
Seagrove, Moore County, North Carolina
Stoneware; commercial and local clay
Feldspathic glazes, in several colors; salt glaze;
 frogskin glaze
Tunnel, brick kiln; wood, c. 1,260°C (C/10);
 electricity, 1,190°C (C/6)
Bowls, mugs, pie plates, mixing bowls; jugs,
 cannister sets, pitchers; vases, jars

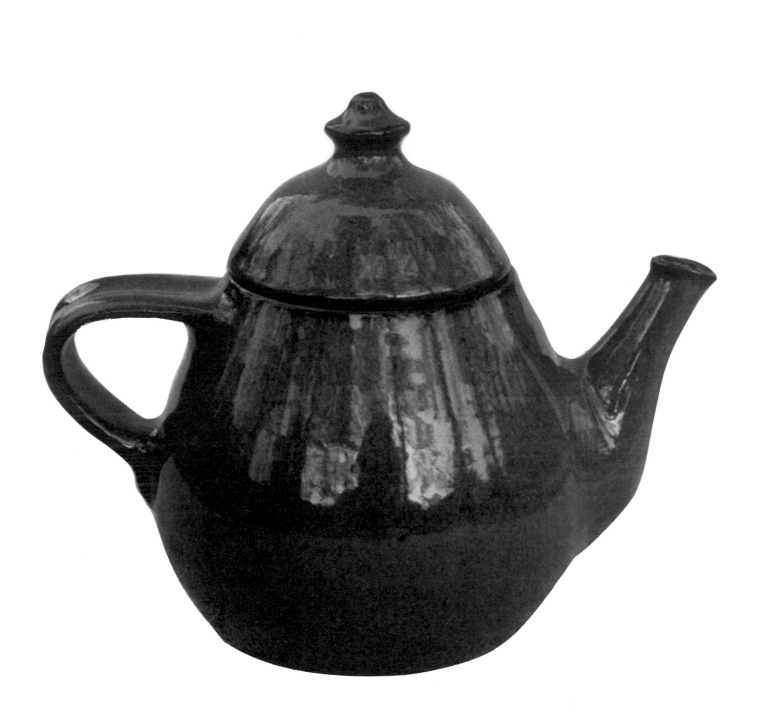

*Clear glazed earthenware teapot made by
Vernon Owens.*

Jugtown Pottery

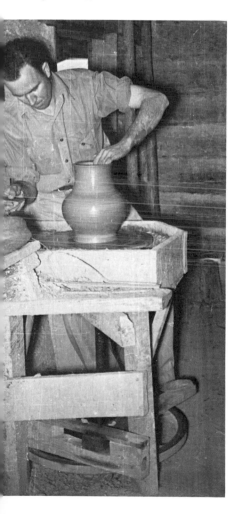

Jugtown was founded in 1921 as a traditional pottery. It has been owned in turn by its founders, Jacques and Juliana Busbee of Raleigh, North Carolina; by a businessman from Long Island, John Maré; by Country Roads, Inc., a nonprofit corporation founded to foster traditional arts; and since early 1983 by Vernon Owens. Son of potter M. L. Owens, Vernon Owens has been the principal potter at Jugtown since 1960.

The Busbees sought to preserve the folk pottery made in Moore and Randolph counties, the salt glazed stoneware and particularly the orange earthen kitchen and tableware, known locally as "dirt dishes." The Busbees became aware of this pottery in 1917, when many of the old stoneware shops had closed. The Busbee's original plan was to purchase pottery from these shops and sell it in New York. To that end, Juliana opened a teahouse in Greenwich Village and Jacques journeyed to Steeds, North Carolina (now part of Seagrove), seeking potters who would produce this ware for them to market.

From the moment Jacques stepped off the train in Seagrove he was suspected of being a German spy, because his clothes, manner, and speech were so alien to this isolated community "in the dark corner of Moore County." Vernon's grandfather Jim Owens had enough courage to work with him, but people said of Jim, "He may not have no idea of what he's in for, he's liable to get into a mess." The two men worked together for five years.

In 1921 Jacques opened Jugtown Pottery around the corner from the Owens Pottery and went into production with young potters. The first potter to turn at the new shop was Charles Teague, followed by Ben Owen in 1923. Charles left eight years later, while Ben continued to work at Jugtown for thirty-six years. Busbee's idea was to retain the essence of simple country pottery while refining it to a purer, more classic form.

After the market was well established and the pottery venture in North Carolina underway, Juliana closed the shop in New York in 1926 and joined Jacques at Jugtown, where they lived and worked for the rest of their lives. Neither turned on the wheel, but Juliana decorated the saltware with cobalt brushwork, and Jacques developed the Jugtown ware by working closely with the potters, defining the shapes they turned; applying glazes; and supervising the firing. Once the production of earthen- and stoneware was established, Jacques Busbee added a number of new stoneware forms inspired by Chinese and Korean pots at the suggestion of the Tiffany Studios in New York. The oriental adaptations were glazed with salt, with Albany slip salted to frogskin green, with prepared white and black glazes, and with a glaze he designed and called Chinese Blue.

For four decades this unusual collaboration between the Busbees and Ben Owen produced a folk pottery of great distinction. Describing a process as well as product, "Jugtown philosophy" became widely known, establishing Ben Owen as a master potter and focusing attention on the area's potteries. Oriental shapes, produced with local materials and traditional turning and firing techniques, were assimilated into the local idiom and soon "belonged" to Jugtown.

Jacques Busbee died in 1947, and the pottery was continued by Juliana and Ben Owen. In 1959 the pottery was closed for a few months, when Ben Owen left and opened the Old Plank Road Pottery nearby. Jugtown reopened under the ownership

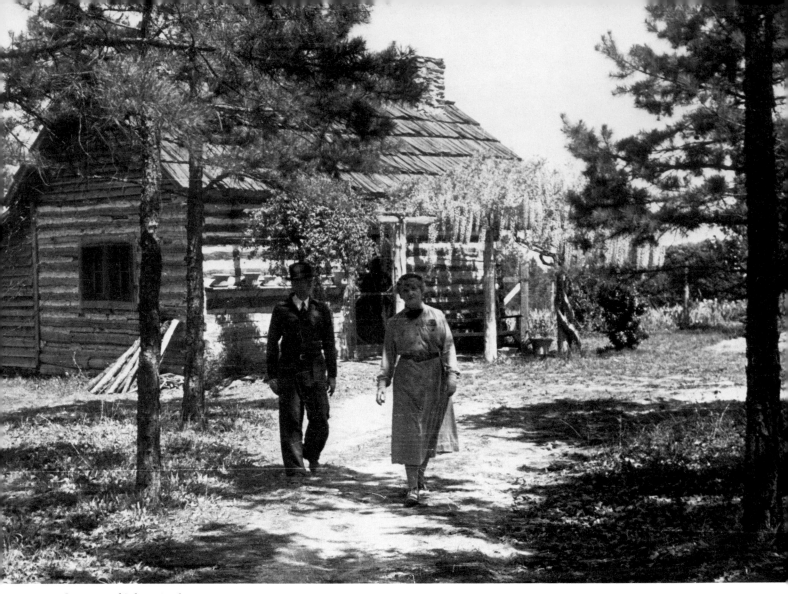

Jacques and Juliana Busbee. Jugtown Pottery, 1930s.
Photograph courtesy North Carolina Department of Archives.

of John Maré in 1960 with Vernon Owens turning and his brother Bobby and Charles Moore glazing and burning the ware. Charles was raised across the road and had helped load kilns at Jugtown during his school years. Mrs. Busbee and John Maré died in 1962, and for the next six years Vernon, Bobby, and sometimes Charles, kept the pottery going through various arrangements with the executors of Maré's estate. Vernon learned to turn the Jugtown ware by studying pots made by Ben Owen.

I just picked up old pieces and weighed 'em and guessed the clay weight, measured them and guessed about the shrinkage. I tried to make 'em exactly like the old pots, and that's where I went wrong. You just can't do that, it didn't come out right. It wasn't enough of me in the pots. Course, I never had made that complicated a pottery either. People around here said the Jugtown pots, the shape, is so simple and all. They do look simple, but it's a whole different story when you go to make them. They are very complicated to make and make look right. You think it looks good, and a year later you see what is wrong with it. Or while you're turning you know there's something wrong with it but [you do] not know what it is. It just takes a long time and a lot of being able to be critical of your own work to ever correct it.

The problem of a piece of clay . . . the pot changes so much from just after it's been turned till it's finished up. Even though it's a uniform shrinkage when it's finished up, the bottom of a pitcher may be too small, the top may be too wide, or the neck not small enough. I don't think it changes, but with the shrinkage it shows up.

At first I just made the old Jugtown shapes. It never crossed my mind that we'd make any other shapes. And what I had on my mind was whether the pot was too thick and what the color looked like. It wasn't till I took it over to run for myself in 1964 that I began to think, "I'm making this pottery and I can't make it exactly like the old Jugtown. I need to make a good pot—similar—but let it be my pot." I can't make somebody else's pot. Nobody did when they was making churns. Everybody had their own shape. That's why there's so many different ones around.

Gradually, Vernon solved one problem at a time and began to make the shapes a little differently, beginning consciously to develop his eye for form.

From the beginning of their involvement with Jugtown, the Owenses continued to work with the local red clay that had been used there since the 1950s, although it had always presented problems: the walls of a pot sometimes split open on the wheel, or, too often, pots cracked in drying or bisque firing. Also, the stoneware clay was difficult to turn and subject to cracking in the cooling kiln.

It was disgusting, but you learned to expect to lose a certain amount of pottery. I don't know why people thought there's nothing could be done about it. If you grow up thinking that is the way it is, then you accept it. It's a funny thing that people have made pottery around here for years and years, and they still didn't have any idea of any technical thing about it. They just dug clay and turned pots. Knowed they could throw salt in the kiln to salt it, knowed they could glaze it with red lead. They did learn to make other glazes with lead later, but they didn't have any idea what it was they were putting into it.

Till the late 1960s I didn't really care that much. It was just a way to make money. You could lose some and still get enough money to eat, so—let it break. I just made pottery cause daddy made pottery, you know, and I didn't put any value whatsoever on it.

After 1968, when Country Roads purchased the pottery, the earthenware glaze for cooking and tableware was changed from red lead to a clear fritted glaze. Difficulties with applying and firing this glaze led to a further, more definite change begun in 1970. Clay and glazes were adapted to the intermediate temperature of 1,190 degrees Celsius (C/6), making it possible to produce more durable, leadfree pottery.

The warm, luminous orange browns of the traditional earthenware are obtainable only with lead glaze on low-fired ware. Since this soft ware leaches lead under some circumstances, its sale was prohibited by the Food and Drug Administration in 1971. The new glazes were developed at Jugtown to replace what is sometimes called "the old, true glaze." This midrange ware, glazed in blue, green, and a range of browns and whites, has become the staple Jugtown ware. Twice a year the potters make frit-glazed orange earthenware in the forms of platters, candlesticks, jars, lamps, and chicken pie dishes (a low, wide, English earthenware form made by eighteenth-century potters in Jamestown, Virginia). Frogskin and a stoneware white (made in large part from local material) are burned occasionally on pitchers, vases, jugs, and bowls. Salt glaze continues to be an important part of production, with some sixteen kilns a year burned—half with wood, half with oil. Vernon salt glazes old Jugtown shapes—pitchers, jugs, and candlesticks—and also churns, crocks, and jars traditional to the area but not produced during the Busbee years.

The clay bodies used are a mixture of local and commercially prepared clays. The pit clays are first beaten to powder in an old hammer mill (see diagram, p. 39, illustration, p. 38), screened with purchased clays, mixed in a wet mill, pugged through an old brick mill, stored, and, finally, repugged in a deairing mill by each turner before the clay is used.

Many red clays in the area are iron-bearing stoneware clays. When used to pro-

Vernon Owens handles stoneware pitcher.
Photograph courtesy Randolph Technical
College.

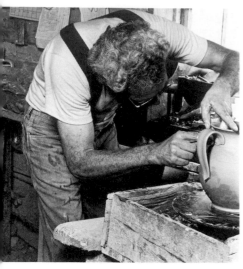

Working pulled handle onto
shoulder of pitcher

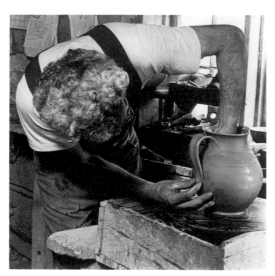

Joining bottom of handle

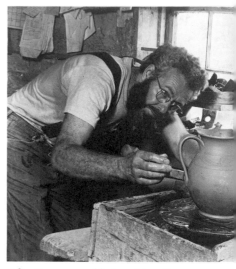

Adjusting curve of fastened handle

duce earthenware at Jugtown and many other potteries, they were underfired. While a soft body clay is suitable for cooking and resulted in the traditional, warm orange colors, its use with the clear lead glaze and other earthenware glazes involved functional problems.

> *This is a good-turning clay, but it's not mature at C/02 [1,095 degrees Celsius]. Your glaze is going to craze on you. The more real low-temperature clay you add to it, the more you change the turning of it. Lots of times you get to where the clay is almost soap. It don't have no tooth to it, it won't hold a shape, just turns to slip on you. The next problem with it is to make a good durable glaze [that will fit] with anything except lead. If you raise the firing temperature, you lose the orange color because the clay darkens under the glaze. Food gets into the crazed places and makes the most awful smell. It's just not possible to make pottery like that anymore and sell it. So, with all the problems of C/6, it's still the best range for us to work in.*

The problems of burning to C/6 arise from the complex clay bodies and glazes necessary at this medium range. Most natural clays mature at higher or lower temperatures and must be combined in such a way as to retain both strength and plasticity. At Jugtown six clays are mixed together and the dark Barnard clay is added to obtain a warm brown color. From five to twelve ingredients comprise each glaze. These precise requirements in making up clay body and glazes, in applying glaze, and in firing to a narrow range are somewhat burdensome for potters who grew up in a one-clay, one-ingredient glaze potting tradition.

> *This is far better ware, but it's a touchy temperature. You got to have a clay you can fire high enough to where it won't leak. Then you're getting to that fine line where it could crack in the oven. Overfire it, and you'll take it too hard; underfire it, and it'll leak. It can be perfectly tight at C/6, never get damp on the bottom. But C/7 is too high, and at C/5 it will leak. That's a pretty close range to have to work with.*

Since 1968 Jugtown has forged a strong workforce to deal knowledgeably with these technical problems. At present, Vernon, his wife, Pamela, and Cynthia Mon-

roe do the turning; Bob is responsible for glazing; Charles for kiln loading; Cynthia
and Viola Owens Brady for simple brush decoration; and Jeanette Moore for the
sales cabin; while Vernon does all the firing. There is, of course, some interchange
of responsiblities. Charles Craven turns old stoneware forms, which are fired in
salt glaze and sold at Jugtown; Boyce Yow models catfish, as he once did while
working for the Busbees. These are fired in the frogskin glaze, and they are also sold
at Jugtown. During the nearly fifteen years of Country Roads ownership there was a
full-time apprenticeship program in which more than forty potters received train-
ing.

 Although most of the ware is burned in a large, rectangular oil-fueled brick kiln,
there are seven kilns in the firing area, three of them wood burning. Firing with

Jugtown Pottery, ground plan.

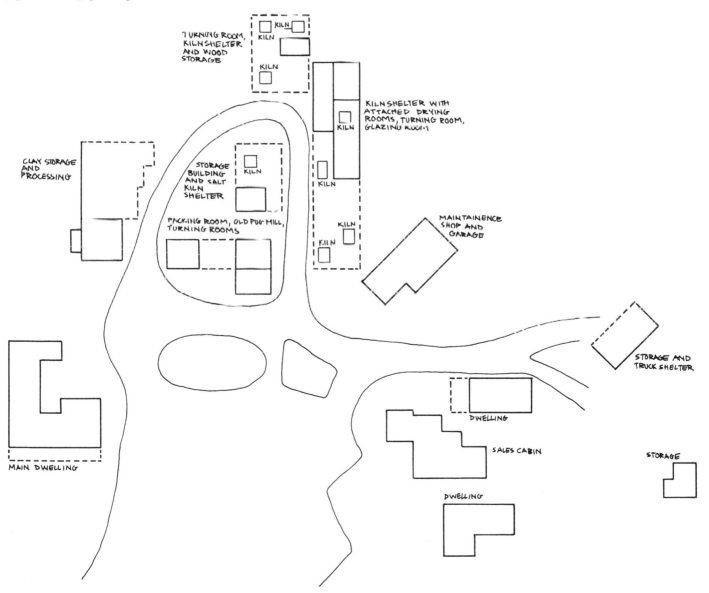

Vernon and Bobby Owens by kiln shelter

wood is the most demanding and satisfying of the burning methods. Vernon believes that wood burning in a groundhog kiln is economically impractical for a production pottery making glazed ware. There is, however, scarcely a potter who does not have a desire for it now and then.

> *I wouldn't want to have to depend on firing with wood for income. We had to keep cutting down on the size of the groundhog kiln to make it burn right, so the pots in back get hot enough and you don't burn it up at the front. That limits us to how many and how big of pots we can burn. You're with that kiln all day long—ten to twelve hours—and getting out a small amount of pots. But, it's necessary to do a certain amount, to show the public what the old ware was all about. And I've got to do it for me, because that's what I grow'd up doing. I can go a long time without firing a wood kiln, and then the thing strikes me: it's time to burn a wood kiln. I just have to do it.*

Vernon burns hardwood slabs from the sawmill and dry pine to "blast off" at the end of a firing. The pine has a long flame that reaches to the back of the kiln and raises the temperature quickly. To fire saltware he burns clean (oxidizing) to about 1,005 degrees Celsius (C/6), then covers the chimney with a sheet of metal, putting the kiln into reduction. At 1,225 degrees Celsius (C/8) he uncovers the chimney, and a less concentrated reduction continues, with the whole chamber and chimney full of flame.

> *Jerk a brick off the top of the arch and the blaze stands out a foot high. It's the blaze, not the smoke, that takes the oxygen out of the kiln. We used to cover up the chimney at the first, then take it off when it got hot. We done the reduction at the wrong end of the firing. Sometimes we got those salmony pink spots. We used to say it didn't get hot enough, but it mostly come from the pots being underreduced. The reduction is the main thing to make it gray and make it salt, in the clays we have around here.*

Vernon suggests that sometimes potters stay too long with traditional practices.

If you make a shape once and decide it's right, you make it on and on and don't question it. With earthenware, it's the tradition that it leaks, so you can't change it. That's just too bad because our forefathers had to make churns and crocks to hold wine, vinegar, molasses. If it hadn't helt they'd have had to done somethin' about it. You know, I like tradition. I'd like to go back and make pottery in the old way with groundhog kilns and that. But, I'd hate to know that I let tradition get in my way of making something that somebody could really use. Somebody comes in here and buys a pot, takes it off, and has a problem with it—that really bothers me.

Jugtown Pottery
Seagrove, Moore County, North Carolina
Stoneware; local and commercial clay
Feldspathic, frogskin, salt glazes
Rectangular kiln; oil; 1,095°C (C/02) and 1,190°C (C/6)
Groundhog kiln; wood; 1,190°C (C/6) and 1,260°C (C/10)
Tunnel kiln; oil; 1,260°C (C/10) and 1,310°C (C/12)
Cooking and tableware, including plates, teapots,
 casseroles; jugs, jars, candlesticks, vases

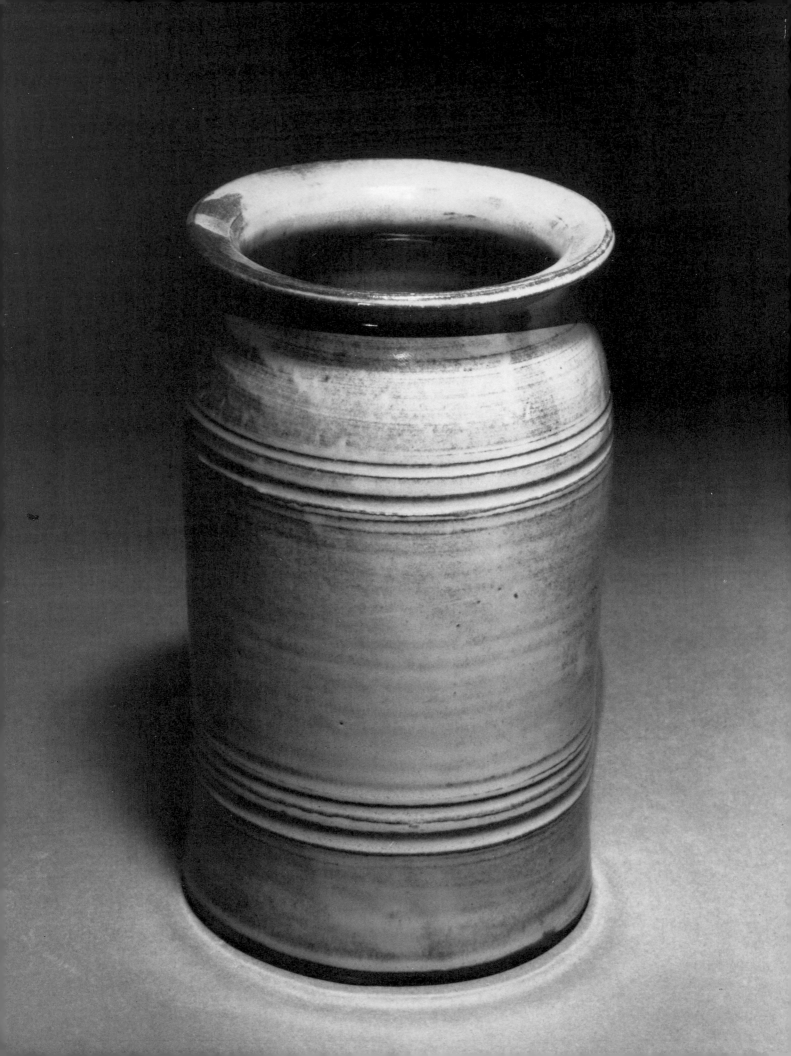

Oakland Pottery

Earthenware soda jar with incised rings and green glaze made by Robert Armfield. Photograph by Rob Griffin; courtesy Randolph Technical College.

In school, at age fifteen, Robert Armfield (born 1952) was first introduced to pottery making. Not until he was in college, however, did he develop a strong interest in the craft. He pursued a teaching career for a few years but found himself increasingly drawn to pottery. He was familiar with Seagrove-area pottery and had grown up using pie plates, mugs, and pots made there. When he returned to Randolph County to teach, Melvin Owens offered to build a wheel for him, "and that's where the story really begins," says Robert.

> I had talked to my cousin's husband and said—as a joke—"If I had a building, I'd start a pottery shop." He said, "All right, you've got a building" and showed it to me. It was an old tobacco barn, used as a chicken coop and later as a mule stable. Two foundation walls had fallen in. My father and I put them back and fixed it up. It had a showroom upstairs and a work room down [below].

In 1974, while still teaching school, he began to make pots, spurred by the discovery that his maternal grandfather, William Murphy Williams, was a potter before the turn of the century. Williams had worked in Moore County and Robert has two salt-glazed pieces made by him: a buttermilk pitcher and a signed, miniature salt cellar in the shape of a milk crock.

Melvin Owens provided Robert with clay, which he burned to 945 degrees Celsius (C/08), with a glaze made of colemanite, nepheline syenite (a feldspar), and soda ash, without lead. Initially the glaze on his pie plates and cups melted well, producing good colors, especially greens, but, with the clay body so underfired, the glazes crazed and the pottery seeped.

In 1976 Robert began to work full time at Seagrove Pottery where, for the next 5½ years, he learned the trade thoroughly while working at his own pottery at night and on Saturdays. At this time he started using the Seagrove Pottery low-fire mat glaze, firing it to 1,095 degrees Celsius (C/02) in a small commercial gas kiln. The mat glaze had been developed by the Drakenfeld Ceramic Supply Co. and was widely used on pottery made in the area for the Carolina Soap and Candle Company and the Pinehurst Candle Company of Southern Pines, North Carolina.

In 1980 Robert began using a local high-temperature red clay for both earthen- and stoneware clay bodies. He adds a lower temperature clay to it for earthenware and adds fire clay to it for stoneware. The hard-fired earthenware rings resoundingly when tapped with a knife. His production is centered on this ware.

> I powder the Smith clay in an old hammer mill run with a gasoline motor, mix all the clay powders together dry in a blunger, a piece of junk that came out of Keith Von Cannon's pottery up on Highway 64 many years ago. I got it along with the hammer mill. I put the mix in water in buckets and let it soak over a period of time. When it's fixed that way—soaking up slow—it's more apt to be able to be turned when it comes out of the pugmill. I wedge it after pugging.

Robert has four small commercial electric and gas kilns. He fires a salt glaze in the top-loading gas kilns, moving the lid to one side just enough at 1,190 degrees Celsius (C/6) to slip the salt in, the fumes from which are vented outside. He also burns an alkaline glaze in a gas kiln. It fires hotter than the salt glaze, but he does not know the exact temperature; his cones made of the glaze sag as the glaze melts

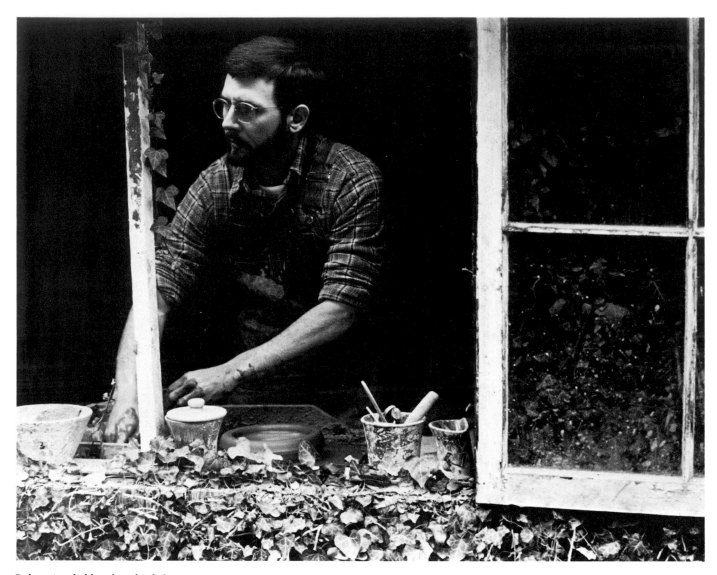

*Robert Armfield at the wheel. Seagrove
(N.C.) Pottery.*
*Photograph courtesy Randolph Technical
College.*

but do not measure temperature. He makes this stoneware glaze from a base of ash from his wood stove and nepheline syenite. Earthenware is burned with both electricity and gas with fritted glazes made slightly mat with rutile, "a metamorphosis, really, from what I had learned to something more my own."

Currently Robert works full time at his own pottery. He says that the old pots at the Potters Museum influenced his own shapes.

> *I still like the earthenware. If I could come back in a different era it would be around 1930 and 1940. I'd turn nothing but large pots, twenty-five pounds or more—the big urns. I'd like to come back at Royal Crown [Pottery] and work there, that had to be one of the tops. Three of the most talented turners [were] all in one shop—Jack Kiser, Charlie Craven, and Thurston Cole. Jack turned nothing but large pieces. Charlie was capable of turning both, and Thurston*

was, too, but he was younger and they had him on the small pots. The colors of the glazes and a certain delicacy of the shapes, which drew on so many cultures, is what appeals to me.

A collection of old pots is exhibited in the sales area. One, a puzzle jug with three spouts, falls in the general category of monkey jugs (jugs with two walls and several spouts that pour in unexpected ways).

The shape was originally made at Baxter Welch's shop at Harpers Crossroads. They were made for the wagoners around the turn of the century. This one was made by Jacon or Wrenn Cole. They sent the wagoners out with the jug, [which was kept] on the seat by them and it was quite a conversation piece. Each one had the wagoner's name on it. They kept drinking water, or something stronger, in it.

Robert prefers to work alone, responsible for every aspect of his pots. Then "whatever goes on, it's my fault." His wife is the quality controller.

She's the one who tells me to take things off the shelf, but [I think] flaws are the beauty of pottery. I do it to make a living. I enjoy it, but . . . art? That's for the people who buy it [to know]. Each pot is distinctly different from the one made just before it and the one made just after it.[1]

Oakland Pottery
Ramseur, Randolph County, North Carolina
Earthenware and stoneware; local and commercial
 clays
Feldspathic and fritted glazes; salt glaze; ash
 glaze
Gas kiln; 1,110°C (C/1)
Electric kiln; 1,190°C (C/6)
Baking dishes, egg separators, corn plates,
 porringers, garlic pots, soda jars, pitchers,
 churns; unglazed flowerpots, birdhouses

Note

1. Robert Armfield, interview, *Asheboro, North Carolina, Courier-Tribune*, March 11, 1979.

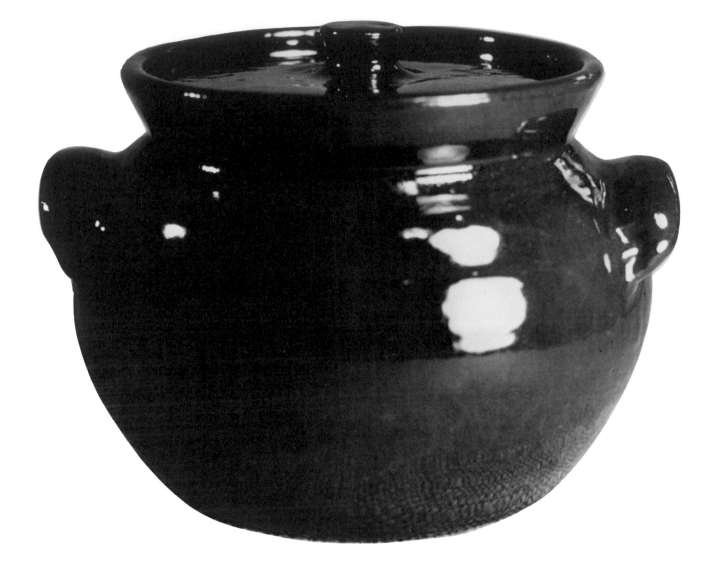

Joe Owen Pottery

Earthenware bean pot with brown glaze made by Joe Owen.

Two branches of the North Carolina Owen family descend from Benjamin Franklin Owen (1848–1917), who ran a pottery but did not turn himself. He had two sons, Rufus (1872–1948) and James H., who changed his last name to Owens. Rufus learned to make pottery in his father's shop and spent his life farming and making pots He turned for nearby shops, and then, with his sons Joseph Thomas (born 1910) and Charlie (born 1901), he built a log cabin shop on family land, which was later replaced by the brick Glenn Art Pottery building. Another son, Benjamin W. Owen (1905–1983), was the Jugtown potter for thirty-six years before opening his Old Plank Road Pottery. Later his son Joe Owen built the present shop, a steeply gabled plank building

Joe's mother, Martha McNeill, was from a pottery family. Her father, Macon McNeill, ran a pottery shop nearby. Raised on the family farm, Joe was in constant contact with potteries in the community. At seventeen he left home to work in a furniture making company in High Point, North Carolina. He returned a year later to begin his life's career as a potter. "I just got to messing with it and learned. It weren't too hard for me to get to where I could turn it."

Through the 1930s the Owens made salt-glazed utilitarian stoneware and unglazed flowerpots. They also made flue thimbles or "joints," as Joe calls them, and occasionally some lead-glazed cooking pots. At the time they were burning three groundhog kilns once a week or more and hiring workers to cut wood, build kilns, and sell ware. Recalling his early days at the pottery, he says:

> I had a treadle wheel then. The balance wheel was homemade of wood, and we had wood head blocks about fourteen inches wide. The shaft was sitting in a big white flint rock. You'd take a hammer and knock you out a little hole, put grease in there, and that thing would run just as good . . . well, back then it was good, wouldn't be good now. We'd keep our old banjo strings to cut the clay and pick it, and we had homemade balance scales hanging up with a little old sack of rocks at one end and the wood platform for your clay at the other.
>
> We got clay from all around—Candor, Holly Springs. . . . The Auman's [Mitchfield] was the strongest pond clay around here. It was blue and slick in the ground and burned out white. My daddy turned thousands of gallons of stoneware out of that pond clay, and it ruined his arm because it had to be turned hard [stiff] to get it thin enough for a churn. It was like butter when it was soft, couldn't get the weight out of the bottom. If they could-a just got out and got 'em a little plastic clay. But, how they used to do, they'd find a good spot of clay and work it till it worked out and then go hunt another one. What they ought to been doing is putting two or three clays together. Course, now the best clays people know about is gone, just spots left here and there.
>
> We built one kiln [with arch brick going] sideways. We'd always put the brick endways, but we had a man come to build one and he said, "nah, just sideways—be stout enough." We burned it, and that arch just bowed up and fell in, just the middle part. It was a big hot fire, weren't no use to put it out, so I got some salt and sprinkled around in there. . . . You know, a lot of those pieces were all right. They were just little red brick, too light turned sideways. If we'd put some heavy rocks on top of the arch, probably wouldn't have done

223

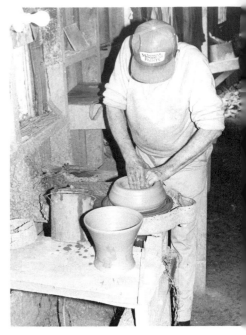

Centering clay to turn top of pitcher

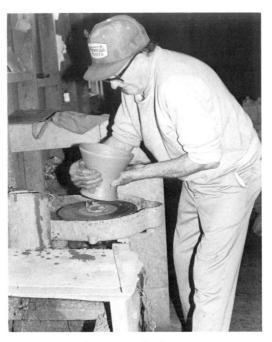

Removing top piece from wheel

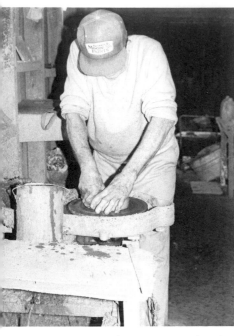

Centering and opening clay to turn bottom of pitcher

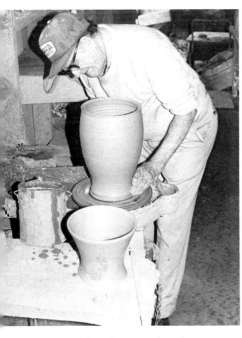

Finishing bottom of pitcher

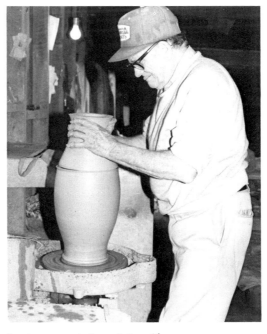

Setting top on indented rim of bottom

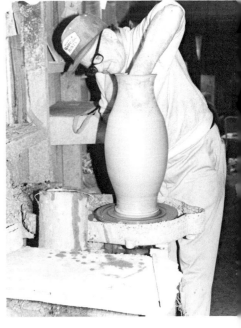

Turning top and bottom parts together

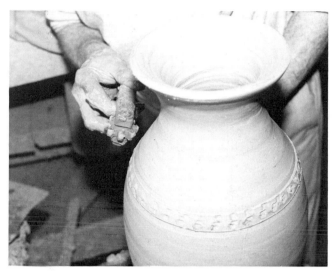

Decorating soft clay with coggle wheel

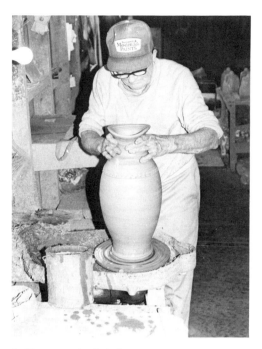

Pulling in neck of pitcher

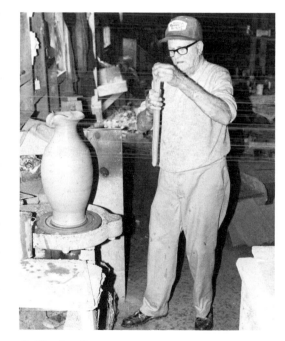

Pulling handle

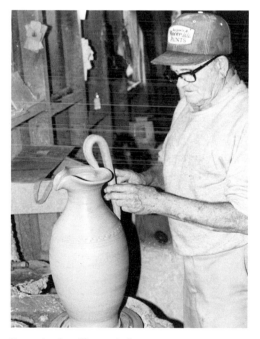

Fastening handle on pitcher

Wall of Joe Owen's shop.

that. We got those red brick hot enough sometimes, and they'd drip, make black strikes on your churn, just like grease.

Clay from the Auman pond in the Mitchfield area north of Seagrove was used by most of the big-ware turners until the Pamona Company bought and removed acres of it. Every man who worked it battled to turn it, because it was not sufficiently plastic, but it was white and took salt with a fine grain, so they continued to use it. Some still seek what spots of it are left today, but they now combine it with other clays to make a workable clay body. The Owens burned with oak, pine, and "lighter'd" (rich pine) and stopped up the chimney with milk crocks to force the blaze and salt down through the pots before the heat and fumes went out the chimney. "Put that rich pine in to blast the last two hours, and boy, the black smoke would roll."

Joe was enticed away from his own shop twice. Once he spent a year in Williamsburg, Virginia, turning in a shop on the James River. From 1949 to 1968 he managed the Glenn Art Pottery in partnership with a businessman from Southern Pines and a number of local potters who were associated with the shop for various lengths of time. By this time his production had changed to low-fire glazed urns, vases and many other forms. At Glenn Art they pressed flowerpots; turned terra cotta planters, strawberry jars, and Rebecca pitchers; molded a canoe planter designed by Harwood Graves; glazed big urns; and even made a few kilns of slip-glazed churns. At this time North Carolina potters and entrepreneurs were influenced by the huge production potteries in Ohio and saw Georgia potters like themselves becoming successful making planters on a large commercial scale. The venture, however, was not wholly successful, perhaps these individualist potters could not—or would not—settle down to the demands of mass-production. Moreover, the introduction of plastic flower containers contributed to the decrease in the production of clay flowerpots. During the Glenn Art period, wholesale buyers were requesting light-colored clay flowerpots.

We worked out with a water-based paint. Put it on with a brush when the pot was turned. And, by dog, if it didn't come out in the clay and show up light enough . . . burned right in there.

In 1968 Joe reclaimed his own pottery, and with his brother Charlie began making low-fired glazed and unglazed ware. Joe Owen is a private man—often referred to as "the shy potter"—and has worked alone since his brother retired. His gentleness and kind concern draw people to him. He turns almost daily, without haste, and his production is now of moderate size.

When you get older, if you want to sit down and think, I declare, you can give up real quick. First thing you think, "Maybe I can't do nothing," and you can't if you think about it. But if you keep going, you'll do a lot more than you think you could, and it'll be better for you.

His clay, loaded mechanically onto a truck in Cheraw, South Carolina, is mixed with a little local brick clay and some commercial earthenware clay.

If you get your clay around here, you've got to dig it, and it's hard work. Get somebody to help you now, and he'll walk off before you get your truck loaded and say, "I can't stand this."

To prepare for turning, Joe pulls some clay down with a hoe to a flat place by the pile outside his shop, where it is chopped and soaked for a few days before it is run through a screening pugmill. He once used a hammer mill, but now says that it kills the clay a bit and he prefers to avoid the dust it creates.

When the big pieces were in demand, he turned thirty-five pounds regularly;

now the largest pieces he makes weigh fifteen pounds. He has always turned large pieces by capping.

> *It's easier to turn in two or three pieces than to put all that big wad of clay on there and pull it. You could keep on making caps, just keep going. I don't know how large, . . . but, what would you do with it when you got it? You couldn't get it out of the shop.*

On unglazed pots he uses notched, wood threadspools on rollers to incise decorative patterns.

When the cost of burning oil increased from 13 to 118 dollars a kiln load in 1981, he shut the big kiln down and bought two electric kilns. Electricity is not only less expensive but also less trouble. At first he used cones in the smaller kilns.

> *I've tried with the cones and without. I got along as good one way as I did the other, so I said, "to heck with you."*

Joe makes large Rebecca pitchers, churns, vases, and smaller pieces, such as beanpots and pie plates. His principal glazes, fluxed by frits, are a tobacco-spit brown, a white—on which he often paints blue bands—and a multicolor finish. He takes orders from small shops and individual customers. He has made special occasional pieces: monkey jugs, a portable cooking grill; flue pipes for the repair of old Moravian tile stoves.

As with many people who have made the transition from one lifestyle to another, Joe speaks fondly of the old times and uneasily about the present:

> *Used to be people had long porches and had 'em set full of flowers. Even with times like it was, they had flowers—and they had time to visit and talk to other people. Weren't a lot of people right nearby, but when they came they'd stay two to three hours. Now they've got the fastest way of doing work and the least time. They go out at night to do their planting . . . can't catch up and get everything done. I hate to see it get like this, but we're all in the same boat. You can't say, "I'm not going to do that." If you do, you'll be setting out to the side. You have to go along with the rest.*
>
> *In my days, what I went through with, in making pottery I've had help. In now days I'd just rather go out there and work like I want to. What do I want to get out and hire and mess with pushing, I've done enough of that. I'll be seventy-two [in April 1982]. Went and got my driver's license . . . so I'm good for four more years.*

Joe Owen Pottery
Seagrove, Moore County, North Carolina
Earthenware; local clay
Feldspathic and fritted glazes
Electric kiln; 1,125°C (C/2)
Casseroles, beanpots, mugs, pitchers, churns,
 vases, urns, Rebecca pitchers

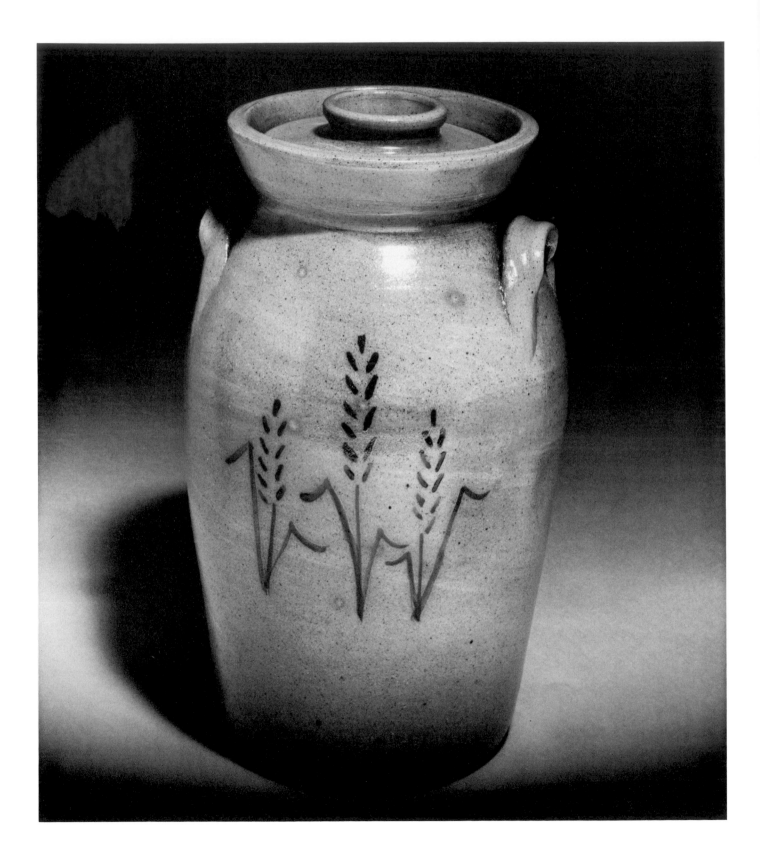

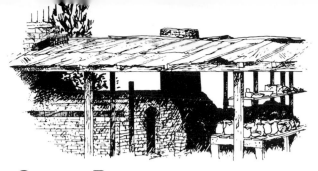

Owens Pottery

Salt-glazed churn with cobalt decoration made by M. L. Owens.
Photograph by Karl Austin; courtesy Randolph Technical College.

The Owens family began making pottery more than one hundred years ago when James H. Owens (1866–1923) at age seventeen began work at Pascal Marable's pottery in 1883 in Steeds, North Carolina. Later Jim's brother Rufus and his father, Benjamin Franklin Owen, built and operated a shop. Jim was apparently a man who went his own way, for he not only started the family in potting but also made his own identity clear by changing his name to Owens. His son Melvin L. Owens (born 1917) has continued the family pottery.

> When I was growing up there were probably twenty-five potters within ten miles of Steeds. About just everywhere you went you'd see a potter's shop. They'd be a firing, be a-grinding clay with a mule. Back then it's a little different from what the pottery is now. Each man had his own job, and that's all he done. If he was going to work on the wheel, he worked on the wheel. Most then, they had somebody workin' their clay up. If one shop was out of clay, the potter, he'd go somewhere else, find somebody that had some clay. But, if the man who owned the shop was in there working the wheel and ran out of clay, he'd stop and grind it. That way went out back in the 1930s.

All six of Jim's sons eventually became potters. The older ones worked with him until they left home, then for a time Jim had the help of Frank Moody (an uncle of Dorothy Auman).

> Frank only lived out about three miles, but he stayed from Monday morning till Friday night, and then he'd go home. He'd stay in his wagon till cold weather, then he'd come up to the house to sleep.

When Jacques Busbee came into the area, Jim Owens worked with him for five years until 1923, and when Busbee opened Jugtown Pottery, Jim continued to make large pots for him fired in the new kilns. During those years, Jim turned and Jacques decorated and glazed the ware destined for a New York market.

> Busbee would design his own shapes—teapots, beanpots, bulb dishes, tall candlesticks—and my daddy would turn them. He had two kilns here. The salt kiln was probably eighteen feet long and six feet wide. Most people thought if their salt kiln wasn't at least sixteen feet long it wasn't worth their time to fool with it. They left it open at the back to the chimney and packed it full of crocks. They would burn big logs of rich pine three to four hours to finish it. Burnt on it twenty hours . . . all day and all night fire it. That rich pine run out in the 1940s.

The other kiln for low-fire glazes was shallow, not more than three by four feet, and open at the top with a flue extending from the back to a chimney.

> I remember it from when I was small. He'd put daubing mud all over the top brick and cover it with a piece of sheet metal. But I think he and Mr. Busbee built a long groundhog kiln here for the earthenware. Probably my daddy used the small glaze kiln after that to make his own glazed ware when he got done making Mr. Busbee's orders. Lot of potters built small kilns like that.

Jim Owens died in 1923, with seven children still at home. At that time, the

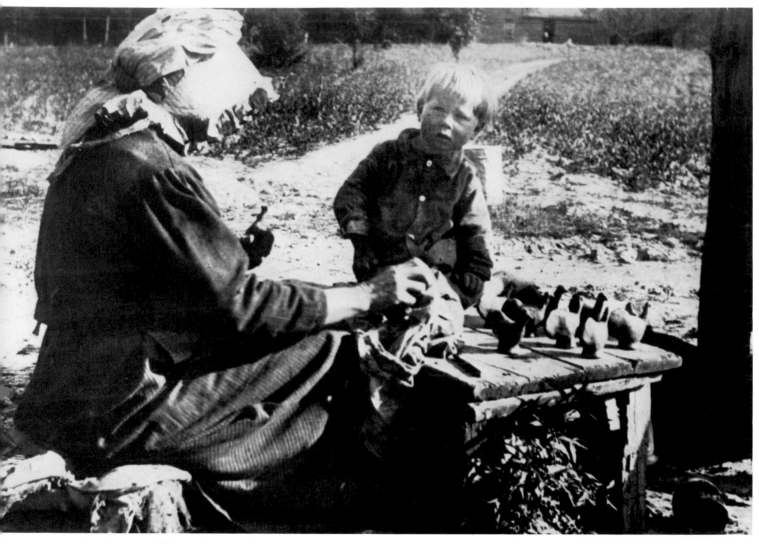

Melvin Owens with his mother, Martha Scott Owens, making clay chickens, c. 1920.
Photograph courtesy Marie Owens.

Owens brothers worked at various potteries some distance from home but would return to the family shop and turn for nearby shops that finished the ware. The Owens' kilns eventually collapsed from disuse. During his early years, Melvin only prepared clay and "done anything but turn on the wheel." At age twenty-one he decided to make pots. "See, I didn't hardly have to learn. Within a week I was a-makin' stuff and selling it."

In 1938 Melvin started to make glazed earthenware at the family shop. He continued to use stoneware clay but fired it at low temperatures.

> *We didn't know about earthenware clay. I didn't start using it till the 1950s. We had to bisque the old stoneware clay high to get it hard enough, and when you bisque with wood sometimes you got a tan color that would show through and spoil the look of the glaze. The pots would leak even if you did bisque 'em hard. [When we changed to] the red clay it helped some on that, but they'd still seep.*

Recent testing has shown that the red clay, presumed to be earthenware, was in

fact stoneware clay colored by iron but sufficiently refractory overall so it is not mature at low temperatures. Lower-temperature red clays can be found in the area, but generally these clays turn poorly. The piedmont potters have had a long struggle with this clay and to lower its maturing temperature, some have added other clays. For a time Melvin added colemanite—one part to one hundred parts—to his clay body, thereby substantially reducing its maturing point. By the 1980s most area potters (including Owens) had redesigned their glazes and were firing at a higher temperature, which both solves the clay problem and allows them to eliminate lead from their glazes. Potteries that have continued to produce low-fire earthenware have modified their clays to mature properly at lower temperatures and flux the glazes with frits.

When the potters first went to red clay they added metal oxides and later opacifiers to conceal the dark body.

> *Firing with wood and making "art" pottery you just about had to put one glaze over another to make it look good. The wood fire would burn off a thin glaze, and a thick one didn't look right. You could take two glazes, dip it in one first, then another.*

This practice led to new glazing effects, among them pots with "coats of many colors" prevalent in the decorative period of the late 1920s and 1930s and used on the pots made for gift shops in the 1940s and 1950s and today still used occasionally. These glossy glazes were fluxed with white lead and frits. Discovery of the opacifying effects of rutile led to the development of the mat glaze used by C. C. Cole, the Aumans, and Owens Pottery.

> *People found out about glazes by books and from glaze companies. I would send them pieces of pottery. They would send them back glazed and tell me the formula. But I was firing with wood not gas or electricity, and it wouldn't work the same for me. So it took us a little time to figure the glazes out.*

Melvin continued to make salt glaze through the 1940s. At that time Jim Teague turned for him a shopful of big churns for salt glaze. To burn the salt ware he built a groundhog kiln with small flue holes leading into the chimney.

> *They had always left it open, which let the fire go through too fast. You couldn't get the kiln red hot without letting it blaze up, which, of course, cracked the pots.*

In 1940 Melvin built a large upright kiln. Since he had never used saggers and had no shelves, he set the ware with firebrick, which occupied much firing space.

> *Back about 1940 the pottery business got real dull. Wages went to goin' up, and by 1945 they was a-paying fifty cents an hour, and the textiles mills had come through the countryside, and a lot of younger people quit and went into textile.*

In the 1950s Melvin started producing ware for the Carolina and then for the Pinehurst Soap and Candle companies. At that time many potteries survived largely because of huge wholesale commissions. In 1956 the Carolina Company ordered three thousand salt-glazed shaving mugs. Since he had not fired stoneware for six years, he had to rebuild a kiln to fill the order. Thereafter he continued to make a little salt glaze through 1967, including a large order for jugs impressed with the name Daniel Boone. During the 1950s and 1960s, the pottery made thousands of miniature pieces to hold candles or wax. For twenty years production of this ware kept the pottery open and occupied most of his time, that of his wife, Marie, who did the glazing (and still does), and six of their eight children. Sometimes there were simply not enough hands; consequently some women in the neighborhood learned to dip glaze.

The candle business, necessary for the survival of many potteries in the 1950s and 1960s, was challenging only in quantitative terms. Production potteries have always made ware in quantity; the secret of success in the current marketplace, however, is in a balance of quality and quantity.

In 1975 Melvin sold the business to his youngest son, Boyd, who operates it today. Melvin, Nancy Owens Brewer, Melvin's youngest daughter, and Emmett Albright (a local potter, age seventy-two) turn for the shop. Lula Belle Owens Bolick, another daughter, now has her own pottery near Blowing Rock, North Carolina.

Currently the pottery produces three wares: salt-glazed stoneware, fired at 1,225 degrees Celsius (C/8); feldspathic-glazed stoneware, for table and kitchen, fired at 1,190 degrees Celsius (C/6); and rutile, clear-glazed, and unglazed earthenware, fired at 1,050 degrees Celsius (C/04). Two clay bodies are made of local clays with a coarser Ohio clay added to each for "tooth" and bentonite for plasticity. The red clay body is used for both C/6 and C/04 wares.

To prepare the clay, it is beaten in a tractor-driven horizontal hammer mill that blows the powdered clay and funnels it down to be bagged or run directly into the wet mill. The pottery has a large commercial wet mixing mill, seven feet long, with twenty-two cutting blades, aluminum lined to prevent rusting. The clay is then pugged and stored. Unless the surface of the stored pugs becomes hard, it is not wedged but simply rolled into balls.

The shop has four oil-burning kilns: two tunnel and two rectangular "walkins." Nancy Brewer decorates the salt-glaze ware with cobalt. A grandnephew of Melvin's, Billy Ray Hussey, sculpts animals and faces on jugs. Having grown up across the road with his grandparents, Billy Ray shows considerable talent for handling clay in sculptural ways.

Boyd Owens unloading kiln.
Photograph courtesy Randolph Technical College.

M. L. Owens

While the pottery is now owned by Boyd Owens, Melvin's skill at the wheel; his knowledge of clays, glazes, firing, and machinery; and his tenacity are central to its operation. Potters young and old around the region know that Melvin Owens will help them with any and all problems. He has led people to clay pits and has assisted them in hauling; helped them build wheels, machines, and shops; and in earlier years built kilns all over the countryside, for C. C. Cole, North State Pottery in Sanford, Royal Crown Pottery in Merry Oaks, and several for Jugtown Pottery.

Owens Pottery
Seagrove, Moore County, North Carolina
Stoneware and earthenware; local clay
Feldspathic and salt glazes
Tunnel and rectangular kilns; oil; 1,190°C (C/6),
 1,225°C (C/8), 1,050°C (C/04)
Cooking and tableware, including pitchers, teapots,
 casseroles, pie plates, jugs, jars, bowls,
 cannisters; modeled animals; bird jugs

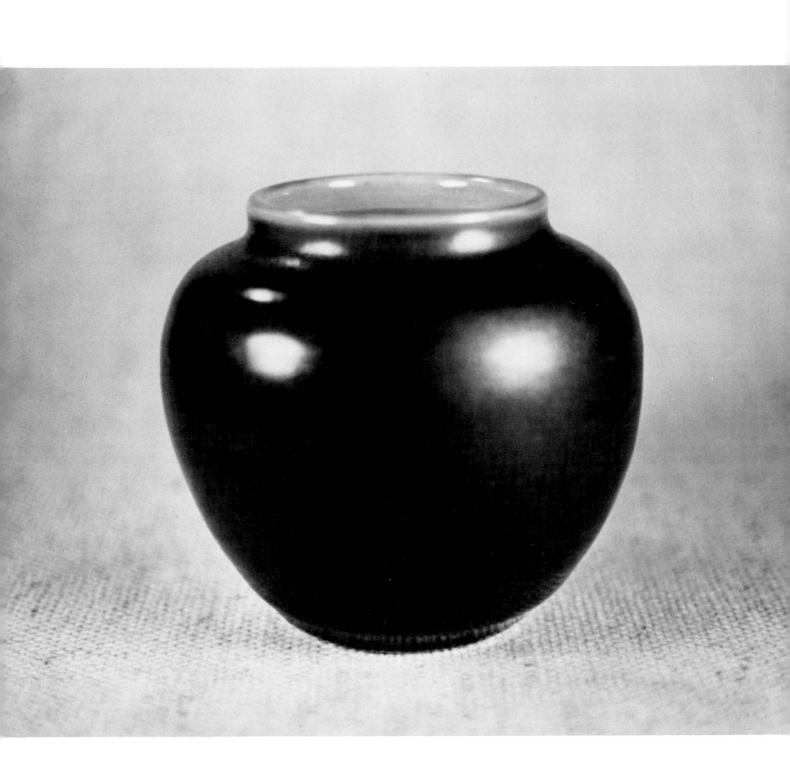

Pisgah Forest Pottery

Porcelain vase with green glaze and yellow interior made by Grady Ledbetter.

Walter B. Stephen (1875–1961) began to work with clay while living on his father's farm in Tennessee. He and his artist mother developed a cameoware, similar to that produced in England at the Minton and Worcester factories and in France at Sèvres. They depicted romantic and religious scenes—the Buffalo Hunt, the Lord's Supper, the Covered Wagon. These were built up of porcelain paste brushed over mat blue and green glazes on porcelain pots, wheel turned and made in molds. Stephen's step-daughter-in-law, Katherine Case, says:

> The Covered Wagon design was special, because he [Walter] actually rode in one when he was small, and he traveled with his parents to Nebraska, where they lived in a sod house.

In 1913, three years after his mother died, Walter moved to North Carolina and built the Nonconnah Pottery in Skyland. In 1920 he bought thirty acres of land in Arden and built the Pisgah Forest Pottery, which was completed in 1924. Here he continued to produce cameoware and designed glazed porcelain. He married a woman with three children, raised them, and taught a step-grandson, Tom Case (born 1929), to make pottery. As a child, Tom helped around the pottery and by age fifteen he had learned to turn at the wheel. Tom now owns the pottery and runs it with his partner, Grady G. Ledbetter (born 1908). Grady began work for Walter in the 1930s and learned from him all aspects of the trade. For both Tom and Grady pottery making is part-time work, and Tom's mother, Katherine Case, tends the shop.

The porcelain clay is a mixture of ball clay, kaolin, feldspar, and quartz. The clay body is made into a liquid slip, then squeezed to a turning consistency in a press to filter out excess water. After two days, the clay cakes are removed, wedged, and stored for a week's aging. The potters wedge it again and weigh it before turning. Grady does most of the turning now, using about fifty pounds of clay a day, while Tom also turns, glazes, and puts handles on both his and Grady's pots. Both potters sit down at homemade wheels to turn: "We've had wheels where you sit down and wheels where you stand up and turn. My grandfather did it both ways." They use ribs, a "spreader" (ball opener), and homemade lifters. The pots are air dried outdoors on shelves under shelter in summer and in a separate room heated for drying in the winter.

The pottery has a small bottle kiln of a type used in Staffordshire, England, and occasionally in the South. The kiln fires readily to 1,250 degrees Celsius (C/9). The ware is bisqued in an upper level chamber of the bottle-shaped kiln, with heat coming through it from the glaze chamber below. The bisque chamber is reached from the second floor. Enough ware is bisqued in each burning for two glaze firings: one in the bottle kiln, the other in a supplemental gas kiln. Earlier, there were two bottle kilns, one burned with coal and one with wood. In the early 1940s Walter Stephen and Grady Ledbetter built the kiln used today. For each firing it holds about 350 glazed pots. "We can all three set the kiln in a day," Katherine Case observes:

> There's shelves around the inside, which stay there all the time. They are filled first, then the saggers are stacked in the center. All the glazes are fired in saggers, except the blue and the wine. Pieces with those glazes are put on the

SAW

CHOPPING BLOCK

OPEN SHED FOR WOOD STORAGE

SAGGER GRINDER

ROOFED PORCH

WINDOW WINDOW

SHELVES

TABLE

SLIP TANK

OLD AIR COMPRESSOR

CONCRETE TABLE

SHELVES

GAS KILN

SIT-DOWN WHEEL (NOT USED NOW)

SHELVES

WORKTABLE FOR CHAIN SAWS

AIR COMPRESSOR AND TANK

FILTER PRESS

SHELVES

SINK

SHELVES

WINDOW

SAGGER CLAY STORAGE

SHELVES

GRINDER

SHELVES

SHELF AND SAGGER STORAGE

(SHELVES)

WEDDING TABLE

OLD AIR TANK

POTTERY SHELVES

SINK + CABINET

MRS. CASE'S DESK

SIT-DOWN WHEEL

WINDOWS

BOTTLE KILN

TWO OLD STAND-UP WHEELS (NOT USED NOW)

BLUNGER

MR. STEPHEN'S CHAIR (DECORATING)

HEATER

STAIRS TO BISQUE CHAMBER

HEATER

DRYING ROOM

TABLE

BALL MILL (SHELVES ABOVE)

WINDOW WINDOW

GABLE WINDOWS

CHIMNEY

CLAY STORAGE BUILDING

Pisgah Forest Pottery shop, floor plan

shelves or on top of the saggers [each is set on an inverted toadstool-turned shape to catch the running glaze].

The glazes are made of the same ingredients as comprise the clay body, with the addition of calcium carbonate as a flux. The dozen glazes have been changed somewhat over the years but are recognizable as an evolution of Walter's glazes. A stamp showing a man seated at a wheel is impressed on the bottom of each pot. The glossy glazes—yellow, green, white, buff, turquoise, and wine—are used interchangeably on all forms.

Wood for firing is bought as slabs and logs, which they split into splinters a couple of inches in diameter.

When the kiln is sealed, we use a little trash to get it started and burn splinters

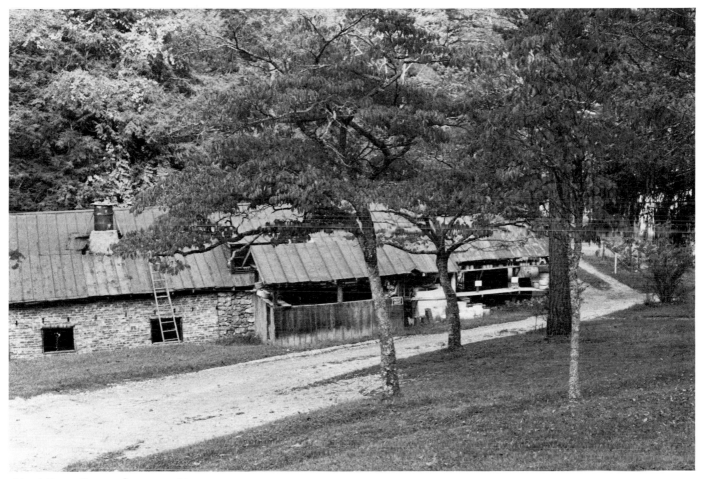

*Pisgah Forest Pottery shop; note chimney
stack of bottle kiln emerging from roof.*

*of wood to heat it up slow for about an hour. Then you can fill your fireboxes
up and you'll be all right. We go round the kiln once every ten to fifteen
minutes feeding the five fireboxes. We place the wood around the kiln between
the fireboxes before we start and keep those stacks full from the supply outside.
We use four cones, C/1 and C/2 to see how we're progressing, then C/9 and
C/10. C/1 goes down in about eight hours, C/6 in twelve hours, and C/9 in
eighteen hours. We put a C/9 [1,250 degrees Celsius] flat with the C/10 starting
to bend. All through the burning we keep the fire going as hard as we can. When
we stop, we damper the firebox mouths with sheet metal and damper the
chimney down to about a fourth. I just climb up on the roof and put a cover of
sheet metal over the chimney.*

During the firing they make as little smoke as possible to keep the fire oxidizing all
the time. They burn about three quarters of a cord of wood, using yellow pine
because it has a longer blaze and the resin creates more heat.

Tom and Grady have begun to make tableware, such as mugs and bowls, and
continue to make the smaller early forms, mostly vases and jars: "In Mr. Stephen's
day they used to make vases and urns thirty-six inches high, but on big pieces like
that if you lose one, you've lost a lot." In all they produce about thirty shapes,

including an unusual teapot designed with a ledge turned in above the lid flange, part of which is cut away when the pot has stiffened. This rim ledge holds the lid in place. Newer shapes have been added at customer request.

As is customary the price of the pots is determined by the cost of producing them. When production was larger, Pisgah Forest Pottery sold through the Southern Highland Handicrafts Guild, but now they sell entirely from the pottery to tourists and local people. Tom observes with some dismay: "I don't have any children, so when I'm gone it will stop."

Pisgah Forest Pottery
Arden, Buncombe County, North Carolina
Porcelain; commercial clay
Porcelain glaze made of body clay with calcium flux
Bottle, brick kiln; wood; c. 1,250°C (C/9)
Bowls, teapots, candlesticks, mugs, cream-and-sugar
 sets, cup-and-saucer sets; vases
See also Daisy Wade Bridges and Kathryn Preyer,
 eds., *The Pottery of Walter B. Stephen*

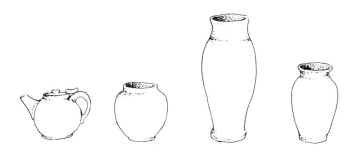

Potluck Pottery

Laura Teague Moore (born 1943) is a third-generation potter, daughter of James Teague (born 1906) and granddaughter of John Wesley Teague. She and her six sisters and brother helped in their father's pottery in Seagrove, North Carolina.

Jim Teague grew up in his father's pottery, then located on the family land across the road from his present home in Seagrove. Here utilitarian salt-glazed ware was made and, occasionally, a kiln of flowerpots and "dirt dishes," burned in a large groundhog kiln. J. W. Teague died when Jim was only ten, and his mother hired Rufus Owen (father of Joe and Ben Owen) to turn and help her sons run the shop. "The whole community had to have containers, . . . but people didn't go in for anything fancy." When Jim married he started his own shop. As a very able turner, his skill was in demand. Preferring to work at the wheel, he turned at many shops, including one in New Jersey. During his last years in pottery he turned in his own shop for his brother, Duck Teague, who brought him the clay and took the dried pots to finish and sell at his own pottery nearby.

Although churns larger than six gallons were rarely made, Jim regularly turned fifteen-gallon pickling jars. Jars larger than eight gallons were capped in two or more pieces. Jim gradually taught himself to turn eight-gallon pots from one piece of clay.

It's not the strengh as much as it is the know-how. The feeling you get of the clay, if you work in it long enough, is worth more to you than anything else.

Jim speaks eagerly of his life's trade. Even though poor health has forced his retirement, he retains his wry country humor. When talking of his family, for instance, he said, "We had eight children. Still got eight as far as I know." One is Laura who lives next door, and who, growing up, had no desire to turn but instead modeled chickens, hens and eggs in a nest, and marbles. Laura and the other children all helped dig clay, "pick" it, and made balls for Jim to turn.

We all had to get in on unloading the kiln. Squatting down on a board in the

Jim and Mary Teague with collection of Jim's pots, including water bucket, churn, jug, and urn.
Photograph courtesy Randolph Technical College.

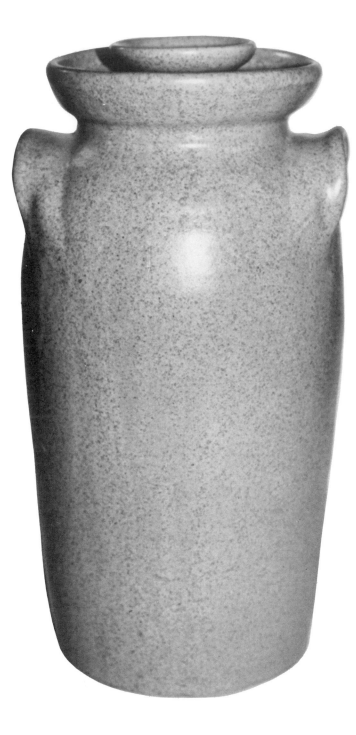

*Stoneware churn with flecked glaze made
by Laura T. Moore.*

firebox and passing the pots in. Sometimes the kiln wouldn't even get cooled and we'd unload it and load it back. My sister fell off the board onto the coals in the firebox one day—burned her feet and legs awful. We've not forgot that.

Laura married John Moore and lived outside North Carolina for ten years. When she and her family returned to the state, she decided she wanted "to conquer" pottery.[1] She obtained clay from her Uncle Duck, a wheel from Melvin Owens, and began to learn to turn in 1975. To increase her knowledge of glazes, she enrolled in a course for production pottery at a nearby technical school. Although her turning improved, she found the instruction had little relation to production work.

I can't see me doing one piece and decorating on it so I've got to charge $250, and it set there five years before the right person comes along to buy it. To me that's not making pottery. I wanted to do a bunch of pots. I was supposed to be

Laura Teague Moore slip decorates a bowl. Photograph courtesy Randolph Technical College.

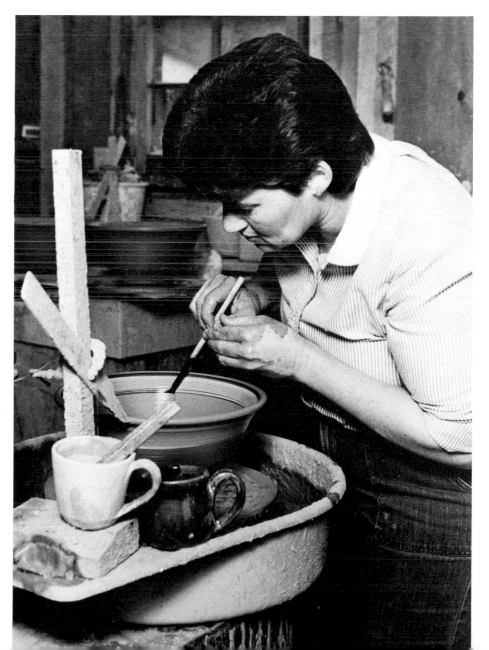

trimming a foot on everything and decorating. Do you realize how many days it would take you to make enough pots to even pay the bills? Who is going to support you like that? You can't make a living at it. I love what I'm doing. I never thought it would be supporting a family, but it is.

Laura developed clay bodies for two stoneware temperatures. John mixes the commercial powdered clays by hand in a tub and then air dries the clay outdoors until enough water has evaporated to make it the right consistency.

Although she had read about glaze minerals, it was only after three years of trial and error that she was satisfied with her glazes. She is not bound by tradition, but her goal of making pots to suit both herself and her customers expresses the particular balance—between earning a living and retaining personal individualism—on which traditional potting is based. Laura says, "I really believe in my public. I listen to them, but I'm going to have what I want out of it, too."

Laura has developed clay bodies and glazes, with such names as Amber Waves and Dixie Classic, for stoneware, earthenware, and the midrange ware. She and her husband, John, who in the last two years has joined her in the pottery, have built two gas kilns, a catenary-arch and a tunnel kiln, which was supplemented by two electric kilns (see illustration, p. 73). She salts at the unusually low temperature of 1,190 degrees Celsius (C/6) by adding borax. The mixture is blown into the kiln sporadically at C/6 for 1½ hours with a "leaf blower" to which a metal pipe has been added. The finished salt ware ranges in color from light to dark brown.

Salt glaze is so [like] pottery. I want to make churns for people to use for kraut and pickles. If a piece has glaze on it, I don't care a thing in the world about it looking traditional. But, salt glaze, . . . it's just all in my mind that there's a way it's supposed to be. Jugs and pitchers in salt glaze speak to me.

She judges pots by the tactile qualities of texture, shape, weight, and balance rather than by their color. Her honey pot "has got to feel good" in the hands, and a pot "has got to pass good" when being handed from one person to another.

Two influences have shaped Potluck Pottery: Jim Teague's forms and methods, absorbed by Laura in her youth; and the contemporary production shapes and glazes she has learned more recently in school and from ceramic magazines. Her father's excellence continues to be an inspiration, "How good daddy was is just always in front of me." Laura turns standing. She feels that sitting is the lazy way, showing no care or ambition, and believes that trimming is unnecessary, except on footed bowls.[2]

If you trim, you leave a lot of thickness at the bottom of a pot while turning it. Then it's hard to get enough of the shape so you know what the whole shape is going to be like. You need to get the shape while it's plastic rather than carving it away. Trimming does something to it. I see shapes not coming out spontaneously, not true, if they have been cut later. You get the pot right while it's on the wheel. You're not ever going to do it justice when you take it back on the wheel again.

Laura has strong ties to traditional pottery but is aware of historical change.

Once people needed that traditional pottery, but when that stopped, the potters had to change. The economic situation made them, so they went into glazes. Nothing stays the same. I'm not certain now why people buy pottery. Maybe they can afford it, and they see it as an art that is being lost. Years ago, when people made their own quilts, no one gave a twiddle about a quilt as long as it was warm. Then there was a period when people had to have store-bought quilts. Now it's back in the handmade again. It goes back to people being afraid

of losing their past. What I see as tradition now is just potting being handed down through the family.

Potluck Pottery
Seagrove, Moore County, North Carolina
Stoneware; commercial clay
Feldspathic glazes, in several colors; salt glaze
Catenary-arch, brick kiln, gas; 1,260°C (C/10)
Tunnel, brick kiln; gas; 1,190°C (C/6)
Cooking and tableware, including baking dishes,
 teapots; cannister sets; virgin and
 hurricane lamps; jugs, churns, pitchers

Notes

1. An article by Erma Bombeck, "Cheer up Girls, It's Never too Late to Start a New Career," inspired Laura Teague to take up pottery (*Asheboro, N.C., Courier Tribune*, November 8, 1981).

2. Traditional southern potters do not trim their pots and have adopted the term "turning" to describe the forming of a pot on a spinning wheel.

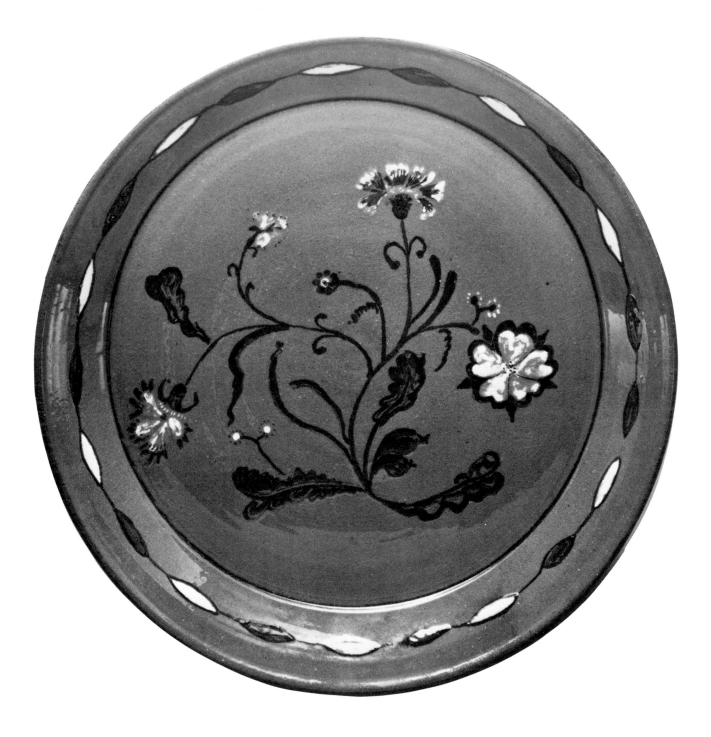

Seagrove Pottery

Earthenware slip-decorated plate with clear glaze made by Dorothy Cole Auman. Photograph by Glen Tucker; courtesy Randolph Technical College.

A member of the fifth generation of Coles to produce pottery, Dorothy Cole Auman (born 1925) grew up surrounded by an extended family of potters—grandfather, father, uncles, cousins, and brother. Her father, Charles ("Charlie") C. Cole (1887–1967), had been raised making stoneware at a shop in Steeds owned by his father, Ruffin Cole. For several years during the depression, he worked building textile machinery to support the work of his brothers who were developing the new glazed ware. Charlie helped his brother Everett set up the New Hill Pottery near Durham, where the Coles were then living. Dorothy always wanted to go over to the pottery.

> You got your work done at home or you couldn't go. I just couldn't wait to get over there. . . . They'd give me a hunk of clay and put me on the wheel to keep me out from under foot. They fixed me a box and raised up the pedal and I could get it going. Those treadle wheels were just more fun than an electric. You could run 'em half circles, and after you cut your piece off you could make all those pretty designs with you finger. You start off and learn that if that piece of mud is not in the center of that wheel it comes out pretty whop-sided. After you get a hole in it, getting it to keep to the center is a learning process. Gradually your muscles build. It doesn't come in a day's time either.

In 1937 Charlie moved his family back to the old pottery site at Steeds to make the new earthenware with his son, Thurston (1920–1966). Dorothy five years younger than Thurston—persisted in learning to turn, often seizing a chance to use a wheel when the turners were at dinner.

> They'd go back out, . . . I'd move their chip, I'd break the wire Seems like a potters wheel is his own possession, and nobody should dare touch it but him. He has this pride and joy in it. Daddy said, "I can't stand it no longer, I'll just fix you a wheel." He made a bend in a steel rod by heating it and fixed it to make short strokes. That's where I turned miniatures. They were a big thing along there and would sell when nothing else would. I remember like seven bushel baskets of miniatures coming out of a kiln—little Rebecca pitchers, jugs, the little jugs were used for salt and pepper shakers. [To make them] you pinch off a little piece of clay the size of a Toby marble. That was the first thing they put me one.

Charlie brought his uncle Lorenzo ("Wren") Cole to the shop to teach Dot to turn and allow the older man use of the pottery. Uncle Wren taught her turning skills, but most importantly he taught her to "see."

Before she began producing miniatures, she learned to make small baskets and vases. By the 1930s all the Cole potters were discontinuing production of stoneware and making large ornamental glazed earthenware shapes, such as jardinieres and other patio pieces, measured by height in inches instead of by volume in gallons. They turned many shapes that were three feet tall or taller, large enough for a small child to squat down and hide inside.

> One shape we called a "drug" jar because it was a shape used for storing drugs in pharmacies. The potters just made a larger version. It was round, had a tremendous belly and split handles. To make them, you pull a wide, long

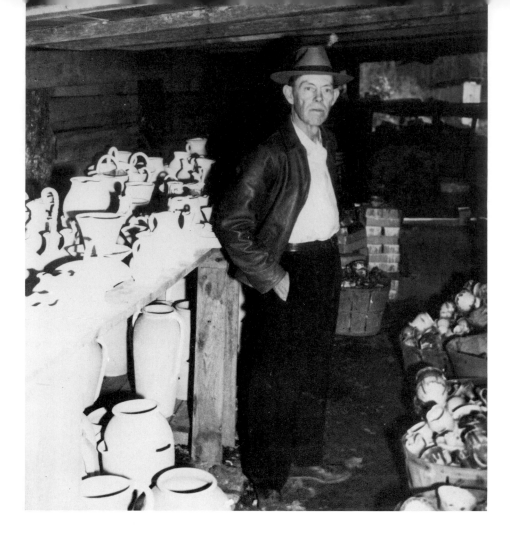

Charles C. Cole at his pottery shop, c. 1940.
Photograph courtesy Dorothy Auman.

handle, split it in half to about two-thirds the way up. Each half goes to one side of the shoulder, kind of like a fork. Then make a big loop and fasten at the bottom where the handle is in one piece. Do the same on the other side of the jar. When you look down, it is a very pretty pattern. They made 'em in all sizes—even up to about ten gallons—everybody made 'em. People still make 'em—small.

Small pieces made by the younger turners filled in the kiln. The slow and arduous process of developing glazes for the lower temperature took time and resources.

Mama would get provoked and aggravated when poor kids needed shoes and clothes and she was trying to maintain a decent home and there was no money. But there was always money to be poured down into that glazing. Mama was right in her way, but daddy was . . . well, he was just a potter.

The transition made by this generation of potters was initially from one to another type of large form. The skills needed to turn a storage jar were the same used to turn large decorative ware. In the early 1920s a rivalry developed as to who could make the biggest pot. With so many turners journeying from one pottery to another, a network of communication developed.

Lots of 'em was in on it—Jack Kiser, Charlie Craven, Arthur Cole, Jim Teague, Waymon, and, of course, the Browns—it reached even up to Arden. One would send word, "I got one thirty-six inches high." Word would come back, "I got one thirty-seven inches." Thurston and daddy would go over and watch Waymon Cole. Waymon would take a blowtorch and dry the bottom hard. He built a scaffold way up to reach the top, and somebody else did the peddling. It took maybe four people to get the sections on they were so big. When word

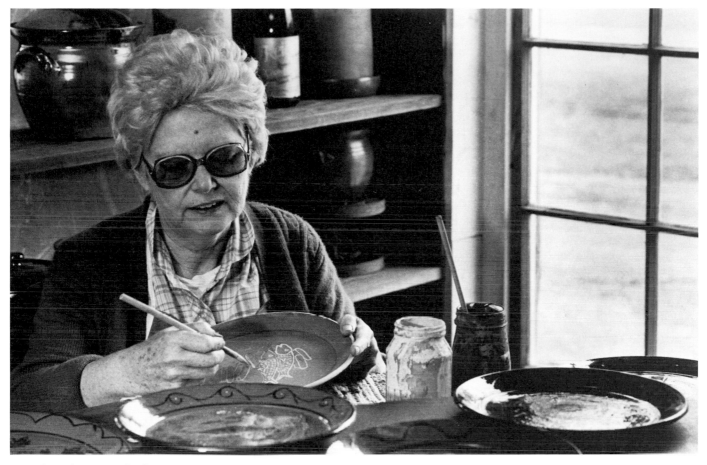

Dorothy Cole Auman slip decorates an
earthenware plate.
Photograph courtesy Randolph Technical
College.

came of the one the Browns made, an urn six feet, four inches tall, that finished
it [see illustration, p. 164].

The Cole Pottery became heavily involved with wholesaling after the Second
World War. Dorothy's husband, Walter Auman (born 1926), worked for C. C. Cole
from 1952 to 1971. His family came to North Carolina from Maryland and Pennsyl-
vania, and his grandfather Fletcher Auman ran a pottery shop on "Auman Hill,"
while his father, Hadley Auman, hauled wares. Walter became a potter himself
when he married Dorothy Cole in 1949.

*On average at Coles we put out three thousand pieces a day. There was a big oil
kiln, eighteen feet long and eight feet wide. It was fired twice a week with five
thousand pieces in it. And there were two other kilns—one fired every day. We
were making syrup and honey jugs then. The nylon boxes from the hosiery mill
would hold just one hundred jugs. When we had one hundred boxes [ten
thousand jugs], we'd load them on a truck and deliver them to Knoxville,
Tennessee, and Winchester, Virginia. Thurston and Dot and Virginia King
[Shelton] did most of the turning. Every once in a while we'd get Melvin,
Vernon—anybody we could get—to turn some for us. We put the variegated
glaze on them. A thin white glaze was put on—made almost a pink over the red*

Walter Auman unloads bisqued ware from kiln.
Photograph courtesy Randolph Technical College.

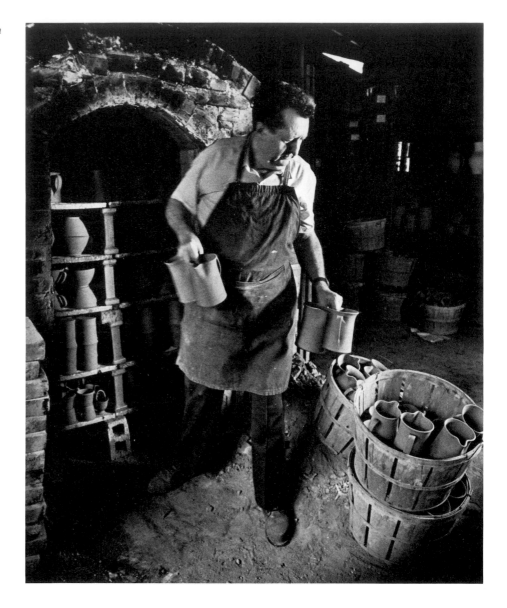

clay—then you'd just reach down into all the glaze colors and drip it on the jug from the ends of your fingers.

To start with, the shop got fifteen cents, the turner three cents apiece. Mr. Cole finally got it to twenty-two cents for the eight-ounce, thirty-three cents for the sixteen-ounce jug. Full of honey the small jug sold for $2.98 and later $4.98. After about ten years that run out, but by then we were working with the Carolina Soap and Candle Company and they wanted candleholders in quantity. We made different items for them: a flat saucer holder, two to three sizes of cups to pour wax in, little black washpots, a jug cut out on the sides called a manger lantern. All this was glazed in the mat glaze. We were with them another ten to twelve years. During this time Dot was making some pots for

our pottery, lots of pieces that took eight ounces of clay to make for which we got $2.75 a dozen. About seventy-five percent of the business of both shops was wholesale.

By adding rutile, which opacifies and causes a flecked appearance, this low-fired mat glaze was developed. The shops were also stocked with brightly glazed pitchers, pie plates, teapots, casseroles. Dorothy remembers Thurston making unglazed flowerpots. People wanted them painted, so Dot would paint flowers on them in reds, blues, and yellows after they came from the kiln, but that fad quickly disappeared.

Thurston just killed himself for the pottery. He was only in his forties when he died. He would go to work at four or five A.M. and stop at ten P.M., and turn at least 650 pieces a day even 900, if he was pushed. He did it from the drive that was in him. We had orders and we hadn't been having orders. He wanted to fill them to get the business going, but he ran himself down.

And mama worked on and on for no money and no appreciation really: sanding, getting things from the kiln, keeping track of orders. She's also the one that kept us all fed. And, I'll tell you, that's no little job.

Dorothy had worked for her father since she returned from college in 1946 and continued to work there with Walter after they married. In 1953 they bought their own place and started building a shop. While raising their son, Snoten, Dorothy produced wares to fulfill the Cole wholesale orders and supply stock for their own shop.

People were so picky. You were trying to appeal to them enough to buy. So you made many, many shapes. The very same turned bowl shape ended up in several forms, it's been crimped, fluted, pulled in, and made squat. . . . Along that time was this craze of bonsai, so we did an awful lot of flat bowl-type things. Pottery from Ohio was pictured in magazines, and it was copied, just religiously. We'd try to make it just like 'em. Never did, of course. It wasn't that people ran over each other to buy your pottery. . . . You grew up under struggle and defeat.

Dorothy's wanted a small shop in which to make ware different from her father's. She wanted to produce the old, salt-glazed ware. They have continued to make many old shapes, influenced by pots in their museums, "because they are pretty shapes and I hate to see them go." They have not made salt glaze. They make a milk crock used now as a decorative container for a florist's pot, cuspidors, shaving mugs, inkwells, pipes, beanpots, old thunder mugs. On request, they also produced new shapes.

I have not found a teapot made way back with crocks and churns. They started after people from Pinehurst came up here and asked for them. They would have been the tea drinkers. People here were coffee drinkers, you see.

Casseroles are bound to have come in here around the 1930s. I believe it started off as a taller shape to be cooked in—bean- and stewpot shapes—and gradually got flatter.

For six years after her husband died, Ida Cole ran the Cole shop with Dorothy, Dorothy's sister, Edith, and Walter. The strain of maintaining two shops was not part of Dot's dream, however.

I didn't want daddy's headaches, didn't want eleven people standing at me with hands held out for pay at the end of the week or asking me what to do. I just wanted a little bitty kiln and little bitty shop. Daddy had said to me, "A little bitty kiln, you'll never make it burn right." I thought if I just make a few pots somebody'll come down the road and buy 'em. We started and like topsy, it just sort of grew and grew.

In the 1960s their wholesale business was still strong, but expenses were increasing and the big buyers balked at higher prices. The day was in sight when they would not break even financially. The Aumans drew the attention of Hargrove Bowles, then a state representative, to the predicament of the potters. He initiated state promotion for the North Carolina pottery industry, thereby encouraging North Carolina potteries to sell directly to customers in their shops.

The Aumans use pit clay dug a few miles away. For two weeks in the fall the year's supply of clay—ten to twelve tons—is prepared. It is powdered in a hammer mill, mixed in a vat with water and some local red earthenware clay to lower the maturing temperature of the body, then pugged and stored.

The Aumans use three base glazes fluxed with frits: a rutile mat, a clear glaze for orange and tobacco-spit colors, and a high-gloss glaze used with many colors in various combinations. Occasionally Dorothy decorates with colored slips, which are brushed on a red clay plate and later coated with a clear glaze. The ware, glazed by dipping, is burned in a rectangular brick kiln 6 feet wide by 10 feet long by 6½ feet high to 1,050 degrees Celsius (C/04) once every two weeks (see diagram, p. 72). An efficient method of keeping their shop filled with a variety of shapes and glazes results from retaining large stocks of bisque fired ware, which can readily be burned in the next glaze kiln when any item or color is sold out.

Through the 1970s apprentices have worked with the Aumans, and from 1976 to 1983 Robert Armfield (who now operates Oakland Pottery) worked at the pottery.

In addition to running the Seagrove Pottery and working for C. C. Cole, the Aumans have gradually collected an exceptional representation of early pottery from the Seagrove area and the South in general. The collection is housed in the Seagrove Potters Museum behind their shop in the old Seagrove Depot.[1] The collection includes early salt-, alkaline-, and Albany-slip glazed stoneware; a few rare early earthenwares; and pots representing the various phases of change since the utilitarian stoneware period. The largest part of the collection is salt glazed, the dominant ware in the area for one hundred years (see illustration, p. 21).

Seagrove Pottery
Seagrove, Randolph County, North Carolina
Earthenware; local clay
Feldspathic and fritted glazes, in several colors
Rectangular, brick kiln; oil; 1,050°C (C/04)
Cooking and tableware, including teapots, pitchers,
 mugs; vases, inkwells, shaving mugs, cuspidors,
 milk crocks; slip-decorated plates and platters
See also Dorothy Auman and Charles G. Zug III,
 "Nine Generations of Potters."

Note

1. "The Seagrove Depot was built on [the railroad] line in 1896 for thirty-five dollars by Jefferson Auman, kin to Walter. The site was to be named Seagroves, after Edwin G. Seagroves, but the man hired to paint the depot took a nip or two of whiskey between swipes with the paintbrush. When it came time to paint the sign with the name of the community, he didn't judge his distance right, so he left the last letter off" (Dorothy Cole Auman, interview, *Charlotte, N.C., News*, October 9, 1980).

Shearwater Pottery

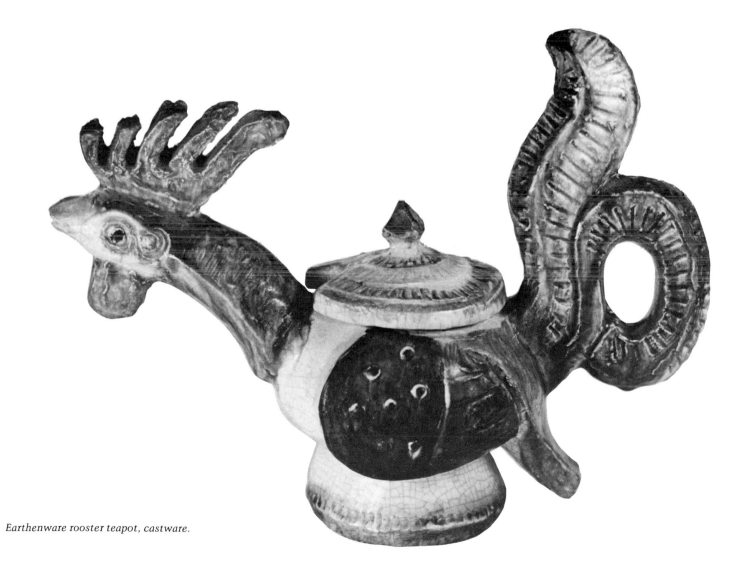

Earthenware rooster teapot, castware.

Born of an old New Orleans family, Annette McConnell Anderson (1867–1963) settled in 1922 with her family on twenty-four acres of densely wooded Gulf Coast land, which she had purchased before the First World War for fifteen hundred dollars. Annette Anderson had learned to decorate pottery while studying at Newcomb College and her mother had been a china painter of distinction. Her husband, George W. Anderson (1861–1937), emigrated from Scotland and became a cotton broker in America. The couple had three sons, Peter (born 1901), Walter, and James ("Mac") McConnel.

After working briefly in a Pennsylvania pottery and studying the craft during one summer at Alfred College in New York, Peter built a pottery on the Gulf land in 1927–28. Walter's widow, Sissy Anderson, remembers the pottery's beginning:

> Peter had the idea of a small art pottery in which he would produce earthenware pots, both useful and decorative, with very fine glazes. His first firings were in the side of a hill, burning wood; the kiln was in a rectangle shape covered with an iron top and earth. It didn't work at all.

Peter's brothers, Walter (1903–1965), a painter, and Mac, an architect, soon helped him, mainly as decorators. Their mother worked actively in the pottery until she died at age ninety-six. Today the pottery is a family undertaking, with Peter directing it at age eighty-two.

The Andersons now use clays found sixty miles to the north. In the ground this clay is purple and gray with some patches of yellow sand. As they dig with pickax and shovel they mix in sandy clay. In a year about two tons of clay are used.

For years Peter sailed to Biloxi and up the Tchootaca-Bouffa River in a twenty-six-foot sailing boat, trailing a skiff to dig his clay from the river's cliffs. Later, he sailed down the sound to Mobile Bay and up Fish River to a brickyard on the same mission.

> I wanted to use the clay that underlies all of this region, down about four to six feet, a fine-grained sedimentary clay. I thought I might use it as part of a stoneware body by taking it to a soft bisque and powdering it to add to plastic clays [as grog], but it fuses in the kiln, bloats, looks like a cinder. Jimmy is testing it for glazes but so far has found it to be a pretty heavy flux.

Shearwater turning clay body is equal parts central Alabama clay and a combination of ball clay, feldspar, and flint. The ingredients are mixed into a liquid slip in a blunger with paddles. The slip drains out the bottom of the blunger, through a screen into a tub. From there it is hand dipped into a tank and forced by air pressure into the filter press. After four to six hours in the press, the clay cakes are removed, stacked, and covered. Stored a little too wet to turn, they are air dried as needed by the turners, Peter and his son, Jimmy.

The Andersons have an unusual method of working the clay for turning. A heavy wedging table made of a huge cross section of a pine tree is elevated on sturdy feet, covered with inner tube rubber, and fitted with a cutting wire. With a rubber-covered mallet of dense, live oak wood, Peter beats the air out of the clay on this table. As the clay cakes naturally dry unevenly, resulting in hard edges and soft middles, this manipulation mixes the clay to an even consistency and removes air pockets. He pounds the clay flat, splits it on the wire, puts two smooth sides together, and flattens it again—continually turning, cutting, and mauling it.

This system of wedging is also used to prepare heavier clay for making saggers. Old saggers, crushed by an edge-running mill in a dry pan (see illustration, p. 41), are added as grog to a mix of sagger clay; the body is then pugged and wedged. The oval saggers are made in two press molds—one for the bottom, the other for the side wall, which, when stiff, is wrapped around the bottom piece and joined to it. The saggers last from two to ten years.

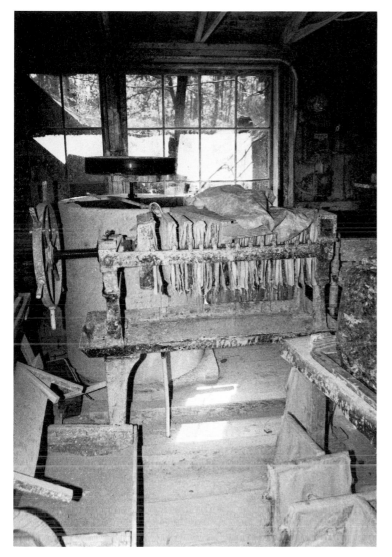

Filter press

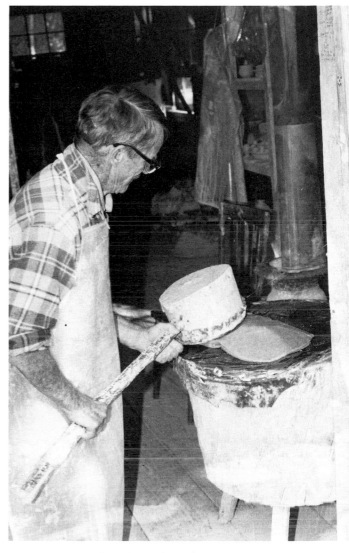

Peter Anderson wedges clay with maul.

The turning body is very plastic, usually shrinking twelve to fifteen percent. It has a long firing range and is vitreous at 1,190 degrees Celsius (C/6). As the kiln temperature ranges from C/1 to C/6, most ware is fired in the C/2 to C/5 range, which is suitable for their earthenware forms and well-modulated glazes. Shearwater produces ware by turning, jiggering, and casting.

Small to medium pots are turned by Peter, who is at his wheel daily, and by Jimmy, when he finds time from other pottery tasks. Peter's only turning tools are a sponge stick to remove any water remaining in the bottom of a finished piece and a rib to shape the bottom of platters. When making a batch of mugs or other pieces he wishes to look alike, he weighs balls of clay and turns the shapes to gauged height. Very small pieces he will turn "off the hump."[1] Peter makes "chucks" (open cylin-

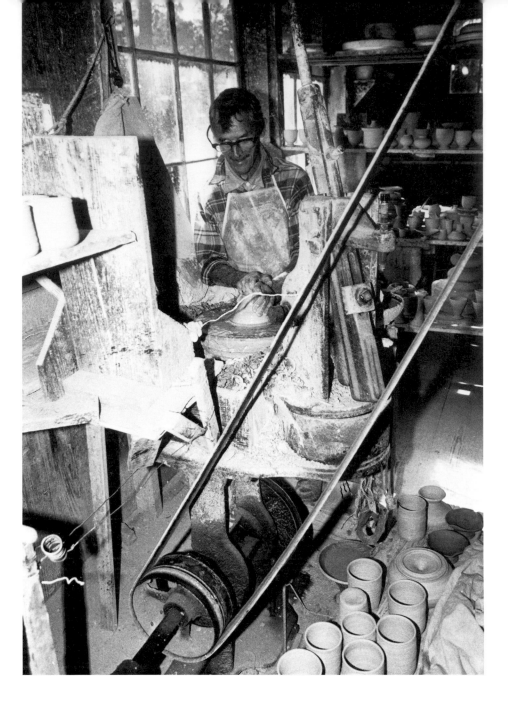

Peter Anderson turns pottery on a belt-driven wheel.

ders) to use in trimming. When the chuck is stiff, a thin skim of clay is put on the wheel head to catch and hold it.

> *With our clay you can make pots thin, but I always throw a little thicker at the bottom than I need. Every piece gets centered on the wheel or in a chuck upside down and trimmed. Sometimes I like ridges . . . I get tired of a smooth surface.*

Handles are shaped by rolling clay on a piece of glass, then pressing it flat; casserole handles are turned in the French style on the wheel.

The pottery now uses six basic glazes, each with several color variations. Two are made of minerals burned to glass in a small fritting furnace built by Peter in the early 1930s and used steadily since (see diagram, p. 59). Two frits—one soda, one boron—are made one after another, twice a year. Chunks of fritted glass are ground to a powder in a ball mill and mixed with other glaze ingredients, including a small

amount of lead carbonate. After comparing glazes made with raw and fritted materials, the Shearwater potters concluded that fritting improved the color substantially.

The ingredients of some glazes are milled together, while others are simply stirred and then screened through sixty-mesh wire. Glaze requiring a very light coating is sprayed on the ware; most glazes are applied by dipping and some are then oversprayed lightly with a second glaze for depth and color variation. Peter is selective of the particular finish on a pot in a way many traditional production potters are not: glazes, both glossy and mat, are designed for certain forms and are not used on other forms.

For soft and porous ware, they fire a low bisque. When the soot is burned off the kiln floor, they know the desired temperature has been reached.

The round, downdraft, oil-burning kiln was built in 1930 of three layers of brick entirely encased in metal.

The whole thrust of the dome is on that metal band. When the kiln expands from the heat the dome rises. As the kiln cools, the dome falls back against the band. The original metal around the kiln was welded and the weld let go, so we slipped another band on without a weld. Brick for the dome were all handcut and locked into position when the dome was built.

Heat radiation from the brick ensures slow temperature changes that "soak" the glazes as desired. The heat is drawn out of the kiln through a tunnel beneath the ware floor to a twenty-foot stack some distance away from the building.

The glazed ware is set in thirty-six two-cubic-foot saggers, stacked five high; some pieces are set open in the twelve-inch space left above them. The unevenness of the kiln, which burns from C/1 to C/6, allows them to fire several types of glaze simultaneously: "It's just a matter of knowing the kiln and loading it right." The kiln burns to 1,190 degrees Celsius (C/6) in the hot upper parts and consumes ninety to ninety-five gallons of fuel oil in ten hours.

Shapes and glazes produced by the pottery have not changed much over the years, although copper reds are no longer made. "People want what they can use. We make a lot of vases and bowls, but we get a lot of repeat customers and they can only use so many vases."

In addition to jars and vases—many with pierced designs on their shoulders cut by Mac Anderson—they also turn cooking and tableware. Pie plates are jiggered from an old flowerpot saucer mold. Turned pieces are usually glazed without further decoration. Jiggered and cast pieces are decorated with slip and sgraffito designs or with underglaze painting before they are glazed.

In the early days the Andersons went on the road to sell the pottery. Now it is mainly sold at the shop, with some pots going to museum or gallery shops on commission.

The Shearwater compound includes homes for Peter, Mac (a rammed earth house he built in the 1930s), Walter's widow, Sissy Anderson, and members of the younger generation who maintain the enterprise. The primary work complex consists of two board-and-batten buildings connected by a roofed and decked breezeway with an adjacent metal kiln house, reached by an enclosed passage. The building for clay work has an overhead line shaft that powers the wheels and other machines by a series of flat belts. Another building is for glazing. A fourth and separate building is a decorating shop for cast and jiggered ware. Nearer the shore is the sales cabin, surrounded by azalea bushes. As the potters turn, decorate, or do other production tasks, they look out to the pine woods and Gulf marsh beyond. A path of brightly colored shards leads to the water and is aptly called "the glory road." Along the path and dotted through the woods are Walter Anderson's sculptures, birds or reptiles carved of wood now weathered.

Shearwater Pottery, ground plan.

KILN
SMOKE STACK

KILN HOUSE

OLD KILN
HOUSE

DISTEFANO
HOUSE

GLAZE
ROOM

MAIN WORK-
SHOP

ANNEX

ANNEX
KILN HOUSE

MRS.
WALTER
ANDERSON
HOUSE

BILLY AND
CAROLYN
ANDERSON
HOUSE

WALTER
ANDERSON
HOUSE

POTTERY
SHOWROOM

BARN CONVERTED
TO RESIDENCE BY
SENIOR
MRS. ANDERSON

MICHAEL
ANDERSON
HOUSE

JAMES
McCONNELL
ANDERSON
HOUSE

MARY AND
ED PICARD
HOUSE

PETER
ANDERSON
HOUSE

Shearwater Pottery
Ocean Springs, Jackson County, Mississippi,
Earthenware; local and commercial clays
Fritted soda and boron glazes, feldspathic-lead
 glaze, Bristol-type glaze
Round, brick kiln; oil; 1,190°C (C/6)
Casseroles, pitchers, egg cups, ramkins, bowls,
 vases, jars; jiggered plates and pie plates;
 castware

Note

1. "Off the hump" refers to a method of turning, devised in the Orient and frequently used by studio potters. A large lump of clay is centered into a cone, a piece is turned at the top of the cone, removed, and another turned until all the clay has been used.

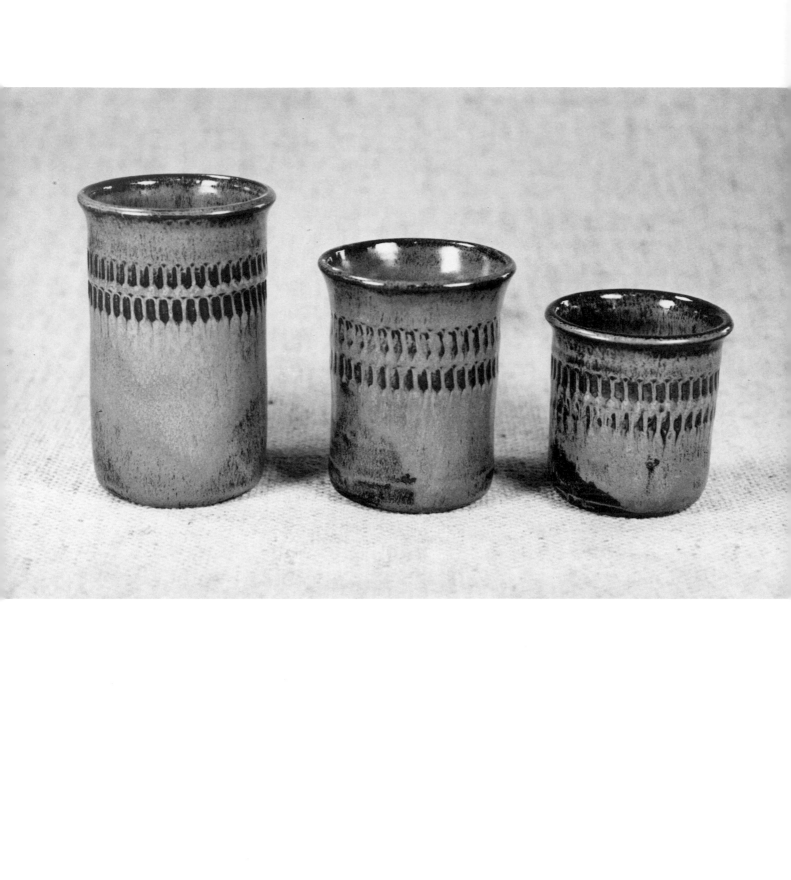

Teague Pottery

Earthenware cups with blue glaze and coggled decoration made by Hobart Garner.

B. D. ("Duck") Teague was born in 1898 into a potting family. His father, John Wesley Teague (1867–1916), began to learn the pottery trade in J. D. Craven's shop when he was nine years old.

> There was Owens and McNeills, Lucks and a whole generation of potters spring right up about the same time my daddy did, cause they all learned on the old man, J. D. Craven.
>
> How come old man Craven [was] into the pottery business so big? He was making foodware for the Confederacy during the Civil War [and the demand continued after the war]. They didn't have much then but stoneware.
>
> I can remember back to 1907 or '8 when I started to do pot work, and, of course, I piddled and piddled on it. It was my job to haul the clay, grind it, cut the wood, fire the kiln. There was seven of us boys, and everyone of us could turn pots. My daddy'd got out from Craven's shop . . . had his own when I was born.

Duck Teague married Bessie Craven, daughter of Daniel Craven and granddaughter of J. D. Craven. The family pottery tradition was continued by their daughter Zedith Teague Garner (1927–1976). Her son Daniel (born 1951), who today works with his father, Hobart Garner, is a ninth-generation potter.

Stoneware was made at John Wesley Teague's shop in Steeds and burned in a groundhog kiln. Duck describes their choice of firing wood:

> We het up with green pulpwood, because dead wood first would make too big a flame and break the pots. When we get to a certain way, we'd put it over on dead wood, then—when it got red hot—we'd put it on fat lighter'd all the way till we put the salt on, for about three hours. There was plenty lighter'd then for miles around. We used the trees that had gotten overage and died. We had an old "man-killer" saw, then split the logs with a maul and wedge. Daniel says the lighter'd was mostly long-leaf pine.

He also remembers making in his father's shop two-gallon sealing jars used for canning food. Prepared food stored in jars sealed with beeswax, would keep for years, if the jars were made of nonporous clay. Although the shop produced primarily large ware, the potters also made drinking cups, which they described as "toy" ware. Duck claims it was awkward to make the small pieces when one's hands were used to turning large ware. While his sons made ware, Duck's father hauled it east in North Carolina on a wagon to sell.

> He hauled some off in February, about nineteen and twelve [1912], and there come a lot of rain and got the rivers and swamps up down there, and he was gone twenty-eight days. There was no communication, and we didn't know what had come of him.

After serving in the merchant marines during the First World War, he worked in the building trade in New York City and then made furniture in North Carolina. He says that in 1929, "I decided that was enough, and I came back into the pottin' business." Duck built a shop, groundhog kiln, and home in Robbins. His wife, Bessie, remembers that time:

Took my little young'ns in the woods and took a quilt and spread it out and let 'em set on it and play. He cut the logs and I peeled 'em. We built four rooms, covered it with tin, and then just built along as we were able till it's got nine rooms now.

Bessie also helped with pottery work, both in her father's shop and then in her husband's.

My daddy got clay all around, and we'd go with him. He'd put two of us on the wagon to pick out rocks and roots and throw 'em out while he was putting the clay in. Had a clay box to put it in [at the shop], put ole sacks on it, keep it wet. We had an old-timey mill, and he had a little dog that set up on top of the mule, and it kept the mule going. Just tickled you to see it.

Duck produced salt-glazed large ware and low-fired earthenware until 1933. The large utilitarian pieces were occasionally decorated with blue smalt. The churn and jug shapes were familiar.

From a practical part, a churn can't have a bulge on it—has to be straight up and down so the dasher will fit up agin the jar. The jugs were straight sided, too, so you could pack 'em easy. I'd want to get one hundred two-gallon jugs in the kiln, and the wagon man when he come wanted them all to lay tight together. Course the fellas who drunk out of [it] didn't pay no 'tention to the shape no way.

Teague Pottery was also making the glazed earthenware garden pieces then popular. During the 1930s and early 1940s, the shop produced more than two hundred shapes in eleven colors, and Duck had a number of turners working for him, including his brother Jim Teague, Jack Kiser, and Farrell Craven.

I had to watch the turning all the time in the shop. I'd look down the board where they were setting, and if there's a [pot] out of shape from what I wanted, my eyes would stop on it just like that.

To keep a stock of that many colors and shapes, it'd run you to death. You couldn't maybe turn more than fifty pieces at a time before you had to switch over to fifty of another shape. The way to do it is make one to two hundred of one thing.

They burned the ware in saggers, which were four to eight inches high with rings extending the enclosed space to thirty inches or more. Pots were crated for shipping in eight-bushel plywood boxes obtained from a local textile mill.

I'd buy them and have every house and barn stove full of 'em. Take about two of them thirty-pound jars in one box, and then the jars was packed full of small things in wheat straw. We'd haul 'em to Robbins and ship out by freight.

Sometimes they varied the earthenware shapes for special orders. For example, on request, they made small-necked bud vases. At that time, people were coming from Pinehurst, "'till you couldn't stir 'em," from George Washington's birthday through the summer.

Now we used to copy two jars. One was a Greek amphora and the other was the Portland vase, discovered by the Duke of York way back. And several Asian shapes—some of those biblical pictures, you know, like Rebecca's pitcher. Then there's those big oil jars from Egypt.

This generation of potters built their own labor-saving machinery.

Everytime anybody can make something easier for themselves, they are going to do it. I built the first power wheel there was in these counties. I asked an old

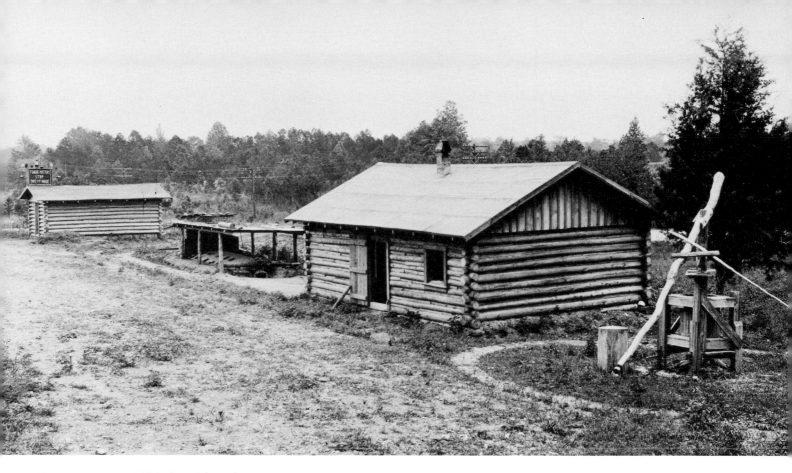

Teague Pottery, c. 1930. Left to right: *sales cabin, groundhog kiln, pottery shop, mule-driven clay mixer.*
Photograph courtesy B. D. Teague.

potter, Henry Chrisco, about a power wheel run by gasoline engine, water, anything, he says, "It won't work, you couldn't control it." I hated to give it up. I went to old man Suggs machineshop, drew up what I wanted, and he made it. Well, it still didn't have no power, so I went a-huntin' me a little old one-horse gasoline engine. Fellow had one he run a waterpump with, so I hooked that thing up, and, boy, I turned pottery on it for years. Had a clutch, throw up your lever into gear, fill up the tank, and off she'd go.

Gasoline rationing during the Second World War restricted travel for supplies and deliveries and kept retail customers at home. The Teague Pottery was forced to close. In 1945 Duck's daughter Zedith began work with him, and together they made earthenware for home use. Jim Teague also turned large pots for them to finish. In 1955 Duck built an unusually large oil-burning kiln, which he fired only two or three times. Daniel describes it as "big enough to live in." It still stands today, covered with vines and used for storage. In 1955 illness slowed Duck's production, and in 1962 he closed the shop.

Five years later in 1967, Zedith Teague Garner decided to repair and reopen the shop with the assistance of her husband, Hobart, who worked full time at a local mill.

Old wheel cribs was rotted down. You know, they was built onto the wall. We had to rework them and build a kiln. We used a lot of his materials and glaze formulas.

The pottery opened in 1968 with Zedith producing cooking and table earthenware burned on shelves in a large, rectangular oil kiln. She and Hobart soon began testing glazes and by 1971 had developed leadless, fritted glazes for firing to 1,135 degrees Celsius (C/2). That same year Farrell Craven left Ben Owen's shop, where he had been turning for nine years, and began work with Zedith. Farrell turned, prepared clay and glazes, and loaded the kiln. Zedith also found time to teach production-pottery at a nearby technical school and brought a talented student, Jennifer Gardner, into the pottery in 1972. Jennifer now operates her own pottery with a wood-burn-

Zedith Teague Garner and the author, 1974.
Photograph by Sam Sweezy.

ing kiln in Creston, North Carolina. When Zedith died unexpectedly in 1976, Hobart and Daniel decided to continue the pottery. Daniel's interest in pottery had been sparked fifteen years earlier, when his grandfather had burned an old ground-hog kiln one final time.

> *Firing that big kiln was the neatest firing I've ever seen. We used oak round wood, four foot long—better than slabs cause it don't choke down. Generally not much went on around then in the pottery. I played with the wheel some in the fourth grade when I could reach it. After that, I didn't do anything with it 'til '76.*

The Teague Pottery had always used a mixture of local clays ground, in the early years, in a mule-drawn pugmill. Ware is now made of a local clay found in South Carolina with small additions of blue clay from North Carolina and red clay from their own pottery. The red clay lowers the temperature of the other two clays, while the blue clay makes the body fine grained. Daniel located the blue clay while he was prospecting with an auger bit in the sandhill area east of Robbins.

> *If it's deeper than five feet, we generally leave it cause it's too far to dig. I saw it in the road, but you can't get it out of a road bank, that's just not right. So I walked up the hill, digging holes, and I hit it. First I could hardly reach it, but there was a knob at the top of the hill, and in the center of that I could. The*

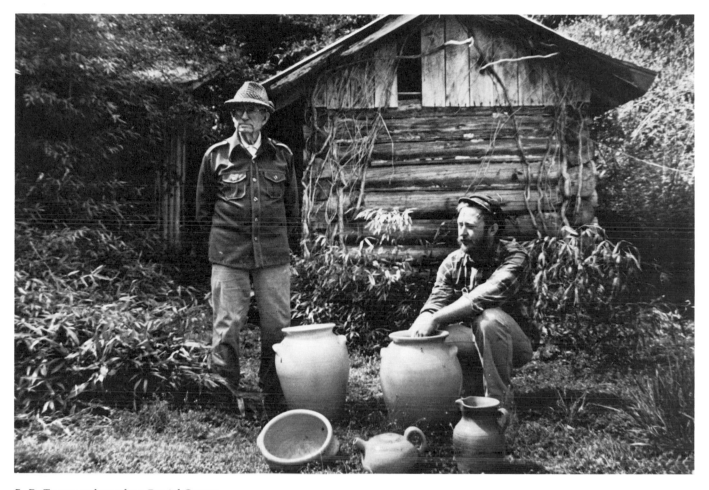

*B. D. Teague and grandson Daniel Garner
with pottery turned by Charles and Farrell
Craven.
Photograph courtesy Randolph Technical
College.*

*man who owned it said it was O.K. to dig it by hand. We shoveled off a place
about six feet thick. There wasn't nothing in that clay—not a crawfish hole, not
a rock, nothing.*

They dry the three clays under a shelter, then run them through a hammer mill
and a window screen. The powdered clays are weighed and poured into a measured
amount of water, roughly mixed by hand and then put through a pugmill.

*Used to we'd just eyeball it for the amount of water, and we'd work it and
work it through the pugmill. The more we worked it, the worse it was 'til
you couldn't turn a pot out of it. With the measuring we just put it through a
couple of times, and the consistency is right.*

*People must have had a fantastic knowledge of the clay around. I've seen
old J. D. Craven pots that was so light. I don't care what kind of pugmill you
got, I don't think you could turn as light as that with these clays.*

They prepare about a ton of clay every four to six weeks and would prefer to age it, but as Daniel says, "Who has time to let clay set around?" Hobart does most of the turning now with increasing skill. Daniel does all handling and some ball making. He also sets the kiln, occasionally turns jugs and other custom pots, and keeps ware bisqued as it dries in the small electric kiln. The two men dip the glaze together. A new catenary-arch firebrick kiln is used for glaze firing, but they prefer to bisque fire in an electric kiln.

> *You get a much better, cleaner bisque, cause it's solid oxidizing. In the big [oil] kiln, pots would come out black. The depth of the glaze would seem shallow over that. Also, with electricity, every pot is equally hard, not some hard, some soft.*

Many earthenware potters, including the Teagues, leave a skim of glaze on the bottom of the pots and set them on three-pointed stilts above the kiln shelves. After firing, the pot bottoms are ground smooth.

Using principally one base glaze with modifications for finish and color variety, the potters burn the kiln to 1,190 degrees Celsius (C/6). Some glazes designed for 1,145 to 1,165 degrees Celsius (C/3 to C/4) are set in cooler areas. The shop produces fifty shapes, including pitchers, bowls, and beanpots (see illustration, p. 58). Charles Craven turns a variety of shapes for them, including large vases and candlesticks. The ware is glazed brown, blue, white, and white speckled with blue. Daniel and Glory hope to use only Moore County clays and eventually some ash glazes, possibly also salt glaze fired with wood. Glory would like to use the old glazes: "We're getting tired of vividness, of talking about the colors. The beauty of a pot is in the most subtle glaze you can find."

Reflecting upon what makes a great pot, Daniel describes the turning of his two great-uncles, Charlie and Farrell Craven:

> *Their pots are distinguished cause they are crisp and definite. They have a positiveness, like in a painting. It's harder to paint a picture with a very few brushstrokes. You have to know exactly what you want to [do]. If you're going to paint with a lot of brushstrokes, you can muddle around and get something that will pass. A great potter, he knows what he wants, has it in his hands . . . has the vision with his eyes and goes ahead and makes it.*

Teague Pottery
Robbins, Moore County, North Carolina
Earthenware; local clay
Feldspathic and fritted glazes, in several colors
Catenary-arch kiln; oil; 1,165–1,190° C (C/4–C/6)
Pitchers, teapots, bowls, pie plates, mugs, jugs; vases, cannisters, candlesticks

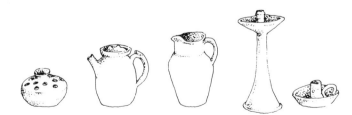

Westmoore Pottery

*Earthenware slip-trailed plate with clear
glaze made by Mary Farrell.
Photograph by Gabriella Koonce; courtesy
Randolph Technical College.*

*Mary Livingstone (Farrell) with potter
Ben Owen at his Old Plank Road Pottery,
Seagrove, N.C., late 1950s.
Photograph courtesy Mary Farrell.*

Mary Livingstone Farrell (born 1955) and David Farrell (born 1951) met as apprentices at Jugtown Pottery and opened Westmoore Pottery in 1977. Mary's mother often brought her five children to the Seagrove potteries when they were young. They visited the Coles, from whom Mrs. Livingston bought wares because they were cheap, and Ben Owen because he "took up a lot of time with the children." At the Coles they could always be assured that someone would be making pottery.

As a child Mary liked to shape animals from the clay she dug out of her backyard in Durham, North Carolina. It was not until high school that she first used a wheel. She claims, "I wasn't a natural at all."

I struggled for years, even in college. When I told the teacher I would like to do pottery she thought I was crazy because I had no talent. Pottery wasn't looked at as a thing you did for your living. It wasn't like maybe you'd be a doctor or a lawyer or a potter. It just didn't fit in that way. It was thought of more as a hobby, something you do in your spare time. So, for several years I thought of pottery that way, too. She didn't want me to make dishes and for the last two years I didn't. I made what they wanted me to, got my degree, and got out.

The teacher was training people to be teachers of pottery and [to make] all this crazy stuff, which isn't really pottery—more sculpture and nonfunctional things made of clay—but not dishes. It wasn't really her decision. It came down from the art department and from the head of the university. I knew she was always struggling to keep ceramics in the department. The art department and people above were pressuring her, saying that dishes weren't art. When I got out I went off looking for places to apprentice, at dishes.

Mary worked a summer at Jugtown and then apprenticed, first for eight months at Port Clyde Pottery in Nova Scotia near where her paternal grandparents lived and then at Jugtown Pottery beginning in early 1977.

As a youngster in Suffern, New York, Dave Farrell and a friend built with plasticene clay miniature cities and towns filled with people and animals.

We built the city up for six years, it must have weighed 250 pounds. My father was down on the floor with us for years, too. If I hadn't gone to college, I'd still be doing it.

Dave's father taught in Haverstaw, New York, and would bring home "hardening" clay from local mining sites. With this material Dave made sculptures of people, mostly Indians and cowboys. These were then fired in a studio in which ceramic Christmas trees were also made. He learned some of the physical properties of natural clay by modeling but only discovered that it would stretch when he started turning pots.

At college I was taking biology and stuff, trying to perpare myself for the real world, I suppose. . . . I took sculpture, too, and it was next to the pottery room. Pottery was an offshoot of sculpture, so I figured I'd give that a shot. I finally was realizing I would have to "do" something—that there is life after college. I didn't want to be a lawyer or dentist or teacher. You couldn't earn a living by being a sculptor, but I could see it was a semifeasible thing with pots. I have the first piece I ever put on the wheel. It's a jug and it's barely hollow.

New York University at Plattsburgh has one of the few university ceramic departments where the making of functional ware is taught. At Plattsburgh Dave worked with Bill Klock, who had spent a summer with Melvin Owens in Seagrove and from him had learned many traditional pottery techniques. After a year of graduate school in art, Dave worked at George Skatchard's pottery in Vermont, spent four months as an apprentice at Jugtown Pottery, returned north to work with Bill

Klock at his home pottery for a winter, then moved back to Jugtown in the spring of 1977. During his work at Jugtown, he developed his own forms, clays, and glazes; built a kiln; fired it; and sold his ware. Dave and Mary took his new line of pots to peddle door to door in Charleston. They returned certain that Seagrove was the best area for them to set up a shop. With Charles Moore's encouragement, they agreed with Lucille and Ben Owen to rent a recently vacated building of theirs.

Charles came with us to introduce us. We were scared and didn't realize then [that] the way you do things around here is, you visit. You go one time, go back, after about five times we were supposed to ask. Well, we waited about fifteen minutes! They kept hemming and hawing and nobody said yes or no. Then Charles said, "Well, you study on that Ben." In the end it was only two weeks from when we started looking till we rented that shop. At first we'd thought to try it here for a year. By the time another week went by we were aiming for a three-year lease. We spent October building the kiln and opened Thanksgiving weekend in 1977 with a lot of help from the people of Jugtown.

The Farrells started making medium range C/6 ware and slip-decorated earthenware. Dave had fired slipware with Bill Klock who had learned something of English slipware during a year at Bernard Leach's pottery in Cornwall. They tried more fully decorated slipware later when a customer showed them a photograph of a pot she wanted. They thought, "My, this is ugly, but if she wants it, we'll make it for her." In making the pot, however, they began to like it. In 1978 they built a second kiln to produce salt-glazed stoneware.

Their stoneware forms are drawn from traditional local shapes and early English forms. Their slip decoration has been influenced by early Moravian stoneware made in Old Salem, North Carolina (heavily decorated but without sgraffito design scratched through the slip), early Pennsylvania Dutch slipware (which has simpler brushed decoration with sgraffito design), and European slipware.

One branch of European potters crossed the ocean. We've gone back and picked up the trails of those who stayed there, especially their pierced work. They have a wider color range, and the Swiss have a deep blue we like.

Although their work is derived from diverse sources, their own turning and decorating styles impose a cohesiveness on the ware produced. Their annual production consists of one third slip-decorated earthenware and two thirds salt-glazed stoneware, with a few firings each of frogskin-glazed stoneware and feldspathic-glazed dinnerware. Ware to be salted is stacked in the kiln two or four pieces high and is separated by "snakes" of combined china clay, alumina hydrate, and sand. It is fired slowly in a tunnel kiln and kept in oxidation for five hours or until it reaches C/04. From then on the atmosphere is reduced, and slivered wood is burned as well as gas. The Farrells blow in forty pounds of salt at one time when the final temperature of 1,225 degrees Celsius (C/8) has been reached; the kiln is then burned for fifteen minutes and turned off. All other ware is burned in the rectangular, walk-in kiln. Dave is aware that gas kilns can explode. Therefore, flexible rubber gas hoses are connected to the burners, which are lit away from the kiln, then placed in the cinderblock port for the firing, and removed when finished. Four Venturi burners are used to fire both kilns.

Mary and Dave do not use local clays and consequently have some difficulty in making full curves on their large shapes. By adding bentonite, the clay's plastic strength is increased, but they are not wholly satisfied with the mixture and may begin a search for local clays. Their C/6 feldspathic glazes are fluxed with boron, the clear earthenware glaze with frits. The blue glaze used as a liner and salt-glaze decoration are made of stoneware scrap glazes with cobalt. The blue flower-and-bird decoration on this ware was inspired by early American stoneware motifs.

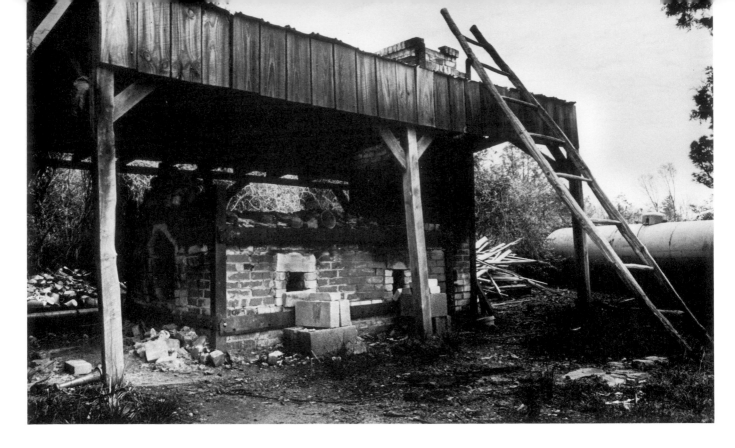

Tunnel kiln for salt firing
*Photograph courtesy Randolph Technical
College.*

David and Mary Farrell
*Photograph courtesy Randolph Technical
College.*

The Farrells pursue their goals energetically. They run a full-time shop and are building their own timber-and-brick home inspired by old-Salem architecture. They plan to build a shop next to their house by the spring of 1985. Mary and Dave were at first uneasy about settling in Seagrove among traditional potters. They felt isolated from the community at Jugtown, but once they opened the shop on Route 705 they had many local visitors.

The community accepts them because they work hard and have pursued the early potting tradition of the area. Mary sums up her feelings regarding Seagrove:

> *There's just a nice feeling to think you're living in an area where people have made a living making pots for a long time and to have working potters around. It's nice to know there is a background, especially for those who didn't grow up in it and wish they had. It's the next best thing to being adopted.*

Westmoore Pottery

Seagrove, Moore County, North Carolina
Stoneware and earthenware; commercial clay
Frogskin glaze, salt glaze, feldspathic, and fritted glazes
Tunnel and rectangular kilns; gas; 1,080°C (C/03),
 1,190°C (C/6), 1,125°C (C/8), 1,260°C (C/10)
Cooking and tableware, including plates, beanpots,
 mugs, coffee pots, platters; jugs, jars, churns,
 vases, flasks, lamps

Conclusion

The South's isolation from the rest of the country continued into the twentieth century and yielded only slowly to modernization. Agriculture remained central to the economy; migration to or from local areas was rare. The rural Southerner remained rooted to the land but became increasingly dependent upon a cash economy. Not until the Great Depression were men and women forced to look for work outside the community. In search of factory work, many moved temporarily to cities in the South and Midwest and sent their pay home. Others resettled their families permanently. While some desired modern urban life, most did not wish to be uprooted from their birthplace; this sense of loss is well documented in folk song.

Gradually the region attracted both tourists and permanent settlers seeking warm climates and escape from the crowded cities of the North. The civil rights movement and the move of industry to the Sun Belt have further opened the region. Despite the changes accompanying the rapid development of the South in recent decades, old ways still interlace the social fabric. In rural areas, individuals and families retain as much as possible their self-sufficiency and oral tradition. They continue to demonstrate those frontier qualities that have persisted through war, poverty, and unsettled times. Personal independence is central among these qualities, and to protect it individuals resist external regulation. Strengthened by a fatalistic acceptance of life, deeply held religious tenets, and the need to live by one's wits, the rural Southerner values hard work and community support.

Melvin Owens illustrates this outlook in describing glaze testing in the 1930s:

> It took us a little time to figure the glazes out, but it didn't cost too much money. Materials and freight was cheap then. I'd mix up five gallons of a new glaze. If it worked, it worked. If it didn't, [I'd] take it, pour it out, and forget about it. Marie's help[ed] me tote tons of it out. I'm talking about washtubs full.

Generosity, pride, a self-mocking humor, and common sense—traits, based on strong ties to land, family, community, and faith—have contributed to the perpetuation of southern culture as a whole and its pottery tradition in particular. An earthy, canny, and sometimes rolicking perception of human frailties and foibles has served Southerners with grace through hard times. While their humor can be poignant, it can also be playful. Dorothy Auman relates a common prank:

> The boys would go back out to the shop after supper and work up their clay for the next day. One of 'em would get there first, roll out a hunk of clay, make it look like a snake, coil it up. Always the shop had the log sill, six inches high at least, you had to step over as you went through the door. O.K., by then it was pretty dark, no light in the shop anyway, and just as you put your foot down, there it was. They would straddle that thing, try to jump back, or make a high jump over it, and everybody of course was watching. It was always good for a laugh. Do you know some of those snakes survived?

Whole communities, including potters, are interlocked by kinship, close or distant, direct or by marriage. Waymon Cole, says, "They told me they wouldn't let nobody marry into the family [in the old days] unless they promised to make pots." By the retelling of anecdotes, usually prefaced by, "Remember when," the fabric of

271

communal lore is woven with small and weighty occurrences. In this dynamic, shared memory, incidents of twenty-five and fifty years ago are kept so vivid that they are often related as recent happenings. A potter born in this century says, "We used Albany slip around 1890"; a potter speaking of his father says, "He would be 117 next February, if he was alive." Family identity reaches wide and deep giving continuity to the past.

Keen and retentive memory, common to all people of oral tradition, is an asset to traditional potters who are able to recall needed information as they constantly assess the variables of clays, glazes, and fire. Although a day's search for clay may have occurred ten years ago, a potter can still "see" the path and site of a clay pit deep in a woods; "see" the color of the clay as it was dug and after it was fired; "feel" how it turned; "know" its properties. Arthur Cole tested glazes constantly, keeping the results "in his head somewhere," with occasional cryptic reminders scratched on the shop wall in symbols and words meaningless to anyone else. Traditional potters have mistrusted information obtained from outside sources and prefer to rely and build on their own firsthand experience. Vernon Owens describes his ambivalence toward information obtained from outside sources:

> When I first started studying something about it, I didn't believe in oxidation and reduction. Didn't think there was anything to it, just a term these new potters had come up with. I had to convince myself before I believed it. Now there's no doubt in my mind. You've got to work at it in your mind, study on it. I thought and thought how to reduce [the kiln's atmosphere of oxygen] and make it work. When I quit a firing, the thing is always on your mind. You've got to remember what you've done, cause you had a different firing each time. You're burning with different wood, there's a different weather pattern, the kiln's got bigger pieces in it, or it's loaded a different way. It has to be in your mind. It doesn't make sense to write it down.

The economic structure that shaped a way of life and way of making pottery has been replaced, but the integral social structure supporting this lifestyle is changing only gradually. Long-respected moral values continue to guide behavior and inspire men and women. While Southerners seek and enjoy the boons of progress, they are also reluctant to abandon old ways. Perhaps the methods and ware produced by the traditional potteries are so cherished in the region because they are tangible reminders of the ways and values of the past.

Afterword

It is appropriate that this study of the traditions of southern pottery making, undertaken a decade ago, now has its home in the University of North Carolina Press. For this afterword to the new edition, I contacted many of the thirty-five traditional potteries featured in the preceding pages for an update on the changes that have taken place since the original edition of this book was published.

The early 1980s was an opportune time to examine the continuing pottery tradition of the South. I was able to tap the memories of older potters who were raised around shops making big ware like churns and jars or who had worked in shops struggling to change over to new types of ware for a broader market—such as smaller shapes for homes or earthenware pots for garden or patio—as the number of farming homesteads decreased. In the 1990s, the older generation of potters with roots in the late nineteenth and early twentieth centuries, who could or would not make different ware when the economy and life-style changed, are mostly gone. The mid-century generations (as well as younger ones, of course) have adapted to the commercial world successfully; they now both follow and help shape consumer demand. So we do see change, as is expected of a living, evolving tradition. The distinction between the three types of ware as categorized in the book, while never rigid, is blurring. Potters of each group now make large jugs and jars because their customers are interested in an earlier period of American history and want a touch of it in their homes. Likewise, some potters from each group are now making face jugs in considerable numbers, whereas once only utilitarian ware potters applied human features to jugs in occasional playfulness. The pottery families who moved into production of unglazed gardenware a half century ago are now under competitive pressure from imports and have, to some extent, resumed making jars and jugs.

Southern pottery, much documented and well publicized (for the very good reason that the pots, the potters, and their shops are unique of character), has once again been "found," and collectors vie with each other to purchase old pots and seek the "old-timey" look in newly made ones. In responding to this interest, potters have been pulled toward amalgamation of the types of ware they make, but individually they have kept their distinct styles. Despite this individuality, running through their collective work is an overriding southern potting style that emerged long ago from their shared community and innovative methods of making pottery. This style is the signature by which we know them.

Because of the general success of the traditional potters, there has been an unprecedented expansion of shops in central North Carolina and to some extent in other regions. In the Seagrove-Sanford area, where twelve of the potteries of the book's glazed ware category are located, there are now sixty-two shops, a substantial increase from the seven located there when I moved to Jugtown Pottery in 1968. Some of these new shops are related to the tradition by family or choice, but they are all drawn to the area by marketing opportunity.

Besides these general trends, the potteries covered in the book report the following news.

Potters who have now passed from the scene include Peter Anderson, Dot and Walter Auman, Viola Owens Brady, G. F. Cole, Waymon Cole, Howard Connor, Charles Craven, Hobart Garner, Bill Gordy, Arie Meaders, Ben Owen, Joe Owen, Marie Owens, Norman Smith, Gerald Stewart, and Duck and Jim Teague. These

potters each made distinct contributions to the occupation and art of pottery making. Their passing pulls threads from the overcovering fabric of the southern pottery tradition, leaving gaps that remind us of them but also of the durability of the whole fabric, which continues to reweave itself.

Some of the potters in the utilitarian stoneware tradition are stronger than ever, while others are slowing down; most are passing their knowledge on to younger family members. Jerry Brown says, "About all the change is I make more face jugs and got a different mule." Burlon Craig makes a little ware (one kiln a year), and his grandson Dwayne makes pots in the shop; Irene Craig says, "Dwayne learns by watching and being around him. You know how it is." Cleater Meaders burned twenty-three kilns last year; Cleater, Jr., has his own shop, where he makes alkaline-glazed stoneware using a mule-drawn mill to pug clay and a typical Meaders wood-fired kiln. Edwin Meaders continues to make roosters, firing them now in an electric kiln. Lanier Meaders makes a few candlesticks, while his nephew David and his wife Anita pot in his shop and burn the old kiln. Marie Rogers makes buggy jugs and other shapes and works "most times, unless I get to feeling lazy."

Whereas some of the potters making unglazed gardenware have expanded their production, others now also make some "old-timey" utilitarian glazed stoneware while operating retail gift shops or producing clay for local public schools. Wayne Boggs, Eric Miller, and the Wilsons fall into this latter category. Marshall Pottery has been sold by the Ellis family to another local family, the Illes family. They report no changes in the ware produced; five potters turn on wheels, but most of their pots are produced by early industrial methods. At Craven Pottery, Joe makes gardenware in the same way but also has turned his entrepreneurial talents toward large-scale retail marketing and other enterprises, including development of several garden centers and a campground. Hewell Pottery has expanded gardenware production, built an old-style log shop, and keeps the younger generation, Matthew and Nathaniel, at the wheels. Chester now makes alkaline-glazed stoneware burned with wood in a tunnel kiln, and Grace, sounding ever energetic, says, "Sure I still eat my Snickers bars—buy them fifty at a time."

Most of the potteries making glazed ware are operating as they were ten years ago; any changes involve saving labor and improving the product (in clay preparation or in burning more durable pottery at higher temperatures with electric or efficient gas kilns). As is the case with the gardenware potters, more are making "old-timey" stoneware as part of their production. Charlie Brown and his wife Jeannette make a new line of hard-fired cookware and some stoneware jars and jugs, burned in a groundhog kiln; Robert has opened a pottery making the same type of ware in Montana. In 1983 Walter Cornelison's sons at Bybee Pottery were agitating for change, but "Buzz" says "not a thing has changed except selling. People line up at dawn three times a week and sometimes use their cartons as weapons to get at what we've just burned." Nell Cole Graves now turns in the candle shop behind her home, where Richard Gillson burns her pots in his kiln; the old Cole shop opens only on Saturdays to sell what Nell makes. The Sanford Cole shop burned down in October 1993; it will reopen in early 1994, after which Neolia will continue to work full-time and Celia two days a week, making "same ware, same glazes, and I do still cut messages into the bottoms." After Foister Cole's death in 1991, Peggy, always a full partner, has continued to operate the G. F. Cole shop in the same way. Evan and Mercedes Brown and their daughter Cherry make the same ware (but not the big pieces) at Evan's Pottery, but with a new clay body "because the old clay pit gave out." D. X. Gordy is no longer making pots but allows a few local people to work in his shop and "hopes to burn the old kiln once more." At Hickory Hill, Danny and Leanne Marley farm as well as making "the same kind of pots with some new shapes and glazes." The Owenses at Jugtown Pottery have new gas kilns, some new glazes, and a museum. Vernon says he plans to focus more on making the tradition-

al shapes of the area in salt glaze and less on the Busbee Chinese-inspired forms. Oakland Pottery's Bob Armfield has added "old-timey" stoneware and a small groundhog kiln. Owens Pottery continues as a family business run by Boyd (with his father Melvin and his sister Nancy); it produces about 1,000 pieces a week, burned now at higher temperatures. Pisgah Forest Pottery makes only a little ware. Laura Moore makes "same ware, same way" at Potluck Pottery and says, "Why change if it works and I like it?" Seagrove Pottery closed immediately after the Aumanses' untimely deaths in an automobile accident in 1991; their son Snowden now rents out the shop. After Peter Anderson's death in 1984, Shearwater Pottery continues to be operated by the extended Anderson family; Jim, the youngest son, has assumed Peter's role as principal potter. Daniel Garner closed Teague Pottery shortly after Hobart Garner's death, but rumor has it that he and his brother J. D. Garner go down to the old shop once in a while and "fool around with some clay." Mary and Dave Farrell at Westmoore Pottery still burn a few gas kilns of salt-glazed stoneware, but most of their production is redware, decorated simply in a style influenced by local eighteenth- and nineteenth-century pottery and burned in electric kilns.

Other potters now working in the Seagrove area using methods related to the tradition include Sandy Cole Brown and Kevin Brown at North Cole Pottery; Billy Ray Hussey at Southern Folk Pottery Collector's Society Shop; Sidney Luck at Luck's Ware; Ben Owen III at Ben Owen Pottery; Hal and Eleanor Pugh at New Salem Pottery; and Archie and Yvonne Teague at A Teague Pottery, who sell their ware, as was once done, at a roadside stand.

The long-term future of the southern potting trade can only be surmised. However, if the proposed North Carolina Pottery Museum comes into existence in Seagrove, we can continue to study the work of a wide range of past and present southern potters and to learn more of the tradition's distinctive local and regional characteristics. A museum would enable the public (and the potters) to observe quietly the many variations of the art form and its subtleties of shape, texture, and glaze; to learn that the look and feel of a pot result from choices potters make about clay, glaze, and fire; and to understand how potters feel about their work. The museum would be a considerable asset to the pottery community and to the region and deserves strong support.

In closing this new edition of *Raised in Clay*, I would like to acknowledge the enormous contribution of my friend and colleague, Ralph Rinzler. While working with him over the past thirty years, I have been absorbing—by whatever magical process it is that occurs when one's caring and intellect are both aroused—the seminal concepts about folk art and folklife that he has been developing and bringing into public forums. Ralph enjoined me, and many of our colleagues, into "listening" to the heartbeat of American folklife and discovering the creativity of everyday people, and then into becoming advocates for and celebrators of folklife and its arts and artists. Because I have been "caught" by what Ralph has been working to define and make visible, my life has followed a special curve of adventure and learning.

I also thank my children, Sam, Lybess, and Martha Sweezy, for their always-ready support and generous spirits, and their children, Kate, Molly, Lily, Isabel, and Theo, for the many wonderful moments we share.

Bibliography

Compiled by Stuart C. Schwartz

Curator of History
Mint Museum, Charlotte,
North Carolina

Books and Articles

Auman, Dorothy, Robert Armfield and Susan King. *First Annual Seagrove Pottery Festival*. Seagrove, N.C.: First Annual Seagrove Pottery Festival Committee, 1982.

———, and Walter Auman. *Seagrove Area*. Asheboro, N.C.: Village Printing Company, 1976.

———, and Charles G. Zug III. "Nine Generations of Potters: The Cole Family." In *Long Journey Home: Folklore in the South*, edited by Allen Tullos, pp. 166–74. Chapel Hill, N.C.: Southern Exposure, 1977.

Barber, Edwin Atlee. *The Pottery and Porcelain of the United States*. 1902. Reprint. Watkins Glen, N.Y.: Century House American, 1973.

Barka, Norman F. *The Archeology of Kiln 2 Yorktown Pottery Factory, Yorktown, Virginia*. Yorktown Research Series, no. 4. Williamsburg, Va.: College of William and Mary, 1979.

———. "The Kiln and Ceramics of the Poor Potter of Yorktown: A Preliminary Report." In *Ceramics in America*, edited by Ian M. G. Quimby. Winterthur Conference Report, 1972. Charlottesville: University Press of Virginia, 1973.

———, and Chris Sheridan. "The Yorktown Pottery Industry, Yorktown, Virginia." *Northeast Historical Archaeology* 6, no. 1–2 (Spring 1977): 21–32.

Barnhill, William A. "Reems Creek Pottery." *Studio Potter* 7, no. 1 (1978).

Ben Owen Pottery. Catalog of an exhibition held at North Carolina Museum of History, Raleigh, N.C., June 1–July 15, 1974.

Bivens, John F., Jr. *The Moravian Potters in North Carolina*. Chapel Hill: University of North Carolina Press, 1972.

———. "The Moravian Potters in North Carolina." In *Ceramics in America*, edited by Ian M. G. Quimby. Winterthur Conference Report, 1972. Charlottesville: University Press of Virginia, 1973.

———, and Paula Welshimer. *Moravian Decorative Arts in North Carolina: An Introduction to the Old Salem Collection*. Winston-Salem, N.C.: Old Salem, Inc., 1981.

Blasberg, Robert W., and J. W. Carpenter. *George Ohr and His Biloxi Art Pottery*. Port Jervis, N.Y., 1973.

Brackner, Elmer Joe, Jr. "The Wilson Potteries." Master's thesis, University of Texas, Austin, 1981.

Branda, E., ed. *The Handbook of Texas*. Vol. 3. Austin: Texas State Historical Association, 1977.

Bridges, Daisy Wade. "Catawba Valley Pottery Has Unique Beauty." *Antiques Monthly* 13, no. 7 (May 1980): 13B.

———. "North Carolina Art Pottery." *1982 Mint Museum Antiques Show*. Charlotte, N.C.

———, ed. *Potters of the Catawba Valley, North Carolina*. Charlotte, N.C.: Mint Museum of History, 1980–81.

———, and Kathryn preyer, ed. *The Pottery of Walter B. Stephen*. Catalog of an exhibition sponsored by Ceramics Circle of Charlotte, 1978.

Burbage, Beverly S. "The Remarkable Pottery of Charles Decker and His Sons." *Tennessee Conservationist* 37, no. 11 (1971).

"Burlon Craig, Folk Potter." *Foxfire* 15, no. 3 (Fall 1981): 200–225.

Burrison, John A. "Afro-American Folk Pottery in the South." *Southern Folklore Quarterly* 42, no. 2–3 (1978). Reprinted in *Afro-American Folk Arts and Crafts*, edited by William Ferris. Boston: G. K. Hall & Co., 1983.

———. "Alkaline-glazed Stoneware: A Deep South Pottery Tradition." *Southern Folklore Quarterly* 39, no. 4 (1975): 377–403.

———. *Brothers in Clay: The Story of Georgia Folk Pottery*. Athens: University of Georgia Press, 1983.

———. "Clay Clans: Georgia's Pottery Dynasties." *Family Heritage* 2, no. 3 (1979): 70–77.

———. "Folk Pottery of Georgia." In *Missing Pieces: Georgia Folk Art, 1770–1976*, edited by Anna Wadsworth, pp. 24–29, 66–103. Catalog of an exhibition sponsored by Georgia Council for the Arts and Humanities, 1976.

———. "Georgia Jug Makers: The Story of Folk Pottery in a Southern State." Ph.D. dissertation, University of Pennsylvania, 1973.

———. "The Living Tradition: A Comparison of Three Southern Folk Potters." *Northeast Historical Archaeology* 7–9 (1978–80): 33–38.

———. *The Meaders Family of Mossy Creek: Eighty Years of North Georgia Pottery*. Catalog of an exhibition. Atlanta: Georgia State University Art Gallery, 1976.

———. "The Story of Southern Folk Pottery Has Yet to be Written." *Antiques Monthly* 2, no. 10 (1978).

———. "Traditional Stoneware of the Deep South." *American Ceramic Circle Bulletin* 3 (1982): 119–32.

Busbee, Jacques. "Jugtown Pottery." *Ceramic Age* (October 1929): 127–30.

Busbee, Juliana R. "A New Way for Old Jugs." *Bulletin of the American Ceramics Society* (October 1937).

"Bybee Pottery." *Pottery Collectors' Newsletter* 2, no. 10 (July 1973): 125–26.

Byrd, Joan Falconer. *A Conversation with Lanier Meaders*. Catalog of an exhibition held at Western Carolina University, Cullowhee, N.C. 1980.

———. "Lanier Meaders: Georgia Folk Potter." *Ceramics Monthly* 24 (October 1976).

———. "Meaders' Pottery, White County, Georgia." *Pottery Collectors' Newsletter* 3, no. 6 (March 1974): 73–77.

Byrd, Lonnie Dale. *One Hundred Years of Texas Pottery*. Winona, Tex., 1981.

Carson, Courtenay. "Seven Generations of Pottery Makers." *Sandlapper* 1, no. 8 (1968).

Chappell, Edward A. "Morgan Jones and Dennis White: Country Potters in Seventeenth-century Virginia." *Virginia Cavalcade* 24, no. 4 (1975): 148–55.

Clark, Garth. "George E. Ohr." In *Biloxi Art Pottery of George Ohr*. Catalog of an exhibition held at Mississippi State Historical Museum, Jackson, April 21–May 31, 1978.

———. "George E. Ohr: Further Aesthetic Notes." In *George E. Ohr*, edited by Ron Dale. Catalog of an exhibition held at University of Mississippi, 1983.

Clement, Arthur W. "Ceramics in the South." *Antiques* 59 (1951).

Conway, Bob. "The Golden Era of Mountain Potters." *State* 43, no. 5 (October 1975).

———. "Last of the Catawba Valley Potters." *State* 49, no. 2 (July 1981): 8–9.

———. "Wherein We May Be Number One." *State* 43, no. 5 (1975).

———, and Ed Gilreath. *Traditional Pottery in North Carolina: A Pictorial Publication*. Waynesville, N.C.: Mountaineer, 1974.

Counts, Charles, and Bill Haddox. *Common Clay*. Atlanta, Ga.: Drake House/Hallux, 1971.

———. *Common Clay/Indiana Revisions.* Indiana, Pa.: Halldin Publishing Co., 1977.

Coyne, John. "The Meaderses of Mossy Creek: A Dynasty of Folk Potters." *Americana* 8, no. 1 (March/April 1980): 44–45.

"The Craft Potters of North Carolina: Busbee, Hilton, and Stephen: The Influence of Oscar Louis Bachelder." *Bulletin of the American Ceramics Society* 21, no. 6 (1942).

Craig, James H. *The Arts and Crafts in North Carolina.* Winston-Salem, N.C.: Museum of Early Southern Decorative Arts, Old Salem, Inc., 1965.

Crawford, Jean. "Jugtown Pottery." *Western Collector* (July 1968).

———. *Jugtown Pottery: History and Design.* Winston-Salem, N.C.: John F. Blair, Publisher, 1964.

———. "Jugtown Pottery: A Way of Life." *Spinning Wheel* (May 1976).

Davis, Bert. "The Roosters I Make Aren't Just Like the Ones Momma Used to Make,' Edwin Meaders, Potter." *Foxfire* 17, no. 2 (Summer 1983).

Dunnagan, M. R. "Pottery Making, Ancient Art, Increasing in State." *E.S.C. Quarterly* 5, no. 2–3 (1947): 53–59.

DuPuy, Edward L., and Emma Weaver. *Artisans of the Appalachians.* Asheville, N.C.: Miller Printing Company, 1967.

Eaton, Allen H. *Handicrafts of the Southern Highlands.* 1937. Reprint. New York: Dover Publications, Inc., 1973.

Evans, Paul. *Art Pottery of the United States: An Encyclopedia of Producers and Their Marks.* New York: Charles Scribner's Sons, 1974.

Febres, George. "The Mad Potter of Biloxi: 'To Be Ohr Not to Be.'" *Arts Quarterly* 3, no. 4 (October–December 1981): 13–14, 28–29.

Fenengo, Franklin. "Pots, Pans, and Placenames: A Potter's Gazetteer of the American South." *Pottery Collector's Newsletter* 1, no. 5 (February 1972).

Ferrell, Stephen, and T. M. Ferrell. *Early Decorated Stoneware of the Edgefield District, South Carolina.* Catalog of an exhibition held at Greenville (S.C.) County Museum of Art, 1976.

Fields, Mary Durland. "Jugtown Pottery: A Ceramics Monthly Portfolio." *Ceramics Monthly* 31, no. 3 (March 1983): 53–60.

Fosset, Mildred Beedle. "The Hilton Craftsman." *Mountain Living* 4, no. 2 (Spring 1974)

Fredgant, Don. "The Case of the 'Lost' Potteries." *American Clay Exchange* 1, no. 10 (November 1981): 3–6, 15.

———. "Florida's Crary Pottery, 1933–1939." *Antiques Journal* 35, no. 4 (April 1980): 14–17, 47.

———. "T. B. Odom and J. W. Kohler: Two Nineteenth-century West Florida Potters." *Antiques Journal* (June 1981).

Gamp, Helen B. "A Craftsman of the Old School (O. L. Bachelder)." *International Studio* (October 1923).

Greer, Georgeanna H. "Alkaline Glazes and Groundhog Kilns: Southern Pottery Traditions." *Antiques* 61, no. 4 (1977): 42–54.

———. *American Stonewares: The Art and Craft of Utilitarian Potters.* Exton, Pa.: Schiffer Publishing Company, 1981.

———. "Basic Forms of Historic Pottery Kilns which May be Encountered in the United States." In *The Conference on Historic Site Archaeology Papers 1978,* pp. 133–47. Columbia, S.C.: Institute of Archaeology and Anthropology, University of South Carolina, 1979.

———. "The Folk Pottery of Mississippi. In *Made by Hand: Mississippi Folk Art,* pp. 45–54. Catalog of an exhibition held at Mississippi State Historical

Museum, Jackson, January 22–May 25, 1980.

————. "Groundhog Kilns: Rectangular American Kilns of the Nineteenth and Early Twentieth Centuries." *Northeast Historical Archaeology* 6, no. 1–2 (Spring 1977): 42–54.

————. "Meyer Family Pottery: A Ceramics Monthly Portfolio." *Ceramics Monthly* (June 22, 1974).

————. "Preliminary Information on the Use of Alkaline Glaze for Stoneware in the South, 1800–1970," pp. 159, 161–62. In *The Conference on Historic Site Archaeology Papers 1970*. Vol. 5. Columbia: Institute of Archaeology and Anthropology, University of South Carolina, 1971.

————. "The Wilson Potteries." *Ceramics Monthly* 29, no. 6 (Summer 1981).

————, and Harding Black. *The Meyer Family: Master Potters of Texas*. San Antonio, Tex.: Trinity University Press for San Antonio Museum Association, 1971.

Guilland, Harold G. *Early American Folk Pottery*. Philadelphia and New York: Chilton Book Company, 1971.

Hecht, Eugene. "An Ohr Primer, Part I: The Grand Deceit." *American Art Pottery* 67 (December 1981): 1, 4–5.

————. "An Ohr Primer, Part II: A Chronology with Beasties." *American Art Pottery* 73 (June 1983): 1, 6–8.

Helms, Charles Douglas. "An Historical Study of Folk Potters in and around Alton Community of Union County, North Carolina, from 1800–1950, with Emphasis on the Pottery of 'JugJim' Broome." Master's thesis, East Carolina University, Greenville, N.C., 1974.

Henzke, Lucile. *American Art Pottery*. Camden, N.J.: Thomas Nelson, Inc., 1970.

Hodon, Leona. "A Note (on the Marshall Pottery, Texas)." *Pottery Collectors' Newsletter* 5, no. 9 (November 1976): 100.

————. "Pisgah Forest Pottery Today." *Pottery Collectors' Newsletter* 5, no. 8 (October 1976): 88–90.

Horwitz, Elinor Lander. "Baskets and Pottery." In *Mountain People, Mountain Crafts*. Philadelphia and New York: J. B. Lippincott Company, 1974.

Hough, Walter, "An Early West Virginia Pottery." In *Report of the U.S. National Museum for the Year Ending June 29, 1899*. Washington, D.C.: U.S. Government Printing Office, 1901.

Hudson, J. Paul, and S. C. Malcolm Watkins. "The Earliest Known English Pottery in America." *Antiques* (January 1957).

Hume, Ivor Noël. *Here Lies Virginia: An Archaeologist's View of Colonial Life and History*. New York: Alfred A. Knopf, 1963.

————. "A Late-Seventeenth-century Pottery Kiln Site near Jamestown." *Antiques* 83, no. 5 (1963).

Humphreys, Sherry B., and Johnell L. Schmidt. *Texas Pottery: Caddo Indian to Contemporary*. Catalog of an exhibition held at Star of the Republic Museum, Washington, Tex., 1976.

Johnson, Lucille. "Poe Pottery." *Fayetteville Observer*, September 4, 1977. Reprinted in *Pottery Collectors' Newsletter* 7, no. 5 (June 1978).

Johnston, Pat H. "O. L. Bachelder: Omar Khayyam Pottery." *Pottery Collectors' Newsletter* 1, no. 11 (August 1972): 144–48.

————. "Omar Khayyam Pottery." *Antiques Journal* 29, no. 9 (September 1974).

————. "Pisgah Forest and Nonconnah Pottery." *Antiques Journal* 32, no. 5 (May 1977).

————. "Pisgah Forest Pottery." *Pottery Collectors' Newsletter* 1, no. 5 (February 1972): 58–59.

"Jugtown Has Gone to Pots." *Southern Living* (May 1974).

Jugtown: Jacques Busbee, 1873–1947. Catalog of an exhibition held at State Art Gallery, Raleigh, N.C., 1950.

Jugtown Pottery. Catalog an exhibition held at Salem (N.C.) College and Academy, September 10–28, 1972.

Jugtown Pottery: An American Folk Craft. Catalog of an exhibition held at University of North Carolina, Chapel Hill, November 30–December 23, 1947.

Kaufman, Stanley A. *Heatwole and Sutter Pottery.* Catalog of an exhibition held at Eastern Mennonite College, Harrisonburg, Va., February 5–March 5, 1978.

Keen, Kirsten Hoving. *American Art Pottery, 1875–1930.* Wilmington: Delaware Art Museum, 1978.

Kelso, William M., and Edward A. Chapell. "Excavation of a Seventeenth-century Pottery Kiln at Glebe Harbor, Westmoreland County, Virginia." *Historical Archaeology 1974* 9 (1974).

Ketchum, William C., Jr. "American Stoneware: The Product of a Single Century." *Antique Collecting* 1, no. 4 (August 1977): 6–7.

———. *The Pottery and Porcelain Collector's Handbook.* New York: Funk & Wagnalls, 1971.

———. "The Pottery of the South." *Antiques Journal* 28, no. 9 (September 1973).

Kindig, Joe, Jr. "A Note on Early North Carolina Pottery." *Country Things: From the Pages of the Magazine Antiques,* edited by Eric De Jong. Princeton, N.J.: Pyne Press, 1973.

Kovel, Ralph and Terry. *The Kovels Collector's Guide to American Art Pottery.* New York: Crown Publishers, Inc., 1974.

Landreth, Gerald K. "Excavations at the Trapp and Chandler Pottery Site (38-GN-169)." Master's thesis, University of Idaho, Moscow, 1983.

Leiby, Joyce. "George Ohr: The Potter's Potter." *Antique Collecting* 1, no. 4 (August 1977): 10.

Made by Hand: Mississippi Folk Art. Catalog of an exhibition held at Mississippi State Historical Museum, Jackson, January 22–May 25, 1980.

Mock, Esther. "An American Cart with a Pedigree." *Early American Life* (June 1973).

———. "The High Craft of Jugtown." *Hobbies* (November 1972).

Moore, J. Roderick. "Earthenware Potters along the Great Road in Virginia and Tennessee." *Antiques* 74, no. 3 (September 3, 1983).

Moose, Ruth. "Frogskin and Tobacco Spit: An Old Art Revived in the Piedmont." *Tar Heel* 7, no. 1 (January–February 1979): 15–17.

The Moravian Potters: An Exhibit of the Work of the Moravian Potters in North Carolina. Catalog of an exhibition held at Wachovia Museum, Old Salem, Inc., Winston-Salem, N.C., 1973.

"Nineteen Potters from North Carolina." *Studio Potter* 3, no. 1 (1974).

Northrop, Jo. "North Carolina's Country Potters." *Country Living* (April–May 1980): 62–65.

Norton, Robert. *Southern Antiques and Folk Art.* Birmingham, Ala.: Oxmoor House, Inc., 1976.

Ormond, Suzanne, and Mary E. Irvine. *Louisiana's Art Nouveau: The Crafts of the Newcomb Style.* Gretna, La.: Pelican Publishing Company, 1976.

Owen, Ben. "Reflections of a Pottery." In *The State of the Arts.* Raleigh: North Carolina Arts Council, 1969.

Owens, Vernon. "Building and Burning a Groundhog Kiln." *Studio Potter* 3, no. 1 (Summer 1974).

"The Pottery of Shearwater." *Southern Living* 8, no. 5 (May 1973): 48, 50.

Quimby, Ian M. G., ed. *Ceramics in America.* Winterthur Conference Report, 1972. Charlottesville: University Press of Virginia, 1973.

Radford, Fred W. *A. Radford Pottery: His Life and Works.* Privately printed, 1973.

Ramsay, John. *American Potters and Pottery.* 1929. Reprint. Ann Arbor, Mich.: Ars Ceramics, Ltd., 1976.

Rauschenberg, Bradford L. "American Tin-Glaze: The John Bell Inkstand." *Journal of Early Southern Decorative Arts* 3, no. 1 (May 1977).

———. "B. Du Val & Co./Richmond: A Newly Discovered Pottery." *Journal of Early Southern Decorative Arts* 4, no. 1 (1978).

———. "The Mysterious Duche." *Luminary: Newsletter of the Museum of Early Southern Decorative Arts* 4, no. 1 (Winter 1983): 6.

———. "A Sprigg Mould for 'Flowers for the Fine Pottery.'" In *The Conference on Historic Site Archaeology Papers, 1967.* Vol. 2. Columbia: Institute of Archaeology and Anthropology, University of South Carolina, 1968.

———. "Reflection on the Salem Master Potters." Manuscript on file at Old Salem, Winston-Salem, N.C.

Ray, Marcia. *Collectible Ceramics.* New York: Crown Publishers, Inc., 1974.

———. "Pisgah Forest Pottery." *Spinning Wheel* 27, no. 1 (January–February 1971).

Rice, Alvin H., and John Baer Stoudt. *The Shenandoah Pottery.* 1929. Reprint. Berryville: Virginia Book Company, 1974.

Rinzler, Ralph. "Cheever Meaders: North Georgia Potter (1887–1967)." In *Forms upon the Frontier,* edited by Austin Fife, Alta Fife, and Henry Glassie, pp. 77–78. Utah State University Monograph Series 16. 1969.

———, and Robert Sayers. *The Meaders Family: North Georgia Potters.* Smithsonian Folklife Studies, no. 1. Washington, D.C.: Smithsonian Institution Press, 1980.

Roberts, Nancy. "A Visit to Jugtown: Home of Rare Pottery." *State* (January 24, 1959).

Rush, Julia. "Journey to Jugtown." *State* 49, no. 8 (January 1982): 18–20, 53.

Sanders, Fred, and Milton Brock. "Lanier Meaders: Folk Potter." *Foxfire* 16, no. 1 (Spring 1982).

Sayers, Robert. "Potters in a Changing South." In *The Not-so Solid South: Anthropological Studies in a Regional Subculture,* edited by J. Kenneth Morland, pp. 93–107. Proceedings of the Southern Anthropological Society. 1971.

Schwartz, Stuart C. *North Carolina Pottery: A Bibliography.* Charlotte, N.C.: Mint Museum of History, 1978.

———. *The North State Pottery Company, Sanford, North Carolina, 1924–1959.* Charlotte, N.C.: Mint Museum of History, 1977.

———. "Royal Crown Pottery." *American Clay Exchange* 2, no. 9 (October 1982): 14–16 and no. 10 (November 1982): 4–5.

———. "The Royal Crown Pottery and Porcelain Company, Merry Oaks, North Carolina." *Pottery Collectors' Newsletter* 3, no. 5 (February 1974): 57–62.

———. "Traditional Pottery Making in the Piedmont." *Tarheel Junior Historian* 17, no. 2 (1978).

Settle, Stephen C. "The Tradition of Ben Owen, Master Potter." *G. Magazine* 3, no. 3 (May/June 1980): 24–25.

Sherrill, William L. *Annals of Lincoln County, North Carolina.* Charlotte, N.C., 1937.

Smith, Elizabeth S. "Burlon B. Craig, Potter." *Tar Heel* 8, no. 1 (February 1980): 52, 54.

Smith, Joseph Johnson. *Regional Aspects of American Folk Pottery.* Catalog of an exhibition held at Historical Society of York County, Pa., May 12–October 12, 1974.

Smith, Samuel D., and Stephen T. Rogers. *A Survey of Historic Pottery Making in Tennessee.* Nashville: Division of Archaeology, Tennessee Department of Conservation, 1979.

Smith, Thomas G. "Pottersville Museum: The Result of McClendon Serendipity." *Sandlapper* 3, no. 4 (1970).

Solis-Cohen, Lita, and Samuel Pennington. "Beware of Smiling Lions." *Maine Antique Digest* 8, no. 10 (October 1980): 16A–17A.

South, Stanley. "Alkaline-Glazed Pottery from South Carolina to Texas." *Notebook*. Institute of Archaeology and Anthropology, University of South Carolina, Columbia. 2, no. 9–12 (September–December 1970).

———. "Anthropomorphic Pipes from the Kiln Waster Dump of Gottfried Aust, 1755–1771." *Florida Anthropologist* 17, no. 2 (September 1965).

———. "The Ceramic Forms of the Potter Gottfried Aust at Betharbara, North Carolina, 1755 to 1771." In *The Conference on Historic Site Archaeology Papers*. Vol. 1. Columbia: Institute of Archaeology and Anthropology, University of South Carolina, 1967.

———. "The Ceramic Ware of the Potter Rudolph Christ at Bethabara and Salem, North Carolina, 1776–1821." In *The Conference on Historic Site Archaeology Papers*. Vol. 1. Columbia: Institute of Archaeology and Anthropology, University of South Carolina, 1970.

———. "Pottery of Gottfried Aust and Rudolph Christ at Bethabara and Salem." Paper presented at the Nineteenth Annual Conference on Historic Site Archaeology, Old Salem, Winston-Salem, N.C., 1978.

Spangler, Meredith. "In Prayse of Potts." *Journal of Studies of the Ceramic Circle of Charlotte* 2 (1973).

Stienfeldt, Cecelia, and Donald Stover. *Early Texas Furniture and Decorative Arts*. San Antonio, Tex.: Trinity University Press, 1973.

Stradling, Diana, and J. Garrison, eds. *The Art of the Potter: Redware and Stoneware*. New York: Universe Books, 1977.

Sweezy, Nancy. "Apprenticeship at a Traditional Pottery in North Carolina." In *Apprenticeship in Craft*. Goffstown, N.H.: Daniel Clark Books, 1981.

——— "A Hammermill in Jugtown." *Studio Potter* 4, no. 1.

———. "Tradition in Clay: Piedmont Pottery." *Historic Preservation* 27, no. 4 (1975): 20–23.

———. "Woodfiring in Traditional Southern Potteries." *Studio Potter* 11, no. 1.

Swick, Kathryn M. "Traditional Folk Pottery." *Mountain Living* 2, no. 4 (Fall 1980): 12–14.

Terry, George D., and Lynn R. Myers. *Southern Make: The Southern Folk Heritage*. Catalog of an exhibition held at McKessick Museum, University of South Carolina, Columbia, 1981.

Thompson, Robert, "African Influences on the Art of the United States." In *Black Studies in the University*, edited by Armstead Robinson et al., pp. 130–39. New Haven: Yale University Press, 1969.

Turner, Evan H. "'Is Granda's Pickle Jar the Work of a Master?': A Look at North Carolina Folk Pottery." *Carolina Arts* 1, no. 1 (Spring 1981): 20, 25.

Vlach, John M. *The Afro-American Tradition in Decorative Arts*. Kent, Ohio: Kent State University Press for Cleveland Museum of Art, 1978.

———. "Slave Potters." *Ceramics Monthly* 26, no. 7 (September 1978): 66–69.

Walker, Iain C. "Note on the Bethabara, North Carolina, Tobacco Pipes." In *The Conference on Historic Site Archaeology Papers, 1969*. Vol. 4. Columbia: Institute of Archaeology and Anthropology, University of South Carolina, 1971.

Wallach, Amei. "The Flamboyant Pottery of George E. Ohr." *Antiques World* 1, no. 1 (November 1978): 64–70.

Watkins, C. Malcolm, and Ivor Noël Hume. "The 'Poor Potter' of Yorktown." In *Contributions from the Museum of History and Technology*. Paper 54, pp. 73–111. Washington, D.C.: Smithsonian Institution Press, 1971.

Whatley, L. McKay. "The Mount Shepherd Pottery: Correlating Archaeology and History." *Journal of Early Southern Decorative Arts* 6, no. 1 (May 1980): 21–57.

Whitfield, Mary. "Jugtown: The Clay Spot of the South." *A Catalogue of the South.* Birmingham, Ala.: Oxmoor House, 1974.

Wigginton, Eliot, ed. *Foxfire 8: Folk Pottery, Cockfighting, Mule Swapping: Portraits of Five Black Appalachians.* Garden City, N.Y.: Anchor Press/Doubleday, forthcoming.

Willett, E. Henry, and Joey Brachner. *The Traditional Pottery of Alabama.* Montgomery, Ala.: Montgomery Museum of Fine Arts, 1983.

Williams, Ben F. "The Jugtown Pottery Collections." *Bulletin of the North Carolina Museum of Art* 5, no. 1–2 (Fall 1964–Winter 1965).

Wiltshire, William E., III. *Folk Pottery of the Shenandoah Valley.* New York: E. P. Dutton & Company, 1975.

Wunsch, Allen. "West Coast Florida Art Pottery, Ward/H. A. Graack & Sons Pottery (1915–1925?)." *American Art Pottery* 55 (December 1980): 1, 3.

Zug, Charles G., III. "The Alkaline-Glazed Stoneware of North Carolina." *Northeast Historical Archaeology* 7–9 (1978–80): 15–20.

———. "Jugtown Reborn: The North Carolina Folk Potter in Transition." *Pioneer America Society Transactions.* Vol. 3: 1–24. Akron: University of Ohio, 1980.

———. "Pursuing Pots: On Writing a History of North Carolina Folk Pottery." *North Carolina Folklore Journal* 2, no. 2 (November 1970): 34–55.

———. *The Traditional Potters of North Carolina.* Catalog of an exhibition held at Ackland Art Museum, University of North Carolina, Chapel Hill, 1981.

———. *Turners and Burners: The Folk Potters of North Carolina.* Chapel Hill: University of North Carolina Press, forthcoming.

Audio/Visuals

Crocks, Jugs, and Jars: The Smith Pottery. Slide/tape program on Norman Smith, traditional potter from Chilton County, Ala. Berea, Ky: Appalachian Museum, Berea College.

Earth, Fire, Water. Filmed interviews with eight Seagrove-area potters. Washington, D.C.: Davis Productions.

Jugtown: Pottery Tradition in Change. 16mm color film documentary, 28 min. Penn State University.

The Meaders Family: North Georgia Potters. Film. Washington, D.C.: Office of Folklife Programs in conjunction with the National Anthropological Film Center, Smithsonian Institution, 1978.

North Carolina Pottery. Slide program with script. Raleigh: North Carolina Museum of History.

Potters of the Piedmont. Film. Raleigh, N.C.: Halcyon Films.